Poitier Revisited

Poitier Revisited

Reconsidering a Black Icon in the Obama Age

Edited by
Ian Gregory Strachan and Mia Mask

Bloomsbury Academic
An imprint of Bloomsbury Publishing Inc

B L O O M S B U R Y
NEW YORK · LONDON · OXFORD · NEW DELHI · SYDNEY

Bloomsbury Academic

An imprint of Bloomsbury Publishing Inc

1385 Broadway	50 Bedford Square
New York	London
NY 10018	WC1B 3DP
USA	UK

www.bloomsbury.com

BLOOMSBURY and the Diana logo are trademarks of Bloomsbury Publishing Plc

First published 2015
Paperback edition first published 2016

© Ian Gregory Strachan, Mia Mask, and Contributors 2015

Library of Congress Cataloging-in-Publication Data
Poitier revisited: reconsidering a Black icon in the Obama age/edited
by Ian Gregory Strachan and Mia Mask.
pages cm
Summary: "A critical anthology re-contextualizing the work of one of America's most
recognized and celebrated actors, Sidney Poitier" – Provided by publisher.
Includes bibliographical references and index.
ISBN 978-1-62356-491-9 (hardback)
1. Poitier, Sidney–Criticism and interpretation. I. Strachan, Ian G. (Ian Gregory),
1969– editor. II. Mask, Mia, 1969– editor.
PN2287.P57P65 2014
791.43028'092–dc23
2014025350

ISBN: HB: 978-1-6235-6491-9
PB: 978-1-5013-1982-2
ePDF: 978-1-6235-6297-7
ePub: 978-1-6235-6923-5

Typeset by Deanta Global Publishing Services, Chennai, India

Contents

List of Figures vii

Acknowledgments viii

Notes on Contributors ix

Introduction: The Angry Angel 1

 1 Walking with Kings: Poitier, King, and Obama *Aram Goudsouzian* 5

 2 Historicizing the Shadows and the Acts: *No Way Out* and the
 Imagining of Black Activist Communities *Ryan De Rosa* 31

 3 Caribbean All-Stars: Sidney Poitier, Harry Belafonte, and the Rise
 of the African American Leading Man *Belinda Edmondson* 61

 4 "Draggin' the Chain": Linking Civil Rights and African American
 Representation in *The Defiant Ones* and *In the Heat of the Night*
 Emma Hamilton and Troy Saxby 73

 5 Whisper Campaign on Catfish Row: Sidney Poitier and
 Porgy and Bess *Jeff Smith* 97

 6 *To Sir, with Love:* A Black British Perspective *Mark Christian* 129

 7 "You'd be criminals!": Transgression, Legal Union, and Interracial
 Marriage in 1967 Film and Law *Kim Cary Warren* 145

 8 A Blues for Tom: Sidney Poitier's Filmic Sexual
 Identities *Ian Gregory Strachan* 163

 9 "Black Masculinity on Horseback: From *Duel at Diablo* to
 Buck and the Preacher . . . and Beyond" *Mia Mask* 189

10 Stepping behind the Camera: Sidney Poitier's Directorial
 Career *Keith Corson* 217

11 No Shafts, Super Flys, or Foxy Browns: Sidney Poitier's
Uptown Saturday Night as Alternative to Blaxploitation
Cinema *Novotny Lawrence* 233

12 Transcending Paul Poitier: *Six Degrees of Separation* and
the Construction of Will Smith *Willie Tolliver Jr.* 253

Index 271

List of Figures

Figure 1 Poitier's Rau Ru returns to kill Hamish Bond in *Band of Angels*. 3

Figure 2 Poitier is Dr John Wade Prentice in *Guess Who's Coming to Dinner*. 16

Figure 3 A surprise attack in *No Way Out*. 32

Figure 4 Poitier's Dr Brooks helps Ray Biddle. 37

Figure 5 Sidney Poitier in *Guess Who's Coming to Dinner*. 64

Figure 6 Harry Belafonte is David Boyeur in *Island in the Sun*. 66

Figure 7 Poitier helps Curtis blacken his face in *The Defiant Ones*. 81

Figure 8 The distance between Tibbs and Gillespie. 84

Figure 9 Poitier enters in his goat-drawn cart in *Porgy and Bess*. 115

Figure 10 Sidney Poitier and Brock Peters in a fatal struggle in *Porgy and Bess*. 117

Figure 11 Poitier as Thackery reflects after his talk with Seales. 131

Figure 12 Thackery shares a moment with Miss Blanchard. 136

Figure 13 The lovers share a kiss visible only in the rearview mirror. 147

Figure 14 John Wade Prentice is introduced by his fiancée. 154

Figure 15 Poitier and Hartman share a passionate kiss and embrace. 175

Figure 16 Poitier's Jack Parks kisses Abbey Lincoln's Ivy. 176

Figure 17 Virgil Tibbs spanks his wife's derrière. 179

Figure 18 Poitier and Khambatta in the closet. 183

Figure 19 Poitier and Garner in *Duel at Diablo*. 196

Figure 20 Poitier plays Toller in *Duel at Diablo*. 201

Figure 21 Poitier on horseback in *Buck and the Preacher*. 208

Figure 22 Gene Wilder and Richard Pryor star in *Stir Crazy*. 223

Figure 23 Harry Belafonte, Calvin Lockhart, et al. in *Uptown Saturday Night*. 239

Figure 24 Cosby and Poitier in *Uptown Saturday Night*. 243

Figure 25 Smith plays Paul Poitier in *Six Degrees of Separation*. 256

Figure 26 Smith plays Jay in *Men in Black*. 265

Acknowledgments

Ian Strachan: Many stories and many lives intersect to make a book like this possible. I am grateful to all my colleagues, particularly at the School of English at The College of the Bahamas, who helped make the Sidney Poitier International Conference and Film Festival possible in 2010.

I thank all the authors who have so generously agreed to have their work included in this volume. Their commitment to seeing a deeper and more nuanced appreciation of Sidney Poitier's work and its legacies reach the bookshelves is inspiring.

I wish to single out Mia Mask for her encouragement, persistence, patience, and positive attitude throughout this process. I also thank Shaniqua Higgs for her excellent work in helping me prepare this manuscript. And last but not least, I thank my wife Latasha, always my first reader.

Mia Mask: I thank Dr Ian Strachan for his vision, dedication, and perseverance. He had the vision to imagine a conference held at The College of the Bahamas that brought together a community of scholars from a variety of disciplines. He had the dedication to pursue this anthology as a result of our meeting. And he had the perseverance to bring the anthology project to fruition. It has been an honor and a pleasure to work with him. I look forward to future collaboration.

Notes on Contributors

Mark Christian received his PhD in sociology from The University of Sheffield, England. Currently, he is the book review editor for the *Journal of African American Studies*. His latest interdisciplinary research interests include the Liverpool Black Atlantic, African American music influences on The Beatles, and the development and struggle of African and African American Studies as a field/discipline in the twenty-first century.

Keith Corson received his PhD in Cinema Studies at New York University. He currently teaches courses related to film, television, and popular music at Rhodes College and Memphis College of Art. In addition to chapters in book anthologies, his work has appeared in the journals *Souls* and *Callaloo*. He is currently completing his own book about African American filmmakers in the decade following the blaxploitation cycle.

Ryan De Rosa teaches English in Los Angeles public schools. He has a PhD in Cinema Studies from New York University (2007) and has taught film and African American studies at Ohio University. His writing has appeared in *Cinema Journal* and the collection *American Cinema and the Southern Imaginary* (2011).

Belinda Edmondson is a professor in the Departments of English and African American and African Studies, an affiliate member of both American Studies and Women's and Gender Studies. She holds a PhD from Northwestern University. She is the author of *Caribbean Middlebrow: Leisure Culture and the Middle Class* (2009) and *Making Men* (1999) and she is the editor of *Caribbean Romances* (1999).

Aram Goudsouzian is the chair of the Department of History at the University of Memphis. His research interests are in American popular culture, African American history, and twentieth-century US history. Among his publications are *Sidney Poitier: Man, Actor, Icon* (2004), and *King of the Court: Bill Russell and the Basketball Revolution* (2010).

Emma Hamilton is a lecturer in History at the University of Newcastle, Australia. Her research interests involve the intersections between gender, history, and media representation in American and Australian culture. She has previously published works exploring the filmic representations of the American West, and discussions of the representation of the child in Australian cinema.

Novotny Lawrence received his PhD from the Department of Theatre and Film at the University of Kansas. He is currently an associate professor of Race, Media, and Popular Culture in the Radio-Television Department at Southern Illinois University-Carbondale, where he teaches courses such as Understanding Electronic Media, Media and Society, Documenting the Black Experience, and the History of African American Images in Film and Television. Dr Lawrence is the author of *Blaxploitation Films of the 1970s: Blackness and Genre* (2007).

Mia Mask, associate professor of Film, received her PhD from the New York University. At Vassar College, Mask teaches African American cinema, documentary film history, seminars on special topics such as horror film, and auteurs like Spike Lee. She also teaches feminist film theory, African national cinemas, and various genre courses. She is the author of *Divas on Screen: Black Women in American Film*. Her scholarly essays are published in the *African American National Biography*, *Screen Stars of the 1990s*, *Film and Literature*, and *American Cinema of the 1970s*.

Troy Saxby is a current PhD graduate student at the University of Newcastle, Australia. His current work examines the life and activism of the Rev. Dr Pauli Murray. He researches more broadly on the intersections between race and gender in American history, particularly during the civil rights movement.

Jeff Smith is a professor of Film in the Department of Communications at the University of Wisconsin-Madison. His research focuses on questions and issues arising from the study of film music/sound, cognitive film theory, and the American film industry. He is the author of *The Sounds of Commerce: Marketing Popular Film Music* (1998) and *Film Criticism, the Cold War, and the Blacklist: Reading the Hollywood Reds* (2014).

Ian Gregory Strachan is a professor of English at the College of The Bahamas. His research interests include Caribbean literature, politics, tourism, history and popular culture; literature, culture and gender identities in the Black diaspora; and race and film. His publications include *Paradise and Plantation: Tourism and Culture in the Anglophone Caribbean* (2002). He is also a published poet, playwright, and novelist.

Willie Tolliver Jr. is a professor of English, the director of Film and Media Studies, and the director of Africana Studies at Agnes Scott. Professor Tolliver's interests include African American literature, nineteenth-century American literature, Henry James, and film. He is currently working on a manuscript titled, *Deconstructing Will Smith: Theorizing Race, Celebrity, and Masculinity*. This study proposes to read actor/rapper Will Smith, perhaps the most successful black male entertainer in a generation, as a cultural icon.

Kim Cary Warren is an associate professor of history at the University of Kansas. She holds a PhD from Stanford University and is a scholar of gender and race in African American and Native American studies, history of education, and United States history. Warren's publications include *The Quest of Citizenship: African American and Native American Education in Kansas, 1880–1935* (2010).

Introduction: The Angry Angel

There is a notion of Sidney Poitier that is etched in our minds, an image immortalized in film. It is a powerful image. He stands before us, a dark prince. His eyes are magnetic, his smile disarming, and his voice gentle. His movements are confident, but light, graceful. His gestures are simple, precise, understated, but never wasted. There is no overt machismo. He emits warmth, decency, hopefulness, a willingness to believe the best about everyone he meets. He demonstrates sensitivity, empathy. He is capable of arresting silences, calm, cool; a stoicism even, which is abandoned only by an occasional fierce stare or razor sharp word shot through clenched teeth. This Poitier presents himself to us powerfully in films that captured the imagination of millions across the globe. Films that not only entertained but did work in the world as well: the work of black uplift, of social reform, of moral consciousness-raising, and of inspiration.

In these films Poitier presents a mask: the mask of the accomplished, well-spoken, aspiring, mild-mannered black man that America ought not fear, that the black middle class ought to be proud of, that racist white America would have trouble hating. His message was peace; his weapons were intelligence, fortitude, self-control, and love. His bearing was proud, but he was not vengeful, not confrontational.

He was beautiful and strong. He spoke in a tone that could not really be geographically located—an American English approximation forged by a West Indian immigrant struggling to fit in after spending the first 15 years of his life in the Caribbean. He was American enough, and different enough, to please. He smiles at us in a business suit, clean shaven, shirt perfectly white, hair never too low or too high to call attention to itself, always neat. The first appearance of this persona is Dr. Luther Brooks in *No Way Out* (1950). He presents himself to us again (albeit with fewer credentials) in *Edge of the City* (1957) and then finds his full form in films like *A Patch of Blue* (1965), and *In the Heat of the Night* (1967). He is meant to be the bourgeois wish-fulfilling symbol of a race: isolated, singular, invested in the white Other, reflecting the Other in values, in faith in the American Dream.

He is "the same" in all it would seem but skin color. He is not pushy; his dignity, intelligence, and moral fortitude call attention to his existential plight: he is not just equal but *better* than the Other. And yet he is excluded. The problem must be resolved. He does not beg or grovel, but neither is he prepared to kick the doors down with his big black size 12 shoe. Some came to see the pose as that of an Uncle Tom; some saw it always as the bearing of a hero.

Scholarship has left Sidney Poitier there, frozen somewhere between 1963 and 1967. And it seems to have forgotten him, perhaps dismissed him. It certainly reduces him or worse yet, ignores him. And yet it is impossible to have a discussion of the history of blacks in film that excludes him. Indeed, it is hard to discuss the range of notions white America has had of black masculinity in the past 60 years and exclude him.

Interestingly, at the dawn of this so-called post-racial age of Barack Obama, Poitier's iconicity was again invoked. Obama was elected in 2008 and assumed office on January 20, 2009. Four days before his inauguration a *New York Times* story entitled "How the Movies Made a President," featured a still of Poitier, Katherine Houghton, and Spencer Tracy from Stanley Kramer's controversial classic, *Guess Who's Coming to Dinner*. What people saw in candidate and President Obama they had seen decades before in the Poitier persona described above: cool, eloquence, beauty, genuine warmth, exceptionality, and ambiguity of identity. Indeed, it was clear to conservatives and liberals alike that one had paved the way for the other; that Poitier had primed the white American imagination as it were, for the historic election of the first black President of the United States. As Jabari Asim contends in his 2009 book, *What Obama Means*, "No Poitier, no [Denzel] Washington. No Poitier, no Jamie Foxx, no Forest Whitaker. And quite possibly no Barack Obama."

But there is more to the Poitier oeuvre than the 1960s model Negro he played in liberal race problem films, much more. There are other performances by Poitier that go ignored. There is, for instance, the angry angel we meet in most of his 1950s films; films like *A Band of Angels* (1957) where Poitier plays Rau Ru, the educated slave raised as the son of a plantation owner, Hamish Bond (Clark Gable). Rau Ru speaks angrily and passionately about black oppression and swears he will kill his master. He strikes a white slave owner and flees for his life, returning to the South as a member of the Union Army. Poitier's performance transcends the offensive paternalism of the film's Hollywood narrative and resonates with anger, defiance, intelligence, humanity, and unbowed pride.

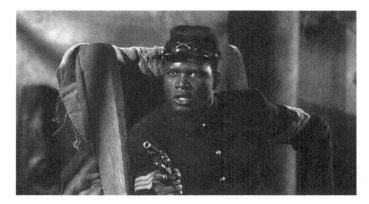

Figure 1 Poitier's Rau Ru returns to kill Hamish Bond in *Band of Angels*.

This is the same pride and fearlessness we see from Poitier's Corporal Robertson in the 1952 World War II drama *Red Ball Express*. Here Poitier plays a black soldier in German-occupied France who is insulted by a fellow American soldier. "Black boy you give orders to no one. You take'em." Poitier's response is, "Well I'm not taking any from you." For his defiance, the white soldier takes a swing at him. Poitier blocks the punch and then strikes the white soldier.

Poitier brings a number of complex, strong characters to the screen in the 1950s, like Gregory Miller of *Blackboard Jungle* (1955), Kimani of *Something of Value* (1957), and Porgy of *Porgy and Bess* (1959). What distinguishes most of these roles from the ones America rewarded with huge box office returns is that the characters mentioned herein struggled with internal conflicts. They could be dangerous, even lethal; they were ambivalent and multifaceted; and they were not always clear about right and wrong. Poitier's layered performance as Walter Lee Younger, perfected over years on Broadway in the 1950s, is another fine example. In *A Raisin in the Sun* (1961), Walter Lee is a ball of passion, confusion, frustration, and occasional stupidity. He wants desperately to be more than he is and he questions the value, not only of his own life, but also of the sacrifices others made for him. He is seduced by materialism, contemptuous of the work he does to feed his family and despises white racism. When Walter Lee lunges at George Murchisson (Louis Gossett Jr.), when he leaps over a table with an imaginary spear in his hand, or when he imagines himself selling out to the racist white neighborhood association, we see a protean figure, struggling to make himself in a world that seduces and betrays him, not a cardboard fabrication produced to soothe the troubled mind of white America. He is an angry angel, a man ill at ease with the world in which he finds himself, boiling over with passion and

longing, ready to explode in the face of hopelessness, but possessing, despite the odds, a sense of decency. But Hollywood preferred simplicity.

It was this recognition that so much had yet to be said about Poitier's life on the silver screen that inspired the Sidney Poitier International Conference and Film Festival, held at The College of the Bahamas in February 2010. Scholars came together to engage in spirited dialogue about Poitier's 50-year career in cinema. The highlight of the occasion was a telephone interview with Poitier himself, shared with the entire conference audience.

Out of that wonderful, multidisciplinary exchange of ideas came the beginnings of this book, *Poitier Revisited: Reconsidering a Black Icon in the Obama Age*. There is a mixture here of original conference papers, previously published essays on Poitier and commissioned pieces. It makes for a rich and diverse dialogue/debate about Poitier's enduring legacy, his place in the pantheon of American cinematic icons, and his role in shaping representations of black masculinity.

The significance of the Poitier icon and the Poitier oeuvre to the Obama age is explored here but our focus, more broadly, is on the multivalent legacy of a fascinating and gifted artist. The chapters cover the course of his long career, from Zanuck's *No Way Out* and Sam Goldwyn's fraught project *Porgy and Bess*, to Poitier's Westerns, his forays as a director and his impact on the next generation of black male movie stars. What we hope emerges is a keen sense of the enormity of his contribution, influence, and achievement, not merely as "a collector of firsts" but as a man who from the most unlikely of origins rose to symbolize the hopes and aspirations of an entire race, a man who sought, against the odds, to open a space in the very closed world of Hollywood for people of African descent to tell stories of hope and of victory.

The chapters in this book speak to each other, echoing and challenging, unpacking, interrogating, and deepening our understanding of the man, the actor, the activist, the director, and the author. Our goal has been to add significantly to the body of scholarship on a subject woefully underexamined. I believe we have done just that.

Bibliography

Asim, Jabari. *What Obama Means: For Our Culture, Our Politics Our Future* (New York: HarperCollins, 2009).

Dargis, Manohla and A. O. Scott. "How the Movies Made a President," *New York Times*, January 16, 2009.

1

Walking with Kings: Poitier, King, and Obama

Aram Goudsouzian

It was 2003. A tall, thin man with pointy ears and brown skin named Barack Hussein Obama was running for the US Senate. At first glance, his chances for victory seemed slim. He spoke candidly about his peculiar racial heritage, and unlike some other black politicians, he refused to tack to the center in an effort to reach a broad swath of voters. He opposed the war in Iraq, and, as an Illinois State Senator, he had helped pass legislation to reduce wrongful executions, curb racial profiling of criminal suspects, extend a program for state-sponsored children's health insurance, and start a job-training program for unskilled workers.

Yet Obama was winning over white voters—even the older, blue-collar types who tended to perceive African American politicians as serving only black interests. "The thing about Obama," admired one middle-aged white union official, "is that there are no racial lines, there are no party lines. He reaches everybody." Obama disarmed his audiences with modesty and restraint, and then he appealed to their better instincts, calling for progressive reforms based on the shared ideals of humanity. He often cited his own background as the child of a black man from Kenya and a white woman from Kansas. He both took pride in his blackness and appeared comfortable within elite institutions. He had been the editor of the *Harvard Law Review*, law professor at the University of Chicago, and Illinois State senator. Now he set his sights even higher.

Early in the race, Obama's campaign manager Jim Cauley ran focus groups with well-to-do, liberal women from Chicago's North Shore. If the campaign were to broaden beyond Obama's base in the African American community, he needed these voters. Cauley showed photos of the candidates to one group of women, aged 55 and older. What did they think when they saw Dan Hynes, the state comptroller from an eminent family in Chicago politics? "Dan Quayle,"

they answered. How about the multimillionaire Blair Hull? "Embalmed," cracked one woman. And how about Barack Obama? "Sidney Poitier."

"Shit," thought Cauley. "This is real."[1]

It was 1967. Under a cloud of gloom and doubt, Martin Luther King Jr. was introducing the keynote speaker for the tenth anniversary convention banquet of the Southern Christian Leadership Conference (SCLC). In the decade since the formation of the SCLC, the civil rights movement had delivered awe-inspiring accomplishments: it had stirred the nation's conscience, inspired federal legislation that eroded Jim Crow, and stoked the pride of African Americans. King's stirring powers of oratory, his appeals to man's better nature, his fusion of Christian brotherhood and constitutional democracy, and his ethic of nonviolence had defined a generation of black activism, and he had emerged as a central figure in American public life.[2]

But by SCLC's tenth anniversary, the movement was in disarray. That summer, race riots had plagued many cities, with particularly bloody results in Detroit and Newark. Many African Americans continued to suffer from deep poverty. The Civil Rights Bill of 1966 had died on the Senate floor, and "white backlash" had become part of the political lexicon. The Vietnam War drained resources to combat domestic ills, and it wasted the lives of young Americans. The recent cry of "Black Power" called for racial pride and unity, but in King's mind, it remained "a nihilistic philosophy born out of the conviction that the Negro can't win." If he occupied the moral center of the movement, he increasingly found himself pulled in multiple directions, and he encountered agonizing political dilemmas—a confusion evident by the convention, whose theme was "Where Do We Go from Here?"[3]

King called the keynote speaker his "soul brother." Like King, he expressed a noble ideal, seeking peace in an uncertain time. "From the moment I met him I found him to be one of the finest and warmest human beings that I have ever met. . . . I consider him a real friend. . . . He is a man of great depth. . . . Here is a man who has never lost a basic concern for the least of these God's children." King stated that this man "has carved for himself an imperishable niche in the annals of our nation's history." He had served his own role in the fight for racial equality by projecting a public dignity, charm, and essential goodness that reflected upon a broader quest for justice. He was, concluded King, "a man with an unswerving devotion to the principles of freedom and human dignity, a man of genuine humanitarian concern and basic goodwill, my friend and your friend, Sidney Poitier."[4]

Sidney Poitier never registered a voter, never led a civil rights organization, never ran for elected office. Yet, in the struggle for racial equality, he occupies a central place in the American imagination. His status reveals the power of Hollywood, which can reflect popular ideals and prejudices, as well as mold public opinion. Moreover, it speaks to Poitier's talents as a barrier-breaking icon. Until Poitier, black film characters were relegated to stock stereotypes of comic sidekicks, loyal servants, and tragic mulattoes. Poitier was Hollywood's first black leading man, the first black star to consistently portray charismatic characters of integrity. His image possessed profound power, but also showcased the double standards imposed upon black public figures. His life and career intersects, in different and interesting ways, with those of the two most important men in African American political history.[5]

Poitier's career was molded by the odyssey of Martin Luther King. Poitier rose to stardom in the mid- to late 1950s through films such as *Blackboard Jungle* and *The Defiant Ones*, just as King was emerging as the preeminent voice of the civil rights movement and leading such campaigns as the Montgomery Bus Boycott. In 1964, Poitier won the Academy Award for Best Actor for his role in *Lilies of the Field*, within a climate created by the Birmingham Campaign and the March on Washington, when King most effectively stirred the nation's moral conscience. And Poitier's most successful movies—*To Sir, with Love*, *In the Heat of the Night*, and *Guess Who's Coming to Dinner*—appeared in the uncertain political atmosphere of the late 1960s, amidst urban riots, Black Power, and conservative backlash, when King and Poitier both sought to recapture a lost ideal. King's assassination in April 1968 signaled, to some degree, the demise of Poitier's superstardom.

In the years since then, the memory of Martin Luther King has become sanitized and sanctified, and Sidney Poitier has become his Hollywood stand-in: a symbol of pure black goodness, an archetype of inclusion and forgiveness. That icon has served the political career of Barack Obama. Like the Bahamian-born Poitier, Obama represents Black America without the burden of America's tortured past of slavery and Jim Crow. Political commentators and voters have understood Obama through their appreciation of Poitier, a "Magic Negro" who transcended the nation's racial ills, even as political opponents have used Poitier as a weapon against Obama. Again and again during Obama's historic 2008 campaign for the presidency, his appeal was explained by citing *Guess Who's Coming to Dinner*—the movie that most exaggerated the attributes associated with the Poitier hero.

But to fully understand Poitier's connections to both King and Obama, one must recognize Poitier as not just an actor and icon, but also as a man. He has long considered the links between his humanity and his image, while also recognizing the distinctions between them. He has seen his life as a series of passages, and his identity has straddled national borders. He has constantly appreciated his life's lessons—the fragile and important faith in his choices, the intricate construction of his personal notions of manhood, and the recognition of his social and political responsibilities. When his life, his career, and his adopted nation approached their crossroads, he confronted the challenges before him. And, when the world recognized his supporting role in the historic milestone of the election of a black president, he appreciated the longer journey.

In 1957, just as Poitier was emerging as a screen actor of consequence, Dorothy Masters of the *New York Daily News* suggested that "Sidney would, if he elected to change careers, make a fine minister of the gospel." Four years later, with Poitier's stardom established, Masters wrote that "with his tremendous empathy, acute sensitivity and inner fire, he ought to approach the Pearly Gates as an evangelist." Then, in 1962, she elaborated that he "has the attributes of an evangelist—spontaneity, compassion, warmth, courage, and integrity." Masters liked Poitier as a person, but she was also associating him with the characteristics of Martin Luther King.[6]

Poitier had supported King since the young minister's emergence in the mid-1950s, after the Montgomery Bus Boycott. In 1957, he had joined King at the Prayer Pilgrimage in Washington DC, when civil rights leaders sought the attention of the Eisenhower administration. In 1960, he joined a committee to support King's legal defense against a spurious lawsuit by Alabama officials, and the next year he spoke at a fund-raising "Tribute to Martin Luther King" at Carnegie Hall. In 1963, he participated in the March on Washington, the nationally televised mass meeting climaxed by King's famous "I Have a Dream" speech. In the late 1960s, as Black Power activists offered public criticisms of King's core goals of racial integration through nonviolent direct action, Poitier continued to support King, as witnessed by his keynote speech at the 1967 SCLC conference.[7]

But it was Poitier's screen image that most tied him to King. In a host of movies, his characters engaged in sacrifice, building bridges of understanding with white characters. In *Edge of the City* (1957), his Tommy Tyler dies after intervening in a dispute between his white friend and a corrupt dockworker, stimulating his friend's sense of self-worth. In *The Defiant Ones* (1958), his

Noah Cullen jumps off a train to accompany his fellow escaped convict, a white man whom he once hated and now embraces. In *Lilies of the Field* (1963), his Homer Smith builds a chapel for some German nuns with altruistic pluck. His mannered, conscientious, dignified screen image—primarily the construction of white liberal screenwriters and directors—served as an advertisement for racial integration. Like civil rights demonstrations, they placed black heroes on a higher moral plane.

Lilies of the Field, in particular, capitalized upon a swelling mood in support of racial equality. In the spring of 1963, SCLC's civil rights campaign in Birmingham, Alabama, won international support. The world looked on with horror as police responded to nonviolent street demonstrations with attacks from fire hoses and dogs, along with mass arrests of men, women, and children. That August, the March on Washington rallied support for civil rights legislation. Though a modest, low-budget film, *Lilies of the Field* captured the era's racial sentiment, making the film an unlikely phenomenon and helping Poitier win the Academy Award for Best Actor.[8]

Poitier was a "race man," a hero whose success reflected upon all black people. Yet, African Americans tended to understand that Poitier's sacrificial characters, like nonviolent civil rights protests, bore costs. Both held black people to a higher standard, suggesting that their path to genuine citizenship demanded that they showcase extraordinary discipline and morality. Famously, in 1958, James Baldwin watched *The Defiant Ones* in a downtown New York theater and was struck by how the primarily white audience applauded and wept when Poitier's character dove off the train to stay with his new white friend, even though he could have rode that train to freedom. When Baldwin watched the movie again at a Harlem theater, the black audience screamed "Get back on the train, you fool!"[9]

By the time Poitier addressed the SCLC conference in 1967, debates over the relevance of his image had increasingly entered the public realm. The media's focus had turned to violent urban uprisings and the overheated rhetoric of militants such as Stokely Carmichael and H. Rap Brown. In this context, Poitier's virtuous heroes offered a balm for the nation's racial wounds. In *To Sir, with Love*, he played a teacher who tames a rowdy classroom in London's East End, transforming the white working-class ruffians into sweet-tempered graduates. *In the Heat of the Night* features his ultra-talented Philadelphia detective Virgil Tibbs, who is stuck in the South and helps a racist white sheriff solve a murder. In both films, Poitier's characters enlightened whites while exhibiting talent,

restraint, and virtue. During the fall of 1967, the films traded the top spot at the box office, and a Gallup poll determined that more than any other actor, Poitier's name alone would sell movie tickets. He was a black hero who contradicted the images of urban unrest and black militancy.[10]

Moreover, Poitier continued to exhibit a sizzling vitality on screen. In the film *In the Heat of the Night*, he is a man of unimpeachable intelligence, class, dignity, and pride. Some African American critics, including Baldwin, lamented the lack of a black perspective—Virgil Tibbs lets Rod Steiger's lowly, uncouth southern sheriff dictate the terms of their relationship. But when Tibbs is slapped by an effeminate white aristocrat for a perceived insult, Tibbs slaps him back. "The repressed wrath of the Black Man for his American bondage was finally portrayed on screen," noted one reviewer, who saw the scene as a cathartic milestone in the history of Black Hollywood, a moment "invested with atonement for the shufflin' indignities and foolish 'singin' darkies' of a dreadful past."[11]

The rise of Black Power was nevertheless disrupting the political foundation underneath Poitier's career. An emerging generation of black militants considered his films white liberal fantasies of black people, not authentic black creations. They argued instead that black people should control their own destiny, determine their own heroes. As one African American woman in Los Angeles wrote in early 1967, the "Lily White Negro, Poitier . . . is not symbolic of us and we do not identify with him"; he is a "clean-cut eunuch in the white world."[12]

In September 1967, a headline in the *New York Times* asked: "Why Does White American Love Sidney Poitier So?" The black playwright Clifford Mason referred to Poitier's screen image as "the antiseptic, one-dimensional hero . . . a good guy in a totally white world, with no wife, no sweetheart, no woman to love or kiss, helping the white man solve the white man's problems." Writing from the perspective of Black Power and the Black Arts Movement, Mason condemned the politics underlying Poitier's hero. Black heroes should not solve white people's problems, he suggested, but should exhibit black pride, black manhood, black aggression. In Mason's nastiest turn of phrase, he referred to Poitier as a "showcase nigger."[13]

A few months later, *Guess Who's Coming to Dinner* premiered. The star-laden spectacle became Poitier's third runaway success in a span of 6 months, but it also inflated every aspect of the Poitier icon. *Newsweek* described his character, John Prentice, as a "composite Schweitzer, Salk and Christ"—a world-renowned

doctor who defers to the parents of his prospective bride, a younger white woman, whether to continue his marriage plans. If Poitier soothed a liberal center that cherished his mannered black hero, he also inspired a new round of derision. When director Stanley Kramer toured college campuses, students complained that the film bent over backward to sanitize interracial marriage without showing any interracial sex. It had been conceived as groundbreaking, but it exhibited an old-fashioned do-gooder liberalism. The radical critic Maxine Hall Elliston rhetorically spit on it: "Whites will love to see this Black nigger try to crawl into white society, and at the same time hate him for kissing a white girl." She judged the entire premise "warmed-over white shit."[14]

Guess Who's Coming to Dinner represented the final appearance of Poitier's saintly icon, the final box-office chart topper, and the final film to inspire deep vitriol among Black Power critics. The nation's racial politics had shifted much faster than Hollywood's moviemaking cycle, rendering the movie an instant antique. Driven by both loyalty and sincere political beliefs, Poitier defended the film's message. "I try to make motion pictures about the dignity, nobility, the magnificence of human life," he said. He considered the film, like his previous efforts, part of a culture that urged the public "to understand, to tolerate, to love, to enjoy."[15]

So Poitier's image refracted both hope and rage. It was an outsized political burden, which he recognized better than anyone. "I'm the only one," he said. "I'm the only Negro actor who works with any degree of regularity. I represent 10,000,000 people in this country, and millions more in Africa."[16] No one man could effectively represent the entirety of black people, and that was the exact responsibility that Hollywood had ladled upon him. He knew that scripts neutered his characters, that they compromised his humanity, that they created too-perfect characters that satisfied white liberal neuroses. But what was his alternative? To play villains? To resuscitate old stereotypes of black brutality or inanity? No, he would continue trying to spread positive messages of love and understanding. His films, he said in August 1967, "are interesting, marvelous fables, and I like what they have to say. They warm the heart, and there's nothing wrong with that."[17]

At the same historical moment, Martin Luther King found himself in a similar political bind. When a gunman wounded James Meredith on his "March against Fear" through Mississippi in June 1966, King had envisioned a crusade that would coalesce support for a civil rights bill before Congress; instead philosophical disputes and Black Power colored media portrayals of the mass

march. Later that summer, the SCLC campaign for open housing in Chicago faltered due to Mayor Richard Daley's powerful political machine, the violent resentment of the city's ethnic whites, and King's own inability to build an effective coalition.[18]

King's pursuit of social justice kept evolving—becoming more radical, but more inclusive. In November 1966, he met with his closest compatriots at an SCLC staff retreat in Frogmore, South Carolina. After celebrating how the civil rights movement was dismantling the system of Jim Crow in the South, he acknowledged that Black Power was "a cry of pain," while a white backlash surfaced due to the consistent challenge of the civil rights movement. High unemployment rates for black urban youths suggested the continuing problems of ghetto conditions, class inequality, and entrenched poverty. "We must honestly face the fact," he told his fellow ministers and activists, "that the Movement must address itself to the restructuring of the whole of American society."[19]

In his final years, King called for all Americans to acknowledge their social responsibilities. Whites needed to realize that the ideals embodied in the Declaration of Independence entailed sacrifice—among King's calls for a radical restructuring of the nation's value system, he proposed a guaranteed annual income for every American citizen. As for African Americans, they needed to not only realize their self-worth and overcome assumptions of white superiority, but also engage in continued political action that projected their concerns and values on a wider stage. Black Power suggested an admirable self-pride, but it also portrayed a problematic renunciation of white allies as well as a lack of faith in the nation's highest ideals. The entire nation, he argued, needed to understand the global dimensions of social and economic inequality. "A true revolution of values will soon look uneasily on the glaring contrast of poverty and wealth," he wrote.[20]

King knew that his prescriptions would cost him mainstream salience, but he pushed further. Disgusted by the impact of warfare upon the people of Vietnam, and discouraged by the Johnson administration's futile attempts to fund both domestic programs and a costly overseas war, King became one of the most prominent critics of Vietnam War. By early 1967, he was marching in antiwar rallies, and, in April, he delivered his famous speech at Riverside Church in the New York City, when he asked how Americans could remain faithful to nonviolence when their government was engaged in such massive violence.[21]

On April 4, 1968, King was assassinated in Memphis, Tennessee. In this period of national mourning, Poitier was a poignant Hollywood stand-in for King.

The same issue of the *Pittsburgh Courier* that reported the assassination also featured a still of Poitier—as Simon of Cyrene, in *The Greatest Story Ever Told*, when he helps Jesus Christ carry the cross up Calvary. And, at the Academy Awards, which were initially postponed due to King's assassination, *In the Heat of the Night* and *Guess Who's Coming to Dinner* dominated the proceedings, winning between them Best Picture, Best Actor, Best Actress, Best Original Screenplay, and Best Adapted Screenplay. Poitier won a massive ovation when presenting an award. Gregory Peck celebrated both films for their messages of racial equality. Poitier's *In the Heat of the Night* costar Rod Steiger ended his acceptance speech with the words, "We Shall Overcome."[22]

After the Oscars, Poitier's place in American culture shifted. No longer would he serve as Hollywood's single response to the civil rights movement. No longer would he bear Hollywood's burden of representing the plight of the world's dark-skinned people. No longer would debates about his films reflect larger divisions about the possibilities and limitations of the black freedom movement. Yet, for a generation, Poitier had served as popular culture's most preeminent expression of the ideals embodied by Martin Luther King.

Sidney Poitier influenced the life of Barack Obama—even his very birth. In 1959, Poitier was among the leaders and celebrities who met with the Kenyan politician Tom Mboya during his 5-week tour of the United States. Along with figures such as Jackie Robinson and Harry Belafonte, Poitier funded the African American Students Association, which provided university scholarships to Kenyan students. The endeavor provoked the suspicions of the British Embassy and the US State Department; both institutions feared that these students would stir anti-American sentiment and cause racial unrest. Yet the program allowed for a Kenyan named Barack Obama to attend the University of Hawaii, where he met Ann Dunham. In 1961, they sired a son who bore his name.[23]

Moreover, because his father was a black man marrying a white woman at the dawn of the civil rights era, a Poitier character infiltrated the family narrative. "Have you ever seen *Guess Who's Coming to Dinner*?" Ann's father, Stanley Dunham, often asked. "Well, I lived it." When she brought home a Kenyan student, Stanley admitted to feeling like Spencer Tracy's character, Matt Drayton. He professed to believe in racial equality, expressed confusion when his ideals clashed with his gut reaction, and ultimately accepted the marriage with some admiration for the black man's polish. Even though the film appeared years after the Obama–Dunham wedding, it resonated with the older white man.[24]

The younger Barack Obama has called himself "a prisoner of his own biography." Tied by his skin color to the experience and history of African Americans, he nevertheless had to seek his own black identity, which helped him see multiple perspectives on race and politics. While he grew up in Hawaii and Indonesia, his father was in Kenya, an absent and distant ideal. Far from the continental United States, he first grabbed a hold of African American life through his white mother, who fed him a diet of black achievement and excellence. He recalled that in his mother's telling, "Every black man was Thurgood Marshall or Sidney Poitier; every black woman Fannie Lou Hamer or Lena Horne." She played him records by Mahalia Jackson and read him books about Martin Luther King. Young Obama understood African American culture through such picture-perfect models.[25]

If Obama later understood this narrative as romantic, he also embraced the history of the civil rights generation as his own. In time he applied his own story—the mixed-race outsider, transcending society's divisions with pluck and idealism—to his larger political odyssey. "There's not a liberal America and a conservative America; there's the United States of America," he intoned at the 2004 Democratic National Convention. "There's not a black America and a white America and Latino America and Asian America; there's the United States of America." In January 2007, just before declaring his presidential candidacy, Obama delivered a speech in Selma, Alabama, site of a historic civil rights campaign in 1965. He painted the African American freedom struggle as a universal lesson for equality. Throughout his political ascent, moreover, Obama invoked Martin Luther King—not the embattled radical of the late 1960s, but the pure and loving icon that emerged in the popular consciousness in the decades since his assassination.[26]

Like Poitier, Obama exuded a restrained assurance; his campaign manager described him as "grounded, sane, and relatively happy . . . methodical, calm, and purposeful." Also, like Poitier, Obama did not have a typical African American background; even as his skin color made him a representative of black aspirations, he avoided associations with black American stereotypes such as laziness, violence, or ignorance. And, just as Poitier's heroes continually sacrificed to help white characters, Obama made the conscious decision to keep race in the background of his campaigns. Rather than play on the liberal guilt, he engendered a spirit of racial unity.[27]

On the one hand, black voters were part of Obama's core constituency. On the other hand, he stood in contrast to politicians such as Jesse Jackson

or Al Sharpton, whom whites perceived as engaging in racial confrontation and representing only blacks. In 2004, Don Terry, a biracial author who grew up in the Chicago neighborhood of Hyde Park, wrote about the political upstart with whom he shared many similarities. His article in the Sunday magazine of the *Chicago Tribune* was titled "The Skin Game: Do White Voters Like Barack Obama Because 'He's Not Really Black'?" It troubled Terry that white supporters kept saying that Obama transcended race, or that he was "postracial," or that they did not consider Obama black. Such opinions were not only wishful thinking, but also implied negative assumptions about "regular" black people.

At the article's conclusion, Terry recalled flipping on *Guess Who's Coming to Dinner*, starring Sidney Poitier. His character, John Prentice, was "a super-qualified, super-handsome, super-dashing doctor living in Hawaii." He had to be absurdly exceptional just to attract a white woman and win favor with her liberal white parents. "As I watched," wrote Terry, "I realized that Barack Obama and John Prentice have a lot in common."[28]

The invocation of Poitier reappeared during Obama's presidential campaign. During the South Carolina democratic primary election in January 2008, Obama's team was locked in a battle with Hillary Clinton's camp over her remarks about the civil rights era: Clinton had celebrated Lyndon Johnson for translating Martin Luther King's protests into civil rights legislation, prompting a media kerfuffle that she had maligned King's legacy. In the midst of this jockeying over the candidates' projections of leadership and racial progress, Robert Johnson, the founder of Black Entertainment Television, spoke at a pro-Clinton rally. He said that Bill and Hillary Clinton had immersed themselves in black politics "since Barack Obama was doing something in the neighborhood—and I won't say what he was doing, but he said it in the book." Johnson seemed to be alluding to Obama's memoir *Dreams from My Father*, in which he admitted to having experimented with drugs.[29]

"That kind of behavior does not resonate with me, for a guy who says, 'I want to be a reasonable, likable, Sidney Poitier 'Guess Who's Coming to Dinner,'" continued Johnson. "And I'm thinking, I'm thinking to myself, this ain't a movie, Sidney, this is real life." Though widely publicized, Johnson's comments never gained much traction: his moral authority was as dubious as his logic and syntax. After all, as one critic stated, he had won his fortune by "building and then selling a network known for a steady stream of rump-shaking and thug videos."[30]

Yet, throughout the election, commentators drew connections between Poitier and Obama. They surmised that Poitier's image helped explain the rising Obama phenomenon of 2008. Black critics, in particular, referenced *In the Heat of the Night*; Poitier's Virgil Tibbs is, like Obama, a man of intelligence, professional success, steely pride, and conscious restraint. Others recalled *A Raisin in the Sun*; Poitier's Walter Lee Younger shows resolve, breaks psychological chains, and seizes a better life despite white resentment.[31]

The *Guardian*, a British publication, noted that decades after the politically charged 1960s, "the Poitier model—composure, smarts, quiet authority— suddenly makes a lot of sense. It's a long time since a black man in a suit got called an Uncle Tom by his own people or a dolled-up monkey by racists." In the *New York Times*, Manohla Dargis and A. O. Scott argued that popular culture helped foster Obama's election by providing "fantasies of black heroism": strong leaders, father figures, and forgiving messiahs that originally derived from Poitier's groundbreaking image.[32]

Guess Who's Coming to Dinner most often served as a touchstone. Poitier's John Prentice is a black man who, despite extraordinary achievement and talent, has to plea for acceptance by liberal white America, as symbolized by Spencer Tracy and Katharine Hepburn. Prentice places the fate of his marriage in the older couple's hands, conveys a sincere charm, and exudes restraint. Also, he offers a lighthearted "prediction" about his mixed-race children. Talking to Tracy about his daughter's sunny idealism, Prentice says, "She feels that every single one of our children will be President of the United States, and they'll all have colorful administrations."

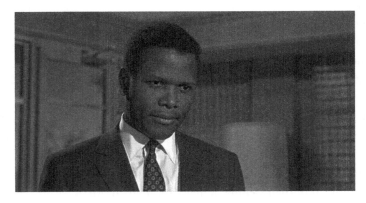

Figure 2 Poitier is Dr John Wade Prentice in *Guess Who's Coming to Dinner*.

That line resonated in 2008, when a mixed-race child won the highest office in the land. A diverse host of thinkers—film critics, African American political commentators, newspaper columnists from Canada and Kansas, bloggers based in Japan, progressive academics in India—drew parallels to the movie. "Forty-two years later . . . in astoundingly prophetic form, Poitier's words are proven true," wrote Morris O'Kelly in the *Los Angeles Examiner*. Upon Obama's election, he posted the clip from *Guess Who's Coming to Dinner* online. "I can think of no better way to contextualize the significance of this moment in American history."[33]

Yet, during the campaign and its aftermath, others acknowledged that the redemptive power of the Obama phenomenon raised some troubling questions. As early as March 2007, *Los Angeles Times* columnist David Ehrenstein cast a cynical eye on white liberals' admiration of Obama: "Like a comic-book superhero, Obama is there to help, out of the sheer goodness of a heart we need not know or understand." Ehrenstein placed Obama in the tradition of "The Magic Negro"—the benevolent black man who emerges without a background, never changes, and helps white heroes. The Magic Negro is a staple of modern American popular culture. This recurring character, Ehrenstein writes, is "there to assuage white 'guilt' (i.e. the minimal discomfort they feel) over the role of slavery and racial segregation in American history, while replacing stereotypes of a dangerous, highly sexualized black man with a benign figure for whom interracial sexual congress holds no interest."

The Magic Negro has been played by Morgan Freeman, Michael Clarke Duncan, and Will Smith, but its founding father is Sidney Poitier. Ehrenstein mentions *Lilies of the Field* and *To Sir, With Love*, but *Guess Who's Coming to Dinner*, he writes, "is particularly striking in this regard, as it posits miscegenation without evoking sex. (Talk about magic!)." Ehrenstein further recalls the saga of David Hampton, a young black man who masqueraded as the son of Sidney Poitier to win favors in New York high society, a story popularized through the play and movie *Six Degrees of Separation*. As Obama prepared to run for the presidency, there remained this liberal impulse for the "noble, healing Negro"—the same impulse that led people to adore Poitier's movies or to assume David Hampton told the truth. "That's where Obama comes in: as Poitier's 'real' fake son."[34]

Ehrenstein cautioned that the Magic Negro played by Poitier and Obama allowed whites to indulge in fantasies of racial healing, rather than confronting actual racial barriers. But his opinion piece, written from a progressive

perspective, won additional attention as a source of controversy within the Republican Party, just as conservatives were grappling with Obama's popularity and fashioning new narratives about race in America.

Paul Shanklin, a conservative comedian and satirical songwriter, read Ehrenstein's column and heard Al Sharpton's subsequent criticism that Obama needed to more actively champion African American causes. To the tune of "Puff the Magic Dragon," Shanklin fashioned a song called "Barack the Magic Negro," in which he imitated Sharpton singing through a bullhorn. The song opens with lines about how voting for Obama absolves liberal whites of their guilt, and then it contrasts Obama to "real black men" like Sharpton, Louis Farrakhan, and Snoop Dogg, who "have talked the talk, walked the walk./Not come in late and won!" Shanklin regularly appeared on the radio program of Rush Limbaugh, and this song proved a hit among listeners on the political right. In March and April 2008, it often played on Limbaugh's program.[35]

The song plugged into a swelling resentment among many conservatives. They griped that voters saw Obama as a messiah, while liberals excused black criminality and lack of upward mobility. They, too, drew parallels to Poitier. On one conservative blog, an online discussion about white guilt and liberal voters was titled "The Return of Sidney Poitier." It started:

> A not insignificant reason why white Americans in the early 1960s supported racial equality was that they inchoately believed that blacks were like Sidney Poitier. . . . Obama is Sidney Poitier, a nice-looking, friendly, intelligent, nonthreatening, civilized black man with great personal appeal. That is what the white American imagination found to its delight in the early Sixties, then lost, and now has found again—and this time whites don't just get to see him in a movie, they get to vote for him to be the Democratic presidential nominee.[36]

Until late December of 2008, "Barack the Magic Negro" stayed off the radar screens of most Americans. By then, Obama was the president-elect, and the Republican Party was losing minority voters. It struggled with the question of how to oppose a black president without seeming racist. At this point, one of the seven candidates running for the chairman of the Republican National Committee, Chip Saltsman, sent committee members Paul Shanklin's CD *We Hate the USA*, which included the song "Barack the Magic Negro." He meant it as a "lighthearted" Christmas gift to be received in "good humor." But without the context of Ehrenstein's column, the gag backfired. "This is so inappropriate

that it should disqualify any Republican National Committee candidate who would use it," said Newt Gingrich. "There are no grounds for demeaning him or using racist descriptions."[37]

Obama's election to the presidency ultimately compelled reflection across the political spectrum. What, on the whole, did it say about the state of African American life? Jabari Asim, editor of the NAACP's magazine *The Crisis*, answered that question with a book titled *What Obama Means: for Our Culture, Our Politics, Our Future*. Shelby Steele, a senior fellow at the Hoover Institute and prominent black conservative, answered the question with his own book, *A Bound Man: Why We Are Excited about Obama and Why He Can't Win*. Both authors, despite their opposing outlooks, interpret Obama through the prism of Sidney Poitier.

While placing Poitier's film roles within the model of the Magic Negro, Asim acknowledges that Obama has adopted a similar role as a dark-skinned outsider sent to redeem America's racial sins. He realizes, too, that both Poitier and Obama have frustrated their supporters with their consistent, calculated restraint, even in the face of gross attacks. Yet, Asim argues that Obama's success stems from channeling Poitier's version of cool. The unruffled exterior, the effortless courtesy—it appeals to women and disarms white men. Asim also recalls a story from Poitier's past, when, before making *Guess Who's Coming to Dinner*, Spencer Tracy and Katharine Hepburn invited him over and sized him up. The moment smacked of condescension, but it also began what Poitier called "an intense creative partnership with a black man." Asim sees that phrase as a metaphor for the nation and Obama—"an intense creative partnership" fraught with challenges but full of possibilities.[38]

Steele recalls the same tale with Tracy and Hepburn, but he does so to place Poitier within the tradition of the "bargainer," the black figure who treats whites with grace and understanding. His movie roles conveyed the same message. Steele argues that this style elevates blacks' moral standing and flatters whites by allowing them to cast off racial guilt. Like other "iconic Negroes" such as Oprah Winfrey and Nelson Mandela, he "embodies the highest and best longings of both races," and "both whites and blacks can see the historic shames of their races at last overcome." Obama is another "bargainer," in contrast to "challengers" such as Al Sharpton and Jesse Jackson, who stake their political careers on identifying and publicizing racist practices. But Steele is skeptical that President Obama can sustain this model: to represent African Americans, he must adhere to the narrative of black victimization that is at odds with his persona.[39]

Obama, of course, is more than an icon: as his own memoir insists, he has traveled a winding path in search of his identity, and as his election reveals, he is a shrewd and hard-nosed politician. On the eve of his election, *New York Times* columnist Frank Rich wrote that the political and media establishments had kept underestimating Obama's candidacy by asking the same questions: Is he black enough? Is he tough enough? They kept reading him through the image of the polished, mannered, accomplished, forgiving racial outsider. In reality, he was black enough, and he was tough enough. As Rich reflected on the nation's racial journey, with all its historic triumphs and continued tribulations, he watched, for the first time in 45 years, Sidney Poitier in *Guess Who's Coming to Dinner*. Rich, like so many others, was struck by a movie star and a popular film that were imprisoned in a foreign past, and yet now, remarkably, appeared once again relevant.[40]

"I have known men who, if their measure were taken, would be found to be living out their lives in ways peculiar to their nature," stated Poitier at the 1967 SCLC convention banquet, after Martin Luther King had introduced him. Those opening words exposed the core of Poitier's long-standing value system, and they evoked his longer personal journey. In his trademark verbal style of roundabout formality, Poitier used the language of his father: the measure of a man.[41]

What did it mean, for the Sidney Poitier of 1967, to be a man? "Of all my father's teachings, the most enduring was the one about the true measure of a man," he later wrote. "That true measure was how well he provided for his children, and it stuck with me as if it were etched in my brain." Providing for children meant far more than supplying food, clothing, and shelter. He was a famous movie star, after all; the Russian Tea Room served as his local hangout, and if the housekeeper was away, he stayed at the Plaza Hotel. Part of him reveled in his wealth, which contrasted so starkly with his hardscrabble early life. But another part fretted about America's materialistic values, which contradicted his understanding of his parents' rock-solid grounding in family unity and personal dignity. His parents, Reginald and Evelyn Poitier, had drilled him with discipline, reinforced by violence, while American parenting styles were more permissive and indulgent. Finally, in his own personal conduct, Poitier struggled to reconcile his values and his behavior. He wanted to be a good father, but he was a lousy husband to his wife Juanita, especially

by carrying on a twisting, agonizing 9-year relationship with the actress Diahann Carroll.[42]

At the SCLC banquet, Poitier reminisced upon a previous time in Atlanta, back in 1943. A lonely sojourner struggling with the Jim Crow South, he was trying to chart his next step. "I stood here in a bus terminal in this city trying to decide, where will I go from here: back to Florida, or out into the world. I made my choice to go out into the world. I bought a ticket and started my journey with a bus ride into the unknown." He rode to New York, where he continued to struggle with bone-chilling winters, empty stomachs, and the racial hypocrisies of American democracy. Yet in Harlem, Poitier encountered the American Negro Theatre, the premier organization for black actors in the postwar years. He embraced the details of the craft, became a voracious reader, traveled the country, met friends and lovers, and developed enough acting chops that he won his first Hollywood role in the 1950 film *No Way Out*.[43]

Yet Poitier's reflections lacked any tinge of self-satisfaction over his consequent stardom. If anything, he considered the challenges ahead. "Twenty-four years have since passed above my head, and now, my journey has led me once more to pause again at the crossroads and wonder, where will I go from here." Unlike his first visit to Atlanta, this crossroads was less geographical than philosophical. Black Power had disrupted the political foundation underneath Poitier's career.

For guidance, Poitier looked to Martin Luther King—not as a political icon, but as a man of character. "I have known men who will not take responsibility for a choice, even a correct choice, if it costs too much," said Poitier. "Men who have tamed their natural instincts to meet the required standard for indifference. Men who have a position of no position, on too many of the issues, that if left unaddressed will corrode further the dignity and integrity of human life." Poitier indicated his disappointment with such men, but he also suggested an understanding: "More than once in my life, I too have been at some of these stations myself."

King, by contrast, made public choices based on private convictions. He understood the potential effectiveness of nonviolent direct action, but he embraced nonviolence as a way of life. While realizing the unique trials, frustrations, and aspirations of African Americans, he envisioned a society built on broader platforms of social justice and human dignity. Sometimes his choices spawned incredible successes. Sometimes they fizzled in failure. In either case,

those choices were rooted in principle. King's courage, said Poitier, "has made a better man of me." On behalf of the assembled guests, Poitier delivered effusive thanks. Instead of restating all of King's accomplishments, he praised King as "a new man in an old world."

A new man in an old world? Should it have been the opposite? Like Poitier's icon of sacrifice and dignity, was not Martin Luther King's embodiment of nonviolence and integration threatened by the new black politics? But if understood on Poitier's terms, both "old world" and "new man" adopt added significance.

Poitier's "old world" described a society built on an unstable foundation. He saw it every day, while reading the newspaper at the breakfast table, while watching the news on television, while listening to the news in his car. In Vietnam, tens of thousands American troops escalated a tragic conflict. In American cities, the persistent poverty and hopelessness of the ghetto spawned arson, attacks on police, looting, anarchy. In Congress, liberal optimism had faded—racism, poverty, war seemed entrenched. For a man who radiated such faith in humanity on screen, Poitier communicated an astonishing pessimism about the state of the world:

> The philosophy of materialism by which men shape and conduct much of their lives seems to have become the principal force in all of their undertakings. So much so that it is leading in my psyche to a harvest of too many negative by-products: greed, selfishness, indifference to the suffering of others, corruption of our value system, and a moral deterioration that has already scarred our souls irrevocably. On my bad days I am guilty of suspecting that there is a national death-wish active within our borders. And on my worst days the death-wish seems to be international.

This chaos of this society, believed Poitier, reflected the selfish values of its men. Its only antidote was a "new man." This man renounced materialism, spurned greed, and embraced the power of love. He found the shreds of social conscience and human dignity, and he reinforced those fibers with his own faith. He offered society a new beginning. The prototype of this new man, of course, was Martin Luther King.

For Poitier, whose career and life could be seen as a never-ending grappling with the applications of his own principles, King lent an example. His first crossroads in Atlanta had been a personal, even selfish, time for decisions. This crossroads was something else. He had felt like an old man in this old world. No longer. "I will go from here back out there into what I have known and try to

make a new world full of love, and that new world . . . will have had its beginning in my old heart . . . here, tonight." Like King, he called for a revolution in values. Tonight, he said, "I have decided to start with myself."[44]

The road ahead remained bumpy. In the coming years, a new generation of films created heroes that consciously reversed the Poitier icon. "Blaxploitation" films such as *Shaft, Superfly,* and *Sweet Sweetback's Badasssss Song* reveled in fantasies of ghetto life, in excesses of violence and women. Poitier grew cynical with his fall from favor, even moving back to Nassau. In private, he burned at the backlash. In a never-published interview with Ruby Dee recorded in January 1970 for historical posterity, Poitier grumbled about a new generation that lacked his work ethic, yet blamed him for Hollywood's race problem. "What kind of shit is this, waiting for Sidney Poitier to lead the way out of the fucking wilderness?" he cried.[45] No longer bound to serve as a solitary symbol, he started to make films that satisfied his own vision.

Through the First Artists Production Company, he crafted movies that affirmed his core values and touched his core audience. He made his directorial debut in 1972 with *Buck and the Preacher,* a Western film costarring his best friend Harry Belafonte. He admitted that another director might have delivered a more entertaining film, but they wanted "a certain substance, a certain nourishment, a certain component of self. We wanted black people to see the film and be proud of themselves, their history."[46] Similarly, the next year's *A Warm December* was an old-fashioned tear-jerking love story, but it injected attractive, appealing blacks into romantic slots that had been historically reserved for white stars. He then directed and produced a comedic trilogy that costarred Bill Cosby and employed a host of black actors and crew members: *Uptown Saturday Night, Let's Do It Again,* and *A Piece of the Action.* His earlier films, he said, "were white guys' pictures. I was part of *their* statements for 20 years. Now these are mine and those of my constituency."[47]

Poitier kept acting, directing, and producing through his golden years, and over time he found work on smaller-scale projects that communicated his values. He has also written three memoirs; if the first is a straightforward narrative of his rags-to-riches story, the later ones are meditations on the lessons of his past, on the nature of his faith, on the challenge of his insecurities, and on the power of love.[48]

If Poitier no longer bears the cross of representing all black people through Hollywood films, he deserves credit for having negotiated the demands upon him with uncommon grace. The Reverend Andrew Young, in his concluding

remarks after Poitier's 1967 SCLC speech, stated it well. Calling Poitier's movies "sermons in cinematography," he described the actor's impact:

> In a society that denies all dignity and worth to black men, he made us proud to be black, and taught us that black was beautiful and it's beautiful to be black. In a country that pronounces God as dead, he made a secular generation sing 'Amen' to the warmth and love in humanity, which is really the ground of all true religion. Amidst the tensions and neuroses of our lives, and of modern life in general, Sidney Poitier has dramatized sensitivity and concern, so that men of prejudice break the emotional shackles that have enslaved them for generations.[49]

After Poitier's birth in 1927, his mother visited a soothsayer. He had been born prematurely, during a trip to Florida to sell their tomato crop, and the baby was tiny, frail, and near-death. "Don't worry about your son," said the fortune-teller. According to family legend, she proclaimed, he would travel around the world, grow rich and famous, and spread the Poitier name. "He will walk with kings," she said. Seventy years later, Poitier literally did so—while serving as the Bahamas' ambassador to Japan, he presented his credentials to Emperor Hirohito.[50]

Poitier has also walked, in a sense, with Martin Luther King. His career swung on an arc laid out by the civil rights movement, and if Poitier represented the best of black people on the silver screen, King communicated those ideals in the political realm. Since their heyday, the long journey for racial justice has traveled up crests and into dells, but each man, in his own way, has helped foster a climate that made possible the election of Barack Obama to the presidency.

On August 12, 2009, Poitier came to the White House. Barack Obama bestowed upon him the Presidential Medal of Freedom, the highest honor for a US civilian. Among the fifteen others receiving the award were physicist Stephen Hawking, retired Supreme Court justice Sandra Day O'Connor, deceased senator Edward Kennedy, pioneer athlete Billie Jean King, and antiapartheid activist Bishop Desmond Tutu. "In front of black and white audiences struggling to right the nation's moral compass, Sidney Poitier brought us the common tragedy of racism, the inspiring possibility of reconciliation, and the simple joys of everyday life," intoned the president. "Ultimately, the man would mirror the character, and both would advance the nation's dialogue on race and respect."[51]

As Obama praised him, Poitier looked straight ahead, standing tall, betraying no emotion. Even as the president approached him, he stayed stoic. When the medal slipped around his neck, though, the corners of his mouth curled upward, and he looked with pride into Obama's eyes. Then the two men hugged, and to the cheers of the assembled audience, they rocked back and forth for about half a minute, wrapped together not just by mutual admiration, but by their intertwined roles in the nation's history.[52]

Notes

1 Noam Scheiber, "Race Against History," *New Republic*, May 31, 2004, 21–2, 24–6.

2 On King see, among other works, David J. Garrow, *Bearing the Cross: Martin Luther King, Jr. and the Southern Christian Leadership Conference* (New York: William Morrow, 1986); Adam Fairclough, *To Redeem the Soul of America: The Southern Christian Leadership Conference and the Martin Luther King Jr.* (Athens: University of Georgia Press, 1990); Taylor Branch, *Parting the Waters: America in the King Years, 1954–1963* (New York: Simon and Schuster, 1988); Taylor Branch, *Pillar of Fire: America in the King Years, 1963–1965* (New York: Simon and Schuster, 1998); Taylor Branch, *At Canaan's Edge: America in the King Years, 1965–1968* (New York: Simon and Schuster, 2006); Thomas F. Jackson, *From Civil Rights to Human Rights: Martin Luther King, Jr., and the Struggle for Economic Justice* (Philadelphia: University of Pennsylvania Press, 2007).

3 Martin Luther King, *Where Do We Go from Here: Chaos or Community?* (Boston: Beacon Press, 1968), 44.

4 "I Have Decided to Start With Myself," Keynote Address by Mr Sidney Poitier, with remarks by Dr Martin Luther King Jr., Mrs Dorothy F. Cotton, and Rev Andrew J. Young, August 14, 1967, Part 3, Reel 10, Papers of the Southern Christian Leadership Conference.

5 On Poitier's life and career see Aram Goudsouzian, *Sidney Poitier: Man, Actor, Icon* (Chapel Hill: University of North Carolina Press, 2004).

6 *New York Daily News*, February 6, 1957, April 16, 1961, October 28, 1962.

7 Branch, *Parting the Waters*, 216–18, 295–6, 370–1, 579–80, 771–2, 872–83; *New York Amsterdam News*, January 21, 1961.

8 Goudsouzian, *Sidney Poitier*, 206–14.

9 James Baldwin, *The Devil Finds Work* (New York: Dial Press, 1976), 62.

10 *New York Times*, November 18, 1967.

11 *Show*, September 1972.

12 *Los Angeles Times*, March 5, 1967.

13 *New York Times*, September 10, 1967.

14 *Newsweek*, December 25, 1967; Mary Omatsu, "Guess Who Came to Lunch?"
 Take One 1 (January-February 1968): 20–1; Maxine Hall Elliston, "Two Sidney
 Poitier Films." *Film Comment* 5 (Winter 1969): 28.

15 *Newsweek*, December 11, 1967; *Seventeen*, February 1968.

16 *Variety*, October 4, 1967.

17 *New York Times*, August 6, 1967.

18 See Aram Goudsouzian, *Down to the Crossroads: Civil Rights, Black Power, and
 the Meredith March Against Fear* (New York: Farrar, Straus, and Giroux, 2014);
 James R. Ralph Jr., *Northern Protest: Martin Luther King, Jr., Chicago, and the Civil
 Rights Movement* (Cambridge: Harvard University Press, 1993).

19 "Dr. King's Speech – Frogmore – November 14, 1966," Part 1, Reel 20, SCLC Papers.

20 King, *Where Do We Go from Here*, 188.

21 Martin Luther King Jr., *I Have a Dream: Writings and Speeches That Changed the
 World* (San Francisco: Harper SanFrancisco, 1992), 136–52.

22 *Pittsburgh Courier*, April 13, 1968; Mark Harris, *Pictures at a Revolution:
 Five Movies and the Birth of a New Hollywood* (New York: Penguin Press, 2008),
 407–17.

23 George M. Houser, "Mboya Visits the U.S." *Africa Today* 6, 3 (1959): 9–11;
 The Times (U.K), April 18, 2012.

24 David Maraniss, *Barack Obama: The Story* (New York: Simon and Schuster, 2012),
 271–2; David Remnick, *The Bridge: The Life and Rise of Barack Obama* (New York:
 Alfred A. Knopf, 2010), 54.

25 Barack Obama, *The Audacity of Hope: Thoughts on Reclaiming the American
 Dream* (New York: Three Rivers Press, 2006), 10; Barack Obama, *Dreams from
 My Father: A Story of Race and Inheritance* (New York: Three Rivers Press, 2004),
 50–1; Maraniss, *Barack Obama*, 242.

26 Remnick, *The Bridge*, 13-22; Thomas J. Sugrue, *Not Even Past: Barack Obama
 and the Burden of Race* (Princeton, NJ: Princeton University Press, 2010), 50–5.

27 David Plouffe, *The Audacity to Win: The Inside Story and Lessons of Barack
 Obama's Historic Victory* (New York: Viking, 2009), 22, 285; Remnick,
 The Bridge, 476–8.

28 Don Terry, "The Skin Game: Do White Voters Like Barack Obama Because 'He's
 Not Really Black'?" *Chicago Tribune Magazine*, October 24, 2004, 15–23.

29 *New York Times*, January 13, 2008.

30 Ibid.; *Washington Post*, January 20, 2008.

31 *Baltimore City Paper*, February 6, 2008; "When Will President Obama Get a
 Little R-E-S-P-E-C-T?," February 7, 2012, www.blackyouthproject.com; "Barack
 Obama + Sidney Poitier In The Heat of the Night," February 14, 2012,
 www.thyblackman.com; *Minnesota Spokesman-Recorder*, December 11–17, 2008.

32 Marvin Jones, "The Othering of Barack Obama," *South Florida Times*, no original date provided, accessed via www.sfltimes.com; *The Guardian*, July 4, 2008; *New York Times*, January 18, 2009.

33 *Memphis Commercial Appeal*, February 3, 2009; *National Post*, June 7, 2008; *Kansas Free Press*, June 2010; "The Quilting Sword," www.quiltingsword.com/tag/sidneypoitier/; Sumanta Banerjee, "Guess Who's Calling Us for Dinner?," *Economic and Political Weekly* 43, 46 (2008): 22–3; *Los Angeles Examiner*, January 19, 2009.

34 *Los Angeles Times*, March 19, 2007.

35 Chris Gonsalves, "Shanklin Responds to Barack 'Negro' Critics," December 30, 2008, www.newsmax.com. For lyrics see http://www.metrolyrics.com/barack-the-magic-negro-lyrics-paul-shanklin.html.

36 "The Return of Sidney Poitier," January 6, 2008, www.amnation.com/vfr/archives/009615.html. See also Steve Sailer, "Obama's Identity Crisis," March 26, 2007, www.theamericanconservative.com; *Washington Times*, December 25, 2007; *Daily Dispatch* (Henderson, N.C.), May 10, 2007; *Daily Breeze* (Torrance, CA), January 4, 2009.

37 *New York Times*, December 28, 2008.

38 Jabari Asim, *What Obama Means: For Our Culture: Our Politics, Our Future* (New York: William Morrow, 2009), 96–117, 152–9.

39 Shelby Steele, *A Bound Man: Why We Are Excited About Obama and Why He Can't Win* (New York: The Free Press, 2008), 73–91; *Washington Post*, November 25, 2007.

40 *New York Times*, November 2, 2008.

41 "I Have Decided to Start With Myself."

42 Sidney Poitier, *The Measure of a Man: A Spiritual Autobiography* (San Francisco: Harper San Francisco, 2000), 100; Diahann Carroll with Ross Firestone, *Diahann: An Autobiography* (Boston: Little, Brown, 1986), 75–103, 123–130.

43 Goudsouzian, *Sidney Poitier*, 25–60.

44 "I Have Decided to Start With Myself."

45 Sidney Poitier Interview with Ruby Dee, Box 4, Folder 9, Ossie Davis and Ruby Dee Papers, Schomburg Center for Research in Black Culture, New York City.

46 *New York*, May 28, 1973.

47 Sidney Poitier, *This Life* (New York: Alfred A. Knopf, 1980), 330; *White Plains Reporter Dispatch*, October 27, 1977.

48 Goudsouzian, *Sidney Poitier*, 358–80; Poitier, *This Life*; Poitier, *Measure of a Man*; Sidney Poitier, *Life Beyond Measure: Letters to My Great-Granddaughter* (New York: HarperOne, 2008), xvi.

49 "I Have Decided to Start With Myself."

50 Poitier, *This Life*, 1–2.

51 White House Press Release, July 30, 2009, www.whitehouse.gov/the-press-office/president-obama-names-medal-freedom-recipients; *San Francisco Examiner*, August 13, 2009.

52 "Obama Gives Sidney Poitier and Rev Joseph Lowery Presidential Medal of Freedom," August 13, 2009, www.newsone.com; "Obama Hugs it Out with Sidney Poitier," August 12, 2009, www.theroot.com.

Bibliography

Archival collections

Asim, Jabari. *What Obama Means: For Our Culture: Our Politics, Our Future* (New York: William Morrow, 2009).

Baldwin, James. *The Devil Finds Work* (New York: Dial Press, 1976).

Banerjee, Sumanta. "Guess Who's Calling Us for Dinner?" *Economic and Political Weekly* 43, 46 (2008): 22–3.

Branch, Taylor. *Parting the Waters: America in the King Years, 1954-1963* (New York: Simon and Schuster, 1988).

—*Pillar of Fire: America in the King Years, 1963-1965* (New York: Simon and Schuster, 1998).

—*At Canaan's Edge: America in the King Years, 1965–1968* (New York: Simon and Schuster, 2006).

Carroll, Diahann with Ross Firestone. *Diahann: An Autobiography* (Boston: Little, Brown, 1986).

Elliston, Maxine Hall. "Two Sidney Poitier Films." *Film Comment* 5 (1969): 28.

Fairclough, Adam. *To Redeem the Soul of America: The Southern Christian Leadership Conference and the Martin Luther King Jr* (Athens: University of Georgia Press, 1990).

Garrow, David J. *Bearing the Cross: Martin Luther King, Jr. and the Southern Christian Leadership Conference* (New York: William Morrow, 1986).

Goudsouzian, Aram. *Sidney Poitier: Man, Actor, Icon* (Chapel Hill: University of North Carolina Press, 2004).

—*Down to the Crossroads: Civil Rights, Black Power, and the Meredith March Against Fear* (New York: Farrar, Straus, and Giroux, 2014).

Harris, Mark. *Pictures at a Revolution: Five Movies and the Birth of a New Hollywood* (New York: Penguin Press, 2008).

Houser, George M. "Mboya Visits the U.S." *Africa Today* 6, 3 (1959): 9–11.

Jackson, Thomas F. *From Civil Rights to Human Rights: Martin Luther King, Jr., and the Struggle for Economic Justice* (Philadelphia: University of Pennsylvania Press, 2007).

King, Martin Luther, Jr. *Where Do We Go from Here: Chaos or Community?* (Boston: Beacon Press, 1968).

—*I Have a Dream: Writings and Speeches That Changed the World* (San Francisco: Harper SanFrancisco, 1992).

Maraniss, David. *Barack Obama: The Story* (New York: Simon and Schuster, 2012).

Obama, Barack. *Dreams from My Father: A Story of Race and Inheritance* (New York: Three Rivers Press, 2004).

—*The Audacity of Hope: Thoughts on Reclaiming the American Dream* (New York: Three Rivers Press, 2006).

Omatsu, Mary. "Guess Who Came to Lunch?" *Take One* 1 (1968): 20–2.

Ossie Davis and Ruby Dee Papers, Schomburg Center for Research in Black Culture, New York City Papers of the Southern Christian Leadership Conference (microfilm)

Plouffe, David. *The Audacity to Win: The Inside Story and Lessons of Barack Obama's Historic Victory* (New York: Viking, 2009).

Poitier, Sidney. *This Life* (New York: Alfred A. Knopf, 1980).

—*The Measure of a Man: A Spiritual Autobiography* (San Francisco: HarperSanFrancisco, 2000).

—*Life Beyond Measure: Letters to My Great-Granddaughter* (New York: HarperOne, 2008).

Ralph, James R., Jr. *Northern Protest: Martin Luther King, Jr., Chicago, and the Civil Rights Movement* (Cambridge: Harvard University Press, 1993).

Remnick, David. *The Bridge: The Life and Rise of Barack Obama* (New York: Alfred A. Knopf, 2010).

Steele, Shelby. *A Bound Man: Why We Are Excited About Obama and Why He Can't Win* (New York: The Free Press, 2008).

Sugrue, Thomas J. *Not Even Past: Barack Obama and the Burden of Race* (Princeton, NJ: Princeton University Press, 2010).

Historicizing the Shadows and the Acts: *No Way Out* and the Imagining of Black Activist Communities

Ryan De Rosa

This chapter argues that the banning of an antiracism film in Chicago helps us understand the dominant form of racial liberalism that emerged after World War II—specifically, how that liberalism did not condone or support independently activist black communities. Although Twentieth Century-Fox Film Corporation bought the story *No Way Out* in January 1949, production on the film did not begin until the end of the year.[1] In the meantime, several movies attacking racism were released that year: *Home of the Brave* (Mark Robson), *Lost Boundaries* (Alfred M. Werker), *Pinky* (Elia Kazan), and *Intruder in the Dust* (Clarence Brown). The popularity of these films with white audiences disturbed Ralph Ellison, who stole time away from writing *Invisible Man* to review them in his article "The Shadow and the Act," which appeared in the *Reporter* in December 1949.

Ellison theorized that the films could elicit "profound emotional catharsis" for many whites, "as though there were some deep relief to be gained merely from seeing these subjects projected upon the screen."[2] Although the films were attempting to represent real problems, he warned against viewing them as reflections of reality, or even as reflections of straightforward values. Their displaced conflicts and fanciful resolutions could help turn "the audience's attention away from reality to focus it upon false issues." In *Lost Boundaries*, for instance, a black doctor and his family "pass for white" before their racial integration in a northern rural town. However, in showing their rejection by blacks in the South and the moral dangers of a black ghetto, the narrative could shift our attention from the problems of segregation and white privilege to problems with the black community and the "problem" of passing.[3]

One wonders what Ellison thought about *No Way Out* (Joseph L. Mankiewicz), released a year after these films in August 1950, in which the main character is a black doctor (Sidney Poitier, in his first film) who integrates into a white medical staff. For the gatekeepers of the movies in Chicago, the film did not evoke catharsis: citing "an ordinance which prohibits events tending to produce a breach of the peace," the board of censors banned it, a decision defended by the police captain in charge of censorship and by the police commissioner.[4] Executive Secretary Walter White of the NAACP lobbied the mayor's office of Chicago, and the local chapter of the NAACP—whose members held a private screening of the film—protested the ban. The mayor assigned an interracial committee to review the film, which recommended its release "with [the single] deletion of a one-minute scene showing Negroes fortifying themselves with clubs and baseball bats for a brawl with whites arming with broken bottles."[5] As the ban lifted in Chicago, the Department of Public Safety of Massachusetts prohibited screenings of *No Way Out* on Sundays in Boston, and Philadelphia banned it "unless objectionable dialogue in a riot scene is cut out."[6]

Judging by these calls for cuts, the intractable problem with the film was its sequence of a race riot. It begins in a pool hall where a hundred black men have gathered to preempt a white attack. "We're going to be in four sections," their strategist—Lefty Jones (Dots Johnson)—explains, a low-angle shot emphasizing his strength and dignity. The next images show working-class men intently listening to Lefty, and wide shots of the assembly, uniformly

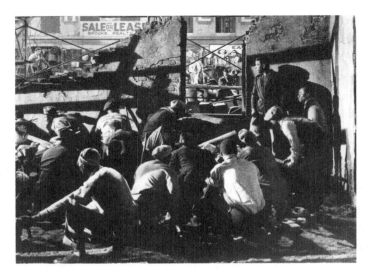

Figure 3 A surprise attack in *No Way Out*.

armed ("Who hasn't [got] clubs," Lefty says, "get them here before you go"). The signal to attack—the light from a navy flare gun—connotes that some are veterans called again to battle. The sequence cuts to a junkyard, where white men break bottles and crack whips, a scene focalized through a sympathetic white named Edie (Linda Darnell). When Rocky, beating on metal with a chain, asks whether she wants to try ("You want to hit a nigger?"), she flees, the camera's high vantage receding as if to follow her escape. This view of the junkyard segues to the blacks quietly taking positions for their surprise attack (Figure 2.1). "Bias is shown in portraying the Negroes sympathetically," wrote the conservative black columnist George Schuyler, "while the poor whites . . . are shown as Neanderthals."[7]

That the film would show a race riot was initially not certain. Listening to a public relations specialist who advised that the film "might touch off violence" in urban centers with large black populations ("Detroit, for example"), producer Darryl Zanuck wanted only a "small race riot—more [like] a fight."[8] *No Way Out* went through many changes before filming, changes discussed in studio meetings and memos and reflected in three extant preproduction documents: the original story by a relatively unknown writer, Lesser Samuels; a first draft of the screenplay by a writer with more studio clout, Philip Yordan; and the final screenplay by a writer-director known for character-driven, budget-conscious pictures, Joseph Mankiewicz, who also directed the film. Tracing changes in the representations of the black community and the black hero from the initial story to the visual text, this chapter identifies two contrary approaches to the film: one in which the black hero is embedded in the black community's struggle against racism and segregation and another in which he and the community are kept apart (socially and morally), even at odds. The chapter then takes a wider cultural approach to consider these ways of seeing the film as ideological positions in a struggle over how to represent both the nation's racial problems and possible remedies.

At every stage of the film's history, from preliminary exchanges between producers and writers to the response in the mainstream press and the ban by censors, efforts were made to undermine the impact of the representations of the race riot and the black community. These efforts reveal that a consensus was developing among white liberals that stressed the racist individual as the cause of racial problems and imagined individualistic solutions, thus evading social and class hierarchies of race through a discourse of color-blind nationalism. Contrary to this consensus, black protest against the film's ban paralleled black protest against the suppression of news about white riots in

Chicago. That there was a consensus of ideas among many white liberals helps to explain the banning of the film in Chicago, the ban itself reinforcing that the liberal consensus was only among whites. To uphold the consensus, white liberals needed to minimize the representation, and marginalize the presence, of activist black communities by carefully controlling racial representations, whether in the movies or in the news media.

Black critics' reviews of *No Way Out* expressed social demands in the figurative form of imagined communities—as black ethnic, black consumer, and interracial working-class communities. Of particular importance was the fact that black journalists grouped the black actors as an ensemble by recalling their work in the American Negro Theater (ANT). Complementing this onscreen community, notices for the film in the *Pittsburgh Courier* conjured an ensemble of consumers having the power to support fair housing in Chicago by watching the film in other cities. These senses of community challenged the liberal discourse of a "cultural unity" in which blacks would gradually assimilate, and implied black struggles outside the liberal purview—struggles for social equality, cultural identity, and consumer survival.

Social spaces for dissent and debate remained relatively open for blacks as the dual consensus on race and the Cold War was forming for liberal whites. In this light, Schuyler's critique of the film engages with blacks who were advocating for it as well as with those qualifying their praise. Writing alongside Schuyler at the *Courier*, Marjorie McKenzie believed that "documentation . . . of [positive] Negro-white relationships, which do occur on many different levels, accomplishes more good than does melodrama, whether of the 'Pinky' or the 'No Way Out' variety. A newsreel of white Southerners playing with Negro Northerners states a solution, not a problem."[9] McKenzie values documentary images for their prescience; Schuyler's call for "authentic" images is a demand for the inclusion of blacks in the process of cultural production. By contrast, white liberals, in the studios and in the audiences, were viewing fictional images of race relations for their documentary or mimetic values, for their potential to reify and construct a racial consensus. This consensus assumed not just the fact of steady national progress in race relations but also that such progress was occurring because whites were at the forefront. As far as these assumptions are still with us, this chapter disconnects liberalism from the framework of natural progress and from the presumption that progress depends on whites by showing alternative visions of racial democracy found within the discourse on the film in the black press.

When not at the margins, the study of race in postwar films has often confirmed preconceived notions of the period—the equivalent of putting punctuation marks on incomplete sentences.[10] To read the period more completely, one must avoid thinking of racial discourse as reflected in film images; rather, ideas of race are fought out through (and over) representations as they circulate through publics that are often overlapping and frictional. *No Way Out*, a film that inspired opposing responses, places in relief this ideological battle over the meaning of race relations on film and outside film—it is this difference between "the shadow and the act" that Ellison insisted that we make the basis of our cultural inquiry.

Film noir meets the race problem film

As its title suggests, the plot of *No Way Out* follows the complexity of the dark psychological film noir, particularly the kind that entangles the hero (usually male) in a threatening world in which he must prove his innocence of a crime (usually murder). Although his idealized traits (charisma, independence, integrity) suggest that he did not commit the crime, he carries the guilt or suspicion of one literally or figuratively accused because the hero does not fully know himself—or we do not fully know him. Contemporaneous examples of this type of noir are *Whirlpool* (Otto Preminger 1949), *In a Lonely Place* (Nicholas Ray 1950), and *Where the Sidewalk Ends* (Otto Preminger 1950).

The noir permutations of *No Way Out* begin when Dr Luther Brooks (Poitier) treats a pair of criminal brothers captured and taken to the hospital for leg wounds. While Ray Biddle (Richard Widmark) taunts Brooks with slurs, his brother Johnny is unresponsive to sensory tests, and Brooks administers a spinal tap, believing (we later find out) that he suffers from a brain tumor. Johnny dies during the procedure, leading Ray to accuse Brooks of murder and to vow revenge. Although we see Brooks's professionalism—images from his point of view align us with his discovery of Johnny's symptoms—elements of mystery, crime, and atmospheric guilt enter through visual and aural signifiers, deflating the authority of this professionalism: the tense silence entwined with Johnny's breathing; the image of Brooks inserting the needle, a strange medium shot that keeps Johnny off-camera, connoting his vulnerability to the doctor; the cut to the guard and orderly outside the room at the moment of Johnny's death, both of whom come in when they hear Ray scream for help; Brooks's fatalistic tone and terse reply ("He's dead") in a close-up in which he averts his gaze in guilt.

An expressionistic image shows Brooks staring at the off-screen Johnny as Ray, in the background, voices a dark but compelling scenario: "He wanted it [the murder victim] to be me but he took it out on Johnny!"[11]

When Ray refuses to permit an autopsy, Brooks accompanies Wharton (Stephen McNally), the Chief Medical Resident and his friend, to the plebeian flat of Edie (Darnell), thinking that as Johnny's wife she could grant the autopsy. Discovering that she and Johnny had divorced and that she had had an affair with Ray, whom she seems to now despise, Wharton tries to manipulate her into persuading Ray to change his mind. Ray, learning of Wharton's ploy, uses her to foment more white anger incipient to an attack on the black neighborhood. However, when the blacks learn of the coming attack, they organize to attack first. In the aftermath, Brooks treats the incoming wounded until the mother of a white patient spits on him. Wiping his cheek, he glances accusingly at Wharton and then abruptly leaves the hospital.

In the morning, his wife, Cora (Mildred Joanne Smith), appears at Wharton's home to deliver the news that Brooks has falsely confessed to the murder of Johnny to force the state to authorize an autopsy. Unlike the earlier scene of Johnny's death, here noir signifiers imbue the words but not the visuals, which use conventional editing and compositions to represent a suburban home in the clarity of the morning (Amanda Randolph plays a straight-thinking but conventionally maternal black housekeeper). Yet the dialogue paints Brooks within a shadowy struggle between his anger and his guilt. Cora explains that he seemed "almost crazy" and "hated everybody [white]," and even "made [his brother-in-law] John take [his sister] Connie and Mother to our cousin's house" because "he said ours wasn't safe" and "we had to realize we weren't human beings, we were just so much dirt." She continues, "Then all of a sudden he was calm. . . . He told me he knew what he had to do—that the only thing that could help him or us or anybody was the truth." Cora and Wharton acknowledge that Brooks could become the victim of this "truth." Wharton says, "There is a chance he made a mistake [in his diagnosis of Johnny]," and Cora relays her husband's paradoxical answer: "Luther says that too. Either way though, he says, we'll know the truth."

Luckily, the coroner determines that Brooks made the right diagnosis, but Ray, distrusting authority, remains vengeful. With the help of another brother, he escapes, captures Edie, and makes her lure Brooks to Wharton's home when he is not there. Edie—who has been fighting her own prejudices—arrives in time to help Brooks disarm Ray, whose wound reopens in the scuffle. In a striking

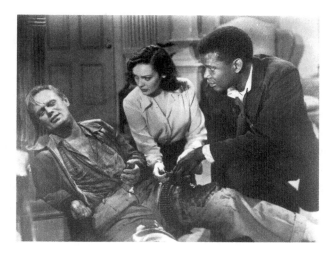

Figure 4 Poitier's Dr Brooks helps Ray Biddle.

tableau, she plays a reluctant role as nurse, helping Brooks (who has been shot in the arm) fashion a tourniquet for Ray's leg (Figure 2.2). A close-up of Brooks as he tightens the tourniquet and speaks the film's last words connotes that he can express and act with (though not necessarily on) his anger—which he had repressed when he first treated Ray—as well as with his authority and value as a doctor, which he had "repressed" in seeking the autopsy (i.e., in seeking verification of his diagnosis). "Don't cry, white boy," he tells Ray, with hints at satisfaction at Ray's pain and humiliation. "You're gonna live."

Recounting this plot, critics and scholars often accept Brooks's guilt as natural: they accept the logic of the "confession" that endangered his career and his freedom. In its rave recommendation, the trade journal *Motion Picture Herald* assumed that Brooks should feel culpable: "There is some doubt whether the dead man actually had [a] tumor, and Poitier, to clear himself, asks Widmark for permission to perform an autopsy." The reviewer continues in this vein: "Poitier gives himself up to the police to force the autopsy, which clears him."[12] Historian Thomas Cripps similarly evades the problem of the hero's guilt and adds another motive for his pursuit of the autopsy—to avert the race riot: "Brooks calls for an autopsy, which would confirm his diagnosis as well as head off the threat of violence. . . . Signs of the street fighting mount. . . . The only remedy looms clear: Brooks must surrender himself as the 'murderer' of his patient, thereby forcing an autopsy that would confirm his finding, discredit the surviving racist, and place a lid on the rioting."[13]

While these commentators trace the main plot threads, they remove the key noir element of the hero's ambiguous psychology, his free-floating guilt that becomes projected or attached onto a "real" crime (a real death). Beginning with the screenplay by Joseph Mankiewicz and continuing to the final release print, Brooks is highly skilled, yet deeply doubtful about his talents as a doctor—a troubled mindset that is projected onto a situation that inscribes his guilt and prolongs his self-doubt but also reveals more about his character, a trait not shown at first.[14] I maintain that his "crime," that is, his guilt and self-doubt, points to his repressed anger over racism and his repressed connection to the struggle of the film's black community. This idea of repression, or the hero's anxious unconscious, is a convention of noir—yet it is one that would seem to counter, for many liberal viewers of the film, their belief in individual integration and white edification as the primary remedies for racial inequality. Although noir and the dominant liberal ideology thus seem at odds, the noir shading of the film becomes sharply defined if we compare Mankiewicz's depiction of Brooks to both the story by Lesser Samuels and the first screenplay by Philip Yordan.

All these versions contain an opening scene in which Brooks, having passed the state medical exam, talks with Wharton. In the original story, Brooks is saccharinely deferential toward Wharton: "'Thanks, Doctor, for being so interested in my marks. It means a lot to have somebody like you rooting for me . . .'. He spoke with sincerity but it was so tinged with idolatry and devotion that the effect was embarrassingly emotional."[15] After this scene, Lefty Jones, a black elevator operator, asks Brooks: "Ain't you a doctor when you get out of college, or is that exam only for colored boys?" The exam is "for everybody," Brooks explains, an answer the other accepts: "Lefty was relieved. 'Now you're all set, huh?'"[16]

Yordan revisits these scenes, establishing that Brooks, despite his opportunity to advance, will remain for a voluntary period in the working class. Brooks tells Wharton that he wants "to stay on for another year," but Wharton queries: "At sixty dollars a month? That suit won't hold together another year." Brooks explains "with a smile": "What I can learn here in another year is worth a lot more to me than money. . . . And I sure need money. My wife's been supporting me for so long, folks are beginning to talk."[17] Hence, Brooks seems reconciled to social stasis despite the hardship it entails. Further, the scene connotes that his prolonged class struggle is not due to discrimination: he has less status, less income, because he chooses to have less. In the following scene when Lefty

suggests that racism makes the road to success hard for blacks, Brooks refutes him with his own example: "You're all wrong, Lefty. I've had a fair shake ever since I've been here," to which Lefty grumbles, "Yeah."[18]

By contrast, in Mankiewicz's script and the final film, Brooks does not seem so simple; rather, his psyche provides the initial narrative enigma.[19] As Brooks and Wharton converse at their lockers, they are visually paralleled: Brooks puts on his "whites" as Wharton dons his dark coat. Into this scene of pictorial integration comes social tension. Wharton comments that Cora must be relieved Brooks has finished his residency, but Brooks—through Poitier's restrained yet ardent style—responds with dissonance: "I guess so. That part hasn't been much fun—it's no *good* a man's wife supporting *him*, his mother [laughs], and the rest of the family." Wharton's reply—"Well, it's all over now"—fails to catch Brooks's underlying urgency, and Brooks must restart the conversation to tell Wharton that he has volunteered to remain a year as junior resident. When Wharton wonders why, the camera reframes Brooks, a reframing that underlines the inadequacy of his answer: "Because I think it's more important than a few extra dollars, a little easier living. I've got a lot to learn."

In Samuels's story and Yordan's screenplay, the first dialogue is between Brooks and Wharton. The scenario by Mankiewicz, however, begins by showing Brooks with Lefty. The opening sequence stages hospital staff walking to work; among them is Brooks, who pauses and calls out, "Hi, Lefty." The camera pans to show Lefty, who returns the familiar greeting: "Hey, Lu, what do you know? I've been looking for you" (behind him is another black character, called Jonah in the screenplay and played by Bob Davis). Brooks and Lefty clasp each other in friendship and proceed together. Unlike earlier versions of the script, Brooks is immediately and unambiguously part of the black community.[20]

Following this connection between Brooks and Lefty, the scene in the elevator represents a political dialogue rather than Brooks's "straightening" the opinion of Lefty. After Brooks stresses that all doctors, black and white, have to take the exam, Lefty replies that the state probably made Brooks's exam tougher because he is black: "I'll bet they laid it on you!" The fact that we have witnessed Brooks postponing his upward mobility ("I think I need a little more time than the others," he told Wharton) makes Lefty's words ironic, and Brooks quickly becomes exasperated with him, saying "Why don't you just quit!" During this dialogue, shadows cast through the window grate as the elevator passes between floors fall across Brooks, connoting a metaphoric prison in which he works even before he starts work in the prison ward. Johnson's performance

as a forthright militant and Lefty's confidence in his stance give Lefty's politics further legitimacy as a viable position.

In the following scene, also in the elevator, Brooks inspects Johnny while Ray harasses Brooks. At this point, both the Samuels story and the Yordan screenplay equate Lefty's anger with Ray's racism, describing Lefty as simmering "with primitive hate," requiring Brooks to intervene against Lefty. In Samuels's version, "Luther laid a calming hand on [Lefty's] arm. . . . 'None of that talk,' said Luther sharply [to Lefty]," while in Yordan's version, "Luther catches Lefty's attention and reproves him with a gesture. Lefty calms down."[21] In these versions, Lefty has no moral authority. By contrast, Mankiewicz's dialogue and Johnson's acting give Lefty dignity; moreover, in the film, the camera connects, rather than separates, Lefty and Brooks. When Brooks asks Ray about Johnny's sense of direction, a low-angle shot from the stretcher toward Brooks pairs the doctor with Lefty, so that as Ray answers with a sneering threat to the black community—"Every time Beaver Canal went over to clean up Niggertown, Johnny knew just what direction it was"—Brooks and Lefty are joined visually as the victims of Ray's racism. But the shot contrasts their different reactions. Brooks is tensely focused, if passive, and Lefty stays focused on his work but voices his anger: "Shut up! You're talking to a doctor!" The composition thus replays their prior difference of opinion, when Brooks had dismissed Lefty's insinuation that race still matters in an "integrated" society, and points to the enigmatic quality of Brooks's psyche, evident from the scene between Brooks and Wharton: Lefty is positioned, visually and aurally, as if speaking for Brooks, who is unable to voice self-interest (his anger or his need to protect himself from Ray). These opening scenes, all before Johnny's death sparks white violence, establish that Brooks denies his self-worth—he depreciates his talent and knowledge when he speaks with Wharton—and denies the presence of racism in his life. These denials provide the psychic texture of his status as an integrated, working-class physician.

Mankiewicz's screenplay and the film link Brooks and Lefty in friendship, which allows Brooks more identification with the black community and its political dialogues. The earlier versions of the screenplay, on the contrary, play Brooks against Lefty and the black militants. In Samuels's story, the black neighborhood is divided between "Lefty and his gang" and everyone else: Cora warns the alderman "that Lefty . . . and a lot of the boys were going over to Beaver Canal. . . . The Alderman received the news gloomily but he swung at once into action, furious in his denunciation of these hoodlums." The

story briefly takes the alderman's point of view as he calls "two squad cars" for help.[22] Unlike the film, in which blacks defend themselves, in Yordan's script whites must defend their rights against blacks: Lefty tells Ray "to get out of town," a demand which could justify white hysteria. Yordan transfers moral authority from the alderman (in Samuels's story) to Brooks, who braves the white "flophouse" to broker peace. Importantly, Brooks visits the whites instead of joining the black community: "Maybe there's no harm in the talk my people are having tonight," he preaches to the white ruffians, "but we're building a lot of bad feeling. Sooner or later there's going to be a clash."[23] Yordan thus distributes blame for racial violence equally between blacks and whites, and he casts Brooks on a higher moral plane from both racial groups in the lower classes. After the riot, the dying words of Lefty to Brooks—"We showed 'em"—allow Brooks to unequivocally separate himself from the black militants: "Yes, Lefty. *You* showed 'em."[24]

Omitting this postriot dialogue between Brooks and Lefty, the corresponding scene in the film shows Lefty in dignified silhouette, already dead: we do not see him dying or suffering. Tellingly, John (Ossie Davis), Brooks's brother-in-law who is studying for the postal exam, leads one of the black sections but is not punished with death or apparent injury; like a soldier, he "walks" into battle, with the consent of his mother-in-law (Maude Simmons). "Let him go!" she tells her trembling daughter Connie (Ruby Dee) as John, with profound seriousness, feigns going out for a walk. "Go ahead, John. Take your walk." The performances of the black actors, most of whom had worked together in the black theater, represent and legitimate difference and dialogue within the black community. One critical change in the Mankiewicz screenplay goes against a directive of Zanuck, relayed in a memo to Mankiewicz: "Lefty should *not* tell Luther where the Negroes are meeting. He should not tell him of their plan to move in on Beaver Canal. . . . All Luther should learn is that Beaver Canal is coming over [to attack the black neighborhood]."[25] Zanuck thus would insulate Brooks from black dialogue: if Brooks is not included in the plans of the black community, then he would not have to choose, like John, to "take his walk," and might more closely embody an idealized form of integration that could cancel the need for collective black activism.

Instead of heeding Zanuck, Mankiewicz included a scene that continues the earlier heated exchange between Brooks and Lefty. The camera is inside the elevator as Brooks enters and Lefty tells a white man to wait for the next ride; the door shuts and Brooks, exhausted, leans beside his friend, who says he

has been looking for him. Lefty confides that he is leaving work because whites are "coming over," and Brooks faces him for more information—the camera moving to center Lefty, yet not aligning itself with Brooks's point of view. As earlier, the shadow of the window grate suggests that Brooks is imprisoned, but this time Lefty is escaping his subordinate role, also symbolized by the elevator. After filling Brooks in on the imminent white attack and the strategy to repulse it peremptorily, he reaches for the elevator door, but Brooks stops him; the camera inches closer, keeping Lefty the focus of attention while continuing to frame them together.

Their exchange raises the problem of Brooks's loyalty to the black community: "You've got to stop them, Lefty." "Stop who? Beaver Canal?" No, Brooks means for Lefty to stop the blacks: "[Fighting back] won't help. It never has. It only makes things worse," he insists. Lefty counters crisply: "Not for us it won't. Not tonight—we're gonna be *ready* tonight." When Brooks responds that his friend seems "crazy," Lefty admits, "Sometimes I do get a little crazy when these things happen." Looking away, he recalls "six years ago when Beaver Canal came over. You were in school." Brooks may not remember the white violence of the past. "My kid sister's still in a wheelchair," Lefty says, adding, "I got this [points to a long scar on his cheek] from a broken bottle."

This moment of remembrance rhymes with an earlier scene, another Mankiewicz addition, which explores Brooks's need to remember his own social struggle in order to valorize his labor. When he realizes that his family is preparing to entertain the head of a hospital who might offer him a residency, he displays doubt to Cora in the privacy of their bedroom: "I'm not even a good intern yet," he reflects as he falls asleep. Cora then reflects in a soliloquy about Brooks: "You've worked so hard, harder than anybody to get where you are. The shoes you shined, the dishes you washed, the garbage you dumped, the food you couldn't buy because you needed books, remember?" If "remember?" is Cora's rhetorical question, it is Lefty's political imperative. Brooks must remember the struggle of the black community in order to understand the position of the militant blacks, just as he must remember his own struggle in the black working class in order to defend his right to upward mobility.

Exiting the elevator, Lefty is poised to join other black men, whom we see waiting in the background. Brooks implores: "But don't you see? This way you're no better than [the white racists]." Even as Brooks and Lefty separate, Lefty's reply enfolds Brooks in the black community, referring to the burden of his friend's impeccable professionalism as much as to black communal struggle: "Ain't that

asking a lot for us to be better than them when we get killed just trying to be as good?" The camera pans with Lefty, then cuts to Brooks, who stares several seconds in mute consternation in Lefty's direction.

The character relations written by Mankiewicz and performed by the black actors situate Brooks in the social struggle and politics of the black community. This connection between Brooks and the community is consistent with reading *No Way Out* as a film noir because it implies the complex psychology of the hero in which his guilt or self-doubt over a patient's death marks the displacement of his anger that would link him with the blacks who take arms to protect themselves. This displacement resolves in the final lines, "Don't cry, white boy. You're gonna live," lines that are not only Brooks's but also Lefty's. They are spoken in Lefty's style: deliberate, ironic, and race conscious. Brooks and Lefty are thus joined symbolically at the beginning and the end of the film. Moving from his precarious status of "integration," Brooks takes his place as part of the black community that acts to protect itself: he recognizes racism as a threat and sees himself as a full-fledged doctor, both explaining and showing that he must save Ray because he has the ability to do so and must protect his own interests ("I've got to live, too").

Although we have ample reason to locate Brooks within the black community, mainstream reviews, like the Samuels story and the Yordan screenplay, kept Brooks and the black community as separate as possible. Against the film's "cerebral story," Richard Coe of the *Washington Post* found the race riot dangerously "melodramatic" because "to suggest physical violence between the races" is neither "accurate" nor "wise." He mentions the film's black community only in a socially regressive context: "The Negro group is warned and beats the thugs to the punch by starting a riot of its own."[26] The *New York Herald Tribune* critic, while praising the film, portrayed the blacks as equal partners in crime: "A race riot ensues, for which Negroes are as much to blame as the riffraff from a white slum district."[27] *Newsweek* extolled the movie for "[pulling] no punches either in dialogue or conception" but faulted "unworthy lapses into violence-for-its-own-sake"; the review carefully excised the agency of the black men: "And the chance to accuse a college-graduate Negro like Brooks of murder kindles the wizened egos of the entire [white working class] community. The result is a race riot after which Brooks gets spit upon for trying to treat white casualties." The black community exists only as "a warmly human background" provided by the wife and the mother of Brooks.[28] These readings, though supporting the film's attack on racism, suggested—by distortion or omission—an equally grave threat

to "white society" (*Herald Tribune*) in the figure of a black community coming together in dialogue and decisive action.

The same fear of the black community arose in more intellectual discourse. Two social scientists in the American Jewish Committee journal *Commentary* saw the visual ambiguities in the scene of Johnny's death as supporting a "fantasy of the Negro as a killer." Looking through a psychoanalytic lens, they critiqued the desire of the masses to "enjoy forbidden fantasies without feeling guilty." However, they echoed mainstream reviews that disparaged the representations of the black community: "[T]he race riot contains images which tend to confirm the fantasy of the Negro as a dangerous attacker." Lefty in particular is "overaggressive and dangerous" with respect to "American concepts of normal self-reliance. . . . Contrasted with the Negro doctor is another Negro, *who has not tried to improve his social and professional position*, but works as an elevator operator." Using images of racial integration to affirm individualism ("normal self-reliance") and to eclipse black working-class struggle, they surmise that "the Negro doctor has withdrawn from the struggle of the Negroes," although this withdrawal is more characteristic of their interpretation than of the evidence from the film.[29]

The dominant racial liberalism and the American Negro Theater

We can locate all readings of the film between hermeneutic poles in which Brooks is either outside or within the black community. The striking difference between the poles suggests ideological positions struggling to define racial problems and effective solutions. One position—represented by Zanuck and Yordan, and the mainstream reviews of the film—promoted the ideal of color-blindness, that to end racism we need merely to ignore race. The color-blind discourse, tied to Cold War nationalism, was effective in denying the structural or class basis of racial inequality (as opposed to the legal basis), for it implied that even before legal barriers were removed, the assimilation of blacks into a raceless and classless society would sufficiently remedy racial inequality.

After Yordan read Samuels's story, he suggested to Zanuck: "I would introduce Luther in a regular staff meeting . . . and play the scene as though Luther was just another white man." The white staff, in showing "no awkwardness or condescension" toward Brooks, would resemble Wharton, "the Abe Lincoln

of our story" (the scene was never written).[30] Taking a subtler approach, Mankiewicz refers ironically to color-blind discourse in a scene in which Brooks, putting on his uniform, tells a white intern that he will be on duty as "soon as I get my whites on."[31] Yet Mankiewicz, too, could use color-blindness as a rubric for diagnosing racial problems. In a scene not included in the film, a black alderman named Tompkins discourages the autopsy because he knows that Brooks could be charged with murder if his diagnosis is not confirmed, becoming a scapegoat for the race riot. Wharton defends the autopsy, asking, "Do you think that a Negro doctor should be treated differently from a white doctor?" The alderman replies, "I *know* that a Negro doctor is treated differently." Wharton, though, has the last word: "Unhappily, that's apparently true. But do you think . . . a Negro doctor should behave like a doctor—or like a Negro doctor? (Tompkins is uncomfortable. He doesn't answer.) If you think there's a difference, then, basically you agree with everyone who has ever persecuted your race."[32]

This dialogue shows how color-blind discourse can help turn the analysis of the social hierarchy of race into a burden on blacks to act as if that hierarchy does not exist. "An intelligent man like Luther [Brooks] doesn't want to crash a white man's world," Yordan wrote Zanuck. "He does not seek admittance into the white man's world. All he asks for is civility, not condescension. He can handle himself. He's a good doctor." Zanuck repeated these ideas verbatim in his missive to Samuels.[33] Seeing no contradiction between portraying their integrated hero as capable and dignified, yet undemanding and socially passive, Yordan and Zanuck deemed black activism unnecessary, even counterproductive, to the character of Brooks.

In identifying color-blindness as the film's organizing principle, mainstream critics reshaped the narrative to avoid discussion of class inequality. The first dialogue between Brooks and Wharton, in which Brooks recounts his decision to remain as junior resident, ends with Wharton's accepting Brooks's (temporary) social immobility and assuring him, "My interest in you Brooks is no greater than in any other good doctor in my service." Describing this exchange, the review in *Newsweek* ignored Brooks's remarks about his family's sacrifices, rationalizing his remaining in the working class by inferring that he has risen into a new job: "Brooks has passed the requisite examinations with top honors and steps uneasily into his new job as the only colored intern." While the critic does not hear Brooks, he does hear Wharton's color-blind discourse: Wharton "reminds [Brooks] his color doesn't make him any more special than any of the white

interns. The important thing is to be a good doctor."[34] Walter White, cultivating ties with Hollywood as he was breaking with critics of the Cold War such as W. E. B. DuBois, eulogized Wharton as "a man of warm human decency who cares nothing about the color of skin of any member of his staff, but is concerned only with his ability as a doctor." White's review elided the fact that Brooks has already been at the hospital, suggesting that the narrative begins as Brooks "joins the staff of a city hospital."[35] Similarly, Richard Coe recounted the story as about a "Negro doctor, just out of his internship."[36] In "seeing" color-blindness, these critics seemed blind to black working-class struggle and the problems of class hierarchy.

The color-blind discourse was thus promoted at the same time as social differences were accepted between blacks and "the white man's world." In his summary of why *No Way Out* would be "the topper of . . . all" the race problem films being made (including his own *Pinky*), Zanuck imagined and approved the limits of its liberalism: "This story argues for professional fairness and equality. It opposes prejudice and intolerance. It does not seek, *nor should it*, for [*sic*] total social equality."[37] For the writer Nunnally Johnson, the Samuels story seemed "the most reasonable approach to the racial question in a dramatic form" because "[it] argues for professional fairness and equality, not for social reasons but for purely practical purposes." While Johnson may be thinking of the box office, he also contends that common, consensual values should determine racial representations: "People may very well resent an insistence on an equal social arrangement for blacks and whites[,] but I do not believe any except the most prejudiced would object to this professional claim to equal opportunity."[38]

Johnson's words capture how Zanuck and others were conceiving the film: it would represent a racial consensus based on imagining whites as the nation's "people" and what they (whites) would accept as the legitimate agenda for racial reform. This was also the methodological starting point for a study of racial problems in the United States that came to exemplify "the racial commonsense of mid-century American liberalism."[39] Sponsored by the Carnegie Foundation in response to social unrest "caused" by the great migration of blacks to northern cities, and published in 1944 as *An American Dilemma*, the project employed myriad social scientists, black and white, but the "author," the one responsible for its general method and themes, was the Swedish economist Gunnar Myrdal.[40] The two-volume opus postulated that "high national and Christian precepts," an egalitarian and rational social contract, formed the template of US identity.

Undermining these precepts, however, were "whole systems of firmly entrenched popular beliefs concerning the Negro . . . which are bluntly false."[41]

According to the study, the scope and strength of racial reforms must conform to universalizing (if not universal) values called the American Creed, for these values are themselves the impetus for reform. Although the "intensities and proportions" of the values that constitute American identity vary between "and within" individuals, "[t]he cultural unity of the nation consists . . . in the fact that *most Americans have most valuations in common.* . . . This cultural unity is the indispensable basis for discussion between persons and groups. It is the floor upon which the democratic process goes on."[42] In the chapter on class, Myrdal expounds that the floor of basic values includes "[t]here is nothing wrong with economic inequality by itself." This value, in essence, means: "The mere fact that the Negro people are poorer than other population groups does not *per se* constitute a social problem. It does not challenge the American Creed."[43] Myrdal further argues that the black community perpetuates its social problems inasmuch as it is caught in a "vicious circle." Cultural exclusion produces black "deficiencies" ("the Negro is not 'capable' of handling a machine, running a business or learning a profession"), which generate more discrimination and exclusion. Thus, black poverty reflects black community problems as much as the legacy of slavery and the effects of segregation.[44] Imagining cultural unity as a prerequisite for reforms based on shared values, the study returns to its premise that the essential, if not exclusive, task for reform is the elimination of ignorance and irrational thinking in white people. "Our central problem is neither the exploitation of the Negro people nor the various effects of this exploitation on American society, but rather the moral conflict in the heart of white Americans."[45]

Mirroring this ideology, Zanuck and Yordan were preoccupied with showing Ray as redeemable, and Mankiewicz made Edie the redeemed white. "If we are going to demonstrate our theme," Yordan reflected, "the bulwark [*sic*] of anti-Negroism should be someone who[m] we can watch throughout the picture in the hope that he will change or learn something."[46] For Zanuck, a focus on Ray's psyche could channel the film's entire critique of racism: "Through [Edie's] and Dr. Wharton's scenes with Ray and their attempts to argue with him and make him see the light . . . we will be able to probe into as much or as little of the Negro problem as we want."[47] This logic is not far from that of the 1954 *Brown v. Board of Education* desegregation decision, which itself followed the reasoning of a judge in the original *Brown* case in 1951. Both decisions ignored

the material inequalities ("tangible factors") of segregated schools to focus on the psychological harm caused by segregation itself ("No matter how equal the facilities, segregation injures the black child").[48]

As seen in the vanishing remedies of both *Brown* and *An American Dilemma*, what made clinical or social psychology so preferable at this time for interpreting race relations was the potential to imagine remedies without a time frame for implementation. Moreover, analyzing racism as a psychic or personal aberration often implied an unblemished national character against which to judge individual deviance. Although most of the main characters in the film belong to the working class, and the conditions for the riot are shown as class stratification and racial segregation, the mainstream reviews focused exclusively on the problem of individual racism. "The fundamental point of this picture is that ignorance is the real villain," summarized Coe.[49] Echoing *An American Dilemma*, the *New York Times* praised the film for assailing the "bigotry [that] has long festered in our society and is peculiarly at odds with the fundamentals of our political and religious philosophies."[50]

The popular assumptions about race and national identity informing this discourse on the film participated in the marginalizing of black activist voices from the cultural and political mainstream. An important example of black voices that insisted on being heard was the March on Washington Movement, in which tens of thousands protested exclusion from (and segregation within) the defense industries and defense-contracting unions. Most accounts of this activism conclude when President Roosevelt established the Fair Employment Practices Committee (FEPC) ("the first-ever state concessions to a black movement") in June 1941, but in fact the movement continued and demanded an antilynching law, the "withholding of federal funds from any agency which discriminates in the use of the funds," the end to discrimination in all employment, and black participation in the discussions to shape the coming world ("Representation for Negroes on all missions, political and technical, which will be sent to the peace conference").[51] Months after Roosevelt enacted the FEPC, the movement still attracted twenty thousand to its demonstrations; frustrated with the fecklessness of the FEPC, organizer A. Philip Randolph declared: "American democracy is a failure. . . . It has failed because it is a limited and racial and divisible democracy."[52]

The ANT paralleled the rise of the March on Washington Movement, calling for cultural changes complementary to the social demands made by the movement. Answering black exclusion from Broadway and recognizing "a theater

which for too long has been understudied and exploited," playwright Abram Hill and actor Frederick O'Neal envisioned the ANT as a people's theater.[53] The ANT staged experimental plays; trained writers, actors, and technicians; and "built Black audiences for the live theater."[54] These achievements came out of an intimacy with the community of Harlem as much as with the protest theater of the popular front.[55]

In his classic study of Harlem intellectual culture, *The Crisis of the Negro Intellectual,* Harold Cruse portrayed the ANT as balancing two "strains" of black "social opinion," a desire for integration and a desire for empowered black collectivities.[56] He argued that the postwar dominance of the discourse of integration, recasting "integration" as "synonym for civil rights or freedom," overlooked "a new community consciousness" in Harlem.[57] The decline of the ANT in the late 1940s reinforced his assertion that "integration is . . . leading to [black] cultural negation."[58]

The selection of Yordan to draft the screenplay of *No Way Out* supports Cruse's idea that the dominant racial liberalism ignored alternative formations of black political identity. Producer Sol Siegel recommended replacing Samuels as writer "with Phil Yordan, whose knowledge of the Negro he commercialized in 'Anna Lucasta.'"[59] Searching for a producer for Yordan's play about a Polish American family, *Anna Lukaska,* Yordan's agent had passed the play to Abram Hill to consider for the ANT.[60] Hill had experience adapting white-authored plays for black theater from his work in the Federal Theater Project, and he extensively revised it; it was Hill's, not Yordan's, "knowledge of the Negro" that made *Anna Lucasta* a phenomenal success.[61] However, after Yordan saw the ANT's performance, he sold the production rights to a Broadway producer whom the ANT almost had to take to court to gain a share of the profits. Hill did sue Yordan when the latter proclaimed himself the sole author of the play.[62] In light of this history, which points toward the ANT's financial collapse, the actual "knowledge" Yordan brought to the production of *No Way Out* appears as a counterforce to the black community consciousness in which the ANT thrived.

As the ANT was ending in 1950, several of its actors appeared in *No Way Out,* including Ruby Dee, Ossie Davis, Sidney Poitier, and Dots Johnson. Harlem audiences could have seen Poitier and Johnson in *Freight,* a one-act play the ANT performed at the Harlem Children's Center in February 1949. In that play, written by Kenneth White, "nine frightened black men fleeing in a boxcar from a lynching" disarm a white criminal who is "reduced to a cowardly mess, trying to get someone to listen to his claim that his whiteness cannot be altered."[63] This

scenario foreshadowed the psychological melodrama that Poitier and Johnson (and Widmark as the criminal) would enact in *No Way Out*, evoking a narrative in which black collectivity is the protagonist.[64]

While white reviews failed to mention the ANT, many articles in the black press did.[65] Emblematic was Gertrude Gipson's review of *No Way Out* in the *California Eagle*: "Featured Negro players in the Zanuck film are Dots Johnson, Amanda Randolph, Bill Walker, Ruby Dee and Ossie Davis and Maude Simmones [*sic*]. Like Poitier, these artists are all products of Broadway via the American Negro Theater." The review concludes with a quotation extolling the film from "Frederick O'Neal[,] distinguished head of the American Negro Theater."[66] O'Neal thus appears as the critical authority on a film animated by the acting style and standards the ANT helped to create. Following Cruse, I suggest that the ANT could have functioned as a discourse about the black community, a discourse exceeding the emerging dominance of integration liberalism and one that could have complemented an interpretive emphasis on the onscreen representation of the militant black community.

Imagining new democratic communities

Interviewed by Libby Clark of the *Pittsburgh Courier*, Richard Widmark distanced himself from the racist he plays onscreen. Clark began with Widmark's testimony that "discrimination because of race . . . to me never fitted into the American scheme of things." While this reference to "the American scheme of things" accords with the discourse of color-blind nationalism, his description of how he learned about racism evoked a complex relation between race and class: "We moved to the Lake Side District [of Chicago,] where the residents were prejudiced against everybody and everything that didn't pertain to the meat-packing industry, but worst of all was the profound hatred for Negroes. This antagonistic feeling stemmed from their feeling of insecurity in their jobs, I think." He then recalls the activism of the Congress of Industrial Organizations to organize industrial workers: "You recall some fifteen years back, times were mighty black, and the unions were making desperate stands for the integration of Negroes in the meat-packing industry."[67] In this way, Widmark prioritized how racism imperiled not just "the American scheme" but also the labor movement, by inviting whites to identify with their relative social privilege despite their common struggle with black workers.[68]

Linking the film's black actors to the ANT and its white star to integrated unions, the black press conjured two communities, one of black cultural creators and audiences and the other of black and white workers. Both of these communities challenged presumptions of the dominant white liberalism—its faith in integration-as-assimilation into a "cultural unity" and its narrow focus on curing the racism of backward individuals and social pockets. Adam Green has examined another sense of black community that coalesced during the 1940s: black communities as consumer markets. In an analysis of black-targeted radio in Chicago, Green suggests the ambivalence of such consumer identities. On the one hand, consumerism interacted with black entrepreneurship to form new "infrastructures" for black cultural production and to bolster the political valence of black public identity, since consumerism in the United States was linked, through "modernization in retail and advertising," with the "dignity" of (equal) citizenship. On the other hand, "the struggle to legitimate black consumption [is] a key—though understudied—point of entry for blacks into the emerging social order of the American Century."[69] African American consumerism, like consumerism generally, thus has no stable politics, and Green uses it to explore new senses of community reshaping black American identity and to question the presumption of an oppositional nature of black participation in mass culture.

While Green emphasizes black struggles for consumer dignity, I highlight struggles for consumer survival. Black consumption of *No Way Out* had political value because of the film's ban, and that ban had special significance because of its relation to the struggle for fair housing, which for many black Americans meant the struggle for survival as well as dignity. Placing the ban of the film within official attempts to ban news of white resistance to fair housing reveals how the black press imagined black audiences as activist consumers. The growth of the black middle class, especially through participation in the war and the war industry, contributed to hundreds of blacks seeking homes in white neighborhoods. When suburbs began being built and whites moved out of areas adjacent to black districts, many blacks wanting to move found white home dealers eager to sell to them at exorbitant prices, while white residents resisted the black home buyers with vicious tactics.[70]

In Chicago, "from May 1944 to July 1946," Arnold Hirsch chronicles, "forty-six black residences were assaulted," most of these through fire bombings. For 3 days in 1947, whites gathered in mobs as large as 5,000 people to protest black veterans' moving into a Chicago Housing Authority project. "Blacks

were hauled off streetcars and beaten in a fashion reminiscent of [the riot of] 1919."[71] White violence occurred at the Airport Homes in 1946 and in the neighborhood of Englewood in 1949; at the Trumball Park Homes, white attacks on blacks amounted to a "war of attrition," beginning in 1953 and lasting a decade.[72] A year before *No Way Out* was banned for showing a race riot, the *Chicago Defender* reported "a mob of 2,000 whites gathered to protest the [black] occupancy" of a home in the Park Manor neighborhood, "where prejudiced whites have carried on a guerilla warfare against a score or more of Negro residents . . . during the past year."[73]

A startling fact about this report is its brevity and its location buried within the pages of the *Defender*: two paragraphs on page 27. This marginalizing of news of a crisis is explained by the policy of the Chicago Commission on Human Relations to prevent a citywide riot by exerting pressure on news agencies to minimize reporting of racial disturbances; city papers were to avoid covering violence while it was in progress, were not to use photos of such events, and were to script a narrative that condemned the violence and emphasized police control of it.[74] In devising the policy, commission head Thomas Wright was remembering Chicago's 1919 riot, which was thought to have been exacerbated by sensational and inaccurate reporting. But as Hirsch notes, "Chicago 1919" was recurring in 1946 as far as blacks were concerned. Chicago Urban League director Sidney Williams led the opposition to the policy; in 1950 he called the policy a "conspiracy of silence,"—because "no Chicago newspaper has carried an adequate account of the many serious incidents of the past few years"—and a "colossal failure" because the rioting persisted.[75]

The convergence of a policy of suppressing reporting on rioting with the ban of *No Way Out* (for a scene in which blacks successfully defend themselves against white rioting) suggests that the continuation of the commission's policy through years of white violence had an objective beyond preventing another Chicago 1919 or Detroit 1943: to contain the "threat" of organized black self-defense. Although the *Defender* reluctantly followed the policy, it evoked that distinct possibility: "[Black] residents of the [Park Manor] area have met to consider employing an armed guard to protect their homes if the police fail to provide adequate protection."[76] The riot scene of *No Way Out* in effect rehearses the option of "employing an armed guard." The commission's policy and the film's banning, alongside mainstream reviews that disparaged or effaced the film's forceful representations of the black community, met in their fear of black civil

disobedience and black militancy, no matter what the realities of white violence and racial injustice may have been.

Alluding to the contemporary crisis, the *Pittsburgh Courier* attacked not just the ban but also the reasons for it: the paper criticized the captain's reasoning that the film "might stir up 'ashes' in Chicago's recently troubled race relations picture." For the *Courier*, the ban attempted to suppress a social "upheaval, of course, which was caused by segregation and other racial ills which 'No Way Out' attacks vigorously." The *Courier* thus saw the film as a "militant picture" and as "realism." Here, between the recognition of "Chicago's recently troubled race relations picture" and the banning of the film, is where the article envisioned a new community of activist consumers. It named the many civil rights organizations fighting the ban but asserted that "victory must be won" by black consumers: "In the final analysis, however, the victory must be won by little, everyday people who spend their money at the box office and who want the truth." Acknowledging that African Americans had just been sent to fight in Korea, the article refashioned the Double-V campaign from World War II (victory against both segregation at home and fascism abroad) to include the black consumer: "A ticket stub for 'No Way Out' now becomes a tiny badge of honor in the home-front battle against obstructionism."[77] If the "home-front battle" was now occurring at the movie theater, then the "hot" war was occurring not just overseas, but rather next-door and across the nation, in battles for economic and social justice.

The *Courier*'s faith in "little, everyday people" returns us to Ellison's critique of the 1949 films, in which he imagined the critical authority of the black audience: "As an antidote to the sentimentality of these films, I suggest that they be seen in predominantly Negro audiences, for here, when the action goes phony, one will hear derisive laughter, not sobs."[78] Aligning himself with other black spectators, Ellison represented black consumers (as opposed to white filmmakers) as agents of cultural change.

Crucial to understanding the ban of *No Way Out* is the intimation in the black press that black spectators could use the film to imagine new democratic communities. As Ellison suggests, our historiography must go beyond the model of seeing films as reflections, for this does not adequately convey the ideological struggle that made use of such representations, one in which many blacks contested the dominant liberal consensus. Recognizing this struggle allows us to challenge the limited support whites were willing to offer black activists, as well as the conditions that permitted some black voices to be heard but not others. The most radical voices, voices of suffering and of strength, went unheard. Taking

root in 1950 was a framework of cultural unity that promoted integration while filtering and regulating politics that did not meet nationalist and individualist criteria. Black resistance to this consensus meant the evolution of an African American politics of community, a politics that valued difference, dialogue, and a vital continuing role for militancy within black activism.

Notes

1 Donald Henderson, telegram, January 6, 1949; R. A. Kline, memo, October 7, 1949, Twentieth Century Fox produced scripts, collection 10, Box FX–PRS–701, Department of Special Collections, University of California, Los Angeles (hereafter FX-PRS-701).

2 Ralph Ellison, "The Shadow and the Act," in John F. Callahan (ed.), *The Collected Essays of Ralph Ellison* (New York: Modern Library, 2003), 308.

3 Ibid., 306–7.

4 "Chicago Bans Film on Racial Problem," *New York Times*, August 24, 1950, 41.

5 "Chicago Lifts Ban; Boston Nixes Sunday," *Pittsburgh Courier*, September 9, 1950, 14; "Chicago Ban Is Lifted on Film, 'No Way Out,'" *New York Times*, August 31, 1950, 33; "'No Way Out' Ban Lifted after NAACP Protest," *Atlanta Daily World*, September 3, 1950, 3.

6 "Chicago Lifts Ban," *Pittsburgh Courier*; "Philly Bans 'No Way Out' Because of Riot Scenes," *Amsterdam News*, September 9, 1950, 20; "Police and the Movies," *New York Times*, September 4, 1950, 10.

7 George S. Schuyler, "God Save Us from Our 'Friends,'" *Pittsburgh Courier*, August 19, 1950, 9.

8 Jason Joy, memo to Julian Johnson, December 29, 1948, FX–PRS–701. Joy mentioned Detroit to evoke the bloody race riot of 1943. "Small race riot" is from a handwritten note by Zanuck on a loose title page of the Samuels story. To avoid the "financial disaster" of censorship in both the North and the South, Zanuck wanted to represent the "riot" as a "'bar-room brawl,' or a corner street fight." Memo from Zanuck to Lesser Samuels, February 1, 1949, FX–PRS–701.

9 Marjorie McKenzie, "Movies Can Show Whole World What Democracy Really Is," *Pittsburgh Courier*, September 23, 1950, 6; Schuyler, "God Save Us." See also Lillian Scott, "'No Way Out' Hits Bias a Solid Blow," *Chicago Defender*, August 12, 1950, 20.

10 While Thomas Cripps, for example, sees *No Way Out* as the "best" of the 1949–50 race problem films, he does not pay adequate attention to changes in the black

public sphere (e.g., in forms of protest and mass consumption); he adjusts his interpretation to the dominant racial liberalism and the belief in steady progress through integration. Conversely, Michael Rogin, whose study takes a more class-conscious and black nationalist position, does not extensively analyze *No Way Out*, yet places it squarely in his category of "blackface films," a category that has the ironic effect of flattening history. Cripps, *Making Movies Black: The Hollywood Message Movie from World War II to the Civil Rights Era* (New York: Oxford University Press, 1993), 244–9; Rogin, *Blackface, White Noise: Jewish Immigrants in the Hollywood Melting Pot* (Berkeley: University of California Press, 1996), 255, 302–31.

11 *No Way Out* exhibited the skill of cinematographer Milton Krasner, a veteran of many film noirs.

12 Fred Hift, "No Way Out," *Motion Picture Herald*, August 5, 1950, 413.

13 Cripps, *Making Movies Black*, 247–8.

14 Among Mankiewicz's first films as writer-director, *Somewhere in the Night* (1946) was a convoluted noir of this ilk about an amnesiac who carries guilt for possibly having murdered.

15 Lesser Samuels, "No Way Out," n. d. [ca. January 1, 1948], FX–PRS–701, 6.

16 Ibid., 9.

17 Philip Yordan, "Revised First Draft Continuity: *No Way Out*," April 25, 1949, 5, Twentieth Century Fox produced scripts, collection 10, Box FX–PRS–700, Department of Special Collections, University of California, Los Angeles (hereafter FX–PRS–700).

18 Ibid., 9.

19 Mankiewicz's script made changes that were confirmed in the visual style and the acting; thus, this section describes the visual style as it agrees with (and extends and interprets) the Mankiewicz script.

20 Joseph L. Mankiewicz, "Preliminary script of *No Way Out*," June 16, 1949, FX–PRS–700, 1.

21 Samuels, "*No Way Out*," 10–12; Yordan, "First Draft Continuity," 10–13.

22 Ibid., 52–3.

23 Yordan, "First Draft Continuity," 83, 86–8.

24 Ibid., 100.

25 "*No Way Out* Conference on Screenplay of 6/16/49 (with Messrs. Zanuck, Mankiewicz)," June 20, 1949, 7, FX–PRS–700. Emphasis in original.

26 Richard L. Coe, "A Social Problem in Jungle Terms," *Washington Post*, September 14, 1950, 16.

27 Howard Barnes, "On the Screen," *New York Herald Tribune*, August 17, 1950, 14.

28 "*No Way Out*," *Newsweek*, August 21, 1950, 83–4.

29 Martha Wolfenstein and Nathan Leites, "Two Social Scientists View 'No Way Out,'" *Commentary*, October 1950, 389–90. My emphasis.

30 "Conference Note on *No Way Out*," from Philip Yordan to Darryl Zanuck, January 28, 1949, FX–PRS–700. Zanuck repeats this idea in his memo to Samuels, February 1, 1949.

31 Mankiewicz extended the dialogue with the intern's sarcasm, "Putting on whites isn't that easy, doctor." On Zanuck's request, the line was removed. Mankiewicz, "Preliminary Script," 5; "Conference on Screenplay of 6/16/49," 1.

32 Mankiewicz, "Preliminary Script," 114.

33 Conference note from Yordan to Zanuck, January 28, 1949; memo from Zanuck to Samuels, February 1, 1949.

34 "*No Way Out*," *Newsweek*, 84.

35 Walter White, "'No Way Out': A Picture Scarcely without Equal," *Chicago Defender*, August 26, 1950, 7. Cripps researches White's activism in Hollywood in *Making Movies Black*.

36 Coe, "A Social Problem," 16.

37 Darryl Zanuck, memo to Lesser Samuels, February 1, 1949. My emphasis.

38 Nunnally Johnson, memo to Darryl Zanuck, January 3, 1949, FX–PRS–701.

39 Nikhil Pal Singh, *Black Is a Country: Race and the Unfinished Struggle for Democracy* (Cambridge, MA: Harvard University Press, 2004), 143.

40 Ibid., 134, 141–2.

41 Gunnar Myrdal, *An American Dilemma: The Negro Problem and Modern Democracy*, vol. 1 (1944; New York: McGraw-Hill, 1964), lxxi, lxxiii.

42 Ibid., lxxii. Emphasis in original.

43 Ibid., 214.

44 Ibid., 208.

45 Ibid., 215; cf. lxxi.

46 Conference note from Yordan to Zanuck, January 28, 1949.

47 Memo from Zanuck to Samuels, February 1, 1949.

48 The first quote is from *Brown v. Board of Education* (1954), in Paul Brest, *Processes of Constitutional Decisionmaking* (New York: Aspen Law and Business, 2000), 744; the second quote is from Jack Greenberg, *Crusaders in the Courts: Legal Battles of the Civil Rights Movement* (New York: Twelve Tables Press, 2004), 138.

49 Coe, "A Social Problem," 16.

50 T. M. P., "'No Way Out,' Fox Film Study of Racial Prejudice, Opens at the Rivoli Theatre," *New York Times*, August 17, 1950, 23.

51 Singh, *Black Is a Country*, 64; March on Washington Movement, "Eight-Point Program," in Roi Ottley, *New World A-Coming: Inside Black America* (Boston: Houghton Mifflin, 1943), 253.

52 Ottley, *New World A-Coming*, 252.

53 Abram Hill, quoted in Ethel Pitts Walker, "The American Negro Theatre," in Errol Hill (ed.), *The Theater of Black Americans*, vol. 2 (Englewood Cliffs, NJ: Prentice-Hall, 1980), 50–4; Loften Mitchell, *Voices of the Black Theater* (Clifton, NJ: James T. White & Co., 1975), 147.

54 Walker, "American Negro Theater," 49; Mitchell, *Voices*, 118.

55 "We would have certain family nights," Abram Hill remembers. "We'd cater to the churches, the schools and groups that would buy out the whole house," which was a "basement theater in the 135th Street Library." Mitchell, *Voices*, 146–7. On the ANT's welcome in the black community of Chicago, see Ossie Davis and Ruby Dee, *With Ossie and Ruby: In This Life Together* (New York: William Morrow, 1998), 158. Michael Denning, *The Cultural Front: The Laboring of American Culture in the Twentieth Century* (London: Verso, 1997), 369–70.

56 Harold Cruse, *The Crisis of the Negro Intellectual* (1967; New York: Quill, 1984), 4–6, 210.

57 Ibid., 4, 208.

58 Ibid., 85.

59 Sol C. Siegel, letter to Julian Johnson, December 29, 1948, FX–PRS–701.

60 Mitchell, *Voices*, 130–2.

61 Walker, "American Negro Theater," 50, 57; Samuel L. Leiter, *The Encyclopedia of the New York Stage, 1940–1950* (Westport, CT: Greenwood Press, 1992), 22–4.

62 Mitchell, *Voices*, 137–42.

63 Leiter, *Encyclopedia*, 531.

64 Leiter, paraphrasing the *New York Times* critic, writes that the play "lacked a focal character to put the author's views into perspective" (ibid.). This was not a problem for the *Baltimore Afro-American*, which announced the "National Tour" of Baltimore son Dots Johnson, linking *No Way Out*, *Anna Lucasta*, and *Freight*. *Freight* reached Broadway, and the *Afro-American* called it "Broadway's most controversial play to date." "Setting National Tour," *Baltimore Afro-American*, September 9, 1950, 8.

65 "Zanuck Talks of Problems Faced During Casting for 'No Way Out,'" *Chicago Defender*, July 29, 1950, 21; "'No Way Out' Good Story, Says Zanuck; Tells Why," *Baltimore Afro-American*, August 5, 1950, 8; "No Way Out," *Ebony*, March 1950, 33; "Theatre Group Gives Widmark, Zanuck Awards," *Pittsburgh Courier*, September 23, 1950, 14.

66 Gertrude Gipson, "'No Way Out' Presents New Startling Approach to Racial Problem," *California Eagle*, August 25, 1950, 16.

67 Libby Clark, "'I'm Not Prejudiced,' Widmark Tells *Courier*," *Pittsburgh Courier*, August 26, 1950, 13.

68 This idea that workers must unite across races resonates with a speech by
 DuBois in 1946: "Slowly but surely the working people of the South, white
 and black, must come to remember that their emancipation depends upon
 their mutual cooperation; upon their acquaintanceship with each other; upon
 their friendship; upon their social intermingling."—*W. E. B. DuBois Speaks*,
 vol. 2, ed. Philip S. Foner (New York: Pathfinder, 1970), 218. DuBois's vision
 is congruent with the film itself: as Edie and Brooks fight the psychological
 wounds of their social immobility, they unite to repel racism (embodied by
 Ray) as members of the working class. While reviews did not discuss the film in
 such language, the United Electrical, Radio and Machine Workers of America,
 a union that fought for working-class integration, gave the film its highest
 recommendation. Mike Reed, "Hollywood Does Good Job on This One,"
 UE News, October 16, 1950, 15.

69 Adam Green, *Selling the Race: Culture, Community, and Black Chicago, 1940–1955*
 (Chicago: University of Chicago Press, 2007), 80–4.

70 Arnold R. Hirsch, *Making the Second Ghetto: Race and Housing in Chicago,
 1940–1960* (Chicago: University of Chicago Press, 1983), 16–36, 47–8.

71 Ibid., 53–4.

72 Ibid., 55–6.

73 "Nab White Hoodlums for Stoning Homes," *Chicago Defender*, August 6, 1949, 27.

74 Hirsch, *Making the Second Ghetto*, 50–2, 60–1.

75 Williams, quoted in ibid., 61.

76 "Hoodlums Try Again to Burn Park Manor Home," *Chicago Defender*, July 2,
 1949, 2.

77 "Chicago Police Ban 'No Way Out,'" *Pittsburgh Courier*, September 2, 1950, 13.

78 Ellison, "The Shadow and the Act," 308.

Bibliography

Brest, Paul. *Processes of Constitutional Decisionmaking* (New York: Aspen Law and
 Business, 2000).

Cripps, Thomas. *Making Movies Black: The Hollywood Message Movie from World War
 II to the Civil Rights Era* (New York: Oxford University Press, 1993).

Cruse, Harold. *The Crisis of the Negro Intellectual* (1967) (New York: Quill, 1984).

Davis, Ossie and Ruby Dee. *With Ossie and Ruby: In This Life Together* (New York:
 William Morrow, 1998).

Denning, Michael. *The Cultural Front: The Laboring of American Culture in the
 Twentieth Century* (London: Verso, 1997).

DuBois, W. E. B. *W. E. B. DuBois Speaks.*, Vol. 2, ed. Philip S. Foner (New York: Pathfinder, 1970).

Ellison, Ralph. *The Collected Essays of Ralph Ellison*, ed. John F. Callahan (New York: Modern Library, 2003).

Green, Adam. *Selling the Race: Culture, Community, and Black Chicago, 1940–1955* (Chicago: University of Chicago Press, 2007).

Greenberg, Jack. *Crusaders in the Courts: Legal Battles of the Civil Rights Movement* (New York: Twelve Tables Press, 2004).

Hirsch, Arnold R. *Making the Second Ghetto: Race and Housing in Chicago, 1940–1960* (Chicago: University of Chicago Press, 1983).

Leiter, Samuel L. *The Encyclopedia of the New York Stage, 1940–1950* (Westport, CT: Greenwood Press, 1992).

Mitchell, Loften. *Voices of the Black Theater* (Clifton, NJ: James T. White & Co., 1975).

Myrdal, Gunnar. *An American Dilemma: The Negro Problem and Modern Democracy*, Vol. 1 (1944; New York: McGraw-Hill, 1964).

Ottley, Roi. *New World A-Coming: Inside Black America* (Boston: Houghton Mifflin, 1943).

Rogin, Michael. *Blackface, White Noise: Jewish Immigrants in the Hollywood Melting Pot* (Berkeley: University of California Press, 1996).

Singh, Nikhil Pal. *Black Is a Country: Race and the Unfinished Struggle for Democracy* (Cambridge, MA: Harvard University Press, 2004).

Walker, Ethel Pitts. "The American Negro Theatre", in Errol Hill (ed.), *The Theater of Black Americans*, Vol. 2 (Englewood Cliffs, NJ: Prentice-Hall, 1980).

Wolfenstein, Martha and Nathan Leites. "Two Social Scientists View 'No Way Out,'" *Commentary*, October 1950, 389–90.

Caribbean All-Stars: Sidney Poitier, Harry Belafonte, and the Rise of the African American Leading Man

Belinda Edmondson

I'll always be chasing you, Sidney, I'll always be following in your footsteps. There's nothing I would rather do, sir, nothing I would rather do.

Denzel Washington[1]

First, a prologue:

Shortly before Sidney Poitier and Harry Belafonte took America by storm in the 1950s, their prototype (and later, mentor), the incomparable Paul Robeson, took Trinidad and Jamaica by storm with his powerful musical concerts. Before Harry Belafonte seduced American audiences with his Caribbean folk songs, Billy Eckstine and his legendary jazz band mesmerized Caribbean audiences with their powerful projection of black modernity. These two African American performers, in their different ways, together represented for the colonial Caribbean a new type of black man. Robeson—dark-skinned, dignified, cosmopolitan—represented the possibility of black political independence. Eckstine—green-eyed and Hollywood handsome—was an African American sex symbol with white female fans before anyone was willing to discuss it. He represented a new type of black masculinity—sexual, sophisticated, unmistakably African American. As Miles Davis succinctly noted, the suave "Mr. B" "didn't take no shit off nobody."[2] Combined, the unlikely duo of Robeson and Eckstine represented a composite of black desire for the emerging black societies of the Caribbean.

Robeson and Eckstine were African Americans in the Caribbean, black people not quite the same as the black people who watched them so avidly. Sidney Poitier and Harry Belafonte were two Afro-Caribbean men in the United States,

not quite the same as the black people as the African Americans, and not at all the same as the white Americans, who watched *them* so avidly. Yet, like Robeson and Eckstine, Poitier and Belafonte also represented a composite of black and white desire for emergent civil rights era America. What does it say about 1950s America that its icons of Ideal Blackness were two Caribbean men?

What I attempt here is a narrative of how two Caribbean immigrants provided the template for the rise of today's African American leading man. He is epitomized by Will Smith and Denzel Washington, multimillion-dollar-a-picture superstars who can make or break a movie, black men who play every role from villain to hero, romantic idol to action figure. Smith and Washington represent a composite of desirable characteristics for a black man in the American imagination, characteristics carefully crafted and selected from decades of racial conflict and compromise.

The two Afro-Caribbean men, who, 60 years before them, defined the black leading-man archetype, are themselves composites, doppelgangers even. They are Caribbean, they are African American: as their iconic images suggest, one is the very essence of dignified black rectitude, the other of simmering black sexuality. The story of the creation of the African American leading man is irretrievably the story of two West Indian men, both highly talented and ambitious, both friends and rivals, both similar and yet very different.

This is, yes, a story of immigrants who came to symbolize a kind of ideal African Americanness, but as my prologue suggests it should not be taken to mean a one-way flow of immigrant influence into America. African Americans were exerting their own cultural influence on West Indians' "back home."[3] In his excellent book *Caliban and the Yankees*, Harvey Neptune documents how the cultural influence of African American soldiers in Trinidad during World War II was considered a direct threat to the colonial administration.[4] So what I present here as "Caribbean blackness" should be understood as not some kind of essential Caribbeanness, but rather one that was already open to African American ideas and influence.

To understand the extraordinariness of the very *idea* of today's black leading man, we have to understand just how thoroughly black men had been excised from mainstream American films for most of the twentieth century. We are all familiar with the vicious stereotypes of African American men, but the enduring nature of these stereotypes has much to do with America's film history. The notorious 1915 film on the Reconstruction era, *Birth of a Nation*, provided a cinematic template for these stereotypes lodged so deep in the white American

national psyche: it showed African American soldiers pillaging white homes, raping white women, eating fried chicken in congress. The only good black man was the faithful old slave who refused to leave the white family's side, even after slavery ended. It was these images of black men that brought forth the storm of protests from black organizations and prompted state censorship boards to cut objectionable scenes from the film.[5] The protests and censorship that followed *Birth of a Nation* signaled to white filmmakers that black men were best left out of American film altogether, except in comic roles. And with few exceptions until the 1950s, the absence of black men in mainstream American film, even more so than black women, is striking.

And then, in 1955, a young black actor named Sidney Poitier exploded on the American screen in *Blackboard Jungle*.[6] His character, a hyperintelligent juvenile delinquent who leads a multiracial pack of students in an anarchic high school, consciously walked the line on black stereotypes. Here is a young black man, exuding sexual energy in his form-fitting t-shirt and dangerous quietness, understood to be a "bad" kid, yet one who never actually *is* violent, who never actually *is* sexual, and who, as it turns out, has an after-school job, secretly wants to learn, and sings African American spirituals with a group of clean-cut young black men. In the end, Bad Sidney winds up on the side of Good and aids the teacher in his fight against the unreconstructed real juvenile delinquents, who are, pointedly, all white. Although *Blackboard Jungle* is not a particularly good film, it is an important one for its deliberate portrayal of a young black man, America's Boogeyman, as a complex human being, not a purely evil villain, not a saintly Uncle Tom. Even more to the point, this villain is highly articulate, betraying no particular regional or ethnic accent—unlike his white and Latino classmates. It's easy to project the best possibilities onto him. This is the first example of the West Indianization of the African American man: the culturally ambiguous black hero. If the film is self-conscious in its desire to both break away from a stereotype and yet not shy away from images of black men that frighten America, it can be forgiven for its good intentions. But why do those good intentions, like the other "message" films of its generation featuring redeemed black subjects, omit all signs of African Americanness—African American culture, African American accent, African American style?

Blackboard Jungle is important for our discussion here because it is one of the rare occasions in which Sidney Poitier played a villain—albeit a recuperated villain. Given that he carefully chose roles to avoid projecting black stereotypes, this is not an accident. In an era when African Americans were making a great

push for civil rights, the black image was everything, proof that black people *did* deserve a seat at the table. There was no room for moral ambiguity. Clearly, Sidney Poitier was an extraordinary young actor, rigorously trained in theater and highly disciplined and conscious of the importance of image, so we understand these reasons for his success. But what is it that American audiences saw in this young black actor that made him the first black leading man of American film?[7]

The appeal of Sidney Poitier for black and white audiences in the 1960s, according to film critic Donald Bogle, is that he was a model hero for an integrationist age: he was educated and intelligent. He spoke "proper" English, dressed conservatively, and had the best of table manners. For anxious whites, Sidney Poitier was reassuring, a black man who had met their standards, who might be invited for lunch. His characters were tame, never threatening the status quo, offering none of the threatening images of black masculinity lurking in the back of the American national subconscious. For African Americans struggling to get a foothold on the American social ladder, Sidney Poitier was precisely how they wished to be represented: as a professional black man whose films had no dialect, no shuffling, no violence. As Bogle wryly notes, "He was the complete antithesis of all the black buffoons who had appeared before in American movies."[8] Black and white, Americans loved him.

Poitier's performance as Dr John Prentice in *Guess Who's Coming to Dinner* (1967) epitomizes his enduring image of the dignified, super-qualified black professional of whom all can be proud. This, and his similar roles in other films like *To Sir, with Love* (1967), confirms the basic traits associated with Poitier's public persona, despite the multiple roles he has played since then as a cowboy

Figure 5 Sidney Poitier in *Guess Who's Coming to Dinner*.

or a comic sideman (both in all-black films directed by himself).[9] These other images have not gained the same amount of traction. A significant part of the appeal of Dr John Prentice for white America is the same as that which singled out Sidney Poitier in *Blackboard Jungle*: articulate, magnetic, manly, but with a regionally unspecific accent, a stylistic rootlessness. The peculiar "accentlessness" and careful reserve of the assimilated, ambitious immigrant, whose crisp tones betrayed only what Americans would consider "properness"—Britishness, if they cared to inquire further, a hint of the Anglicized accent of the colonial world. (Or, perhaps, the faux-British accent of American actors and newscasters of an earlier generation. According to Poitier, he shed his "thick," working-class Caribbean accent and mimicked that of an American newscaster's in order to get an acting job.)[10]

Nobody in the 1950s America knew, or considered, Sidney Poitier's essential *foreignness*. Even now, the observation that Sidney Poitier is a Bahamian elicits no more than an incurious "oh?" from Americans. It has no bearing on his meaning for them. Yet his un–African Americanness is essential to the construction of his Ideal Blackness. Sidney Poitier, like his most famous character Dr John Prentice, is a black tabula rasa. Because he is *understood* to be African American, the fact that he has no identifiable cultural markers of actual African Americanness is not remarkable; the absence of black markers allows for a projection of American desires, black and white, onto him. It is no accident that Dr John Prentice's most important speech is directed at his angry African American father: "You see yourself as a Black Man, but I see myself as a Man." This is the essential message of *Guess Who's Coming to Dinner*: the acceptable black man, to see himself as equal, must not ever see himself as black. And yet, he must always be representing Blackness—albeit Ideal Blackness. It is unthinkable to have a black hero like Dr John Prentice in contemporary film; today a certain modicum of stylistic blackness is essential to the African American leading man's role. But in 1967 its *lack* was what was essential.

If Sidney Poitier was, as many critics have remarked, the first black man who was famous only for acting, then his colleague and friend Harry Belafonte followed a more conventional path for African American actors. Famous as a singer of West Indian folk songs, he made several forays into film in the 1950s, sometimes vying for the same roles as Sidney Poitier. But it was as a singer that he was known best, and is still known best. Like Sidney Poitier, Harry Belafonte was a Caribbean immigrant, moving back and forth between Jamaica and Harlem. Unlike Sidney Poitier, his fame rested squarely on his highlighting of his

West Indian heritage. That difference is as striking as the difference between the two performers themselves. The iconic images of the two men tell the story: one dark-skinned, conservative, dressed in a suit, exuding professional decorum, assimilated; the other light-skinned, shirt open, exuding sexual dynamism—*not* assimilated. Belafonte's conscious molding of a sexual, West Indian persona is at odds with what we might consider the carefully cultivated sterility of the Dr John Prentice–like Black Ideal. Yet Belafonte's persona is the necessary complement to Sidney Poitier's as the ideal black leading man.

There are many parallel developments in the careers of Sidney Poitier and Harry Belafonte beyond their Caribbean heritage. Both trained in theater with leading African American actors in New York, both began movie careers at a time when Hollywood was exploring the use of conscious antistereotypical black images. In 1953, 2 years before Poitier's star turn in *Blackboard Jungle*, Harry Belafonte costarred in the earnest film *Bright Road* (based, coincidentally, on a short story by a West Indian writer).[11] Belafonte plays a young principal at an all-black elementary school who aids a troubled black boy. The film's theme of black uplift and its images of clean-cut young black professionals anticipate the ideas of the later Poitier films. But Belafonte as black uplift hero never quite caught on.

Belafonte's role in 1957's landmark film *Island in the Sun*, costarring with British star Joan Fontaine, went the opposite route, playing up Belafonte's sensual character and, significantly, linking it to a Caribbean identity.[12] *Island in the Sun* is a melodramatic tale of a colonial Caribbean island seething with racial, sexual, and political tensions as the white ruling class confronts rising

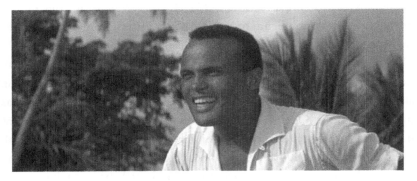

Figure 6 Harry Belafonte is David Boyeur in *Island in the Sun*.

black power. It features the first big-screen interracial romance between a white woman and a black man in the United States. Harry Belafonte plays the fiery young labor leader who threatens white power on the island. Respected British actress Joan Fontaine plays the young white woman who is erotically drawn to him, but can never consummate her desire because of their racial difference. The film's coy avoidance of any actual erotic encounter between the open-shirted Belafonte, so clearly presented as a sex symbol, and the sedate Fontaine only serves to highlight the explosive issue that lurks behind all the Belafonte and Poitier films of this era: the enduring taboo of black male sexuality.

It is no accident, I think, that this first big-screen representation of an interracial love affair takes place in the Caribbean, where it remains reassuringly distant and foreign to a white American audience still jittery at the prospect of integration and miscegenation. The whiff of interracial sex—which never actually happens—is contained because it's exotic, like an old romance novel featuring a white American secretary in love with a sheikh in the desert. It doesn't implicate. And yet the film's power is derived from its peculiar obliqueness: America gets to explore its deepest racial nightmares, its hidden racial desires, via the Caribbean. It is because of its indirect comment on American race politics that *Island in the Sun* has traction: How can a white American audience *not* register the link between a sexually attractive, politically assertive black male character and America's own struggles to contend with black assertion of political and social rights in 1957?

The displacement of African American male sexuality onto the exotic Caribbean leading man allowed white America to play out its own sexual desires without actual consequences. When, 10 years later, white America was finally willing to entertain the idea of an actual African American man in a romantic relationship with a white woman in *Guess Who's Coming to Dinner*, he was the antithesis of Belafonte's rousing labor leader who also, with the exception of a single kiss, never touches his white love. That Belafonte is light-skinned, Poitier dark-skinned, is not irrelevant either: dark-skinned African American men, like dark-skinned black men everywhere, are represented as the essence of the black male stereotype. The light-skinned black man as sex symbol displaces the bigger taboo of the dark-skinned black man as sex symbol: hence the asexual Dr John Prentice, forever suited and tied, even as the romantic lead. But ultimately that displacement meant that there was nowhere for Belafonte the movie star to go: America's reckoning was with his darker complement, not with him. *Island in the Sun* was Belafonte's epitaph as America's African American leading man.

Although he continued to act in films, many from his own production company or Sidney Poitier's, Belafonte's public persona became permanently associated with the sensual singer of West Indian folktales. Belafonte felt that his folk songs were political, songs of the black laboring classes of the Caribbean.[13] But if Belafonte saw his music as political, that's not how his white audiences saw it. A sexy Caribbean native singing "Day O" and "Island in the Sun" is an enduring image for much—most, I daresay—of white America. The happy-go-lucky Caribbean remains a favorite tourist cliché. A parallel image, however, especially for African Americans and West Indians, is of Belafonte, the outspoken civil rights political activist. Belafonte's comments about Jamaican politics would eventually earn him the title of persona non grata from a wrathful Jamaican government, similar to his mentor Paul Robeson's exile from America for radical political views. But if white America was never bothered by this politicization of its favorite Caribbean native, it may be because of the foreignness, the music itself, or both: during a civil rights march in the Deep South, white women who were jeering at the protestors started screaming in admiration when they saw Harry Belafonte among the marchers.[14] Sidney Poitier, by contrast, although also involved in civil rights work, was never so overtly tied to black political struggles. This may have allowed him to retain his stature as a racial unifier and the elemental mystery that still pervades his public persona.

So how did his Caribbean identity help Sidney Poitier become a star? By being assimilable, restrained, unknowable. Sidney Poitier's heirs are easy to see today in Denzel Washington, Will Smith, and the late Howard Rollins, Jr. who literally channeled Poitier in the television series *In the Heat of the Night*. America has always wanted another Sidney Poitier. But where are Belafonte's heirs? There aren't any. Belafonte's overt Caribbeanness could only be a foil, a deflection of and a substitute for America's problem with black male politics (also known as "black male anger") and black male sexuality. Through the prism of these black immigrants America needed to see its options, and Poitier would always be the better one.

Poitier has been, quite literally, a mentor to Denzel Washington, who in turn mentored Will Smith, who has become a superstar of proportions heretofore never imagined for a black actor. Like Poitier, both carefully choose their roles; like Poitier, both avoid erotic scenes with white women; like Poitier, neither is overtly political, although they are clearly grounded in the black community and make a point of acknowledging their black wives. So, although Washington and Smith play symbols of black protest such as Malcolm X and Muhammed

Ali, they are safely rehabilitated symbols of protest. Protest must be followed by resolution, by love.

Interestingly, Will Smith's breakthrough role as a gay hustler in *Six Degrees of Separation* involves a plotline—taken from real life—where the hustler gains entry into the homes of Manhattan's liberal elite by pretending to be Sidney Poitier's son. The rich white folk, smitten by their Poitier proxy, provide the hustler with his every need. The film's point is clear: white America's desire for Sidney Poitier is a desire for a "do-over," a do-over of race relations where rich white people on the Upper East Side can assure themselves they're not racist because the Sidney Poitiers of the world are welcome in their living rooms. West Indian immigrants, Michelle Stephens further suggests, are a "do-over" for white America, an opportunity to do over the wrongs done to Robeson, Eckstine, and black America itself: *these* black people won't be bitter.[15] Film critic Richard Schickel, in a scolding fit over a scholar's less-than-celebratory assessment of Poitier's politics, argued that the scholar didn't understand the more subtle nature of the proud West Indian character, Poitier's birthright. "The former slave culture of the islands was different from that of the United States in many ways," writes Schickel, "particularly in its propensity to turn out proud, self-assured men who tended not to truckle to whites."[16]

So, West Indians didn't 'truckle to whites." But Schickel's unspoken assumption is that African Americans did. And, therefore, because of their refusal to "truckle," Poitier and those like him don't need to engage in overt racial protest. The black immigrant's history, the thinking goes, is an independent one, without American racial baggage. And this necessary contradiction is, in the end, what undergirds Sidney Poitier's continuing appeal for both whites and blacks, Americans and West Indians, a characteristic that infuses his heirs today: the "proud, self-assured" black man who refuses to kowtow, yet who is always welcomed with a place at the table.

And now, an epilogue:

On November 4, 2008, an African American man made history by becoming the first black president of the United States, indeed the first black leader of any wealthy majority-white society in the world. Barack Obama was handsome, light-skinned, biracial, a man whose African ancestors were never enslaved, never a part of the American quarrel with race. Handsome yet buttoned down, asexual yet physically spectacular ("Oh My Bod!" screamed the headlines at the sight of his shirtless form),[17] he was famous for his incantatory prose, prose that summoned an oppositional African American oratorical tradition even as

he mostly avoided all talk of race, prose that married "white" syntax to black style.[18] His admirers called him articulate and dignified. He never appeared angry or strident, never scolded (unless his audience was African American).[19] His political platform was hope. In the end, the only heir of both Sidney Poitier and Harry Belafonte married their complementary traits to become a twenty-first-century incarnation of our collective 1950s Hollywood fantasy.

Notes

1 Denzel Washington, speech on receiving the Oscar for Best Actor in a Leading Role, March 24, 2002, Kodak Theatre, Los Angeles. The Academy of Motion Picture Arts and Sciences, http://aaspeechesdb.oscars.org/link/074-1/.

2 See Miles Davis, *Miles: The Autobiography of Miles Davis with Quincy Troupe* (New York: Simon & Schuster, 1989), 8.

3 I use the term "West Indian" interchangeably with "Caribbean" to denote inhabitants of the English-speaking Caribbean because it is still a term in use in the region as well as for its historical resonances in 1950s America: Poitier and Belafonte would have been referred to as "West Indians."

4 See Harvey Neptune, *Caliban and the Yankees: Trinidad and the United States Occupation* (Chapel Hill: University of North Carolina Press, 2007), 105–57.

5 See Russell Merritt and David Shepard, *The Making of the Birth of a Nation*, documentary film included in the DVD re-issue of *Birth of a Nation* (Film Preservation Associates, 1992).

6 Poitier's first appearance in a lead role was in *No Way Out* (1950), where he plays what is for us a more familiar Poitier character; the upstanding black doctor who treats a white racist.

7 Arguably one could say that Paul Robeson was the first black leading man, playing central or leading roles in both American and foreign films until he was blacklisted in the 1940s.

8 See Donald Bogle, *Toms, Coons, Mulattoes, Mammies, & Bucks: An Interpretive History of Blacks in American Film* (New York: Continuum, 1999), 176.

9 I am referring to films such as *Buck and the Preacher* (1972), Poitier's corrective history of black cowboys in the American West, and his hugely popular—with black audiences anyway—series costarring Bill Cosby, *Uptown Saturday Night* (1972) and *Let's Do It Again* (1974).

10 See Oprah Winfrey, "Oprah Talks to Sidney Poitier," *O: The Oprah Magazine*, October, 2000. Accessed March 14, 2013, http://www.oprah.com/omagazine/ Oprah-Interviews-Sidney-Poitier.

11 The film *Bright Road* was based on the award-winning short story by Mary Elizabeth Vroman, "See How They Run." *Ladies' Home Journal* 68 (June 1951), an Afro-Caribbean immigrant to the United States.

12 I acknowledge the influence of Michelle Stephens's unpublished paper, "A Creole Complex: The Color Problem of *Island in the Sun*" (presented at the Rutgers University, October 5, 2009) in drawing my attention to the racial and national politics of this film.

13 See Michelle Stephens, "The First Negro Matinee Idol: Harry Belafonte and American Culture in the 1950s," in Bill Mullen and James Edward Smethurst (eds), *Left of the Color Line: Race, Radicalism, and Twentieth-Century Literature of the United States* (Chapel Hill: University of North Carolina Press, 2006), 225.

14 This incident is described by James Baldwin in his essay, "Unnameable Objects, Unspeakable Crimes," reproduced in *Blackstate.com*. Accessed March 8, 2014, http://www.blackstate.com/baldwin1.html, 3. I thank Michelle Stephens for this reference.

15 Stephens, "The First Negro Matinee Idol," 230.

16 See Richard Schickel, "The Tightrope Walker," review of *Sidney Poitier: Man, Actor, Icon* by Aram Goudsouzian, *New York Times*, April 25, 2004, http://www.nytimes.com/2004/04/25/books/the-tightrope-walker.html. Schickel also defends Poitier's asexual performances as a leading man by arguing—ludicrously—that "one of the essences of male stardom is sexual reluctance. . . . Poitier, aspiring to be what he became . . . had a perfect right, maybe even an obligation, to embrace this classic star mode."

17 Maggie Haberman, "Oh My Bod! It's Beach Barack," *New York Daily News*, December 30, 2008, 1.

18 I am drawing on the research of H. SamyAlim and Geneva Smitherman, who note President Obama's strategic invocation of the African American preacher tradition while maintaining a "white" syntax. See H. SamyAlim and Geneva Smitherman, "Obama's English," *New York Times*, September 8, 2012. Accessed March 14, 2013, http://www.nytimes.com/2012/09/09/opinion/sunday/obama-and-the-racial-politics-of-american-english.html.

19 Fredrick Harris writes, "As a candidate [Obama] invoke[d] the politics of respectability once associated with Booker T. Washington. He urged blacks to exhibit the 'discipline and fortitude' of their forebears. He lamented that 'too many fathers are M.I.A.' He chided some parents for 'feeding our children junk all day long, giving them no exercise.' See Fredrick Harris, "The Price of a Black President," *New York Times*, October 7, 2012. Accessed March 14, 2013, http://www.nytimes.com/2012/10/28/opinion/sunday/the-price-of-a-black-president.html.

Bibliography

Alim, H. Samy and Geneva Smitherman. "Obama's English," *New York Times*, September 8, 2012. Accessed March 14, 2013, http://www.nytimes.com/2012/09/09/opinion/sunday/obama-and-the-racial-politics-of-american-english.html.

Baldwin, James. "Unnameable Objects, Unspeakable Crimes," in "The White Problem in America." *Ebony* (Chicago: Johnson, 1966). Republished on *Blackstate.com.* Accessed March 8, 2014, http://www.blackstate.com/baldwin1.html, 3.

Davis, Miles and Quincy Troupe, *Miles: The Autobiography of Miles Davis with Quincy Troupe* (New York: Simon & Schuster, 1989).

Haberman, Maggie. "Oh My Bod! It's Beach Barack," *New York Daily News*, December 30, 2008,1.

Harris, Fredrick. "The Price of a Black President," *New York Times*, October 7, 2012. Accessed March 14, 2013, http://www.nytimes.com/2012/10/28/opinion/sunday/the-price-of-a-black-president.html.

Merritt, Russell and David Shepard. *The Making of the Birth of a Nation.* In *Birth of a Nation.* Film Preservation Associates, 1992. DVD re-issue.

Neptune, Harvey. *Caliban and the Yankees: Trinidad and the United States Occupation* (Chapel Hill: University of North Carolina Press, 2007).

Schickel, Richard. "The Tightrope Walker," *New York Times*, April 25, 2004. Accessed March 8, 2014, http://www.nytimes.com/2004/04/25/books/the-tightrope-walker.html.

Stephens, Michelle. "A Creole Complex: The Color Problem of *Island in the Sun.*" Unpublished paper presented at Rutgers University, October 5, 2009.

—"The First Negro Matinee Idol: Harry Belafonte and American Culture in the 1950s," in Bill Mullen and James Edward Smethurst (eds), *Left of the Color Line: Race, Radicalism, and Twentieth-Century Literature of the United States* (Chapel Hill: University of North Carolina Press, 2006), 223–38.

Vroman, Mary Elizabeth. "See How They Run." *Ladies' Home Journal* 68 (June 1951).

Washington, Denzel. Speech, The Academy of Motion Picture Arts and Sciences, Kodak Theatre, Los Angeles, CA, March 24. Accessed March 8, 2014, http://aaspeechesdb.oscars.org/link/074-1/.

Winfrey, Oprah. "Oprah Talks to Sidney Poitier," *O: The Oprah Magazine*, October, 2000. Accessed March 14, 2013, http://www.oprah.com/omagazine/Oprah-Interviews-Sidney-Poitier.

"Draggin' the Chain": Linking Civil Rights and African American Representation in *The Defiant Ones* and *In the Heat of the Night*

Emma Hamilton and Troy Saxby

Traditionally, scholarly interest surrounding African American representation has focused overwhelmingly on the notion of stereotype. In this view, the capacity of mainstream media, particularly film, to present alternative and complex depictions of African American characters is curtailed by its commercial nature, which cyclically anticipates and reenforces white audiences' hegemonic imagining of the racialized other. Thus, what remains is a disturbing continuity: an unchanged set of stereotypes, removed from lived experience and historical reality.[1] While this critical discourse on stereotype is important and aids in cultural recovery and empowerment, including attempts at establishing "black cinema," an uncomplicated focus on stereotype has helped to further cement the homogenized meanings of these very stereotypes, and has obscured the actual processes by which such stereotypes are communicated.[2]

Alternative discourse has made some steps to place stereotype within a historical context, two notable examples being Marlon Rigg's landmark documentary *Ethnic Notions* (1987) and Jan Nederveen Pieterse's *White on Black: Images of Africans and Blacks in Western Popular Culture* (1990). *Ethnic Notions*, examining the perpetuation of negative stereotypes of African Americans over time, put forward the argument that such stereotype serves important social functions such as reconciling America's contradictory notions of ideological equality in contrast to a reality of racial inequality. Such images evolve over time in a historical fashion to suit the changing needs of dominant white patriarchy.[3] Limited by the constraints of documentary filmmaking this piece tends to focus on the effects of negative stereotype without considering the processes by which these stereotypes evolve or the complex and contradictory nature of stereotype

whereby such images can be resisted, subverted, or interpreted in different ways by the audience. It also tends to focus on images in the pre-civil-rights era, without considering how negative stereotypes survive and are perpetuated even in times of mass social change.[4] Pieterse extends this historicization of stereotype, undertaking a comparative analysis of European and American images of African culture, to suggest that the construction of stereotype is not unique to the United States but rather is a Western phenomenon. However, these stereotypes too evolve over time in a way that reflects the unique historical conditions and social needs of a particular context.[5] In undertaking a broad theoretical approach to stereotype the author necessarily sidelines the depth of analysis particularly related to specific artifacts, a concept noted in the critiques of Michael Pickering, Kenneth Vickery, and Winthrop Jordan.[6] Interestingly, Pieterse also marginalizes the idea of stereotype being perpetuated within the period of the civil rights movement, indeed opening with the acknowledgment that "since the rise of the American civil rights movement many stereotypes of blacks are no longer acceptable in the United States and have vanished from advertising and the media."[7] This is an interesting assertion as most would argue that stereotypes of blacks have continued into the present day and, indeed, regardless of this, surely we can conceptualize the civil rights era as one of seminal importance in representation studies as it provides unique insight into the interplay between processes of subversion and containment of change, and how, during periods of mass social upheaval, images can reflect the concerns of imagemakers and evolve, rather than be stymied, over time. In addition to these texts, a variety of cultural studies have examined the representation of African Americans in films and explored the capacity or desirability of "accurate" black representation(s) and the viability of "black cinema."[8]

This chapter undertakes a comparative filmic study of two civil rights era films, *The Defiant Ones* (Stanley Kramer 1958) and *In the Heat of the Night* (Norman Jewison 1967), with two major objectives. First, it proposes a shift away from traditional discourse that equates stereotype with continuity to an examination of stereotype as historical as well as the specific processes by which race is communicated on-screen. In so doing, it is evident that representation functions in a more complex and contested way, opening up a multiplicity of meanings for the audience and a multiplicity of ways in which racialized portrayals both subvert and are contained by white patriarchal structures. Second, this analysis will establish the way these representations are historically contingent, using similar and recognizable themes to convey different messages

over time. Examining films produced during the civil rights movement highlights the importance of examining how the processes of implementing stereotypes and how stereotypical images themselves evolve during periods typically associated with liberalizing and positive change. By looking beneath the surface of stereotype to examine the changing strategies by which they are deployed, and the often contradictory meanings they convey, the veil of seeming dehistoricization surrounding racial representation will be lifted to reveal the historically contingent nature of representation over time.

Both films feature Sidney Poitier in a leading role and as the only central African American character represented. First, in an unsubtle historical parable, *The Defiant Ones* sees Noah Cullen (Sidney Poitier) on the run after escaping from a prison transport. The catch in his escape, however, is that he is chained to prejudiced white inmate, John "Joker" Jackson (Tony Curtis). The two escapees must work together to ensure mutual freedom or else be recaptured by the gaining posse. Although this theme of criminality is inverted, *In the Heat of the Night* similarly sees Detective Virgil Tibbs (Poitier), teamed unwillingly with a bigoted police chief, Gillespie (Rod Steiger), in the hunt for the murderer of a Northern industrialist intending to invest in the small Southern town in which the film is set. Although both films utilize similar stereotypes and have narrative similarities, these are used, it is argued, to convey very different messages regarding both ideas of race and the capacity to resolve obstacles to racial equality. That is, on the one hand, *The Defiant Ones* advocates the overthrow of racial discrimination through the construction of a discourse of sameness that appeals to similarity of experience in economic and social spheres, and the capacity to overcome racism through personal change, rather than institutional restructuring. On the other, *In the Heat of the Night* explicitly rejects this, suggesting, through a discourse of difference, that although interracial cooperation is possible, the concept of a "colour-blind" society, or the complete breaking down of segregationist attitudes, is not. These fundamental racial messages are not ahistorical nor the representations one of stereotype and continuity but, rather, they are in accord with the shifting historical context of the filmic release dates. The intention here is to highlight the way in which, rather than Poitier portraying characters that were little more than the modernized stereotype of "mild-mannered Toms," aspiring to whiteness, a complex interplay of subversion and containment of this stereotype is presented, which reflects the historical context of production.[9]

In making reference to historical context, what is suggested here is that both films reflect the evolution of, and ideas within, the civil rights movement.

Spurred on by the *Brown v Board of Education* decision in 1954, the movement strategically appealed to the discourse of US citizenship around personal morality and individual freedoms, with the initial goal of legalistic reform to redress racism. In progressing in this way, fears of radical and ideologically incompatible reforms to the American system were countered and, indeed, support of desegregation, integration, and legal equality became a method with which to reaffirm American citizenship values of individualism, democracy, and freedom.[10] This strategy of appealing to sameness that fits within, rather than challenges dominant American values, is acknowledged, for example, in Dr King's 1955 speech in the Holt Street Church, which both justified and urged on the Montgomery bus boycott. King stated:

> We are here in a general sense because first and foremost we are American citizens and we are determined to apply our citizenship to the fullness of its meaning. We are here also because of our love for democracy. . . . If we are wrong, the Supreme Court of this nation is wrong. If we are wrong the Constitution of the United States is wrong.[11]

Over the next decade this strategy won significant victories in abolishing segregation in the South of the United States, and prompted federal legislative change, including the Civil Rights Act of 1964 and the Voting Rights Act of 1965. Yet the coalition forged in the movement began to fracture after 1965 and the nonviolent approach was called into question. "We're only flesh." John Lewis later observed, "I could understand people not wanting to be beaten anymore. . . . Black capacity to believe [that a white person] would really open his heart, open his life to non-violent appeal was running out."[12] Disillusionment with nonviolence was accompanied by growing skepticism toward integration, and the new discourse of difference was duly acknowledged in films such as *In the Heat of the Night*.

The connection between African American representation and historical change is examined in these two films in relation to three fundamental and overlapping elements: first, the intimate "buddy" relationship at the center of each film, where stereotypes such as failed African American male leadership and black self-sacrifice are utilized; second, the relationship between the protagonists and broader social structures, which is most obviously created through utilizing stereotypes of bigoted white Southern institutions in contrast to liberal Northern ones (or their embodiment); and, third, the connection between these divergent filmic messages and historical context. This third element emphasizes the ways

in which racial films are profoundly intertextual, interpolated in the wider historical context of their production. They both change to reflect historical context and, where stereotype and narrative similarities are deployed, they convey *different* historical realities, not necessarily historical continuities.

"I Kept You from Pulling Me In": Negotiating sameness and difference in the Bromance

In arguing that *The Defiant Ones* makes an explicit appeal to sameness that accords with its historical context, it is through the "buddy relationship" between Cullen and Jackson that this becomes clear. This occurs through blatant textual means. For example, when the white character Jackson reveals his personal history of economic oppression through menial and underpaid labor, and as the narrative reveals the similar roads that have led both characters to resort to violence and crime, the obvious intention is to expose a history of sameness, around the idea of a shared suffering, particularly through their class location. The self-conscious utilization of class as a fracturing element of racial identity both in this film and *In the Heat of the Night*, may in itself, although to different effect, be seen as a significant step in exploring stereotype. This is because, as Lemke asserts, depth of analysis into stereotype "would attend to the role played by class in structuring class antagonisms."[13] Indeed, Poitier's Cullen actively participates in this process of stripping pretension to expose similarity by telling Jackson the reason for his imprisonment (assault on a debt collector who pulled a gun) and the existence of a wife and child, thereby implicitly subscribing to the view that hegemonic and hierarchical social and economic structures have acted to oppress all people, not only African Americans.[14] However, Cullen's engagement in this process is not as great as Jackson's and the nature of Jackson's revelations—that suffering is shared regardless of racial background—conveys to a predominately white audience shared humanity and the need to stand alongside black protestors. In contrast, *In the Heat of the Night* explicitly rejects such calls for similarity and unity within the homosocial bond.[15] This becomes apparent when the endings of the two films are compared. The concluding scene to *In the Heat of the Night* could be interpreted as one of racial reconciliation or at least mutual respect between the two policemen, and as a Hollywood production a degree of conflict resolution was required in the ending certainly. Yet subtle facts work against such an interpretation. The scene

is punctuated by more silence than dialogue, the characters remain physically and noticeably separate rather than in contact and Tibbs never smiles until he is safely up on the train looking down on Gillespie, thereby creating ambiguity around the possible meanings of his smile. This is a far cry from the conclusion to *The Defiant Ones*. In the earlier film the Poitier character jumps off the train giving up his chance of freedom to be with his new white friend, and the film closes with the two wrapped in each other's arms. Although both these films attempt to communicate blatantly alternate messages of racial conciliation to the audience, both utilize similar processes to communicate either a subversion or containment of racial stereotype, with various effects. Both films allow for an exploration of the perpetuation of stereotype over time; complex, resistant, and multiple uses of stereotype and, ultimately, the way in which these shared leitmotifs (stereotypes) suggest differing meanings over time.

The foremost theme in the personal relationships of the protagonists is competition and the personal struggle for power, which is symbolic of broader political struggles for power. In both films it is the African American character that leads, although this is embodied in varying forms. This may be seen simultaneously as a strategy of containment and of rebellion. On the one hand, his position of leadership places him in greater physical danger, with greater potential to fail and, therefore, he is arguably set up as a foil to the successful action of other characters. This is, as Helan Page notes in her examination of media control exerted over racial images, a prominent strategy of containment. The strategy works by mediating the audience's gaze to cast judgment on African American men, while actually protecting white men from true competition, and thus the potential destabilization of foundational ideas of white superiority that maintain racial hierarchy.[16] In *The Defiant Ones* Cullen's leadership is both intellectual and physical in nature: for example, it is he who initiates their escape plan, and is relied upon as a source of unique knowledge. Specifically, it is Cullen who knows of the North-bound train running near their route, how to arrive at this point, and, because of his agricultural background, how to avoid the physical dangers of the journey. Moreover, Jackson is physically inferior throughout the film, disabled through illness and subsequently a gunshot wound.[17] Ultimately though it is Jackson who consistently acts to assert his control: he saves Cullen from drowning, drags Cullen out of a pit, and when Cullen is tricked into following an alternate route to his doom it is Jackson who pursues and warns him. This control culminates in the ultimate sacrifice: even when they are not chained together Cullen sacrifices his freedom to be with Jackson. In this sense,

racial stereotype is deployed to serve a historical purpose: to comfort a majority-white audience in a time of mass change and social upheaval but also, more significantly, to politicize and inspire the majority-white audience to sympathy and supportive action at a time when the movement grappled with its reliance on white power structures to achieve successful outcomes.[18]

In the Heat of the Night employs a similar concept of contested leadership in a complex and often contradictory way. A subversion of stereotype is obviously used and expected to dominate audience reception, through the positioning of Tibbs as a superior detective, who literally outclasses—in the sense that he is a wealthier, Northern city-dweller—who is able to outthink the local police force to stay one step ahead and ultimately solve the case. In doing this, Tibbs not only reveals his own indispensable ability, but also the incompetence of the town leaders who cannot even perform seemingly simple tasks of policing, such as estimating the time of death. The tale here is not only one of black capability, but also one of superiority over Southern whites. Thus, Chief Gillespie's economic and social inferiority is an explicitly acknowledged fact; for example, he is less articulate and is denied the respect of his team. He also embodies this inferiority: he consistently sweats, is less fit, and is comparatively disheveled. Nonetheless, subtle strategies of containment constantly work against this interpretation and somewhat negate the potential departure this represents from stereotypically dependent black characters. For example, although Tibbs violently strikes out against tangible forms of oppression, it is Gillespie who physically saves Tibbs from the white supremacist posse. It is reinforced implicitly by the constant emphasis on Tibbs' hands, a visual metaphor usually indicative of control; however, this physical control is exerted over objects typically coded as weak and lesser, such as, Colbert's corpse and his hysterical wife.

At the heart of this idea of containment, however, is to what extent the characters played by Sidney Poitier in these films, and played by Poitier generally, can be considered as contained simply because they reinforce white patriarchal values. Broadly, it is important to acknowledge the ongoing role that casting has played in debates over representation. This specifically relates to issues of literal casting, that is, the right to have representations of racial minorities acted by people whose racial identity accords with that role, an issue particularly prominent in films featuring indigenous Americans.[19] The additional issue here is the capacity of individual actors to subvert stereotypical roles in a white-funded film industry.[20] For some scholars Poitier himself became a 1960s stereotype.[21] "Super Sid" was typically a highly intelligent,

well-dressed, well-mannered Northern black man who always did right and is therefore divorced from historical reality or true meaning. Poitier is the actor that a majority-white audience would be happy to, as the famous film title suggests, have to dinner. The extent to which Poitiers' characters can be seen as simply a stand-in for a typically white role is central to this discussion. Such an interpretation suggests that admitting African American actors into "white" filmic spaces sacrifices a sense of African American cultural authenticity, with black actors simply portraying "white characters with black skins," and in so doing the politicization of the so-called racial message genre is neutralized.[22] In opposition, Benshoff argues in his discussion of the generic reinvention of blaxploitation horror films that the placing of African American characters within genres that were previously characterized by racial homogeneity or reinforcement of binary racial opposition is inherently subversive and cannot be adequately contained, a view subscribed to here. This is because the fact of such admission acts to make explicit previous exclusion and hierarchical representation and, therefore, genre is utilized for "more overtly political goals, specifically, to critique the white power structure."[23]

Indeed, both films under discussion here address and reject the idea of the black character as simply a stand-in for a typically white role. This occurs in *The Defiant Ones* through a play on, and inversion of, "black face," shown when Cullen and Jackson attempt to break into a settlement town at night. Here Cullen problematizes Jackson's skin color as being too visible, instructing him to smear himself with mud. This may be seen as an example of "self-directed stereotype," a term used by Margolis to describe the tactic of stereotyped groups using these very images as tools to undermine them and expose the racist ideology upon which they rest.[24] Following this, the reappropriation of blackface representation proffers two fundamentally subversive ideas: first, that whiteness in itself does not create advantage; indeed to argue that it does endorse a racial stereotype on whiteness itself. Second, and more importantly, it aims to convey the constructed nature of race, and that the boundaries separating groups are not rigid and impermeable but malleable and porous: even the act of lynching itself is not seen here as expressly racialized, with the white Jackson under threat. *In the Heat of the Night*, however, rigorously reinforces these boundaries, in that each character is able to enter exclusive space: for Tibbs, the home of a female African American abortionist "where Whitey isn't allowed" and, for Gillespie, the free exchange with radical supremacist groups, reinforcing the discourse of difference advocated by the film.

Ultimately, in presenting concepts of integration, the maintenance of existing social institutions, and an overly positivistic message of interracial friendship, *The Defiant Ones* does reflect and attempt to impact upon broader historical ideas. This process is twofold: first, this message reflects the aims of the civil rights movement at this time. The focus was on legalistic goals such as voter registration, education and transport desegregation, achieved through a philosophy of moral persuasion, and a belief in integration and inclusiveness. The NAACP had long pursued the tactics of persuasion and legal action to achieve integration, yet King emerged from the Montgomery Bus Boycott demonstrating an unparalleled ability to inspire black and white audiences. King played on white guilt for failing to live up to Christian and democratic ideals, but also offered them redemption through support for nonviolent protest.[25] Second, the limitations of this portrayal in terms of the subscription to stereotypical values and containment of subversion may also be seen as an attempt to soothe white anxieties through emphasis on gradual and personal, rather than radical and institutional, change. King's appeal was fundamentally based on an appeal to sameness based on citizenship and shared humanity.[26] However, by the release of *In the Heat of the Night*, the civil rights movement had shifted to focus on differences and disparities arising from the institutional enforcement of racism in both the South and the North: King had launched his campaign against poverty, Stokely Carmichael had proclaimed Black Power,

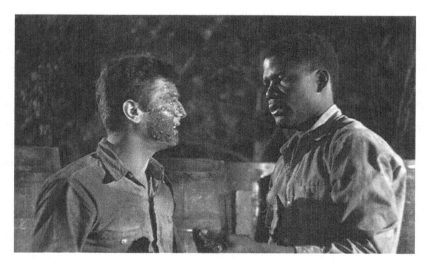

Figure 7 Poitier helps Curtis blacken his face in *The Defiant Ones.*

the worst wave of rioting in US history had occurred and the commitment to nonviolence had splintered.[27] *In the Heat of the Night* reflects such historical development through its exploration of institutional versus individual racism; the intersections between race, class, and gender; sectional antagonism; and the way in which an emphasis on difference impresses a long-term historical perspective.

"No more lonely than you, I suppose": Negotiating the individual in society

This relationship between the historical context of production and the politicization of racial representation is made explicit when the broader social structures represented within these films are examined. In *The Defiant Ones* broader social structures and attitudes are embodied in the pursuing posse composed of lawmen and concerned (male) citizens. Here, the major message of this relationship is that paternalism and encouragement of a dialogue of difference acts to fuel African American radicalization, while the encouragement of "colour blind" treatment (sameness) creates a space for negotiation of difference that leads to an acceptable compromise. This occurs most explicitly in the juxtaposition of the relationship between the attack dogs and their trainer, and the personal relationship between Cullen and Jackson. That is, the consistent central framing of black Dobermans by the camera, and the Sheriff's continually expressed dual concern that the relationship between the trainer and the animal is unnaturally tender—and also, most importantly, that these animals will be unleashed and out of control—may be seen as highly symbolic. Specifically, through these techniques, the dogs are constructed as an anthropomorphic conceptualization of black separatism and "black buck" stereotype: as animalistic, physically strong, impulsive, anarchists intent on social destruction, and are made so by the paternalistic treatment of their trainer. Ultimately, the killer Dobermans are not let off the leash, however, and the film thereby rejects this paternalism and the idea of destructive black separatism, in favor of Jackson's (and the Sheriff's) approach to race relations: a dialogue of sameness that ensures that when Cullen is finally let off the chain he remains internally bound to Jackson and, implicitly, to the maintenance of broader and existing social structures. The film positions the audience to perceive that the criteria for such internalized binding is a sincere recognition of shared experience and mutual codependence, a factor

in itself problematic because it suggests that black and white experiences are indeed similar and that levels of suffering are equal and ahistorical.[28]

However, there exists potential for subversion. This may be seen primarily in the implicit acknowledgment of white anxiety that exists embedded within the portrayal of black rebellion: the Dobermans do not simply track, they kill, and the prospect of their release is a great and real fear conveyed throughout the film. It also represents, on another level, the subversion of stereotype: dogs themselves stand as powerful symbols of white oppression and the physical enforcement of slavery, and the inversion of this may be seen as a potent revision.[29] Also, regardless of whether one engages with the idea of subversion generally, it cannot fail to be acknowledged that stereotypes do not simply work in one direction but, rather, white characters are also bound within this. For example, the white dog trainer and most of the civilian posse are portrayed as effeminate, comedic buffoons, mildly hysterical and constantly under physical threat. In this way, all people are stereotyped and essentialized within a racialized network, and the portrayal of the "Other" reflects more on the values and assumptions of the hegemonic framework that constructs such a stereotype, than on those who are themselves stereotyped.[30] Ultimately, the point here in examining the portrayal of broader social structures, historically, is that the film constructs a narrative around concepts of integration and sameness through the relationship between the two central protagonists and broader society; in so doing it argues that "racism can be unlearned individual by individual. It has nothing to do with economic and power relations."[31] Further, the film also constructs a version of destructive black rebellion that instils in the audience the perception that the tactics and demands of the rest of the movement are a preferable compromise.[32]

In contrast, *In the Heat of the Night* constructs difference at every level of the broader social network: racially, geographically, economically, and culturally. Furthermore, the failure to overcome oppression resides not so much with the individual but with structures that continue to enforce this difference. Even within the African American community, this film identifies class difference to note that progress for some is not progress for all. This is best illustrated in the scene where Tibbs and Gillespie drive past rows and rows of black cotton workers and Gillespie says to Tibbs, "None of that for you, huh" while Tibbs intently watches the men and women pick cotton. In this film, then, the emphasis is on the continuing struggle for freedom from oppression and prejudice beyond individual or legalistic frameworks. Thus, Tibbs represents a character constantly pushing against the fabric of a racist society and in so doing, it may be argued,

Figure 8 The distance between Tibbs and Gillespie.

presenting a departure from stereotype, particularly the "shuffling Tom" model of passive acceptance. For example, Tibbs forces the recognition of his abilities and dignity (as in the famous "They call me mister Tibbs" scene) and literally hits back at white paternalism embodied by Endicott. And Endicott reflects upon historical change here: he remembers a time when a black man would have been murdered for that action but now the police will not enforce a penalty against him.

There are, however, strategies that work to maintain an area of ambiguity around the morality of typically racist scenes, most evident in mise-en-scène. Specifically, during the most explicit moments of white racism—Tibbs' initial arrest while doing nothing more than waiting for a train and his physical confrontation with white supremacists—a subtle repositioning of the audience occurs to negate outrage and empathy for this character. In the first instance, this occurs through the backgrounding of the arresting officer with a sign that prohibits loitering in the area, thereby positioning the audience to accept that there is some justification for his suspicion of Tibbs. In the second instance, when Tibbs is attempting to ward off physical attack by white supremacists after being followed into an abandoned railway yard, signage is prominently positioned above his head stating: "Let Us ALL Be ALERT We Don't Want ANYONE Hurt." This is highly ambiguous with a multiplicity of possible directorial intentions and potential readings by the audience. This sign may imply, for example, that Tibbs himself should have been more alert to his surroundings before entering an unpopulated area and that he, therefore, bears responsibility for this attack; that the audience should be aware of the

realities of racial violence and that, in doing so, attacks will be prevented; or, alternatively, that Gillespie, in proving himself alert enough to prevent this attack, presents an ideal model of individual behavior. The implication of this ambiguity is the blurring of accountability for racially motivated crime and racial hatred generally, and the subsequent neutralizing of the political and moral reaction among the audience. While this does not take away from the revisionist stance toward stereotype in this film, what is ultimately emphasized here is that racism is institutionalized and, because of this, largely invisible, and that despite individual efforts to overcome discrimination, power rests outside of the individual realm.

In both of these films, the role of gender performance and the intersections between race and gender as a reflection of broader institutional values proves a complex addition to this assessment, requiring an incorporation of different manifestations of patriarchal oppression and a context of emergent women's liberation movements by the auteurs. It may be argued that in both these films, at a broader level of social relationships, women are framed as neurotic, needy, and threatening to masculinity and thus as directly oppositional to the central male characters. This allows the development of what McCoy refers to as "masculine sameness," whereby the factors that potentially destabilize a sense of social cohesion, such as race or class divides, are overcome through the maintenance of false gender difference.[33] Cullen's reference to his wife, for instance, as encouraging him to accept mistreatment, and as raising his son to live in fear, effectively emasculated, is seen as responsible for black suffering over other structural or relational factors. Similarly, *In the Heat of the Night* places the responsibility for the death of the industrialist on the promiscuity of the white Delores Purdy and the black female abortionist, who holds the key to solving the case, but is portrayed as more concerned with money than social justice or communal values. *In the Heat of the Night*, however, is distinguished by an acknowledgment of an intramasculine gender hierarchy that, although endorsing men's superiority over women, also supports men's ability to oppress each other. Specifically, when Gillespie allows Tibbs into his home at the end of the day they are shown drinking alcohol and comparing the personal burdens of their police work. This otherwise typical scene of male homosocial bonding soon dissolves: Gillespie asks Tibbs whether he gets lonely and the response, "no more lonely than you, I suppose," reminds him that a truly equal relationship cannot even be found in their gender. His reply reinforces that gender difference impacts on and diminishes their masculine sameness: "don't get smart with

me, black boy." In so doing, historically, a discourse of difference is maintained. Although the sole unifying factor for men across class and race lines in these films is their simultaneous desire for, and opposition to, the feminine, this too is not an uncomplicated phenomenon but rather is historically contingent and explored in different ways to reveal differing approaches to racial discourse. Further, as Henry asserts, the maintenance of strict gender difference can be a paradoxical measure of manhood in this grouping of films: the implication of this construction of the feminine as "Other" in representations of African American men has the potential, in the short term, to create a level of freedom and subversion of racial codes, but, in the long term, this contradictorily works to endorse the very patriarchal codes that maintain the structures of racial oppression.[34]

"There was a time when I could have had you shot": Historical change and filmic representation

The historical context in which each film was made clearly influenced and reshaped the racial stereotypes used in both films. Indeed, the most obvious plot difference between the two films, changing the central characters from criminals to police, is made plausible only by events that occurred in the years between the two films' release dates. Quite simply, an escaped convict was a plausible role for a black man in 1958, whereas an educated senior detective was not. The audience never sees Cullen dressed other than as a convict, unlike Joker, who changes clothes, and Cullen leads but primarily in a physical sense, rather than through education, wealth, or status. Senior Detective Virgil Tibbs, however, is portrayed as educated, well dressed, and financially secure. This is not to suggest that opportunities were widely available to all African Americans in 1967 or that African American progress began and ended with the modern civil rights movement. Rather, audience acceptance of the Tibbs character, and the "Super Sid" stereotype generally, was enhanced by recent historical developments. Some of the civil rights movement's most powerful images were of well-dressed and disciplined college-educated African Americans being abused by white bigots.[35] Not only was an educated, intelligent black man a far more plausible mainstream representation in 1967, Southern whites could easily be cast as villains. More than a decade of extensively reported Southern racial violence prepared audiences well for such a story.[36]

One of the most compelling shifts in representation between the two films is the portrayal of the two police sheriffs. In *The Defiant Ones* sheriff Max Muller (Theodore Bikel) is the liberal ideal of authority. He is measured in his pursuit and determined to avoid violence in recapturing the escapees. At only one point does he lose his temper when he exclaims, "I didn't think it was possible, but I'm beginnin' to hate those two men," after a reporter reminded him that it was an election year. A strong allegory is being made with the Little Rock crisis which occurred the year before the film's release. Little Rock garnered national and international media coverage following the decision by Arkansas governor Orval Faubus to fight school integration, largely to enhance his own reelection prospects.[37] *The Defiant Ones* mirrors these events by having a reporter accompany the posse and periodically remind the sheriff that he is up for reelection and his handling of the manhunt could determine his electoral fate. Sheriff Muller is a liberal good guy and therefore does not resort to populist politics or bow to pressure from state officials represented by the gung-ho state trooper. This stands in stark contrast to sheriff Gillespie from *In the Heat of the Night* who is close to explosion at every point. He holds Tibbs in contempt and bungles the case badly, at one point arresting his own subordinate, another buffoon in a police uniform, for the crime. The real murderer also happens to be a white fool, though not a policeman. This divergence in the portrayal of police authority in a race message film has obvious historical parallels. A decade of police brutality directed toward nonviolent protestors had invalidated the idea of a humane Southern sheriff. Dr King had made it a cornerstone of his nonviolent direct action protest to target regions under the jurisdiction of notoriously short-tempered, racist police officials, such as Eugene "Bull" Connor in Birmingham and Jim Clark in Selma.[38] Just as an intelligent black homicide detective had become a plausible character by 1967, an enlightened Southern sheriff had become implausible, and the stereotype of the ignorant Southern racist took precedence.

The message from *The Defiant Ones*, that simply bringing people together will force them to confront and overcome their prejudice, is also abandoned in *In the Heat of the Night*, where bringing people together has deadly consequences. As discussed, Tibbs is out of his familiar environment and ignores, or fails to recognize, the warning signs. The civil rights era is rife with examples of racialized violence against those who entered unfamiliar surrounds, such as Emmett Till. The segregationist view of such crimes was made explicit following the 1964 murders of civil rights workers James Chaney, Andrew Goodman, and Michael

Schwerner. "When people leave any section of the country and go into another section looking for trouble," said Mississippi congressman Arthur Winstead, "they usually find it."[39] The danger of interracial cooperation is evident in the film when Gillespie saves Tibbs from the rednecks who label him a "nigger lover." Similar hate-filled sentiments, no doubt, flowed through the veins of the killers of Viola Liuzzo, Goodman, Schwerner, and others. Furthermore, Schwerner's wife Rita made a pertinent point when she commented on the investigation into the civil rights workers' disappearance: "We all know that this search with hundreds of sailors is because Andrew Goodman and my husband are white. If only Chaney was involved, nothing would've been done."[40] What gives the murder case in the film its importance is that the murder victim was a wealthy white Northerner.

The national attention given to the Southern civil rights movement during the period between the two films ensures that sectional antagonisms, which are largely absent from *The Defiant Ones*, become a central point of difference in *In the Heat of the Night*. *The Defiant Ones* makes reference to the North–South divide when Cullen and Jackson briefly argue over the direction of their flight. The dispute is quickly resolved, with both Jackson and the audience quickly grasping the importance for Cullen to escape to freedom in the North and the best way to do so, by railway, in this case a literal one. Yet *In the Heat of the Night* positions regional difference as a central source of tension. The murder victim is a Northern white industrialist, and his wife insists that Tibbs, a Northern black man, be allowed to work the case. The murder of Emmett Till and the reporting of the Little Rock crisis confirmed both the brutality of racism and the resistance of Southern racists to outside interference. The freedom rides and nearly 900 volunteers for the Mississippi Summer Project, most from prestigious Northeastern universities, reinvigorated the concept of "uppity northern niggers" and radical white agitators invading the South to stir up racial trouble.[41] By the release of *In the Heat of the Night* audiences had been well prepared for this portrayal of a small town in the Deep South and its bigoted citizenry. To the white racists portrayed in the film, Tibbs is an "uppity northern nigger", while the murdered Northern industrialist is a financier of progress and his wife, the outside agitator. More significantly, to a Northern white audience, the portrayal of sectional dynamics serves to contain racism as a Southern problem at a historical juncture when the focus of the black freedom struggle was actually shifting from the South to Northern ghettos and white activists and money were abandoning the struggle. In this way too, the stereotype of Southern racism

restricts the portrayal of white characters—both black and white characters lack complexity—and it reassures audiences that racism is contained within a distinct sectional sphere rather than being an underlying problem throughout American society.

Thus, while this can be viewed on the one hand as a stereotypical representation of Southern attitudes, it can also be understood as a deflection of racial problems in the North that were being increasingly brought to national and international attention. The foolish white Southerner is deployed as a peripheral comedic character in *The Defiant Ones*; however, the use of this stereotype becomes central to the later film. The 1967 release of *In the Heat of the Night* occurred at the height of the "long, hot summers," which claimed 200 and 50 African American lives, and 8,000 were wounded, and about 50,000 arrested in nearly 300 race riots between 1965 and 1968.[42] King had failed in his 1966 bid to tackle de facto segregated housing in Chicago and continued to lose influence throughout 1967 as he campaigned against the war in Vietnam. New leadership, inspired by Malcolm X, emerged under the broad banner of Black Power, which rejected integration and white coalitions. These developments resulted in a rapid decline in Northern white participation and financial support for the struggle. Therefore, it could be argued that Northern liberals were willing to finance and watch a film that highlighted intractable Southern racism and glorified Northern enlightenment; a film that saw a Northern industrialist who brought wealth and progress to the South, brutally murdered; a film that has the victim's wife, also from the North, insisting that a black policeman, a product of Northern opportunity, be allowed to work the case despite the protests of Southern rednecks. This interpretation is strengthened by the filmmakers' decision to alter the origins of several characters from the original novel: Tibbs is changed from a Californian to a Pennsylvanian, the murder victim is changed from an Italian composer to a Northern industrialist, and Endicott from a liberal philanthropist to the perfect symbol of Southern racism.[43]

The Defiant Ones, as noted, reiterates the strategic approach of civil rights advocates who saw the struggle as a moral one. This interpretation was thoroughly outlined in Gunnar Myrdal's 1944 landmark study of American race relations, *An American Dilemma: The Negro Problem and Modern Democracy*.[44] Myrdal argued that there was a fundamental contradiction between American core values and the treatment accorded African Americans, and this contradiction could be resolved only through a struggle for the white moral conscience. *The Defiant Ones* makes an obvious pitch to the white moral conscience to recognize the humanity

of African Americans. Furthermore, it also provides a filmic representation of alternative responses to the "American dilemma." The relationship between the two authority figures, the local sheriff and the state trooper captain, presents two alternative approaches to racial justice for the audience to evaluate. The sheriff is intent on recapturing the men without violence while the state trooper wants them recaptured at any cost. The alternative approaches are no doubt offered for the audience to evaluate, but perhaps also to reflect recent events, in particular, the Little Rock School Integration Crisis in which different branches of authority acted to impose their will. In Little Rock, the state governor's defiance of federal authority inflamed racial prejudice. The snarling racists who greeted the nine black students trying to enter Central High could easily represent the snarling dogs hunting the escapees in *The Defiant Ones*. A similar dilemma is played out when the escapees are briefly captured by the men of a small town. One man, Mack (Claude Akins), is physically prevented from lynching the pair by Big Sam (Lon Chaney), who berates and dares the rest of the "big men" watching to try and murder the convicts. Like the sheriff, he stands up against immorality and needless violence. The portrayal of difference in this film, then, is not so much between black and white, but the different attitudes whites can adopt toward racial justice and the potential consequences of those choices.

This is in stark contrast to *In the Heat of the Night* where none of the white townspeople speaks up for tolerance. The scene in which Tibbs questions the white supremacist Endicott in the green house bears some similarities with the lynching scene from *The Defiant Ones*. A restrained Cullen spits in the face of a white supremacist, whereas Tibbs retaliates by immediately returning Endicott's slap in the face. The key difference between these two acts of defiance is that in the earlier film the black character is saved only by the direct physical intervention of a white sympathizer whereas in the later film Tibbs' retaliation requires nobody to intervene on his behalf. It is bold, assertive defiance that ultimately exposes the weakness of the white supremacist. On the verge of tears, Endicott laments to Tibbs, "there was a time when I could have had you shot." The unrestrained power of white supremacy is in decline, even the name Endicott is a play on the words "end of cotton."[45] While Tibbs remains harassed by individual white supremacists, Endicott is in far greater danger as his power is clearly eroded. By the late 1960s the American economy had shifted from its traditional agricultural base, and part of this shift resulted in the mechanization of cotton production, which had been the primary economic activity of Southern blacks since the civil war; subsequently, many African Americans migrated North and to urban areas

in search of new economic opportunities.[46] Endicott's traditional race power is diminished by economic changes, such as the murder victim's proposed factory, which is why Tibbs suspects him of the crime. Endicott's power is further diminished by the assertive action of blacks like Tibbs (presumably a recent migrant to the North since he was in Mississippi only to visit his mother) who have benefited from education and employment opportunities and can now meet Endicott blow for blow. Tibbs quite literally struck a blow against white supremacy and a blow against King's nonviolence and the message of black self-sacrifice depicted in the final scene of *The Defiant Ones*.

Karen Ross argues in her analysis of race in the media that "no image is other than a social construction viewed from a particular perspective and situated in a particular historical moment."[47] It is argued here that although the concept of negative and ahistorical racial stereotypes has dominated studies of African American representation, stereotypes can be deployed in different ways, to serve different purposes and, in this way, are deeply historical. This is not to say that stereotypes do not have a harmful effect on their subjects; what is suggested here is that a greater analysis of the process by which stereotypes are used and adapted to suit different circumstances allows scholars to understand how they are perpetuated and, ultimately, how more realistic images can be integrated into media. *The Defiant Ones* and *In the Heat of the Night* provide examples of the ways in which similar stereotypes and narrative strategies can represent complex and often contradictory examples of portrayals typically conceptualized within a continuity of stereotypical representation. When examined in this complexity, these films, as case studies, illustrate the capacity of cinema to reflect changing historical values. In this instance, the evolving aims of the civil rights movement from desegregation, integration, and appeals to personal morality to examinations of institutional disadvantage, the rise of black power, and issues of separatism.

Notes

1 Donald Bogle, *Toms, Coons, Mulattoes, Mammies and Bucks: An Interpretive History of Blacks in American Films* (New York: Continuum, 1998).

2 For an examination of "black cinema" see, for example: Phyllis R Klotman, "About Black Film. . . ." *Black American Literature Forum* 12 (1978): 123–7.

3 Marlon Riggs, *Ethnic Notions*. 56 mins (USA: California Newsreel, 1987).

4 See, for example, reviews of this work such as Nancy Grant, "Review: Ethnic Notions by Marlon Riggs." *The Journal of American History* 74 (1987): 1107–9 and Earl Lewis, "Review: [Untitled]." *The Oral History Review* 16 (1988): 128–30.

5 Jan Nederveen Pieterse, *White on Black: Images of Africans and Blacks in Western Popular Culture* (London: Yale University Press, 1992).

6 Michael Pickering, "Review: [Untitled]." *Journal of Social History* 28 (1994): 387–9; Kenneth P. Vickery, "Review: [Untitled]." *Journal of Interdisciplinary History* 25 (1995): 562–4; Winthrop D. Jordan, "Review: [Untitled]." *The American Historical Review* 98 (1993): 1571–2.

7 Pieterse, *Black on White*, 9.

8 In particular see, Gladstone Lloyd Yearwood, *Black Film as a Signifying Practice: Cinema, Narration and the African-American Aesthetic Tradition* (Trenton: Africa World Press, 2000).

9 Bogle, *Toms, Coons, Mulattoes, Mammies and Bucks*, 176.

10 See, for example, James M. Washington (ed.), "Love, Law and Civil Disobedience," in *A Testament of Hope: The Essential Writings and Speeches of Martin Luther King Jr* (San Francisco: Harper and Row, 1986), 48–51. The merits of Cold War liberalism have been hotly contested, particularly with regard to the NAACP, both at the time and by historians. See for example, Manfred Berg, "Black Civil Rights and Liberal Anticommunism: The NAACP in the Early Cold War." *Journal of American History* 94 (2007): 75–96.

11 Clayborne Carson (ed.), *The Autobiography of Martin Luther King, Jr.* (New York: Abacus, 2000), 60.

12 Clayborne Carson, *In Struggle: SNCC and the Black Awakening of the 1960s* (Cambridge: Harvard University Press, 1981), 161.

13 Sieglinde Lemke, "White on White." *Transition* 60 (1993): 149. This is not simply an issue with representation but also, as Lemke and Ella Shohat note, an issue with studies of stereotype that sideline economics to focus exclusively on race. Ella Shohat, *Unthinking Eurocentrism: Multiculturalism and the Media* (London: Routledge, 1994), 199.

14 Of course, as bell hooks points out, the illusion of sameness is highly problematic: it creates a false similarity that dehistoricizes and devalues a long history of African American oppression. Bell Hooks, *Black Looks: Race and Representation between the Lines* (New York: Routledge, 1992), 14.

15 See, for example, Cynthia J. Fuchs, "The Buddy Politic," in Steven Cohan and Ina Rae Hark (eds), *Screening the Male: Exploring Masculinities in Hollywood Cinema* (London: Routledge, 1993): 194–210.

16 Helan E. Page, "'Black Male' Imagery and Media Containment of African American Men." *American Anthropologist* 99 (1997): 101.

17 It must be acknowledged that this disabling of a white character could be seen as a reversal of stereotype (the traditional disabling of African Americans) or an adherence to it (by forcing the African American character to act as nurse, a role that Cullen appears more than willing to assume, which could be seen as a "noble savage" stereotype). See John Nickel, "Disabling African American Men: Liberalism and Race Message Films." *Cinema Journal* 44 (2004): 25–48.

18 Nickel, "Disabling African American Men," 32.

19 Shohat, *Unthinking Eurocentrism*, 190.

20 Ibid., 189–90.

21 Bogle, *Toms, Coons, Mulattoes, Mammies and Bucks*, 215–17.

22 Karen Ross, *Black and White Media: Black Images in Popular Film and Television* (Cambridge: Polity Press, 1994), 16.

23 Harry M. Benshoff, "Blaxploitation Horror Films: Generic Reappropriation or Reinscription?" *Cinema Journal* 39 (2000): 34.

24 Harriet Margolis, "Stereotypical Strategies: Black Film Aesthetics, Spectator Positioning and Self-Directed Stereotypes in 'Hollywood Shuffle' and 'I'm Gonna Git You Sucka.'" *Cinema Journal* 38 (1999): 53.

25 August Meier, "On the Role of Martin Luther King," in Raymond D'Angelo (ed.), *The American Civil Rights Movement: Readings and Interpretations* (Guilford: McGraw-Hill, 2001), 197.

26 John Nickel, "Disabling African American Men," 32.

27 See as an example of such separatist rhetoric and desire for structural change, Alfred J. Cannon, "Re-Africanization: The Last Alternative for Black America." *Phylon* 38 (1977): 203–10.

28 Bell Hooks, *Black Looks*, 13–14.

29 Robert J. Lilly and Michael B. Puckett, "Social Control and Dogs: A Sociohistorical Analysis." *Crime & Delinquency* 43 (1997): 132.

30 Karen Ross, *Black and White Media*, xxi.

31 John Nickel, "Disabling African American Men," 29.

32 William Lyne, "No Accident: From Black Power to Black Box Office." *African American Review* 34 (2000): 41.

33 Beth McCoy, "Manager, Buddy, Delinquent: 'Blackboard Jungle's' Desegregating Triangle." *Cinema Journal* 38 (1998): 25.

34 Matthew Henry, "He Is a 'Bad Mother*$%@!#': 'Shaft' and Contemporary Black Masculinity." *African American Review* 38 (2004): 126.

35 Harvard Sitkoff, *The Struggle for Black Equality 1954–1992*, 25th Anniversary edn (New York: Hill and Wang, 2008), 80.

36 For a collection of civil rights era print journalism see *Reporting Civil Rights* (New York: Library of America, 2003).

37 Sitkoff, *The Struggle for Black Equality 1954–1992*, 29.
38 Ibid., 121, 74.
39 Juan Williams, *Eyes on the Prize: America's Civil Rights Years, 1954–1965* (New York: Penguin, 1988), 235.
40 Sitkoff, *The Struggle for Black Equality 1954–1992*, 163.
41 Ibid., 102.
42 Ibid., 185.
43 John Ball, *In the Heat of the Night* (New York: Harper and Row, 1965).
44 Gunnar Myrdal, *An American Dilemma: The Negro Problem and Modern Democracy* (New York: Harper, 1944).
45 American Museum of the Moving Image. Accessed July 9, 2010, http://www.movingimage.us/site/education/content/guides/Heat%20of%20the%20Night.pdf.
46 James P. Smith and Finis R. Welch, "Black Economic Progress After Myrdal." *Journal of Economic Literature* 27 (1989): 519.
47 Karen Ross, *Black and White Media*, xx.

Filmography

Blackboard Jungle. (dir. Richard Brooks, 1955).
Guess Who's Coming to Dinner? (dir. Stanley Kramer, 1967).
In the Heat of the Night (dir. Norman Jewison, 1967).
The Defiant Ones (dir. Stanley Kramer, 1958).
To Sir with Love (dir. James Clavell, 1966).

Bibliography

American Museum of the Moving Image. Accessed July 9, 2010, http://www.movingimage.us/site/education/content/guides/Heat%20of%20the%20Night.pdf.
Ball, John. *In the Heat of the Night* (New York: Harper and Row, 1965).
Benshoff, Harry M. "Blaxploitation Horror Films: Generic Reappropriation or Reinscription?" *Cinema Journal* 39 (2000): 31–50.
Berg, Manfred. "Black Civil Rights and Liberal Anticommunism: The NAACP in the Early Cold War." *Journal of American History* 94 (2007): 75–96.
Bogle, Donald. *Toms, Coons, Mulattoes, Mammies, and Bucks: An Interpretive History of Blacks in American Films*, 3rd edn (New York: Continuum, 1998).
Cannon, J. Alfred. "Re-Americanization: The Last Alternative for Black America." *Phylon* 38 (1977): 203–10.

Carson, Clayborne. *In Struggle: SNCC and the Black Awakening of the 1960s* (Cambridge: Harvard University Press, 1981).

—(ed.), *The Autobiography of Martin Luther King, Jr* (New York: Abacus, 2000).

Colaiaco, James A. "The American Dream Unfulfilled: Martin Luther King, Jr. and the 'Letter from Birmingham Jail'." *Phylon* 45 (1984): 1–18.

Cripps, Thomas R. "The Death of Rastus: Negroes in American Films since 1945." *Phylon* 28 (1967): 267–75.

Grant, Nancy. "Review: Ethnic Notions by Marlon Riggs." *The Journal of American History* 74 (1987): 1107–9.

Henry, Matthew. "He Is a 'Bad Mother*$%@!#': 'Shaft' and Contemporary Black Masculinity." *African American Review* 38 (2004): 119–26.

hooks, bell. *Black Looks: Race and Representation between the Lines* (New York: Routledge, 1992).

Jordan, Winthrop D. "Review: [Untitled]." *The American Historical Review* 98 (1993): 1571–2.

King, William M. "The Reemerging Revolutionary Consciousness of the Reverend Doctor Martin Luther King, Jr., 1965–1968." *The Journal of Negro History* 71 (1986): 1–22.

Klotman, Phyllis, R. "About Black Film. . ." *Black American Literature Forum* 12 (1978): 123–7.

Koppes, Clayton R. and Gregory D. Black. "Blacks, Loyalty, and Motion Picture Propaganda in World War II." *The Journal of American History* 73 (1986): 383–406.

Lawrence, Novotny. *Blaxploitation Films of the 1970s: Blackness and Genre* (London and New York: Routledge, 2008).

Lemke, Sieglinde. "Review: White on White." *Transition* 60 (1993): 145–54.

Lewis, Earl. "Review: [Untitled – Ethnic Notions]." *The Oral History Review* 16 (1988): 128–30.

Lilly, Robert J. and Michael B. Puckett. "Social Control and Dogs: A Sociohistorical Analysis." *Crime & Delinquency* 43 (1997): 123–47.

Lott, Tommy L. "A No-Theory Theory of Contemporary Black Cinema." *Black American Literature Forum* 25 (1991): 221–36.

Lyne, William. "No Accident: From Black Power to Black Box Office." *African American Review* 34 (2000): 39–59.

Margolis, Harriet. "Stereotypical Strategies: Black Film Aesthetics, Spectator Positioning, and Self-Directed Stereotypes in 'Hollywood Shuffle' and 'I'm Gonna Git You Sucka'." *Cinema Journal* 38 (1999): 50–66.

McCoy, Beth. "Manager, Buddy, Delinquent: 'Blackboard Jungle's' Desegregating Triangle." *Cinema Journal* 38 (1998): 25–39.

Meier, August. "On the Role of Martin Luther King," in Raymond D'Angelo (ed.), *The American Civil Rights Movement: Readings and Interpretations* (Guilford: McGraw-Hill, 2001).

Morris, Aldon D. "Birmingham Confrontation Reconsidered: An Analysis of the Dynamics and Tactics of Mobilization." *American Sociological Review* 58 (1993): 621–36.

Murray, James P. *To Find an Image: Black Films from Uncle Tom to Superfly* (Indianapolis and New York: The Bobbs-Merrill Company, 1973).

Myrdal, Gunnar. *An American Dilemma: The Negro Problem and Modern Democracy* (New York: Harper, 1944).

Nickel, John. "Disabling African American Men: Liberalism and Race Message Films." *Cinema Journal* 44 (2004): 25–48.

Page, Helan, E. "'Black Male' Imagery and Media Containment of African American Men." *American Anthropologist* 99 (1997): 99–111.

Pickering, Michael. "Review: [Untitled]." *Journal of Social History* 28 (1994): 387–9.

Poussaint, Alvin F. "Blaxploitation Movies: Cheap Thrills that Degrade Blacks." *Psychology Today* 42 (1974): 22–32.

Riggs, Marlon. *Ethnic Notions*. 56 mins (USA: California Newsreel, 1987).

Reporting Civil Rights (New York: Library of America, 2003).

Ross, Karen. *Black and White Media: Black Images in Popular Film and Television* (Cambridge: Polity Press, 1996).

Shohat, Ella. *Unthinking Eurocentrism: Multiculturalism and the Media* (London: Routledge, 1994).

Sitkoff, Harvard. *The Struggle for Black Equality 1954–1992*. 25th Anniversary edn (New York: Hill and Wang, 2008).

Smith, James P. and Finis R. Welch. "Black Economic Progress after Myrdal." *Journal of Economic Literature* 27 (1989): 519–64.

Snead, James. *White Screens/Black Images: Hollywood from the Dark Side* (London and New York: Routledge, 1994).

Vickery, Kenneth P. "Review: [Untitled]." *Journal of Interdisciplinary History* 25 (1995): 562–4.

Wander, Brandon. "Black Dreams: The Fantasy and Ritual of Black Films." *Film Quarterly* 29 (1975): 2–11.

Washington, James, M. "Love, Law and Civil Disobedience," in James M. Washington (ed.), *A Testament of Hope: The Essential Writings and Speeches of Martin Luther King Jr* (San Francisco: Harper & Row, 1986), 43–53.

Williams, Juan. *Eyes on the Prize: America's Civil Rights Years, 1954–1965* (New York: Penguin, 1988).

Yearwood, Gladstone Lloyd. *Black Film as a Signifying Practice: Cinema, Narration and the African-American Aesthetic Tradition* (Trenton: Africa World Press, 2000).

Whisper Campaign on Catfish Row: Sidney Poitier and *Porgy and Bess*

Jeff Smith

On July 2, 1958, *The Los Angeles Mirror News* reported that fire had destroyed a sound stage on the Goldwyn studio lot. At the time, this soundstage was the second largest in Hollywood, with the building alone valued at about $1 million. Also destroyed in the fire were the studio's collection of props, all of the original acetate sound recordings for Goldwyn's films, and the Catfish Row set for *Porgy and Bess* (1959), which production designer Oliver Smith had built for an estimated $200,000.[1] Since the elaborate set had been conceived as the centerpiece for the production, shooting was set back a couple of months to allow time for Catfish Row to be reconstructed. More importantly, arson investigators also examined the studio's smoldering ruins to look for the fire's cause. Although such actions were routine, the *Los Angeles Times* reported that Goldwyn had been the target of racial protests, hinting that the fire may have been a deliberate attempt to sabotage the production. Goldwyn dismissed these rumors as ridiculous as did Loren Miller, chair of the NAACP's West Coast legal committee.[2] Despite the force of such denials, the cast and crew of *Porgy and Bess* couldn't help feeling that the fire was somehow linked to ongoing concerns regarding the film's regressive depiction of African American characters.

The fire that destroyed Catfish Row is perhaps the low point in the long, complex cultural history of Gershwin's famous folk opera. Yet it remains merely a particularly ignominious episode in the film's troubled history. About 8 months prior to the fire, *Variety* reported that Goldwyn was battling an apparent boycott. Noting Goldwyn's puzzlement in the face of this resistance, *Variety* added, "He bought a property that is by now a permanent piece of the

American entertainment scene, plus the fact is that it has never encountered any criticism from any recognized Negro source, yet he now finds himself up against an indefinable but frustrating wall of opposition."[3] Of particular concern was the fact that the boycott did not appear to be led by any organized group. Instead, *Porgy and Bess* appeared to be the victim of a "whispering campaign" that offered no explicit explanation of what made the cinematic adaptation of Gershwin's well-known opera so objectionable. Assessing the impact of the boycott, *Variety* columnist Joe Schoenfeld concludes, "How it started, or where and when it will end, cannot be told."[4]

The pall cast by this whisper campaign lingers to this day. The film version of *Porgy and Bess* has long been withdrawn from public circulation at the behest of both the Gershwin and Goldwyn estates. Although Foster Hirsch, the author of *Otto Preminger: The Man Who Would Be King*, characterizes the film as an unheralded masterpiece, Goldwyn's *Porgy and Bess* largely remains a historical curiosity, occasionally trotted out for rare public screenings in major cities like New York and Los Angeles.[5] The film has never received a proper video release and is only available in bootleg versions of somewhat dubious quality. Because Goldwyn's *Porgy and Bess* is so difficult to see, it has become a kind of "black hole" in the filmographies of its cast, which included such noted African American performers as Dorothy Dandridge, Pearl Bailey, Diahann Carroll, Sammy Davis Jr., and Sidney Poitier.

This chapter examines the somewhat problematic place of *Porgy and Bess* in Poitier's long career. I argue that Poitier's performance as Porgy illustrates the actor's consummate craft and shrewd pragmatism despite the fact that the role itself remains a troubling image of black masculinity. More important, the film's production history not only encapsulates Poitier's largely assimilationist political stance, but it also highlights a particular strand of civil rights politics that strived to make incremental progress, even though the participation in such struggles involved moderating one's personal reservations. As we'll see, Poitier's performance as Porgy came at a crucial juncture of his career, and the actor's decision to accept the role underscores the actor's difficult and complex negotiation of the path to stardom. Before turning to the film version of *Porgy and Bess*, though, I briefly discuss its prehistory as both a theater piece and an opera. In sketching out the historical and cultural context for Poitier's performance, I show that racial issues have long figured as a part of *Porgy and Bess*'s cultural reception.

Gershwin's Porgy

The roots of Poitier's screen portrayal of Porgy can be traced back many years to newspaper reportage about Samuel Smalls, a physically impaired mendicant in Charleston's King Street known to the locals, thanks to the goat and cart that he used to get around. Smalls had been arrested for aggravated assault after attempting to shoot a woman named Maggie Barnes. His story provided inspiration to Southern writer DuBose Heyward, who saw passion, hate, and despair in this otherwise commonplace incident, and used it as the basis of his novel *Porgy*. As Heyward noted in the introduction to his play of the same name, from Smalls's "real, and deeply moving, tragedy sprang Porgy, a creature of my imagination, who synthesized for me a number of divergent impressions and emotions."[6] The novel proved to be both a critical and commercial success, and Heyward soon emerged as one of the most prominent writers of the 1920s on black subjects.

With *Porgy* appearing on best-seller lists, its author soon attracted the attention of Hollywood. While Heyward was on a planned lecture tour in New York, he received an offer for the screen rights to *Porgy* from producer-director Cecil B. DeMille. DeMille's story editor, Charles Beahan, had read the novel when it was in galleys, and even though its publisher believed it was not suitable for the movies, Beahan persuaded DeMille to make a pitch to Heyward. According to Hollis Alpert, Beahan closed the deal for $4500, which Heyward then used to build a new and larger house. When Heyward returned to the Carolinas from New York, he was eager to see the progress his wife Dorothy had made on the mystery novel she was writing. Only it turned out that Dorothy wasn't working on a mystery novel at all, but instead had been secretly writing a play based on *Porgy*.[7]

Meanwhile, as he began work on the score for *Oh, Kay!*, George Gershwin spent a sleepless night in his home on Riverside Drive in New York devouring Heyward's novel. Gershwin was deeply affected by Heyward's sympathetic portrait of African American life in the South. From a modern perspective, Gershwin's response might seem ironic insofar as modern critics have largely rejected Heyward's white paternalist perspective and instead embraced the vibe of Harlem Renaissance writers who were working just blocks away from the composer's doorstep. Gershwin, however, saw the dramatic possibilities that the story offered. The next morning, Gershwin dashed off a letter to Heyward suggesting that they collaborate on adapting the book into an opera.[8]

Gershwin's entreaty forced Dorothy to come clean about her own plans for a stage adaptation. Although Gershwin claimed that an independent drama about Porgy would in no way affect his plans for an opera, the Heywards wondered whether there was enough interest in *Porgy* to support the production of two separate theatrical projects. Dorothy recalled DuBose's initial reaction to Gershwin's proposal: "He was torn between the prospect of the play and the opera. We both thought of it as 'or.'"[9] The Heywards forged ahead with revisions of Dorothy's first draft, insisting that their theatrical version would have to come first. DuBose and Dorothy finished their work on the play in the summer of 1926 and sent copies of *Porgy* to three different producing organizations. Within a week, all three expressed interest in staging the new play. Confronted with a range of options, the Heywards decided the New York's Theatre Guild would be the venue for *Porgy*'s Broadway debut. Casting began in September 1926, and the Guild assigned the play to one of its regular directors, Robert Milton. By June 1927, however, it was clear that Milton was not working out, and a new director was hired to replace him. His name was Rouben Mamoulian, and he would come to be publicly associated with various versions and iterations of *Porgy* for the next 30 years.[10]

Like the novel that served as its source, the Heywards' adaptation of *Porgy* was an immediate success when it debuted in October 1927. It ran for a year on Broadway before then touring several large cities, such as Chicago, Boston, Philadelphia, Baltimore, Denver, Los Angeles, San Francisco, and St Louis. After completing its US tour, *Porgy* then returned briefly to New York before moving onto engagements in London, Paris, Vienna, and Berlin. All in all, the play ran continuously for about 2 years, garnering mostly favorable notices from critics and providing extraordinary exposure to its African American cast members.[11]

Not surprisingly, the success of *Porgy* as a play once again grabbed the attention of Hollywood producers and stars. The planned screen adaptation by Cecil B. DeMille never really got off the ground, but in 1932, Al Jolson approached the Theatre Guild with an offer to make a screen musical of *Porgy*, starring himself in blackface that would feature music by Jerome Kern and a book by Oscar Hammerstein II. (Kern and Hammerstein's *Show Boat* had been a huge success in 1927 as had Jolson's pioneering "talkie" *The Jazz Singer*.) The Theatre Guild pressed Heyward to accept Jolson's terms, but Heyward remained reluctant knowing that a movie musical of *Porgy* might hamper Gershwin's plan to transform the book into an opera. Once again, when confronted with a competing project, Gershwin proved to be magnanimous: "If you can see your

way to making some ready money from Jolson's version I don't know that it would hurt a later version done by an all-colored cast."[12] Heyward ultimately accepted Jolson's deal with the proviso that he would not be available to work on the production since he planned to collaborate with Gershwin whenever the composer was ready to begin. Like its predecessor, the Jolson musical never got off the ground. When Kern and Hammerstein ended their professional partnership, Jolson was left without a show and opted instead to take a part in Lewis Milestone's production of *Hallelujah I'm a Bum!* (1933).[13]

Although Heyward and Gershwin continued to correspond, the composer did not fully turn his attention to *Porgy and Bess* until the summer of 1933. In the interim, Gershwin worked on several projects, including two musicals (*Pardon My English* and *Let Them Eat Cake*) and a piece for piano and orchestra, *Variations on "I Got Rhythm."* On October 17, 1933, Gershwin and Heyward signed a contract to write *Porgy and Bess*, and then immediately began looking for a producer, eventually settling on the Theatre Guild. Heyward remained enthusiastic for the work the Guild previously had done on *Porgy* as well as the organization's demonstrated record in hiring black performers. (Apparently, Gershwin and Heyward also weighed an offer from the Metropolitan Opera, but could not be sure that the Met would hire black singers for the production. As Ira later recalled, George believed it would be impractical for the Met to acquire an all-Negro cast to be available for only six to eight performances a season.)[14]

With a signed contract and a venue for the production, Heyward and Gershwin each went their separate ways. Heyward returned to his home in Hendersonville, North Carolina, and began working immediately on the opera's book and libretto, completing the entire first half by early March, 1934. Gershwin, however, continued to split time between the opera and other projects. He toured and did radio broadcasts at the same time that he was working out *Porgy and Bess*'s major themes and leitmotifs as well as the opera's first few numbers.

Heyward and Gershwin mostly collaborated long distance, relying on the mail system to share their latest efforts. In June 1934, though, Gershwin visited Heyward at his cottage in the Gullahs. The purpose of the visit was twofold. On the one hand, it enabled Gershwin and Heyward to work closely together on the opera's music and libretto. On the other hand, it also offered Gershwin a chance to absorb the local color and atmosphere of life among the Gullahs' African diaspora. During Gershwin's visit, Heyward showed him around Charleston, taking him into several black churches, schools, and praise houses.[15] As Ellen

Noonan points out, the trip later proved to be important in shaping the public reception of *Porgy and Bess*. In a magazine article that Heyward wrote about his collaboration with Gershwin, he characterized the pair as folklorists gathering information about the authentic culture of the islands' "large population of Gullah Negroes."[16]

By January 1935, Gershwin had completed a condensed score for *Porgy and Bess*. Gershwin still needed to finish the massive job of orchestrating his sketches, but the project was far enough along that he could play and sing many of the opera's now familiar numbers to his friends and colleagues. Among the privileged few who had the opportunity to hear *Porgy and Bess* at this nascent stage of development was a 31-year-old music professor from Howard University named Todd Duncan. Gershwin previously had heard Duncan perform in an all-black version of Pietro Mascagni's *Cavalleria Rusticana*, and, on the lookout for a baritone who might fill the role of Porgy, he asked Duncan to visit his New York home for an informal audition. Duncan brought along a copy of Giuseppe Sarti's "Lungi dal caro bene" as an audition piece, but after just a few measures into it, Gershwin interrupted Duncan to ask, "Will you be my Porgy?"[17] Duncan, however, initially balked at Gershwin's proposal, in part because he always had thought of him as a Tin Pan Alley composer. Knowing that this was to be Gershwin's first opera, Duncan replied that he would have to hear the music first. Gershwin brought Duncan back to his apartment a week later, this time for a more formal audition for the Theatre Guild board. Duncan sang for an hour, and then after a brief lunch, George and Ira performed the *Porgy and Bess* score in its entirety. Despite his skepticism, Duncan was so impressed by Gershwin's music that he already had decided to accept the role before Porgy's entrance in the opera's first scene. Duncan, thus, joined fellow cast member, Anne Brown, a 20-year-old Juilliard student who had auditioned for the role of Bess several months earlier.[18]

Rehearsals for the opera began on August 26, 1935, in preparation for *Porgy and Bess*'s Boston premiere on September 30, 1935. In addition to Duncan and Brown, several other cast members were plucked from the African American cast that performed in the Broadway production of Virgil Thomson and Gertrude Stein's opera, *Four Saints in Three Acts*, about 18 months earlier. The initial response from Boston audiences and critics was quite enthusiastic as *Porgy and Bess* sold out its week-long engagement and received encouraging reviews. The show then moved to New York on October 10, but the response from critics was much more mixed. Although most reviewers acknowledged Gershwin's ample

gift for melody, others questioned the opera's reliance on recitatives, hinting that the convention didn't seem to fit the opera's folkloric subject matter. Others simply found the show pretentious and aggrandizing.

The critical response among the African American press in New York was also mixed, albeit for different reasons. Black performers recognized that, in mixing black spirituals with Western concert music, Gershwin simply had adopted a strategy that the Fisk Jubilee Singers had been employing for decades.[19] In other cases, critics sought to dissociate the performers from their roles. As Ellen Noonan observes, "Unlike white critics who enthused over the cast's 'natural' affinity for the opera's characters, features and editorials in some black newspapers emphasized the middle-class status of the *Porgy and Bess* performers and the social, educational, and linguistic distance that separated them from the characters they portrayed onstage."[20]

The opera's use of exaggerated Southern dialect and its images of black buffoonery and tomfoolery put its cast members in something of a cultural bind. Duncan and Brown both acknowledged that they endured a great deal of approbation from the black community that was ashamed of the opera's depiction of its characters as lazy and shiftless craps shooters and dope sniffers. Yet *Porgy and Bess* also presented them with a unique point of entry to the rarefied world of New York opera—one typically denied to African American singers. This was especially true for John W. Bubbles, a vaudeville performer who took on the role of Sportin' Life. Bubbles did not read music and came from a tradition where he never performed anything twice in the same way.[21] That *Porgy*'s performers derived an elevated social status from their depiction of demeaning stereotypes is the kind of Faustian bargain that was already thoroughly familiar to African American actors in films. When asked about her screen roles, Oscar winner Hattie McDaniel famously said, "Why should I complain about making seven thousand dollars a week playing a maid? If I didn't, I'd be making seven dollars a week actually being one!"[22]

Gershwin's opera closed on January 26, 1936, less than 4 months after its much ballyhooed debut. Its disappointing run of 124 performances was far fewer than the 367 performances enjoyed by the DuBose and Dorothy Heyward play that preceded it. According to Walter Rimler, "Gershwin told (Todd) Duncan that Broadway people were avoiding the show because they thought it was opera and operagoers were not going because they thought it was Broadway."[23] Gershwin died of a brain tumor less than 18 months later, believing that his signature achievement was a colossal flop. He was only 38 years old.

The opera's fortunes turned around, however, after successful revivals in 1942 and 1952, both of them resolving some of the problems diagnosed by Gershwin in the aftermath of the first production's failure. Cheryl Crawford's 1942 adaptation remade the opera as a Broadway musical by cutting some of the songs, shrinking the size of the orchestra, and eliminating the recitatives.[24] The 1952 revival, produced by Blevins Davis and Robert Breen, restored some of the songs, but similarly repackaged the opera in an effort to avoid the problems of *Porgy and Bess*'s early reception. As Breen told one theater manager, "I am a little weary of seeing all the type-space used up by the so-called music critics in discussing *Porgy and Bess* and whether it meets the specifications of being an 'opera.' We are not selling it as an opera but as a theatre piece."[25]

The 1952 revival led to an international tour of the production sponsored by the State Department.[26] *Porgy and Bess*'s cast and crew were to be America's goodwill ambassadors as part of a larger program of cultural exchange. More pointedly, though, the tour was intended to serve as anti-Communist propaganda, countering charges lodged in *The Daily Worker* regarding the paucity of opportunities for African American performers on Broadway.[27] A 1956 tour took Davis and Breen's production behind the Iron Curtain with stops in the Soviet Union, Poland, and Czechoslovakia. It proved to be a rousing success, especially in Moscow. More than 12,000 tickets were available for *Porgy and Bess*'s stint at the famed Stanislavsky Theatre, but they sold out long before the troupe's arrival. Indeed, according to Hollis Alpert, tickets to the show were so valuable that they were awarded to factory workers "as a bonus for excellence and productivity in their work."[28] Furthermore, as Bennett Cerf observed in 1957, the anticipation surrounding the production caused Soviet leadership to change their usual theatergoing habits: "(Soviet Premier Nikita) Khruschev attended the *second* Moscow performance, a break with protocol that amazed everybody. Mr. K, usually comes, if at all, to the final performance of a spectacle, but this time he couldn't wait."[29]

By the time cameras began rolling for the film version of *Porgy and Bess*, its place in the canon was firmly secured. With all apologies to comic and pundit Stephen Colbert, the only question up for debate regarding Gershwin's opera was whether *Porgy and Bess* was a great work of American music or the greatest work of American music. Yet, despite the opera's cultural cachet, its successful revival rekindled and even stoked the fires of dissent that had earlier greeted *Porgy and Bess*'s premiere. Obviously, there was a world of difference between the racial politics of 1957 and those of 1935. The Supreme Court's landmark decision in

Brown v. Board of Education and the burgeoning civil rights movement added some urgency to the questions about the way African Americans were depicted on-screen. Within this atmosphere, the opera's use of Negro dialect and the screen image of loose women, craps shooters, and dope sniffers proved to be particularly troubling, inviting a backlash that the film's makers never completely understood.

Goldwyn's Porgy

On May 9, 1957, *Variety* reported that Hollywood *überproducer* Samuel Goldwyn had acquired the screen rights to the Gershwins' opera *Porgy and Bess*. Ever since its successful Broadway revival in 1952, Ira Gershwin had been in almost continual negotiations for a film adaptation of *Porgy*. Gershwin estimated that nearly a hundred different producers had approached him over the years, but no deal ever emerged from these discussions as the lyricist bided his time waiting for the right individual to come along.[30] In and of itself, money did not seem to be the stumbling block in the negotiations over *Porgy*'s screen rights. Once his deal was finalized, Goldwyn bragged that he had secured the rights for $650,000 against 10 percent of the global gross, considerably less than the million dollar offers made by both Columbia Pictures and Louis B. Mayer. In addition, producers George Seaton and William Perlberg also made a pitch to Gershwin using financial backing provided by Paramount Pictures, but the details of their offer were not reported.[31]

Initially, Goldwyn planned to make the film later that same year in "some 'widescreen' process."[32] Instead, Goldwyn spent more than 6 months testing various sound and widescreen formats to see which would be best suited to the expensively mounted musical. After great deliberation, Goldwyn settled on Todd AO, largely because the format's six-track stereophonic sound would provide "the very best sound system available."[33] As the *Los Angeles Times* later reported, Todd AO's wide-gauge process and six-track stereo together accounted for about $1.5 million of the film's $7.5 million budget.

The decision to shoot in Todd AO also necessitated improvements to the Goldwyn studio's recording theater. Todd AO's sound director, Fred Hines, stated that the studio spent about $60,000 upgrading their equipment and converting stage six into a recording space large enough to house its six-track magnetic recording equipment. Like other musicals, the production planned to use

playback techniques in which cast members mimed their parts to prerecorded vocal and instrumental tracks. Goldwyn planned to spend $200,000 and about 10 weeks prerecording the film's various numbers, which were scored for a 107-piece orchestra, a full chorus, and various soloists.[34] Prerecording only began, though, after Goldwyn had successfully extricated himself from a potentially sticky labor issue. Goldwyn made a separate deal with the American Federation of Musicians to get around a strike that had been called on February 20, 1958. The producer agreed to extend the provisions of the basic music contract that had expired on February 15. In doing so, Goldwyn overcame a potential hurdle to the production, one that was especially important insofar as he also planned to use professional opera singers to dub most of the principal cast members' singing voices.[35]

Besides the money tied up in the production itself, Goldwyn also planned to make significant investments in the promotion of *Porgy and Bess*. Goldwyn commissioned the publication of a souvenir booklet for the film with an anticipated first printing of about 1 million copies.[36] Moreover, in addition to Columbia Records' original soundtrack of *Porgy and Bess*, Goldwyn and Gershwin also authorized the use of songs from the musical on nearly a dozen other albums that hoped to cash in on the film's release. Among these other tie-ins was Verve's album of *Porgy and Bess* music featuring Louis Armstrong and Ella Fitzgerald as well as a separate collection of songs performed by the film's cast members, Sammy Davis Jr. and Diahann Carroll, each of whom had existing deals with other labels, besides Columbia.[37] Carroll's album is of particular note since she was among the group of cast members whose singing voice was dubbed. As Carroll explained to the *Associated Press*, "The Gershwin estate has such control over his music that even keys cannot be changed without special permission. I sing about five keys lower than the original score—so I'm disqualified."[38]

By July 1958, Goldwyn had finalized almost all of the important details of the film's production, having decided on the film's budget, its format, and its "above the line" personnel. The one detail that lingered, however, was a distribution deal for the film. On August 25, *Variety* reported that Goldwyn had reached an agreement with Columbia Pictures for the distribution rights to *Porgy and Bess*. The deal called for Columbia to receive a 19.5 percent distribution fee on the total box office revenues.[39] This distribution percentage was the same as that received by MGM in Goldwyn's previous deal for *Guys and Dolls* (1955), but it was surprisingly low in comparison to the 30 percent fee that independent

producers customarily paid to distributors. The reason Goldwyn received such favorable terms is that his films typically burnished the image of any company associated with the producer. As *Variety* noted more than a year after the deal was negotiated, "Goldwyn, who finances his own pictures, is, of course, the only producer currently operating who can come up with such an arrangement. The distribution of a Goldwyn property lends prestige to the company handling the property. Companies are willing to accept what amounts to a break-even fee just to be associated with a Goldwyn project."[40]

Still, despite Goldwyn's considerable reputation and resources, *Porgy and Bess's* production was marred by several problems in addition to the studio fire and threatened boycott that were discussed in the introduction of this chapter. First, while the Catfish Row set was being rebuilt, Goldwyn clashed with director Rouben Mamoulian, who he initially hired on the basis of the latter's success with the various stage versions of *Porgy*. In late July 1958, Goldwyn summarily fired Mamoulian citing creative differences, and replaced him with Otto Preminger, who had previously helmed Twentieth Century Fox's similarly themed Oscar Hammerstein musical *Carmen Jones* (1954). Mamoulian did not go quietly, however, even though Goldwyn paid off the director's $75,000 fee in full. Mamoulian filed a complaint against Goldwyn with the Directors Guild, who in turn condemned the producer for dismissing a director for "frivolous, spiteful, or dictatorial reasons."[41] The fallout from Mamoulian's firing continued when veteran character actor Leigh Whipper announced that he was giving up the role of Crab Man in the film because he believed that Mamoulian's replacement, Otto Preminger, had no real respect for African Americans.[42] Goldwyn rallied to Preminger's defense along with several of *Porgy and Bess's* cast members, many of whom had worked previously with the director during the production of *Carmen Jones*. When the Screen Directors Guild board convened a meeting of all the principals, Preminger was himself ready to take legal action against Mamoulian for slander, saying, "I'm Jewish. I ran away from Hitler. How can they say I'm anti-Negro?"[43] Mamoulian eventually backed off from his complaint, firing his agent and his publicist in the process.

Goldwyn simply traded one headache for another, however, when Mamoulian's replacement filed suit against the producer for breach of contract. Although Preminger was handsomely paid, earning a director's fee double that paid to Mamoulian, he claimed that Goldwyn had promised him a percentage of the net profits. During the hasty negotiations of Preminger's deal, the director balked at Goldwyn's offer of 10 percent of the net profits saying that the figure was far

below his usual fee. Eager to close the deal, though, Preminger agreed to let Goldwyn determine an appropriate profit percentage when the director's work on the film was completed. When the time came to decide the matter, Goldwyn curtly reminded Preminger, "You left the participation to me? So there is no participation."[44] The dispute was definitively resolved in March 1963 when it was determined that Goldwyn had not engaged in any misconduct.[45] Of course, by then, the very notion of profit participation was moot. At the time of the film's release, Goldwyn acknowledged that *Porgy and Bess* would have to earn $16 million just to break even.[46] Instead, it earned only about $3.5 million.[47]

Goldywn's legal problems with Preminger were followed by an even more contentious lawsuit filed by Broadway producer-director Robert Breen. Breen sought damages in excess of $3 million, claiming Goldwyn and his agent, "Swifty" Lazar, secured the film rights to *Porgy and Bess* on the basis of "false and fraudulent promises."[48] Breen argued that he gave up his share of rights and interest in the show—about 40 percent of the total rights—in exchange for Goldwyn's promise that Breen would be credited as coproducer and would have joint artistic control during filming. Goldwyn later testified that he had never promised Breen joint artistic control, but instead had assured him that he would keep an open mind regarding the possibility of employing Breen as a writer or director on the film. Goldwyn claimed he had given the matter due consideration, but decided to hire other people instead of Breen for each of those key positions. In March 1963, nearly 4 years after *Porgy and Bess*'s release, a jury decided the lawsuit in Goldwyn's favor after deliberating for more than 9 hours.[49]

In addition to these legal battles, Goldwyn also faced considerable open resistance from African American groups. In his book on *Porgy and Bess*, Hollis Alpert reports that a group calling itself the Council for the Improvement of Negro Theater Arts took out a two-page advertisement in *The Hollywood Reporter* that denounced Goldwyn's film and urged Negro performers to boycott it. The text of the ad noted the opera's problematic history:

> Dorothy and DuBose Heyward used the race situation in the South to write a lot of allegories in which Negroes were violent or gentle, humble or conniving, and given to erupting with all sorts of goings-on after their day's work in the white folks' kitchen or the white folks' yard was over, like sniffing happy dust, careless love, crapshooting, drinking, topping it all off with knife play.
>
> But it never occurred to them that the Negro was not innately any of this, and that he was just like anybody else and that this was a human being's way of reacting to the dehumanizing pressure of a master race.[50]

What had been, in late 1957, a whisper campaign against Goldwyn's production was now quite open and vocal dissent.

Worse yet, just prior to the film's release, playwright Lorraine Hansberry also criticized both *Porgy and Bess* and its director, Otto Preminger, in a televised debate staged by Chicago broadcaster Irv Kupcinet for his weekly show, *At Random*. Hansberry was then riding high, thanks to the success of her Broadway play, *A Raisin in the Sun*, which had just opened 2 months earlier. Decrying the opera's use of negative stereotypes, Hansberry critiqued Gershwin's exoticized treatment of Negro life, saying, "We, over a period, of time, have apparently decided that within American life we have one great repository where we're going to focus and imagine sensuality and exaggerated sexuality, all very removed and earthy things—and this great image is the American Negro."[51] When Preminger pressed her about whether or not the motives behind the film's production were at issue, Hansberry responded:

> We cannot afford the luxuries of mistakes of other people. So it isn't a matter of being hostile to you, but on the other hand it's also a matter of never ceasing to try to get you to understand that your mistakes can be painful, even those which come from excellent intentions. We've had great wounds from great intentions.[52]

Hansberry's eloquence may have disarmed Preminger, because, when asked about the absence of white characters in *Carmen Jones*, he acknowledged that the world of his film was a fantasy: "It is a world that doesn't really exist."[53]

Goldwyn may well have hoped that the film's eventual release would stem this tide of negative commentary. But any such hope proved to be in vain. Three months after *Porgy and Bess*'s premiere, Era Bell Thompson summarized African American discontent with the film in an essay published in *Ebony*. Noting that dissension has accompanied all previous productions of *Porgy and Bess*, Thompson claimed that for those who disliked the stage play, the movie version is essentially the "same kettle of catfish."[54] Thompson not only cites both Hansberry's comments and the text of the *Hollywood Reporter* advertisement as evidence of the black community's opposition, but also makes reference to an even more trenchant critique mounted by A. S. "Doc" Young in *The Los Angeles Sentinel*. Wrote Young, "The big evil that it does can be charged to this: Hollywood will not, Goldwyn will not produce an antidote. If he will spend $7 million to make the story of Dr. Martin Luther King and the Montgomery walkers, and distribute this great progressive saga around the world, then I'll say: Let him have *Porgy and Bess*."[55]

In an apparent gesture of good will just prior to the film's debut, Goldwyn announced that he would donate all of his profits from *Porgy and Bess* to charity.[56] Yet, after the film had played all of its road show engagements, Goldwyn decided to cut his losses both financially and politically. In February 1961, Goldwyn canceled all of the film's Southern engagements, declaring that he did not want *Porgy and Bess* to contribute to racial tensions in the South. *Variety* acknowledged that a theater showing the film was picketed in Chapel Hill, North Carolina, when it played to a segregated, all-white audience. Yet the trade journal also expressed some skepticism about Goldwyn's sensitivity, particularly when his decision created difficulties for dozens of theater owners who had already booked and advertised their screenings of the film. *Variety* specifically cited an editorial in the *Atlanta Journal* just days earlier, which opined, "Presenting 'Porgy and Bess' for a limited engagement would probably be child's play compared to operating a lunch counter in the South these days."[57]

Bruised by the experience and facing catastrophic losses, Goldwyn did not make another film after *Porgy and Bess*. The veteran producer was one of Hollywood's founders, but after more than 40 odd years in the business, Goldwyn decided to call it quits. Goldwyn hoped *Porgy and Bess* would be his crowning glory, a valedictory achievement that would serve as a fitting cap to his distinguished career. In *A Guide for the Study and Enjoyment of* Porgy *and Bess*, Goldwyn wrote, "Presenting 'Porgy and Bess' as a motion picture represents the fulfillment of a dream I have had for many years. It is also my personal tribute to George Gershwin, America's great composer."[58] Yet the film remains officially unavailable, largely due to the opposition of the Gershwins' estate. During the negotiations for the screen rights, Goldwyn made one huge concession to George Gershwin's heirs; he had agreed to purchase only a 15-year lease on the rights rather than make the deal contingent on an outright sale. When the rights to the film version lapsed back to the Gershwins in 1972, the film could not be publicly screened without the expressly stated permission of the authors or their estates. Thanks to *Porgy and Bess*'s troubled history, the film now more likely brings to mind the old saw about the tree in the woods: if a lavish, $7 million Hollywood musical can't be shown in theaters, does it actually make a sound?

Poitier's Porgy

In *Making Movies Black*, Thomas Cripps argues that the screen image of blacks prior to the civil rights era can be neatly illustrated through a close examination

of the screen personae of two major stars: Harry Belafonte and Sidney Poitier. Cripps argues that many of the social message films about race made both during and after World War II adopted a weak, but conciliatory strategy regarding the politics of integration by limiting their discourse to the image of a single iconic black being admitted to a larger white social circle. These images reinforced a kind of social equilibrium that permeated the mainstream popular culture's view of race relations even as it characterized the breaking of the color barrier as the assimilation of a handful of meritorious "tokens," who were sometimes described as a "credit" to their people.

Against this background, Cripps both compares and contrasts the career arcs of the two leading African American actors of the period:

> Sidney Poitier and Harry Belafonte, the former circumspect, overcontrolled, the latter the product of bohemian cellars where folksongs were sung to leftish audiences. In the decade of the 1950s, as we shall see, Hollywood chose Poitier and elected to exclude Belafonte, to repeat itself rather than break new ground—at least, until the crisis of the civil rights movement provided it with the occasion to restart its stilled engines.[59]

Cripps goes further, though, to suggest that the screen images of these two actors also each evinced the profile of complex, mythic heroes. Belafonte's characters were doomed, Byronic outlaw figures that challenged, but ultimately failed to change the status quo of their social environment. In films like *Carmen Jones* and *Odds Against Tomorrow*, Belafonte exuded an "edgy intensity" that lent itself to a more oppositional or contestatory political stance. In contrast, Poitier took refuge in the gentler politics of the center. Because he adapted his screen personae to the expectations of the white mainstream, Cripps sees Poitier as a figure like Gawain from Arthurian legend. Poitier's characters endure "tests and trials" that can be abstracted into universal experiences. Cripps sums up Poitier's screen persona saying, "Like Lucas Beauchamp in *Intruder in the Dust*, he is the 'conscience of us all.'"[60] Cripps dichotomous treatment of Poitier's and Belafonte's screen images breaks down by the 1970s, particularly in a film like *Buck and the Preacher* (1972), in which the duo pairs up to help freed and escaped slaves evade nightriders hunting them down.

Still, Cripps's treatment of the two actors is more even-handed than that of Donald Bogle, who similarly acknowledges Poitier's integrationist image, but describes his characters as "mild-mannered toms, throwbacks to the humanized Christian servants in the 1930s."[61] Poitier radiated a mixture of intelligence, fortitude, and dignity that made him a model of black respectability, an

aspirational image that was easily embraced by the period's white movie audiences. Yet, as Bogle also points out, over time, the actor's staid nobility made him seem virtually colorless and sexless, a neutered presence whose suffering and self-sacrifice for the sake of white characters glossed over legitimate concerns about the pernicious effects of racism. Bogle adds, "In the 1960s, Hollywood belittled and dehumanized Poitier's great human spirit by making it vulgarly superhuman. He became SuperSidney the Superstar, and he was depicted as too faithful a servant, the famous Poitier code then a mask for bourgeois complacency and sterility."[62]

Not surprisingly, as the two most important black actors of the 1950s, Belafonte and Poitier were both sought by Goldwyn for the lead role of Porgy. Unfortunately, for Goldwyn, neither actor particularly wanted to play the part. Contemporary press reports indicate that Belafonte was first offered the part, presumably based on his previous success as the star of *Carmen Jones*. But Belafonte turned it down.[63] Hollis Alpert claims that Belafonte "didn't want to play a part on his knees," but adds, "Whether the role was actually offered him is doubtful."[64] Goldwyn then approached Poitier to play Porgy. Like Belafonte, Poitier also turned down the part, indicating that he recognized the opera as an American classic, and acknowledging that he didn't have enough interest in the piece.[65] The Goldwyn camp, however, claimed that the producer couldn't come to terms with Poitier after the actor requested script approval.[66] *Variety* columnist Joe Schoenfeld seemed to recognize that Goldwyn's explanation was something of a ruse. Schoenfeld found Poitier's alleged demand for script approval strange since "the highly sympathetic character is so well known."[67]

In truth, Poitier was being squeezed behind the scenes by Hollywood power brokers. The actor relented to Goldwyn when he learned that one of his agents had already committed him to play Porgy. Although Poitier himself wanted nothing to do with the Goldwyn production, he was told that the failure to fulfill this obligation would endanger a part in another film that he was desperate to play: Noah, the escaped prison convict, in Stanley Kramer's *The Defiant Ones* (1959). Ever the pragmatist, Poitier realized that the role in *The Defiant Ones* was the kind of breakthrough he needed, a return to the kinds of parts he played early in the decade in films like Joseph Mankiewicz's *No Way Out* (1950) and Budd Boetticher's *Red Ball Express* (1952). Adopting a "one for them, one for me" attitude toward his Hollywood overlords, Poitier eventually accepted Goldwyn's offer, even though he continued to have serious personal reservations about the part.[68] His conciliation with Goldwyn helped to bring Dorothy Dandridge and

Pearl Bailey into the fold, allaying some of their qualms and concerns about the play's indulgence in racist stereotypes.[69] The only actor who seemed eager to join the Goldwyn production was Sammy Davis Jr., who wanted to play Sportin' Life and used high-profile friends, like Frank Sinatra and George Burns, to lobby Goldwyn on his behalf.[70]

Once production started, though, the qualms and reservations of the cast fueled an open rebellion regarding certain aspects of the film that they found particularly problematic. First, Pearl Bailey threatened to leave the production if the female cast members were forced to wear bandannas as part of *Porgy and Bess*'s costumes.[71] In doing so, Bailey sought to distance the film's female characters from the "mammy" stereotypes that were seen in films like *Gone with the Wind* (1939). Then, following Poitier's lead, the cast refused to use the Southern Negro dialect that N. Richard Nash featured in his screenplay, replacing the demotic forms with Standard English equivalents.[72] As Brock Peters recalled:

> There was the pressure of whether we were doing something that was contributing negatively to Black culture and one's view of what that was, and we didn't want to be guilty of that. And so in essence the sense we had was that we could clean it up in terms of language. . . . We talked about it [those who had dialogue]. . . . We just wouldn't do the dialect, the quote-unquote Southern Black dialect. We would go at it straight.[73]

Pearl Bailey proved an even sterner taskmaster regarding the avoidance of "dese," "dems," and "dose" that cropped up in Nash's screenplay. She publicly took one performer to task for using the line "Ain't I done told you?" Bailey also clashed with other cast members who had been veterans of the Broadway production and had been using the play's dialect for years. Since neither Goldwyn nor Preminger tried to correct the actors' line readings, Bailey concluded that the dialect was simply unnecessary: "I told this kid and some of the others that it's insane to use it if it's not insisted on. It's losing your dignity. It's undignified and unnatural. I don't care if it's Negro or Italian or Greek or French, it's in bad taste."[74]

Despite these problems on the set and his own personal distaste for the material, Poitier delivered a thoughtful, nuanced performance as Porgy, earning plaudits from several critics, some of whom found the film otherwise to be a crashing bore. A *New York Amsterdam News* columnist, for example, lauded Poitier, adding that, as an actor, he "seems to grow in stature in every role."[75] *New York Times* reviewer Bosley Crowther also praised Poitier's strength and

sensitivity as Porgy, but added, "so is the voice of Robert McFerrin doing his musical chores."[76] *Variety* not only described Poitier's performance as "thoroughly believable," but also cautioned that the film likely had an uphill climb at the box office due to "a) the drab story, b) the opera form, c) the known fact that all-Negro casts usually run a hard course."[77]

Just as Gershwin's opera did, Goldwyn's film version of *Porgy and Bess* opens with Clara singing "Summertime" as she sits near the fishermen's docks near Catfish Row. The number not only sets a melancholic tone for the action that follows, but it also displays the broad features of Director Otto Preminger's visual style in the film. As he did in *Carmen Jones*, Preminger photographs the action mostly in long shots and even extreme long shots, relying on blocking, extensive camera movement, and shots of unusually long duration to convey information about the story. This visual approach consistently emphasizes the physical interactions of the characters and the ways in which they relate to their environment. Although *Porgy and Bess*'s plot emphasizes the storylines of the title characters, the visual style of the film treats the people of Catfish Row as a kind of collective, one that situates Porgy and Bess within a larger social milieu.

However, as Lorraine Hansberry implied in her debate with Preminger, that milieu exists mostly as a fantasy world that bears little or no relation to social and material realities. This is especially evident when the film's action shifts to Oliver Smith's famous Catfish Row set, the one that had to be rebuilt after the fire destroyed Goldwyn's soundstage. The contrast with the previous scene is somewhat jarring as the set displays a high degree of stylization and artificiality. From a narrative perspective, the set effectively conveys the sense of deprivation felt by those who live in Catfish Row. Yet, viewers cannot help but feel that this display of poverty has been rather artfully rendered. Although the elaborate stage facades were consistent with the principles of set design used for stage productions of the opera, *Porgy and Bess*'s *mise-en-scéne* signals the film's departure from everyday reality due to Smith's rather picturesque treatment of dilapidation and decay.

The shift in the action to Catfish Row is motivated by the men's return from their daily labors. Once inside the courtyard that serves as the film's principal setting, the men begin shooting craps, resisting requests by their female partners to return home. The homosocial bonding evident in this scene is reinforced by the musical number they perform—"A Woman is a Sometime Thing." Preminger also includes shots of Sportin' Life exiting his garret apartment, sliding down drainpipes, and walking over rooftops to eventually join the group's dice game.

Clad in a bowler and form-fitting suit, these actions highlight Sammy Davis Jr.'s catlike grace in performing the role. His slinky movements convey his devilish personality long before he tempts Bess with "happy dust" and an offer to join him in New York. Later, Bess describes Sportin' Life as a rattlesnake, a term that links the character to the primordial temptations of the serpent in the Garden of Eden. Long before this scene, the association is primed by Davis's light-footed agility.

Porgy's entrance comes roughly about 10 minutes into the film. Preminger stages the entrance in a way that exploits the size and scale of Smith's massive set while also highlighting Porgy's general isolation from the rest of the Catfish Row community. The composition of the shot utilizes deep staging principles with Sportin' Life framed from behind in the left foreground, the middle third of the composition occupied by the huddle of men playing dice, and the right third focused on an archway in the deep background. Porgy enters through the archway, his cart pulled by a goat that travels along the z-axis in the shot. He displays a wad of cash to the group and offers it to the first man who can shoot it off him. Porgy alights from the cart and asks a group of kids to take his goat back to his shack. The camera pans with these kids as they lead the goat away. As is typical of Preminger's long take style, the shot is held for about 37 seconds. Yet, despite its simplicity, it underlines several aspects of the production, in particular, the use of figure movement as a technique to guide the viewer's attention to the most important information in the shot.

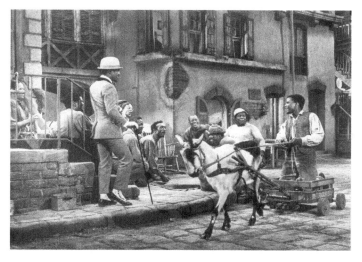

Figure 9 Poitier enters in his goat-drawn cart in *Porgy and Bess*.

The next setup reinforces Porgy's outsider status in the group. Although he is one of the title characters, Preminger keeps Porgy on the right edge of the widescreen frame, far from the composition's center. When the women of Catfish Row begin to badmouth Bess, Porgy crawls toward them, asking the "Gawd-fearing" ladies to keep their mouths off of her. Here again, because figure movement guides the viewer's attention, Preminger uses the technique to increase Porgy's salience to the unfolding story. Porgy's request to lay off Bess prompts Jake to observe that Porgy's "soft on her." This functions as a dangling cause as it later explains why Porgy is willing to shelter Bess from police when the rest of Catfish Row turns their backs on her.

Porgy performs his first number apart from the others, who are engrossed in their dice game. Preminger positions him just off-center in the shot, physically separated from the rest of the group by the metal rail of the staircase. The lyrics that Porgy sings indicate his Job-like acceptance of earthly suffering, saying. "When Gawd make cripple, He mean him to be lonely. Night time, day time, he got to trabble dat lonesome road." Moments later, though, Porgy will appeal to supernatural powers when he prepares to take his turn shooting: "Oh little stars, little stars, roll, roll. 'Leven little stars, come home, come home. Roll dis poor beggar a sun an' a moon, a sun an' a moon." The mention of "stars," of course, not only refers to the little dots embossed on each side of a die, but also serves as a synecdoche for the notion that cosmic forces control one's destiny. It might seem odd to hear Porgy petition the fates so soon after attesting to the power of a Creator, especially since he is about to gamble his meager earnings, a risky and morally dubious behavior. Yet, Porgy's lyrics subtly hint at feelings of pride that do not seem befitting for someone with such a low social station. There's no question that Porgy must beg for handouts in order to scrape by. But gambling, nonetheless, offers Porgy a path to self-respect, even though both the audience and other characters likely see it as a sinful act. Shooting craps may be an illicit behavior, but winning at least temporarily spares Porgy the indignity of begging.

Still, although Porgy eventually returns to the craps game, Preminger again composes the shot in such a way that it reinforces the character's outsider status. He is seated on the left side of the frame at the edge of the group that is amassed in the center. Porgy takes his turn as shooter, and when he makes the point, he quickly gathers up his winnings. Crown, however, grabs Porgy's arm in an attempt to prevent him from collecting the money. Porgy glares back at Crown defiantly and wrenches his arms from the latter's grasp.

This is the first of several moments in the film where Poitier conveys Porgy's extraordinary upper-body strength. The moment, of course, foreshadows the later fight between Crown and Porgy in which the latter prevails. Although Porgy is partially obstructed by the window in his efforts to fend off Crown, the headlock he places on his assailant exerts enough force to strangle him. Moreover, when the police try to take Porgy into custody to identify Crown's body, he grabs the sides of the paddy wagon to stop from being loaded in, engaging a physical struggle that he will ultimately lose, but which requires three officers to subdue him. (Porgy is strong, but he is not superhuman.) As I noted earlier, Harry Belafonte famously announced he wouldn't play the part of Porgy because he found the character's constant posture of supplication demeaning. Yet, even though Poitier had reservations about playing a "love-starved, crippled beggar," the actor nonetheless endows Porgy with both a sense of pride and of physical strength, attributes that tend to complicate or shade the largely negative image of black masculinity that had been part of the character's history.[78]

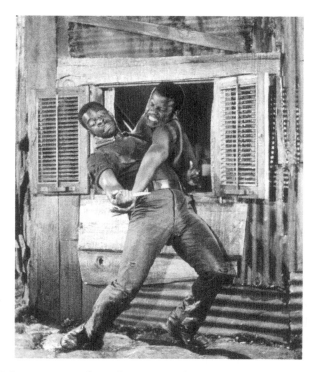

Figure 10 Sidney Poitier and Brock Peters in a fatal struggle in *Porgy and Bess*.

Of course, many African American actors in the 1950s were fully capable of conveying Porgy's vigor and intensity, even in spite of his physical infirmity. Indeed, Brock Peters's performance as Crown is defined almost entirely by the character's strong will and brute force. Poitier, however, is equally adept at showcasing Porgy's kinder, gentler side. This is particularly evident in his big number, "Bess, You Is My Woman Now." The song is prefaced by a brief scene in which Sportin' Life asks Bess to return to New York with him and offers her some "happy dust for old times sake." Preminger cuts to a medium shot of Porgy opening the door of his shack. Porgy enters and the camera quickly tracks backward and to the left to show him crawling toward the couple. The trio of figures is clustered on the left part of the frame. He then grabs Sportin' Life by the wrist and throws him across the room so that he crashes into the wall. The new arrangement of figures reestablishes equilibrium in the scene, a state of affairs expressed through the balance of the composition. Preminger deploys both "clothesline" staging and depth effects created through aperture framings to achieve this balance.[79] Bess, Porgy, and Sportin' Life are arrayed in a way that involves lateral staging; Bess and Sportin' Life occupy the left and right parts of the frame with Porgy positioned just left of the composition center. Preminger, though, adds visual interest to the scene by keeping the people in the courtyard visible in both the open window and open door. Porgy verbally threatens Sportin' Life and orders him out of his one-room shack, drawing upon the sense of righteous anger that was a facet of Poitier's larger screen persona in the 1950s. When Sportin' Life exits, the camera tracks forward and to the right to follow Porgy as he closes the door, returning to a setup quite similar to the one that began the shot.

Having disposed of Sportin' Life, Porgy's demeanor changes quite dramatically. His shoulders relax and his left arm hangs limply at his side. When Porgy sings that Bess must laugh and sing and dance for two instead of one, he folds his arms across his chest. Poitier here adopts a closed stance and also a posture of repose that contrasts with the coiled intensity on display just moments earlier. Preminger then cuts to a medium shot of Bess to show her reaction, finally bringing the 80-second take to an end. This new setup, though, lasts only 17 seconds and it focuses the viewer's attention on the play of emotions across Bess's face as she gazes lovingly off-screen, smiling in response as Porgy describes his newfound happiness. Preminger then returns to a 23-second shot of Porgy as he finishes his verse and crawls to the center of the shack. In the ensuing shot, Bess starts to sing her verse and the camera pans with her as she approaches Porgy.

Having kept his lovers separate during this initial part of the duet, Preminger now brings them into the same frame. The shot initiates an even longer take than the previous shots of the scene, one that runs just over 4 minutes and which concentrates our attention on the way that Porgy and Bess physically and emotionally relate to one another. Once she reaches Porgy, Bess grabs his hand and pulls it to her breast. A slight smile slowly spreads across Porgy's face, his upturned gaze conveying both affection and vulnerability. Porgy then grasps Bess by the hips and pulls her toward him. He rests his head upon her bosom, a classic lovers' pose, but one that also hints at Porgy's emotional dependence. Bess, however, kneels to face him and as she does so, Porgy slides his hands gently down her arms. Bess rocks back on her heels, but the pair remain physically connected by their clasped hands. Each sings the refrain that suggests the union of their souls in a kind eternal bliss: "Mornin' time an' evenin' time an' summer time an' winter time." The couple then kisses and embraces. Porgy and Bess each sing the melodies of their verses, which Gershwin interleaves using counterpoint techniques. At the conclusion of the verse, Porgy tenderly removes Bess's bandanna, a gesture that carries an additional political charge in light of Pearl Bailey's earlier protest regarding the scarf's association with mammy figures on screen. The duet reaches an emotional peak as the pair sings in unison, "From dis minute I'm tellin' you, I keep dis vow." The number concludes as Bess promises Porgy that "I's yo' woman now," and Porgy promises Bess, "We's happy now, we's one now." Porgy and Bess once again kiss and then leave to go to the courtyard. Many critics of the period complained about the apparent mismatch between the actor's bodies and the dubbed operatic singing voices provided by Adele Addison and Robert McFerrin, respectively. Yet, at moments like these in the film, the obvious artifice of the technological ventriloquism is overcome by the sheer chemistry evident in Dorothy Dandridge and Sidney Poitier's physical embodiment of the characters.[80] More important, perhaps, despite playing the part of Porgy on his knees, Poitier uses his body to convey the entire range of emotions in the scene, capturing the character's fortitude and tenderness in almost equal measure.

If there is a chink in Poitier's performance, it might be his rendition of "I Got Plenty o' Nuttin'," a number that long had rankled African American critics of Gershwin's folk opera. As Arthur Knight points out, in 1942, blacks lobbied to have the song removed from the Washington DC public school music curriculum. Knight adds, "Any interested party would have predicted in 1958 that the Goldwyn film would include the song and, thus, would include

Sidney Poitier on his knees singing, 'I got plenty o' nuttin' and nuttin's plenty for me'—perhaps the most viscerally unappealing prospect of the film adaptation for black critics."[81] Indeed, some of the most vocal critics of the film and opera appropriated the song's title to express their displeasure. For example, in "Why Negroes Don't Like 'Porgy and Bess,'" Era Bell Thompson concludes his essay thusly: "To the celebrated movie producer, *Porgy and Bess* may be his 'contribution to the world of art,' and to Ira, brother of George Gershwin, it may be Goldwyn's 'most meaningful memorial,' but to a whole lot of Negroes, drama, novel, or opera, it is 'plenty of nothin'!'"[82]

Walter Rimler, though, notes that Gershwin had always envisioned the song as a bit of social satire. In explaining the piece's function within the opera to Todd Duncan, his first Porgy, Gershwin indicated that it was not meant to be a happy-go-lucky tune. Instead, Gershwin told Duncan, "What you're doing is making fun of us. You're making fun of people who make money and to whom power and position is very important."[83] Whether or not the song ever really worked as satire is an open question. Yet, the placement of the song's lyrics in Poitier's mouth undermines almost any potential that it has to be read against the grain of its denotative meanings. A performer like Harry Belafonte might have used his sexy outcast image to heighten the character's opposition to prevailing social norms, a move more in keeping with Gershwin's perspective on the number's social function. Yet, such a possibility is undercut with Poitier in the role. For audiences familiar with Poitier's previous parts, which, in Ed Guerrero's words, limited the actor to playing "sterile paragons of virtue completely devoid of mature characterization or of any political and social reality," his embodiment of earnestness and sincerity worked against him.[84] Because Poitier's previous roles were largely devoid of any hint of irony, his Porgy could only mouth a bland acceptance of life's misfortunes and heartaches.

Perhaps the most significant scene in the film, though, is one that doesn't include Porgy at all: the church picnic on Kittiwah Island. The scene was actually shot on location on an island in the San Joaquin River near Stockton, and aside from the film's opening, it is the only sequence photographed in a real space. The location shoot was itself the result of Preminger's efforts to alter production plans after Rouben Mamoulian's departure. Once he took over the project, Preminger not only persuaded Goldwyn that the action of the picnic scene would benefit from a natural setting, but also convinced the producer to have the sets redesigned to make them less stage like.[85] In his autobiography, Preminger said simply, "I wanted them changed and Goldwyn agreed."[86]

The sudden shift, though, from Oliver Smith's Catfish Row set to a real outdoor location is probably a bit jarring to the viewer. The scene comes nearly halfway through the film, and having created an aestheticized simulacrum of poverty, replete with cobblestone slum dwellings and threadbare, but colorful costumes, the audience might well expect that this approach to the film's *mise-en-scéne* will continue throughout. The change in visual style is quite noticeable even despite the fact that the picnic scenes still observe the standard conventions of the musical by which characters suddenly burst into song.[87] In other words, the characters' actions retain a degree of unreality even if the setting does not.

Yet, the sudden shift to a real location in *Porgy and Bess* also carries thematic significance and even an affective charge that likely exceeds the intentions and ambitions of the film's makers. The big number performed in the picnic scene is Sportin' Life's "It Ain't Necessarily So," a song that reinforces his position in the narrative as a figure of hedonic temptations. Disrupting Serena's sermon, Sportin' Life recounts various episodes of the Bible involving King David, Jonah, Moses, and Methuselah, only to cast doubt on their veracity. Sportin' Life's retort to the sermon is blasphemous, not only because he questions the literal truth of the Bible, but also because he gives license to the assembled parishioners to do what they like without shame and without sin. The appearance of the song, though, within the context of a real space subtly alters some of the scene's implications. Sportin' Life's proclamation that "Oh, I takes dat gospel whenever it's pos'ble, but wid a grain of salt" hints at the ways that religion itself is implicated in Gershwin's and Goldwyn's depiction of race, despite—or perhaps even because of—the underlying social logic of segregation. As historians like Eugene Genovese note, Christianity was an important tool of racial oppression in the antebellum South. By promising eternal rewards in the afterlife in exchange for pious sufferance in this life, religion served as an ideological tool that not only reconciled blacks to their lower station, but also served as an implicit justification of slavery and segregation insofar as God's plan was believed to "authorize" white dominion over people of color. Performed in this jarringly realistic setting, "It Ain't Necessarily So" both questions the sanction of religious dogma and punctures the fantasy of happy-go-lucky black folk earnestly waiting for deliverance.

The Kittiwah Island scene is a potent reminder of the grim history of racial segregation in another way. As Ellen Noonan observes, the picnic scene is reminiscent of the "large, lavish, church-sponsored picnics" that were held

outside of Charleston, across the Cooper River in Mount Pleasant. Within the film, the excursion to the island promises the kind of physical and spiritual renewal that comes from communing with nature. Yet the historical origins of these events undermine the impression that such sojourns were only an excuse for some innocent fun. Rather, the brute reality is that African Americans *had* to leave Charleston for these church-sponsored picnics since segregation laws prohibited large groups of black people from congregating in the city's public spaces. Goldwyn may not have intended to do so, but by transporting his all-black cast to a distant location hundreds of miles from Hollywood, his production inadvertently brought the cultural experience of the Jim Crow south to the sunny shores of modern California.

In an *Ebony* magazine portrait of Poitier published in May 1959, just weeks before *Porgy and Bess*'s premiere, the actor was asked whether he was "artistically satisfied" with his work on the film. The question appears to be phrased in such a way that it deliberately recalls Poitier's initial public statements about his reasons for passing on Goldwyn's offer. Poitier's response to the question is telling, partly because the actor so obviously tries to dodge it: "I would like to leave that question in abeyance. I want to see first if I'm socially satisfied with it. I know I tried like hell to make it so. Artistic satisfaction? Well, it depends, being as subjective as I am, on how well it comes off socially."[88] Poitier's reluctance to discuss his new film not only seems diplomatic, especially considering all of the problems that plagued the production, but it also attests to the fact that the actor did not view his craft and his individual beliefs as segregated realms. Rather, in recognizing the social import of his screen appearances, Poitier viewed his performances as something that integrated aesthetics and politics.

With the benefit of hindsight, though, Poitier's comments to *Ebony* appear to be an obvious face-saving gesture. In his memoir, Poitier makes crystal clear what he was thinking at the time. When the actor's agent informed him about Goldwyn's interest, Poitier said, "I don't want to go see him. I don't want to do *Porgy and Bess*. *Porgy and Bess* is an insult to black people and I ain't going to play it and that's all there is to it."[89] Even after reluctantly agreeing to meet with Goldwyn, Poitier remained convinced that the role was problematic from a political perspective. During the meeting, Goldwyn tried to persuade Poitier to reconsider, saying, "I understand how you feel, Mr. Poitier, but I disagree with you—this is one of the greatest things that has ever happened for the black race." Knowing Goldwyn's enormous influence in Hollywood, Poitier held his tongue, thinking to himself that the producer's assertion was "an outrageous bullshit

statement." Instead, Poitier hoped to see a twinkle in Goldwyn's eye or some other evidence that the producer was kidding. Instead, he sees nothing and concludes, "He believes every word he's saying." [90]

Recognizing that Goldwyn had boxed him in, Poitier accepted the trade-off entailed in the deal making that led the actor to do both *Porgy and Bess* and *The Defiant Ones*. Although Poitier's reputation might be briefly tarnished by *Porgy*, particularly within the black community, the role of Cullen in *The Defiant Ones* offered, in the actor's own words, "a rare look at a movie character exemplifying the dignity of our people—something that Hollywood had systematically ignored in its shameless capitulation to racism."[91] Poitier's pragmatism paid off as *The Defiant Ones* received eight Oscar nominations, including one for Best Picture and two others for Poitier and costar Tony Curtis as Best Actor. Stanley Kramer's prison escape drama catapulted Poitier to Hollywood's A-list, a position he would maintain for the better part of two decades.

Porgy and Bess? Not so much. Hollywood would periodically return to the black-cast musical, most notably with *The Wiz* (1978) and *Dreamgirls* (2006). But after *Porgy*'s failure, the form was essentially dead, made anachronistic by events taking place in Little Rock and Montgomery and Birmingham and Selma. Considering the fact the film has been publicly unavailable for nearly three decades, Goldwyn's *Porgy and Bess* is today little more than a historical curiosity, a film with wonderful songs, impressive direction, handsome sets, and energetic performances that somehow people still don't like very much. At the end of the day, with contemporary audiences prevented from seeing the film, Poitier's Porgy exists, but only in the discursive traces of surviving trade press, promotional materials, critical reviews, and scholarly articles. In a curious way, the film character's plight parallels the protagonist's situation in Ralph Ellison's pioneering novel on racial identity; Poitier's Porgy has become cinema's "invisible man."

Notes

1 "'Porgy, Bess' Stage Burns," *Los Angeles Mirror News*, July 2, 1958, 1. See also "Goldwyn Studio Fire Razes $2,000,000 Set," *Los Angeles Times*, July 3, 1958, 1.

2 "Goldwyn Studio Fire," 1.

3 Joe Schoenfeld, "Time and Place," *Variety*, November 19, 1957, 3. See also "Boycott in Hollywood?" *Time Magazine*, December 2, 1957, 92.

4 Schoenfeld, "Time and Place," 3.

5 Foster Hirsch, *Otto Preminger: The Man Who Would Be King* (New York: Knopf, 2007), 302.

6 Quoted in Ellen Noonan's *The Strange Career of Porgy & Bess: Race, Culture, and America's Most Famous Opera* (Chapel Hill: University of North Carolina Press, 2012), 35.

7 Hollis Alpert, *The Life and Times of Porgy and Bess: The Story of an American Classic* (New York: Knopf, 1990), 40–1.

8 Ibid., 44–5. As one might expect, there is a wealth of published material on Gershwin's opera *Porgy and Bess*. In addition to the Alpert and Noonan books already cited, see Howard Pollack, *George Gershwin: His Life and Work* (Berkeley: University of California Press, 2006), especially 567–664; and Walter Rimler, *George Gershwin: An Intimate Portrait* (Urbana: University of Illinois Press, 2009).

9 Quoted in Alpert, *Life and Times*, 45.

10 Ibid., 45–52.

11 Noonan, *Strange Career*, 79.

12 Quoted in Robert Wyatt and John Andrew Johnson (eds), *The George Gershwin Reader* (New York: Oxford University Press, 2004), 203.

13 Noonan, *Strange Career*, 76.

14 Rimler, *George Gershwin: An Intimate Portrait*, 65–6; Pollack, *George Gershwin: His Life and Work*, 574.

15 See Rimler, *George Gershwin: An Intimate Portrait*, 83–6; Alpert, *Life and Times*, 87–90; and Pollack, *George Gershwin: His Life and Work,* 577–8.

16 Noonan, *Strange Career*, 176–7.

17 Rimler, *George Gershwin: An Intimate Portrait*, 93–5; and Alpert, *Life and Times*, 92–4.

18 Rimler, *George Gershwin: An Intimate Portrait*, 95–8; and Alpert, *Life and Times*, 94–5.

19 Noonan, *Strange Career*, 160–1.

20 Ibid., 166.

21 See Rimler, *George Gershwin: An Intimate Portrait*, 103–4. Bubbles's unpredictability continued after the show opened. During its New York premiere, Bubbles's missed his cue in the third act. It turned out that he had purchased an emerald green jumpsuit earlier that day as a costume for Sportin' Life, but the zipper had stuck when he put it on. When Bubbles did come on stage, he performed "There's a Boat Dat's Leavin' Soon for New York" with his back to the audience in order to hide his wardrobe malfunction.

22 Donald Bogle, *Toms, Coons, Mulattoes, Mammies, and Bucks: An Interpretive History of Blacks in American Films*, 3rd edn (New York: Continuum, 1994), 82.

23 Rimler, *George Gershwin: An Intimate Portrait*, 117.

24 For more on the 1942 revival, see Rimler, *George Gershwin: An Intimate Portrait*, 170–1; and Alpert, *Life and Times*, 135–40.

25 Quoted in Alpert, *Life and Times*, 179.

26 For a detailed discussion of *Porgy and Bess*'s various tours between 1952 and 1956, see Noonan, *Strange Career*, 185–233; and Alpert, *Life and Times*, 143–242.

27 Alpert, *Life and Time*, 181.

28 Ibid., 236.

29 Bennett Cerf, "The Goldwyn Touch," *This Week*, April 5, 1957. *Porgy and Bess* clippings file, Margaret Herrick Research Library, Academy of Motion Picture Arts and Sciences, Beverly Hills, California. (MH hereafter)

30 Philip K. Scheuer, "'Porgy' Sale Long Stymied," *Los Angeles Times*, April 6, 1956, B7.

31 See "Goldwyn to Pay 10% of Global Gross to Film 'Porgy,'" *Variety*, May 9, 1957, 1, 4; Thomas Pryor, "Hollywood Dossier: 'Porgy and Bess' Heads for Films—Addenda," *New York Times*, May 12, 1957, X5.

32 "Goldwyn to Pay 10%," 1.

33 "Goldwyn's 'Porgy' to be in Todd AO," *Los Angeles Examiner*, April 23, 1958, *Porgy and Bess* clippings file, MH.

34 "60 G Spent in Converting Stage for Recording Goldwyn 'Porgy,'" *Variety*, June 5, 1958, 7.

35 "Goldwyn Signs Interim AFM Pact to Get 'Porgy' Scored," *Hollywood Reporter*, April 10, 1958. *Porgy and Bess* clippings file, MH.

36 Cerf, "The Goldwyn Touch," *Porgy and Bess* clippings file, MH.

37 "Five Waxeries Plan Releases on 'Porgy,'" *Variety*, November 21, 1958: 3; "Goldwyn Nixes Pic's Art for 11 Disk Labels' Albums of 'Porgy' Songs," *Hollywood Reporter*, February 19, 1959, *Porgy and Bess* clippings file, MH.

38 Philip K. Scheuer, "Goldwyn Sees 'Porgy' as His 'Contribution,'" *Los Angeles Times*, October 19, 1958, E1.

39 "Col Getting Goldwyn's 'Porgy,'" *Variety*, August 25, 1958, 1.

40 "Col 'Porgy' Take Said to Be Only 20% Plus Prestige," *Variety*, October 1, 1959, 11.

41 Alpert, *Life and Times*, 265.

42 Hirsch, *Otto Preminger*, 289.

43 Quoted in Alpert, *Life and Times*, 266.

44 Hirsch, *Otto Preminger*, 294–5.

45 "No Misconduct in Goldwyn Suit," *Variety*, March 22, 1963, 1, 4.

46 "Goldwyn Assigns All His 'Porgy' Profit to His Charity Foundation," *Hollywood Reporter*, June 22, 1959. *Porgy and Bess* clippings file, MH.

47 *Porgy and Bess'* box office figures. Accessed September 10, 2013, http://www.imdb.com/title/tt0053182/business?ref_=tt_dt_bus.

48 "$3 Million Suit Hits Goldwyn on 'Porgy' Film," *Los Angeles Times*, April 11, 1959, 3.

49 "Samuel Goldwyn Is Upheld in Breen's $805,000 'Porgy' Suit," *Hollywood Reporter*, March 26, 1963. *Porgy and Bess* clippings file, MH.

50 Alpert, *Life and Times*, 260–1.

51 Jack Pitman, "Lorraine Hansberry Deplores 'Porgy,'" *Variety*, May 27, 1959, 16.

52 Ibid.

53 Ibid.

54 Era Bell Thompson, "Why Negroes Don't Like 'Porgy and Bess,'" *Ebony*, October 1959, 51. For more on African American press coverage of *Porgy and Bess*, see Arthur Knight, *Disintegrating the Musical: Black Performance and American Musical Film* (Durham, NC: Duke University Press, 2002), 162–8.

55 Thompson, "Why Negroes Don't Like," 54.

56 "Goldwyn Assigns," *Porgy and Bess* clippings file, MH.

57 "Sensitive about Yanking of 'Porgy,'" *Variety*, March 1, 1961, 21.

58 *A Guide for the Study and Enjoyment of* Porgy and Bess. *Porgy and Bess* clippings file, MH.

59 Thomas Cripps, *Making Movies Black: The Hollywood Message Movie from World War II to the Civil Rights Era* (New York: Oxford University Press, 1993), 251.

60 Ibid., 251.

61 Bogle, *Toms, Coons, Mulattoes, Mammies & Bucks*, 176.

62 Ibid., 183.

63 "Boycott in Hollywood?" 92.

64 Alpert, *Life and Times*, 260.

65 "Boycott in Hollywood?" 92.

66 Ibid.

67 Schoenfeld, "Time and Place," 3.

68 For Poitier's account of these negotiations, see his autobiography, *This Life* (New York: Alfred A. Knopf, 1980), 205–13.

69 Alpert, *Life and Times*, 261–2; Pollack, *George Gershwin: His Life and Work*, 650; Noonan, *Strange Career*, 264–5; Hirsch, *Otto Preminger*, 286; and Chris Fujiwara, *The World and Its Double: The Life and Work of Otto Preminger* (New York: Faber and Faber, 2008), 223.

70 Alpert, *Life and Times*, 261; Hirsch, *Otto Preminger*, 287–8.

71 Noonan, *Strange Career*, 23; Hirsch, *Otto Preminger*, 287.

72 Hirsch, *Otto Preminger*, 193.

73 Quoted in Fujiwara, *World and Its Double*, 225–6.

74 Quoted in Noonan, *Strange Career*, 268.

75 Jesse H. Walker, "Theatricals," *New York Amsterdam News*, July 14, 1959, 13.

76 Bosley Crowther, "Samuel Goldwyn's 'Porgy and Bess' has Premiere at Warner," *New York Times*, June 25, 1959, 20.

77 "Porgy and Bess," *Variety*, July 1, 1959, 6.

78 Poitier, *This Life*, 222.

79 For more on "clothesline" staging and aperture framing, see David Bordwell's "CinemaScope: The Modern Miracle You See without Glasses," from *Poetics of Cinema* (New York: Routledge, 2008), 281–325; and *Figures Traced in Light: On Cinematic Staging* (Berkeley: University of California Press, 2005).

80 For more on the use of dubbed voices for African American actors, see my essay, "Black Faces, White Voices: The Politics of Dubbing in *Carmen Jones*." *The Velvet Light Trap* 51 (Spring 2003): 29–43.

81 Arthur Knight, "'It Ain't Necessarily So That It Ain't Necessarily So': African American Recordings of *Porgy and Bess* as Cultural Criticism," in Pamela Robertson Wojcik and Arthur Knight (eds), *Soundtrack Available: Essays on Film and Popular Music* (Durham, NC: Duke University Press, 2001), 336.

82 Bell, "Why Negroes Don't Like," 54.

83 Quoted in Rimler, *George Gershwin: An Intimate Portrait*, 70.

84 Ed Guerrero, *Framing Blackness: The African-American Image in Film* (Philadelphia: Temple University Press, 1993), 72.

85 Fujiwara, *The World and Its Double*, p. 226; Hirsch, *Otto Preminger*, 289–90.

86 Otto Preminger, *Preminger: An Autobiography* (New York: Doubleday, 1977), 163.

87 For more on this aspect of the film musical, the reader should consult Rick Altman's discussion of two of the genre's particular stylistic traits, the "audio dissolve" and the "video dissolve," in *The American Film Musical* (Bloomington: Indiana University Press, 1987), 59–80.

88 Lerone Bennett Jr., "Hollywood's First Negro Movie Star," *Ebony* May 1959, 106.

89 Poitier, *This Life*, 206.

90 Ibid., 208.

91 Ibid., 212.

Bibliography

Alpert, Hollis. *The Life and Times of Porgy and Bess: The Story of an American Classic* (New York: Knopf, 1990).

Altman, Rick. *The American Film Musical* (Bloomington: Indiana University Press, 1987).

Bennett Jr., Lerone. "Hollywood's First Negro Movie Star," *Ebony*, May 1959, 100–8.

Bogle, Donald. *Toms, Coons, Mulattoes, Mammies, and Bucks: An Interpretive History of Blacks in American Films,* 3rd edn (New York: Continuum, 1998).

Bordwell, David. *Figures Traced in Light: On Cinematic Staging* (Berkeley: University of California Press, 2005).

—*Poetics of Cinema* (New York: Routledge, 2008).

Cripps, Thomas. *Making Movies Black: The Hollywood Message Movie from World War II to the Civil Rights Era* (New York: Oxford University Press, 1993).

Crowther, Bosley. "Samuel Goldwyn's 'Porgy and Bess' Has Premiere at Warner," *New York Times*, June 25, 1959, 20.

Fujiwara, Chris. *The World and Its Double: The Life and Work of Otto Preminger* (New York: Faber and Faber, 2008).

Guerrero, Ed. *Framing Blackness: The African-American Image in Film* (Philadelphia: Temple University Press, 1993).

Hirsch, Foster. *Otto Preminger: The Man Who Would Be King* (New York: Knopf, 2007).

Knight, Arthur. "'It Ain't Necessarily So That It Ain't Necessarily So': African-American Recordings of *Porgy and Bess* as Cultural Criticism," in Pamela Robertson Wojcik and Arthur Knight (eds), *Soundtrack Available: Essays on Film and Popular Music* (Durham, NC: Duke University Press, 2001), 319–46.

Noonan, Ellen. *The Strange Career of Porgy & Bess: Race, Culture, and America's Most Famous Opera* (Chapel Hill: University of North Carolina Press, 2012).

Pitman, Jack. "Lorraine Hansberry Deplores 'Porgy,'" *Variety*, May 27, 1959, 16.

Poitier, Sidney. *This Life* (New York: Alfred A. Knopf, 1980).

Pollack, Howard. *George Gershwin: His Life and Work* (Berkeley: University of California Press, 2006).

Preminger, Otto. *Preminger: An Autobiography* (New York: Doubleday, 1977).

Pryor, Thomas. "Hollywood Dossier: 'Porgy and Bess' Heads for Films—Addenda," *New York Times*, May 12, 1957, X5.

Rimler, Walter. *George Gershwin: An Intimate Portrait*. Urbana: University of Illinois Press, 2009.

Scheuer, Philip K. "'Porgy' Sale Long Stymied," *Los Angeles Times*, April 6, 1956, B7.

—"Goldwyn Sees 'Porgy' as His 'Contribution,'" *Los Angeles Times*, October 19, 1958, E1.

Schoenfeld, Joe. "Time and Place," *Variety*, November 19, 1957, 3.

Smith, Jeff. "Black Faces, White Voices: The Politics of Dubbing in *Carmen Jones*." *The Velvet Light Trap* 51 (Spring 2003): 29–43.

Thompson, Era Bell. "Why Negroes Don't Like 'Porgy and Bess,'" *Ebony*, October 1959, 50–4.

Wyatt, Robert and John Andrew Johnson (eds), *The George Gershwin Reader* (New York: Oxford University Press, 2004).

To Sir, with Love: A Black British Perspective

Mark Christian

To many in Britain a Negro is a "darky" or a "nigger" or a "black"; he is identi-fied in their minds with inexhaustible brute strength; and often I would hear the remark "working like a nigger" or "labouring like a black" used to empha-sise some occasion of sustained effort. They expect of him a courteous subser-vience and contentment with a lowly state of menial employment and slum accommodation.

E. R. Braithwaite, *To Sir, with Love* (1967)

Published as a semibiographical novel by E. R. Braithwaite in 1959, and later adapted for the big screen by its producer and director James Clavell, *To Sir, with Love* (1967) (in which Sidney Poitier plays the role of Mark Thackeray) is a blend of visions based on the original book: the screenwriter's and director's vision and the interpretative artistic license via Poitier's acting skills. The movie is based in London's working-class East End, and it has many themes beyond the standard "teacher inspires students" genre, which is not the focus of this chapter. Instead, this chapter considers the trope of black presence in Britain; the reality of black British students (the female is present but has no lines, and the male is portrayed as dysfunctional in terms of his negative racialized identity). Certainly, the film can be deemed a conduit for racialized relations in Britain, and a way of comprehending the life of a black teacher in the working-class British education system. Crucially, this chapter aims to delve further into these "hidden" or overlooked aspects of *To Sir, with Love*, and to engage in a black British analysis of the film. Moreover, unlike Sam Selvon's portrayal of a largely working-class African Caribbean migrant experience in London in *The Lonely Londoners* (1956), E. R. Braithwaite's *To Sir, with Love* (1959) focuses on a middle-class understanding of black Britain. Both working- and middle-class

African Caribbeans, however, were inextricably interwoven within the tentacles of the British Empire. Mark Thackeray's staff room demeanor is that of a black middle-class male not wanting to rock the boat, even when he is under incessant racial jibes from the colonial-type master, Weston (played by Geoffrey Bayldon). The mode of the empire, colonized and colonizer, is played out perfectly in that one interaction between Thackeray and Weston.

An underlying theme of antimiscegenation permeates Clavell's adaption of the book. His perspective on black Britain actually engenders pessimism. British colonialism implicitly emerges throughout the movie, but this has rarely been examined and considered by film critics. Not only has it been disregarded, very few critical commentators have actually considered the nuances of black British presence in the film. For example, Marill (1978) in regard to the lack of a black perspective writes,

> Race is virtually ignored in *To Sir, with Love,* although one or two color-oriented quips are hurled at Thackeray—by the cynical teacher, not the students, and the only black student . . . is just "the unhappy non-white," the offspring of a black mother and a white father.[1]

This quote reveals implicitly more than what it states explicitly; Marill is actually incorrect on a number of points. First, "race" can be read as a constant underlining theme that weaves through the movie like an invisible thread. Actually, in addition to Marill's viewpoint, it is essentially via the "unhappy non-white" character that the thread of British blackness is woven. Second, he also states erroneously that this character is the offspring of a black mother and white father. On the contrary, he is in fact depicted in the film (and novel) as the child of a black father and white mother. Indeed, there is a powerful scene whereby the black school teacher Mark Thackeray confronts Seales (the black student of mixed heritage, played by Anthony Villareol) in the playground. The dialogue between them is an important underlining note on black Britain and the state of racialized relations. The scene starts as Thackeray emerges from the school doorway after a difficult class. He sees Seales leaning against the playground wall, smoking, in a crestfallen manner. Indicating a sense of worry for his student, Thackery starts the conversation:

Thackeray: Something the matter Seales? Seales, something wrong?
Seales: It's me mum, she's awful sick.
Thackeray: Oh I'm sorry, anything I can do?
Seales: No nothing. She's English.

Thackeray: I see.

Seales: You're like my old man, except in you're bigger and younger. Rotten bastard!

Thackeray: You shouldn't speak like that about your father.

Seales: You know nothing, I hate him, I hate him! Why I'll never forgive him for what he did to my mum, well he married her didn't he?! Didn't he?!!

The scene closes with Seales angrily kicking a can and walking away from Thackeray to continue his unhappy mental state, leaning against the playground wall. In other words, Seales does not leave the scene completely; he simply moves further down the wall, away from Thackeray's presence, giving the impression that he no longer wants to converse with him. Thackeray turns away, standing still for a moment, toward the exit of the schoolyard, and there is a close-up shot of him thinking deeply about what had just transpired. While thinking he nonchalantly swings his briefcase and the scene ends with him going on about his business.

The problem here is that James Clavell, the screenwriter/producer/director, leaves this important scene "hanging" out there for us to decipher. It is never pursued as a theme further, even though there is another return to Seales's character following the death of his mother. Yet what is stated in the scene described earlier reveals that Seales's mother is English and his father is like Thackeray, a black man, but he's bigger and younger than his black father. Moreover, Seales is depicted as psychologically maladjusted, confused, and angry with his father simply because he married his white mother. In fact, this is fundamentally a scene about self-hatred as this young man of black British

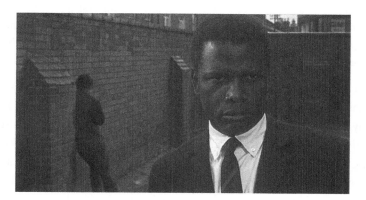

Figure 11 Poitier as Thackery reflects after his talk with Seales.

mixed heritage literally and inadvertently curses his birth, his existence, via the enmity he holds toward his black father. This is not a theme taken directly from the pen of Braithwaite, a black man. Rather, it is Clavell employing his white privileged artistic license as a screenwriter to depict the offspring of a black/white union as being psychologically dysfunctional and consumed with self-hatred. The hatred he feels for his father is pathological and unnerving.

In fact there is nothing particularly positive about Seales in the film in regard to racialized themes, other than his "quiet" respect for Thackeray, and this is merely in line with the other students' collective worldview after the inspirational teacher wields his magic in the classroom. Seales's character certainly does not stand out as a purveyor of racial harmony. It is a discordant and negative portrayal that is qualitatively at variance with the novel. One wonders why James Clavell felt it necessary to rewrite such pessimism into the psychological make-up of Seales. After all, this film's production and release was at the height of the civil rights movement, and Clavell was working with the top black actor in the world at this time. Indeed, to add to this, Poitier was also a friend and supporter to Dr Martin Luther King Jr. and the civil rights movement. On reflection, it is an odd subplot in this movie of ultimate uplift and sanguinity.

As with a number of fundamental rewrites, the film's character depiction of Seales is not that of the author's in the novel. In fact, there is little in the book about Seales other than what E. R. Braithwaite states when explaining the characteristics of selected students. The author's representation of Lawrence Seales is revealing, as he writes,

> He was a well-built dark-skinned boy obviously of mixed parentage named Seales, Lawrence Seales. He never spoke unless addressed directly, and though dressed in the same T-shirt and jeans uniform as his colleagues, he seemed somehow aloof, taking no part in their ribaldry; and yet he showed no willingness to be friendly with me either. He is quite bright and he read very well, but he remained a long, watchful distance from me. (63)

There is nothing in Braithwaite's novel that speaks to Seales being psychologically maladjusted as a person of black mixed heritage. Yes, he has the key trait of many inner city youth: not openly trusting those in positions of authority. Evidently, it is Seales's lack of confidence and aloofness that Braithwaite is alluding to in his teacher's assessment of him. There is no mention of a person with major psychological problems of self-hatred owing to his black British mixed heritage. No, this is something brought into the film by James Clavell.

This is a pivotal insight into the ways in which a screenwriter/producer/director's creative license can distort an original work. The fact that the original work is related to a black teacher's life in London is also curious. It would be interesting to know what Sidney Poitier thought of the Seales character as depicted in the novel, and then altered in the film version. There seems to be nothing specific on record relating to Poitier's knowledge of black Britain or racialized relations in the United Kingdom. This is a rather unfortunate oversight on the part of both the contemporary critics and those who have merely considered the movie as an upbeat teacher–pupil tale. There appears to be, lurking beneath the veneer of positivity, an insidious, possibly subconscious, racism on behalf of James Clavell's worldview and imaginative expression.

In contradiction to his depiction of the Seales character, Clavell is cited in the sleeve notes of the Columbia Pictures (1999) DVD version of the movie stating,

> Both Sidney and I felt that the story was sensational . . . [we] felt it had great social significance. In my opinion, it had added importance in the fact that for the first time the whole matter of integration and acceptance of the Negro became a world problem, and not just an American problem since the locale of the story was set in London.

It is inconsistent that James Clavell would state this, and yet put such a negative spin on racial integration in the movie. Indeed, why make Seales a dysfunctional human being consumed with inner hatred of himself and his father if he wanted to state something of great social significance in the movie? The perspective mentioned is contradictory to what evidently could be deemed the antimiscegenation worldview depicted in the movie. Yet, contemporary critics missed the significance of this subplot, or simply took it as a normative perspective. At the bottom line, the theme was not specific to the feel-good aspect of the movie and therefore did not get the critical examination it deserved. For writers like Marill to even miss the fact that Seales's mother was a white English woman and his father a black man of African Caribbean heritage is curious at the very least. It is an example of how minor this subplot was to the key theme of inspirational black teacher meeting rebellious working-class and largely white students in the rough East End of London education system.

Too often it is articulated that a specific film is simply an adaptation of a book, but without careful assessment of who is "adapting" the original, and in what sense, there can be an oversight of major significance. Another example of distortion relates to how Clavell produces this "hatred" between Seales and his

father. This again does not appear in the novel. In fact, the only mention of his father via Seales is due to the death of his mother. Braithwaite writes,

> On December 6th, Seales was not in his place and I marked him absent. Just before recess he came in and walked briskly to my table.
>
> "Sorry I can't stay, Sir, but my mother died early this morning and I'm helping my Dad with things."[2]

In the novel there is no hatred in Seales for his father, a black man. He is simply helping his dad with the funeral arrangements, no hate in his demeanor. Therefore the scene in the film where he exclaims to Thackeray, in regard to his father, "I hate him, I hate him!!" is again the creative invention of the white screenwriter/producer/director, James Clavell. Moreover, again unlike the novel, there is no major unfolding of why British race relations have the propensity to be so profoundly negative. What better way to make a social statement than to portray Seales as a well-balanced individual in harmony with both parents? Instead, we have a ridiculous psychological misfit moping around the school playground with no purpose or direction, and this is fundamentally due to his hatred of his father? It does not make sense logically in terms of a social comment for improving racialized relations. Clavell's British "colored" indigenous population is clearly marginalized and any white who associates with it is stigmatized—this is the social commentary or vision of Clavell.

Having researched the black experience in the city of Liverpool on the topic of black mixed heritage persons, I contend that Clavell has taken the stance of the racist rather than the antiracist.[3] To put it another way, Clavell's artistic approach to racialized relations in Britain is akin to it being a problem of black presence, not white racism. One could argue that the only positive antiracist perspective in the movie is when the students decide to collectively show up at Seales's home with flowers for the funeral. This follows from the debate in the classroom that ended negatively with the students initially deciding not to attend the funeral.

Some would suggest that the eventual outcome is significant, but if one considers the scene symbolically, the students are *outside* the home of Seales, standing by the hearse. When Thackeray walks around the corner he sees them standing in a group; there is only silence and a warm, a half-smiling expression that closes out the scene. That is the end of the racialized Seales' subplot. It is left to the audience to figure out the nuances of British racism. Evidently, for Clavell, the fact that the students had come to the home of Seales with a wreath is an

indication of racial progress? But what preceded the death of Seales's mother is left unresolved. There is no closure to his psychological maladjustment.

Yet, in the novel, on the contrary, racism is portrayed overtly by Braithwaite as a disease in British society—there is no sugar-coating or denial of its existence throughout the novel. There is reference to British colonialism, his experiences of not being able to gain employment opportunities in post–World War II Britain, and there is an interracial relationship, which we examine in greater detail later. Certainly, when Thackeray is informed that the white students are reluctant to take a wreath to the home of Seales due to the stigma of being near a "colored home," he appears shocked and hit by the reality of his blackness. Yet, the novel takes this situation far more deeply than the movie with Braithwaite writing as if the situation had broken his spirit, as he states,

> Their reaction was like a cold douche. The pleasantly united camaraderie disappeared completely from the room, and in its place was the watchful antagonism I had encountered on my first day. It was as if I had pulled a thick transparent screen between them and myself, effectively shutting us away from each other.

He continues,

> It was ugly to see; I felt excluded, even hated, but all so horribly quickly. . .
> All the weeks and months of delightful association were washed out by those few words.
> Nothing had really mattered, the teaching, the talking, the example, the patience, the worry. It was all as nothing. They, like the strangers on buses and trains, saw only the skins, never the people of those skins. Seales was born among them, grew up among them, played with them; his mother was white, British, of their stock and background and beginnings.[4]

Clearly, there is an underlining appeal in Braithwaite's novel for racial justice, and an open acknowledgment of the absurdity of British racism. His reference to Seales being "born among them" and "of their stock and beginnings" suggests that he is in fact just as British as his fellow white students. Therefore, the novel in this sense gives air to a common British identity among the students, no matter what their color and background, and hence racial equality is espoused. It offers a question regarding Seales and his experience: how can British society ostracize and marginalize "one of their own" in this manner? It is a theme throughout the novel, but virtually nonexistent in the film version. Clavell, at the very least, inadvertently upheld British racism by pandering to a rather

overt antimiscegenation theme. But, more than this, he left out crucial aspects of Braithwaite's book that could have made a profound social statement on racialized matters in the context of what he had earlier implied before making the film.

Apart from his racialized character assassination of Lawrence Seales, Clavell also turned a passionate interracial relationship between Mark Thackeray and his colleague Gillian Blanchard (played by Suzy Kendall), a blond woman, in the novel into a platonic one. Whereas the novel devotes quite some time to their relationship, the film keeps it minimalist and discreetly nonsexual. In the novel there is a chapter devoted to Mark Thackeray visiting with Gillian's parents and had it been included in the film it would have enriched its substance. Moreover, it would have stolen the thunder from one of Sidney Poitier's 1967 hits: *Guess Who's Coming to Dinner.* Instead, Clavell side-stepped what would certainly have been a controversial subplot by keeping Mark Thackeray a safe distance from Gillian, stimulating his or her libido.

When we consider that this movie is in the height of the 1960s' generational revolution it is rather staid, prim, and proper, to omit a theme of interracial love from a novel published almost a decade earlier. This gives a possible insight into either Clavell's mindset on the subject or his monetary concern in losing an audience for the film. Indeed, it appears that from the onset of production, the hierarchy in Columbia Pictures did not give the movie itself much hope in being successful.[5] In this sense it could be explained that Clavell was worried about box office potential in keeping a black man's sexuality, securely in its trousers, so to speak.

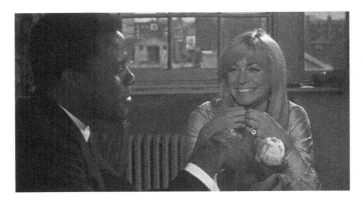

Figure 12 Thackery shares a moment with Miss Blanchard.

However, Clavell does deal with the matter of a white school girl, Pamela Dare (played by Judy Geeson), and her crush on Thackeray. Yet again, it is played out with such emasculation that we view Thackeray's character as this asexual being merely concerned with moral conduct. This is commendable in itself, but juxtaposed with the platonic relationship in regard to his colleague, Gillian, is it not a bit too much in denying the character his manhood—or masculinity? If one recalls the opening scene on the bus, one of the working-class cockney women alludes implicitly to Thackery's sexuality, but only as part of the jocular "banter" among the women. It is not a serious sexual encounter, but more of a phallic stereotyping.

Through the fact that Clavell has portrayed miscegenation as an abomination via Seales, it is easier to comprehend his asexual confinement of Mark Thackeray. To have the top box-office African American male restricted to asexuality was something beyond the power of Sidney Poitier himself. Too many critics have overlooked the power of a director to simply tell the story how he or she wants it to be told. The actor can protest, but most often, and ultimately, the power is out of his/her hands.

Much of Clavell's reluctance to deal head-on with interracial unions could have stemmed from his background and political persuasion. He had been a Japanese prisoner of war and inhumanely treated by them. Steeped in the values of British Empire, Clavell was an ardent capitalist and supporter of individualism. That stated, with his gallant war record, it is surprising why he left out the fact that Braithwaite had been a Royal Air Force veteran of World War II Britain, as one of the British Guyana colonial forces aiding the mother country. With his war efforts in common with Braithwaite, one wonders why Clavell found it necessary to write it out of the screenplay.

When one digs deeper into the production and artistic development of the *To Sir, with Love* screenplay, and its writer, there is much contradiction. In hindsight, it must have come down to "protecting" the movie as a financial product and therefore not wanting to step on a racialized minefield. Indeed, British colonialism embedded a hierarchy of racialized heritage within and beyond its borders, and one should keep this in mind when analyzing Clavell's lack of empowerment toward developing a black British perspective in the movie. There was much rich contextual material at hand to the screenwriter due to the growing black presence in Britain, which was evident with the overt racism in British politics during the 1960s and the rhetoric of the avowedly racist politician Enoch Powell.[6]

In reading the two autobiographies—*This Life* (1980) and *The Measure of a Man* (2000)—and a semiautobiography—*Life Beyond Measure: Letters to My Great-Granddaughter* (2008)—by Sidney Poitier, one certainly gets an overall insight into his life, philosophy, and artistic works. Yet, surprisingly, he refers only briefly to his thoughts on *To Sir, with Love,* and even less when it comes to the racialized element. In his first autobiography, *This Life,* he alludes to getting to know the cast during the making of the film. He regarded them as a "microcosm of the United Nations, Mother England and the Commonwealth were amply represented among them."[7] Well, it is odd that he imagines that one black male of mixed heritage, another black female who does not say a word, and an Asian girl whose only task is to serve Mark Thackeray with his gift near the end of the movie as being representative of the United Nations. If there were more people of color when he was making the film in London, they were left on the cutting room floor. Nevertheless, *To Sir, with Love* cannot be viewed as a microcosm—representative of people of color, not only in Britain but also across the British Commonwealth. At best, it could be deemed only a physical sliver of what black presence represented in everyday British society in the mid- to late 1960s. Poitier goes on to state in this chapter what he considers to be a dire lack of opportunities in acting for British people of color based in London:

> The racial minorities such as the Pakistani, the Malaysian, the West Indian, the East Indian, the African, and the Chinese will unfortunately find very little opportunity for career building as actors and actresses in England, and the fact that a surprising number of them were born and raised in England added a touch of irony that I discovered was not lost on any of them. One young English man of brown skin invited me to his neighborhood to see a play written by a minority playwright that was being presented by the ethnic theater group of which he was a member. While the production was praiseworthy and the work by the cast quite professional I couldn't help thinking how frustrating it must be for them to be pouring themselves into a life of theater in a society where the dominant culture has no interest in, or little use for, their creative output. No, England in that respect was rather not very much better or worse than America.[8]

The insight of Sidney Poitier is quite revealing as he alludes to the dire reality of black British experience when it came to gaining a foothold into the acting business. But more than this, he relates to the postcolonial experience of indigenous black and Asian Britons. It would be interesting to know if the "young Englishman of brown skin" was actually Anthony Villareol who played Seales. Earlier, Poitier had recalled Lulu, Judy Geeson, and Christian Roberts

from the cast, but not Anthony Villareol, even in name. So again, an important aspect of black British film history is inadvertently lost to the major Oscar-winning black actor as he reflects on the film back in 1980. Moreover, he also attributes the success of the film to both the cast and to James Clavell, stating that he contributed "inspired direction" to the film.

It is disappointing that Sidney Poitier could not see the problematic depiction of Seales or, at least, comprehend the role from a black British perspective. How could a black actor become familiar with this novel, yet regard the film as inspired via the directorship of Clavell? Especially, from the insights of a man who worked closely with Dr Martin Luther King Jr. and his close friend Harry Belafonte during the civil rights movement era. What is even more ironic is that he opens up chapter 20 of *This Life* with a reflection of his friend Belafonte and their experiences in the civil rights movement, before moving on to his impressions of *To Sir, with Love* and his other successful movies in the late 1960s.

In Poitier's *The Measure of a Man* he recalls that his inspiration for the Mark Thackeray character was his former schoolmaster in Nassau. He speaks fondly of him in this manner,

> His name was Mr. Fox, William Fox. We called him Bill. Mr. Bill Fox, and he was magical. I learned more from him than virtually anyone. I drew heavily on him as a model for my character in *To Sir, with Love*.[9]

During a telephone conference with Sidney Poitier on February 25, 2010, at a special international film festival of scholars focusing on his body of works, at the College of the Bahamas, I was fortunate to ask him a question regarding Mr Fox being an inspiration for his role in *To Sir, with Love*. After some silence he began to speak of him rather emotionally but veered off the particular question. I also do believe that the mentioning of his former teacher, William Fox, choked him up a little. One could sense that he was thinking back to those days of old when he was in the classroom with Mr Fox. Again, this famous black actor is revealing a connection that is both related to the Mark Thackery role and the insight of a black teacher educated under British colonialism.

It is evident after talking to Sidney Poitier that he was profoundly inspired by his former teacher in developing the Thackery character in *To Sir, with Love*, and within the context of this is a person of integrity and commitment to his students. Yet, within the context of black Britain, the focus herein, there is something missing in that role. I do not want to be overly critical, as a key

theme of this chapter is also to explain the definite constraints on the actor in regard to the material in hand and the power given to him/her via a director. Too often this is overlooked when critical assessment is focused on Sidney Poitier the actor and his works. Nevertheless, having lived the black British experience for some 30-plus years in Liverpool, England, my approach to this movie, after reading a number of related works, is markedly different from most other critical reviewers. As such, the question of the integrity of British blacks and their experience in society is high on my antenna as a scholar when anything related to art form is considered via an analytical lens. In this sense, it is informative that the majority of Sidney Poitier film critics have also overlooked this obvious racialized mauling of the Lawrence Seales character and the black British experience in *To Sir, with Love*.[10]

Having starred in *Blackboard Jungle* (1955) as a delinquent, surly student, Sidney Poitier was well prepared for his role in dealing with blackness in the classroom. Albeit the difference was in the role and the location, he should have gained much insight into the minority experience in the dominant white working-class classroom via his work in *Blackboard Jungle*. Yet the Seales–Thackeray interaction does not reveal much in terms of a meaningful black mentor–mentee relationship. It is just not part of the script to turn this racialized aspect of the film into something more substantial. Again, this is not directly the charge of Sidney Poitier, who is employed as the actor to say words and act on the prompts of the director. This is fundamentally the reason why the film falls short in terms of offering a perspective on black Britain: it was not written into the script to be an empowering theme.

To conclude, the main aim of this chapter was fundamentally to tease out some key aspects of "hidden" black British themes and perspectives in *To Sir, with Love*. Most often the critics of the film have focused on the "teacher inspires unmotivated and unruly students" genre without calling attention to the theme of "race" in Britain. In some ways this is understandable as the black British experience is still a rather marginalized tale. It is a story that is embedded within the context of British history and culture, but only as a footnote. Therefore, this chapter has revealed something not ordinarily considered as considerable. That is, it is an anomaly to the usual critical comprehension of *To Sir, with Love*. Arguably, it is the black mixed heritage male student, Seales, who offers a weaving plethora of problematic associations that encapsulate the embryonic "postcolonial" black British experience in the 1960s, and the presence of blacks in British society is viewed as a problem.

Largely overlooked by critics, the screenwriter/producer/director James Clavell jumped a decade ahead of the novel's original time frame and this is the onset of a significant departure from Braithwaite's original work. Certainly, Clavell took many liberties with certain aspects of the novel that both distort and undermine the moral message that Braithwaite's novel appears to reveal. For example, Clavell refused to deal with the passionate interracial element in the novel. Moreover, he clearly depicted Seales as a psychological misfit imbued with self-hatred and antipathy toward his black father. One is perplexed as to why he did this given his implied objective of wanting to create an uplifting social message in the film. At the bottom, from a black British perspective, the film is rather depressing and leaves one with a distinct unease when considered from the point of view of multiracial identity.

Overall, one should not overly criticize Sidney Poitier for the distortions or selectively negative black British portrayal. However, in examining Poitier's success in 1967, at the height of the Black Power Movement in the United States, one can argue for and against his stature as a mainstream icon. The fact remains that Sidney Poitier changed the way people viewed black masculinity, and his impact at the time was powerful due to his grace and poise as an actor. But in terms of his sexuality and connection to black Britain, it is void of authenticity mainly due to the shackles he was confined in artistically. Crucially, the obvious weaknesses and negative representations of black Britain in *To Sir, with Love* should rightly be laid at the feet of the film's "inspired" screenwriter/producer/director, James Clavell.

Notes

1 Alvin H. Marill, *The Films of Sidney Poitier* (New Jersey: The Citadel, 1978), 143.

2 E. R. Braithwaite, *To Sir, with Love* (London: Coronet Books, 1993), 168.

3 Mark Christian, *Black Identity in the 20th Century: Expressions of the US and UK African Diaspora* (London: Hansib, 2002); Mark Christian, "The Fletcher Report 1930: A Historical Case Study of Contested Black Mixed Heritage Britishness." *Journal of Historical Sociology* 21 (2008): 213–41; Mark Christian, "Mixing Up the Game: Social and Historical Contours of Black Mixed Heritage Players in British Football," in Daniel Burdsey (ed.), *Race, Ethnicity and Football: Persisting Debates and Emergent Issues* (London: Routledge, 2011), 131–44; Mark Christian, *Multiracial Identity: An International Perspective* (New York: St. Martin's Press, 2000).

4 E. R. Braithwaite, *To Sir, with Love*, 169–70.

5 Sidney Poitier, *This Life* (New York: Ballantine, 1980), 279.

6 See Ambalavane Sivanandan, *A Different Hunger: Writings on Black Resistance* (London: Pluto, 1982); Paul Gilroy, *There Ain't No Black in the Union Jack* (London: Routledge, 1987); Mark Christian, "The Politics of Black Presence in Britain and Black Male Exclusion in the British Education System." *Journal of Black Studies* 35 (2005): 327–46.

7 Sidney Poitier, *This Life*, 280.

8 Ibid., 281.

9 Sidney Poitier, *The Measure of a Man: A Spiritual Autobiography* (New York: Harper Collins, 2000), 187.

10 See William Hoffman, *Sidney* (New York: Lyle Stuart, 1971); Daniel J. Leab, *From Sambo to Superspade: The Black Experience in Motion Pictures* (Boston: Houghton Mifflin, 1975); Alvin Marill, *The Films of Sidney Poitier*, 1978; Lester Keyser and Andre Ruszkowski, *The Cinema of Sidney Poitier: The Black Man's Changing Role on the American Screen*, 1980; Paul Bogle, *Toms, Coons, Mulattoes, Mammies and Bucks* (New York: Continuum, 1992); Aram Goudsouzian, *Sidney Poitier: Man, Actor, Icon* (Chapel Hill: The University of North Carolina Press, 2004).

Bibliography

Bogle, Donald. *Toms, Coons, Mulattoes, Mammies and Bucks* (New York: Continuum, 1992).

Braithwaite, E. R. *To Sir, with Love* (London: Coronet Books, 1993).

Christian, Mark. *Multiracial Identity: An International Perspective.* (New York: St. Martin's Press, 2000).

—*Black Identity in the 20th Century: Expressions of the US and UK African Diaspora* (London: Hansib, 2002).

—"The Politics of Black Presence in Britain and Black Male Exclusion in the British Education System." *Journal of Black Studies* 35 (2005): 327–46.

—"The Fletcher Report 1930: A Historical Case Study of Contested Black Mixed Heritage Britishness." *Journal of Historical Sociology* 21 (2008): 213–41.

—"Mixing Up the Game: Social and Historical Contours of Black Mixed Heritage Players in British Football," in Daniel Burdsey (ed.) *Race, Ethnicity and Football: Persisting Debates and Emergent Issues* (London: Routledge, 2011), 131–44.

Gilroy, Paul. *There Ain't No Black in the Union Jack* (London: Routledge, 1987).

Goudsouzian, Aram. *Sidney Poitier: Man, Actor, Icon* (Chapel Hill: The University of North Carolina Press, 2004).

Hoffman, William. *Sidney* (New York: Lyle Stuart, 1971).

Keyser, Lester and Andre Ruszkowski. *The Cinema of Sidney Poitier: The Black Man's Changing Role on the American Screen* (New York: A. S. Barnes, 1980).

Leab, Daniel J. *From Sambo to Superspade: The Black Experience in Motion Pictures* (Boston: Houghton Miffin, 1975).

Marill, Alvin H. *The Films of Sidney Poitier* (New Jersey: The Citadel, 1978).

Poitier, Sidney. *This Life* (New York: Ballatine, 1980).

—*The Measure of a Man: A Spiritual Autobiography* (New York: Harper Collins, 2000).

—*Life Beyond Measure: Letters to My Great-Granddaughter* (New York: Harper Collins, 2008).

Selvon, Sam. *The Lonely Londoners* (London: Longman, 1987).

Sivanandan, Ambalavane. *A Different Hunger: Writings on Black Resistance* (London: Pluto, 1982).

"You'd be criminals!": Transgression, Legal Union, and Interracial Marriage in 1967 Film and Law

Kim Cary Warren

In the autumn of 2009, Terence McKay and Beth Humphrey, both citizens of the United States hailing from Hammond, Louisiana, asked to be married by a justice of the peace, Keith Bardwell. Justice Bardwell, who had been on the bench for 34 years, refused to marry them. Another judge performed the ceremony, and then the couple filed a federal discrimination lawsuit against Judge Bardwell on October 20, 2009, claiming violations against the Equal Protection Clause of the Fourteenth Amendment to the US Constitution. In the face of the suit and criticism from the public and Louisiana's governor Bobby Jindal, Bardwell resigned from his position. Reports say that the white judge and his white wife, Beth Bardwell, who often advised him, refused to marry the couple, simply because, according to Beth Bardwell, "We don't do interracial weddings."[1]

The bride, Beth Humphrey, who is white, confirmed in press statements that she was, of course, looking forward to married life with her new husband, Terence McKay, who is black; and she also stated that she could not believe that such discrimination could take place in modern times. Bardwell responded by reiterating that he was not a racist, but added, "I just don't believe in mixing the races that way. I have piles and piles of black friends. They come to my home; I marry them; they use my bathroom. I treat them just like everyone else."[2]

Keith Bardwell's refusal to marry Terence McKay and Beth Humphrey and the reasons behind his decision parallel concerns that arise in the 1967 Sidney

Poitier film, *Guess Who's Coming to Dinner*. Poitier plays John Prentice, a successful doctor who meets his future bride, Joey Drayton, in Hawaii. After a 10-day courtship, the couple flies to San Francisco to meet her parents and announce their engagement. The film establishes early on that Joey, who is white, has parents who are very liberal in their political and social thinking. However, they consider John's race—he is described in the film alternatively as "colored," "Negro," and "black"—or more specifically, the fact that his race and their daughter's race do not match, a difficulty. To emphasize that the central problem in the film is neither white supremacy nor racism, but rather a concern about race mixing, John's parents (played by Roy Glenn and Beah Richards) meet their son's fiancée and are also shocked to learn that she does not share the same race as their son. "They think you're colored," John whispers to Joey just before the moment they discover that she is not.

What I argue in this chapter is that *Guess Who's Coming to Dinner*, and especially Sidney Poitier's role as Dr John Prentice, provide important portals into the ways that the American public viewed interracial marriage in 1967, the year that the US Supreme Court decided that state laws prohibiting mixed-race unions were unconstitutional. More to the point, I argue that the film is less about racial tensions in 1960s America and more about the limits of racial tolerance that liberally minded white and black Americans possessed. Just as Judge Bardwell's statement reveals the limits of his sense of tolerance—"They come to my home . . . they use my bathroom" which he states with a tinge of self-approving liberalism—*Guess Who's Coming to Dinner*, or specifically the impending possibility of an interracial marriage, highlights the edges of tolerance with regard to the acceptability of racial mixing that both the Drayton and Prentice families embrace. Although the film pivots around John Prentice and the way he is perceived by Joey's parents, it is important to keep in mind that *both* sets of parents are equally distressed when learning of the upcoming marriage. The parallels continue as the film unfolds, showing both mothers allowing their children's love to trump their racial differences, while also revealing both fathers as increasingly troubled. Both fathers believe that a marriage between their children will bring them criticism and potential violence, but John's father is particularly concerned that his son will be considered a criminal in states that still have antimiscegenation laws on their books. Framed by a historical discipline, this chapter anchors *Guess Who's Coming to Dinner* in the context of the changes in marriage laws that were dramatically taking place in 1967 in the United States.

Liberal proponents of equal rights face their challenge

By way of historical background, it is important to note that in 1960s San Francisco, interracial marriage was legal (both in the film and in reality), and yet interracial marriage was still considered a transgression or at least socially challenging in a country burdened with struggles around racial categories, the meaning of race, and the concept of race mixing. The issue of interracial marriage was so fraught with concern that even those considered allies to civil rights issues could not be depended upon to enthusiastically support the cause. A case in point in *Guess Who's Coming to Dinner* is the portrayal of Joey's parents, Christina and Matt Drayton, played by Katharine Hepburn and Spencer Tracy in their ninth and final film partnership. Stanley Kramer, the film's producer and director, and William Rose, the film's writer, present the Draytons as probable (albeit grudging) allies to their daughter's union and strong supporters of civil rights. It is Christina who reminds her husband, "We told her it was wrong to believe that white people were somehow essentially superior to black people or the brown or the red or the yellow ones, for that matter. . . . People who thought that way were wrong to think that way—sometimes hateful, usually stupid, but always wrong." Matt is described by his daughter as a "lifelong fighting liberal who loathes race prejudice and has spent his whole life fighting against discrimination." Yet, Matt Drayton's longtime friend, Monsignor Ryan, jokes about him that he has always believed "that in that fighting liberal façade there must be some sort of reactionary bigot trying to get out." Since the Draytons are otherwise painted as passionate civil rights advocates, those revealing statements make it clear that the film's focus is

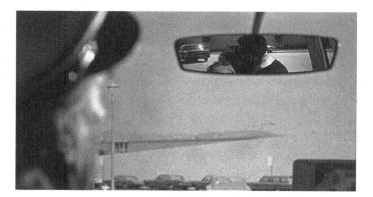

Figure 13 The lovers share a kiss visible only in the rearview mirror.

less about racial prejudice and more about the tensions of 1960s race mixing, or more specifically, the limits of racial tolerance.

The fact that *Guess Who's Coming to Dinner* debuted in the same year that the US Supreme Court decided *Loving v. Virginia*, the case that overturned laws prohibiting interracial marriage, cannot be overlooked. The 1967 court docket included rulings on arbitration, labor, privacy, shipping, and obscenity, and in *Walker v. City of Birmingham*, it upheld, five to four, the contempt of court convictions of the Rev. Martin Luther King Jr. and seven other African American leaders who violated a temporary restraining order to lead desegregation protest marches in Birmingham, Alabama, in 1963.[3] On April 10, 1967, the court also heard arguments in the *Loving* case that would, as one reporter put it, "set the stage for a historic ruling on the last vestige of 'Jim Crow' legislation to survive in the South."[4] That same spring, the final scenes of *Guess Who's Coming to Dinner* were filmed just 10 days before Spencer Tracy's death on June 10, 1967; the court made its decision 2 days later on June 12, 1967.

Laws prohibiting marriage between whites and nonwhites reached back nearly 300 years in US history. In 1786, Thomas Jefferson, whom many scholars believe had fathered children with his biracial slave, Sally Hemings, drafted a bill for the state of Virginia that prohibited marriage between free and enslaved people. But it was more than a century before that when the 1630 *Re Davis* case recorded the first court decision that focused on sexual relations between people of different racial backgrounds.[5] In the seventeenth century, Virginia passed the first miscegenation law in 1691, declaring that "whatsoever English or other white man or woman being free shall intermarry with a negroe [*sic*], mulatto, or Indian man or woman bond or free shall within 3 months after such marriage be banished and removed from this dominion forever."[6] The efforts of American colonists to legally prevent sexual and martial unions between people of different racial backgrounds point to their anxiety about racial mixing. Throughout US history, 41 states enacted laws that prohibited marriages between whites and African Americans, as well as groups defined as Malayan, American Indian, Chinese, Japanese, Korean, Asian Indian, mulatto, Ethiopian, Hindu, mestizo, and half-breed.[7] A few states had even banned marriages between African Americans and other nonwhite groups, but as historian Werner Sollors notes, "*all* such laws restricted marriage choices of blacks and whites, making the black-white divide the deepest and historically most pervasive of all American color lines."[8]

Keeping in mind the civil rights activities of 1967 and the turmoil that awaited Americans in 1968, it is imperative to understand that racial tension in

the United States was not isolated to the South. Sixteen states, including Indiana and Wyoming, still had antimiscegenation laws on their books before the 1967 Supreme Court decision.[9] Fred Graham, a reporter for the *New York Times*, predicted the decision in the *Loving* case, calling it a "foregone conclusion" that the remaining state laws were unconstitutional "and the high Court will probably take the case and strike them down."[10] Graham cites as support for his prediction a 1964 case in which the court struck down a Florida law making it a crime for persons of different races to cohabit because the law denied the defendants equal protection of the laws guaranteed by the Fourteenth Amendment.[11] However, 5 years earlier an African American man and white woman were arrested for violating miscegenation laws in Florida, so the public might not have been as convinced as Graham of the Supreme Court's stance.[12]

Similar doubts are represented in *Guess Who's Coming to Dinner* by the Prentice and the Drayton parents, who not only harbor concerns about interracial marriage as a social transgression, but also fear that their children's marriage would be considered illegal. John's father (only referred to in the film as "Mr. Prentice"), tells his son that he should not marry Joey because "in 16 or 17 states, you'd be breaking the law. You'd be criminals!" Joey's father, Matt Drayton, expresses similar concerns about his daughter: "I'm only thinking only of Joey's welfare." He further admits, "I have nothing against Prentice personally, but he's a grown man and he behaved irresponsibly in the first place by letting this thing happen. Now he wants me to be happy about a situation when I happen to know that they'll both get their brains knocked out." Matt goes on to accuse his own wife of being so wrapped up in the emotional excitement of the engagement that she has failed to act in the best interest of their daughter. The scene concludes with Matt walking upstairs alone and Christina walking by herself through their empty apartment to the terrace. Orange and yellow hues clearly mark the end of the day as the Sun sets behind the Golden Gate Bridge and Christina's eyes fill with tears. Viewers do not know, however, if the tears represent disappointment because her husband has revealed the limits of his liberalism or if they reveal her sadness because of the truth in his words.

Loving v. the Commonwealth of Virginia

In 1967, at the same time that John and Joey struggled on film about their engagement, Mildred Jeter Loving and Richard Loving fought to maintain

the legality of their marriage. In June of 1958, Mildred (an African American woman) and Richard (a white man) got married in Washington, DC, where no laws prohibited their interracial marriage. That same year, they moved to Virginia, where the Racial Integrity Act of 1924 banned marriage between whites and nonwhites. Local police officers entered their home to arrest the couple. The Lovings pled guilty to felony charges in hopes of avoiding a jail sentence of 1–5 years. Indeed, Judge Leon M. Bazile allowed for a suspended, 1-year sentence on the condition that they leave the state of Virginia. Bazile invoked polygenesis race theory when he argued, "Almighty God created the races white, black, yellow, malay and red, and he placed them on separate continents. . . . The fact that he separated the races shows that he did not intend for the races to mix."[13] After Richard and Mildred Loving moved back to the District of Columbia, the American Civil Liberties Union (ACLU) picked up their case. The ACLU joined forces with the NAACP in order to argue the case through the Virginia Court of Appeals in 1965 until it arrived on the Supreme Court's docket.

What was at stake for the Lovings, lawyers from the ACLU argued, was that without the benefit of a nationally recognized marriage, they "would not be able to inherit from each other; their three children, would be deemed illegitimate; they could lose Social Security benefits, the right to file joint income tax returns and even the right to workmen's compensation benefits—all of which are contingent upon a valid marital relationship."[14] Lawyers for the Lovings compared antimiscegenation laws to laws of Nazi Germany and apartheid-era South Africa stating, "They are slavery laws, pure and simple—the most odious of the segregation laws."[15] Attorneys for the Commonwealth of Virginia countered that individuals entering interracial marriages were often "rebellious" and that they used marriages to "express their social hostility."[16]

Ultimately, the Supreme Court ruled unanimously in favor of the Lovings because of the equal protection that the Fourteenth Amendment afforded. Chief Justice Earl Warren summarized the decision by writing, "There can be no doubt that restricting the freedom to marry solely because of racial classifications violates the central meaning of the Equal Protection Clause." In addition, the Warren Court determined that the right to marry was a civil right that the Fourteenth Amendment protected: "[T]the freedom to marry, or not marry, a person of another race resides with the individual and cannot be infringed by the State."[17] States could no longer enforce laws that banned marriage based on race.

From a cultural standpoint, the *Loving* decision chipped away at hundreds of years of American history that often equated sex and marriage between white women and black men with illicit sex and criminality. Historian Martha Hodes notes that such anxiety hit a particular height after the Civil War and especially in the Jim Crow era when violence against African American men increased along with allegations of rape against white women.[18] Those allegations were mostly unfounded, as antilynching crusader Ida B. Wells argued in speeches and in her 1892 pamphlet "Southern Horrors: Lynch Law in All Its Phases." Yet, across the nation, between 1880 and 1930, there were 3,320 lynchings of black people with particularly heavy violence in the 1890s. Only twice did the number of annual lynchings drop below 100 during the 1890s.[19]

History of miscegenation in the United States

The 1967 *Loving v. Virginia* decision brought an end to a long and national history of legal discrimination against interracial marriage that historian Peggy Pascoe so carefully documented. The term "miscegenation" was first coined during the 1860s in the United States, but laws prohibiting marriage between people of different races had earlier origins and were never contained to the South. Indeed, states such as Maine, Rhode Island, Michigan, Illinois, Ohio, California, Nebraska, and Washington allowed for miscegenation laws, and so did the Southern states. "By the end of the nineteenth century," Pascoe writes, "the laws had spread to cover nearly all the states of the U.S. West, where state legislators made it their business to name several racial groups, including Chinese, Japanese, Filipinos, American Indians, native Hawaiians, and South Asians as well as Blacks and Whites." Miscegenation laws, then, became a state-sanctioned strategy to ensure "the larger racial projects of white supremacy and white purity."[20]

Laws legislating marriage for Native Americans, Asian Americans, Mexican Americans, African Americans—among each other and with white Americans—varied in their severity throughout the United States. In addition to laws created by legislators, individual judges and marriage clerks who thought negatively of interracial marriage created another layer of prohibition when they simply refused to issue necessary paperwork or licenses. Antimiscegenation "was woven into the fabric of American law and society." In fact, between the 1860s and the 1960s, Americans did not recognize their opposition to interracial marriage

as a political stance. Instead, they saw their opposition as completely "natural." Framing their views as natural made it easier to rationalize ideologies of white supremacy and expand into a sense of justification for racial discrimination in general.[21]

By the twenty-first century, Americans had changed their views about the acceptability of interracial marriage. Of those polled, 96 percent of African Americans and 84 percent of whites said that they approved when asked about marriage between blacks and whites.[22] These numbers were much higher than in the 1960s, the period in which *Guess Who's Coming to Dinner* was made. At that point, white Americans were largely opposed to interracial marriage at a rate of 75 percent according to a 1968 poll. On the other hand, African Americans approved of interracial marriage at a rate of 56 percent, while 33 percent disapproved.[23] Despite the Supreme Court's decision in 1967, social opposition to intermarriage continued for years—and in the case of at least one Louisiana judge, opposition persists into the present day. In the film, although Joey and John's marriage may have been legal according to California state law—and then by national law by the time the film was released—many Americans would have agreed with the couple's fathers by viewing their engagement as a social transgression.

Guess Who's Coming to Dinner certainly highlights the anxieties of a 1960s culture coming to grips with a rapidly changing society, but in many ways, the film also avoids making a stand-in favor of interracial marriage in the United States by portraying John and Joey not so much as Americans or Californians, but as citizens who have a more transcontinental or global identity. The opening sequence focuses on the landing of Joey and John's flight from Hawaii to San Francisco, and the timeline of the film is dictated by the Draytons' need to get dinner on the table so that Joey and John can catch their evening flight to Geneva by way of New York. John and Joey are just "passing through," as John makes clear at the beginning of the film. John even reassures the housekeeper, Matilda "Tilly" Banks (played by Isabel Sanford), that his bags do not need to be taken upstairs because he is not planning to stay at the Drayton house for very long. The couple is, therefore, temporal and transient on US soil. Although they are both Californians by birth—John is from modest origins in Los Angeles and Joey hails from more affluent beginnings in San Francisco—the film divorces them from their American heritage. The couple first meets in Hawaii, a state geographically disconnected from the continental United States, and they are on their way to the symbolically and politically neutral country of Switzerland,

where they will begin their life together with John working for the World Health Organization. Although John's medical degree was earned at the notable Johns Hopkins University, and he had brief work experiences at the prestigious Yale University, his medical practice, the film makes clear, has already taken him to Europe, including to the London School of Tropical Medicine and to Belgium, where his first wife and child were tragically killed. John's work will undoubtedly continue to focus on health care and reform at an international level, as Matt explains to Monsignor Ryan:

> It's the damnedest thing you ever heard of. They put a whole medical school on trucks. Then they run into some African country . . . pick up the brightest native kids—hundreds at a time—and put them through courses just like they do the U.S. Army Corpsmen. Only his idea is that they're all specialists. You know, each one trained to do one simple thing . . . like sewing up a wound or delivering a baby or what have you. They go into places where people have never heard of an aspirin tablet . . . let alone a doctor. Imagine what that means. For every thousand kids they train, they can save a million lives a year.

In response, Monsignor Ryan observes, "He seems to have made quite an impression on you." To that Matt quietly admits, "Yeah."

In that scene, the audience learns that the length of the film might not provide enough time to list each of John's extraordinary achievements and plans for his future. In fact, critics often claimed that Stanley Kramer created an unrealistically perfect character in John Prentice. The casting of Sidney Poitier, a box office star by 1967 with three successful movies in 6 months, made the public view both Poitier and his characters as consistently noble, altruistic, and pacifist.[24] Poitier portrays John Prentice as an obviously worthy partner for Joey Drayton, but more importantly, Poitier's performance convinces viewers that John's work is too vital to humanity to be isolated in the United States. Several countries require his skills in international health. Joey, young and aimless, is in an ideal position to follow him wherever he goes. With this professional dynamic in mind, viewers are reassured that John does not need to marry Joey to gain access to her family's fortune.

Viewers are also reassured that John and Joey will place their family in global, multicultural environments that are already multiracial. Concerns about how John and Joey would be treated in the United States—possibly as criminals in 16 or 17 states, John's father claims—are allayed because the couple has no plans to reside in America. The Drayton–Prentice marriage will develop in a global

arena rather than in an American one. "This couple, then, is meant to represent an alternative to U.S. racial ideology, which of course includes the historical prohibition of sexual relations between black men and white women," Andrea Levine argues.[25]

The positioning of John and Joey as global citizens would have assured 1960s viewers that the marriage will take place, be consummated, and likely produce mixed-raced children outside of the United States, therefore avoiding challenges to Americans' norms or increasing their anxieties. Vernon Scott, a journalist for the *Chicago Defender*, made this point clear in 1967, when he applauded Stanley Kramer for making positive statements about interracial marriage in *Guess Who's Coming to Dinner*, but he also critiques the film's limits of racial tolerance by never showing John and Joey in any particularly passionate embrace: "Prudently or otherwise [Kramer] scrupulously avoided any outright love scene between the black man and the white girl."[26] By avoiding the possibility of interracial sex on American soil, Kramer essentially relieved his audiences of the duty of figuring out which states Mr Prentice was referring to when he mentioned antimiscegenation laws. Additionally, John and Joey's roles as global citizens allowed Kramer to avoid a direct challenge to the Motion Picture Production Code, adopted in 1930 and abandoned in 1968, that effectively banned interracial marriage and sex on the screen.

Despite the director's strategic decisions to sanitize the Prentice–Drayton engagement, Southerners still raised initial reservations and protests. Some local cinemas refused to show the film, for example. That was the case in Beah Richards' hometown of Vicksburg, Mississippi, so she traveled to Jackson

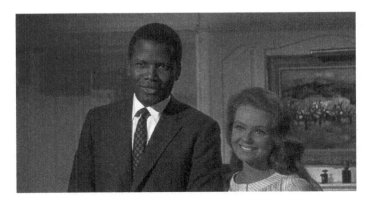

Figure 14 John Wade Prentice is introduced by his fiancée.

in order to watch her own performance on the big screen. Predictably, the Ku Klux Klan planned rallies and briefly considered some attacks on theaters, but eventually *Guess Who's Coming to Dinner* found success throughout the country, even in Southern states.[27]

In the film, Joey's parents, future in-laws, and fiancé struggle over the idea of an upcoming union, but Joey minimizes their concerns, claiming that she wants to live in a "color-blind" world. John views her suggestion as innocent and naive: "It's not just that our color difference doesn't matter to her. It's that she doesn't seem to think there is any difference." Joey—the only character in the film who can totally ignore racial differences—probably has little credibility for viewers on this front. She is more innocent than practical, too sanguine at times, and perhaps even unrealistic; but when imagining the global lifestyle that her doctor-fiancé has planned for them, viewers can seriously consider the kind of optimistic world that Joey believes already exists.

After the 1967 *Loving* decision, however, the United States did not become color-blind, as Joey would have had it. Indeed, days after the court's decision, a couple, Herman McDaniel Jr., an African American man, and Joyce Christine Prescott, a white woman, married in Nashville on July 22, 1967, marking the first legal interracial marriage in Tennessee's history. Television and newspaper crews looked on and reported that the state Attorney General had informed a reluctant county clerk that he would have to issue a marriage license to the couple since there was no longer a prohibition.[28] Despite this interracial marriage victory in Tennessee, many states were slow to enforce the Supreme Court's ruling and took years to repeal their existing laws.[29] Alabama did not officially change the language about interracial marriage in its constitution until 2000.

Still, much has changed with the rates of interracial marriages in the United States. In the 33 years between 1967 and the end of the past century, the rate of interracial marriages increased from 0.7 to 5.4 percent of all American marriages, and the total number of interracial marriages increased from 300,000 to 3.1 million.[30] Marriages between whites and African Americans were still the most infrequent in 2000, but marriages like John and Joey's grew in number from 51,000 in the 1960s compared to 416,000 in 2003.[31] In 2010, the numbers grew to approximately 7 percent of opposite-sex, married, interracial couples (5.4 million) in the United States. African Americans were three times more likely to marry white spouses than in 1980. The Census Bureau also recorded that in 2010, 18 percent of heterosexual, unmarried couples were interracial. In 2010, 21 percent of same-sex couples considered themselves interracial.[32]

In 1967, lawyers for the Commonwealth of Virginia argued that "the progeny are the martyrs" of interracial unions and contended that the state had a legitimate interest in preventing an increase in this demographic of the population.[33] The Kentucky Supreme Court had taken that position a year earlier when it took custody away from a white mother of five children who had been fathered by her ex-husband, a white man. After she divorced him and remarried an African American man, the court made no direct reference to the race of the mother's second husband, but instead cited the couple's home environment "a predominantly Negro apartment" with "three interracial couples living in the building." The judge ruled that "rearing these children in a racially mixed atmosphere per se indoctrinates them with a psychology of inferiority."[34]

Even in Louisiana in 2009, Keith Bardwell defended his decision not to marry the interracial couple, Terence McKay and Beth Humphrey, by saying that in the case of an interracial couple, "My main concern is for the children." Despite these concerns, the increase in interracial unions in the United States has led to an increase in the number of multiracial offspring. The census began collecting data on multiracial individuals in 1990, so it does not have an exact measure of change over a long period of time. However, it has accounted for the number of children living in mixed-race families and maintains that it has increased since 1970 when the total number of mixed-race families was 460,000. Within 10 years, the number reached 996,070, and in 1990, it increased to almost 2,000,000.[35] Organizers of the Loving Decision Conference noted that the 2000 census counted 3,000,000 interracial marriages. On the fortieth anniversary of the *Loving v. Virginia* decision, when nearly 7,000,000 Americans identifying themselves with multiple racial backgrounds and heritages, the organizers decided to expand their own conference to include what they called "interracial" couples, "multiracial/ethnic" individuals, and "transracial" adoptees.[36]

Chasing Daybreak, a 2006 documentary film supported by the MAVIN Foundation, an interracial-advocacy organization, highlighted what it considered "America's multiracial baby boom" by chronicling the "Generation MIX National Awareness Tour," consisting of 10,000 miles, a 26-foot RV, and 5 young adults of various racially mixed backgrounds.[37] The film's producer, Matthew Kelley, comments on the importance of the film by pointing to the fact that there have been mixed-race people for generations, but in the twenty-first century, the first critical mass of adamantly multiracial people exists in America.[38] Scholarship on interraciality, hybrid identity, and mixed-raced experiences in history and literature has proliferated. In the case of the offspring of black–white unions, scholar Naomi Pabst explains, "Endless and passionate debate on how to situate

black/white interraciality has penetrated the realms of legal classification, census taking, and grassroots movements, as well as . . . the discursive, the ideological, and the popular."[39] For the first time, the 2000 census allowed individuals to check multiple boxes when declaring their racial category(ies), thereby undoing some of the invisibility of multiracial people that previous census forms had created.[40] However, the census is still limited in its accounting. For example, President Barack Obama has publicly pointed to his multicultural roots, but when he self-identified on the 2010 census, he only chose the category of African American. Some viewed his singular choice as a way of avoiding political and social disturbances, while others felt disappointed that he did not seize the moment to declare on the census what many multiracial Americans had been waiting for years to do. Others defended his choice, including Michelle Hughes, president of the Chicago Biracial Family Network, who registered her regret but also commented, "I think everybody is entitled to self-identify."[41] Just as self-identifying poses limits to population accounts, it is also important to consider what categories continue in obscurity, or as historian David Roediger puts it, "We simply do not know what racial categories will be in 2060."[42]

In 2009, when asked about the events in Louisiana surrounding the judge's refusal to marry a black man and white woman, a press agent for President Barrack Obama told the Associated Press: "I've found that, actually, the children of biracial couples can do pretty good."[43] While the film *Guess Who's Coming to Dinner* cannot be considered prophetic about President Barack Obama's election in 2008, it is interesting to note the similarities between the film and real life. As Matt Drayton finally concedes that he should give his approval for Joey and John's engagement, he and John ponder the future of their mixed-race children. In his response to Matt's concerns, Sidney Poitier's character shares his support for Joey's belief that the offspring of an interracial couple who met in Hawaii in the 1960s would someday be president of the United States with "colorful administrations."

Notes

The author dedicates this essay in honor of the life and work of historian Peggy Pascoe, who was an intrepid pioneer in so many ways. Much appreciation goes to Giselle Anatol, Tami Albin, Sherrie Tucker, Shana Bernstein, Allison Varzally, Angie McEnany, and Regan Harker, who made various and important contributions to this project.

1 "Louisiana Justice Who Refused Interracial Marriage Resigns," *CNN*, November 3, 2009. Accessed 26 January 2010, http://www.cnn.com/2009/US/11/03/louisiana. interracial.marriage/index.html.

2 "Interracial Couple Denied Marriage License by Louisiana Justice of the Peace," *The Huffington Post*, October 15, 2009. Accessed January 26, 2010, http://www. huffingtonpost.com/2009/10/15/interracial-couple-denied_n_322784.html.

3 "Summary of Actions Taken by the Supreme Court," *New York Times*, June 13, 1967.

4 "Supreme Court Agrees to Rule on State Miscegenation Laws," *New York Times*, December 13, 1966.

5 Helen Tunnicliff Catterall (ed.), *Judicial Cases Concerning American Slavery and the Negro*, 5 vols. (1926; reprint, New York: Octagon Books, 1968), 1–77. Also see http://memory.loc.gov/ammem/awhhtml/awlaw3/slavery.html

6 Act XVI, "*Laws of Virginia*, April 1691" in William Waller Hening, *Hening's Statutes at Large*, Vol. 3 (Philadelphia: Thomas Desilver, 1823), 87. This section of the law with its amendments remained in force until 1967.

7 Fred P. Graham, "The Law: Miscegenation Nears Test in High Court," *New York Times*, March 13, 1966; Martha Hodes, *White Women, Black Men: Illicit Sex in the 19th-Century South* (New Haven: Yale University Press, 1997), fn 1, 213.

8 Werner Sollor, "Introduction," in Werner Sollor (ed.), *Interracialism: Black-White Intermarriage in American History, Literature, and Law* (New York: Oxford University Press, 2000), 3–4; Graham, "The Law," March 13, 1966.

9 Hodes, *White Women, Black Men*, fn 1, 213.

10 Fred P. Graham, "The Law: Supreme Court Previewed: A Quieter Year Ahead," *New York Times*, October 2, 1966.

11 Ibid.

12 Peggy Pascoe, *What Comes Naturally: Miscegenation Law and the Making of Race in America* (New York: Oxford University Press, 2008), 247.

13 Bazile quoted in Sollors, "Introduction," 7.

14 Lawyers for the Lovings quoted in Pascoe, *What Comes Naturally*, 276.

15 Fred P. Graham, "Marriage Curbs by States Scored," *New York Times*, April 11, 1967.

16 Ibid.

17 Earl Warren, Opinion of the Court, Supreme Court of the United States, *Loving v. Virginia*, No. 395, Argued: April 10, 1967, Decided: June 12, 1967.

18 Hodes, *White Women, Black Men*, 1.

19 Kim Cary Warren, *The Quest for Citizenship: African American and Native American Education in Kansas, 1880–1935* (Chapel Hill: University of North Carolina Press, 2010), 101.

20 Pascoe, *What Comes Naturally*, 6.

21 Ibid., 1.

22 The language in the poll changed from the first time Americans were asked about the subject. In 1958, the wording included ". . . marriages between white and colored people," and between 1968 and 1978, the wording included ". . . marriages between whites and non-whites." See Jeffrey M. Jones, "Record-High 86% Approve of Black-White Marriages," Gallup, September 11, 2011. Accessed August 30, 2013, http://www.gallup.com/poll/149390/record-high-approve-black-white-marriages.aspx.

23 Pascoe, *What Comes Naturally*, 292–4.

24 Andrea Levine, "Sidney Poitier's Civil Rights: Rewriting the Mystique of White Womanhood in *Guess Who's Coming to Dinner* and *In the Heat of the Night*." *American Literature* 73 (2001): 381.

25 Ibid., 367.

26 Vernon Scott, "Kramer's Latest Film Also Has a Message," *Chicago Daily Defender*, December 13, 1967.

27 Mark Harris, *Pictures at a Revolution: Five Films and the Birth of a New Hollywood* (New York: Penguin Press, 2008), 375.

28 "Negro and White Wed in Nashville," *New York Times*, July 22, 1967.

29 Pascoe, *What Comes Naturally*, 290.

30 Ibid., 295–6.

31 Ibid.

32 "Interracial Marriage Rising but Not as Fast," *CBS News*, May 26, 2010. Accessed July 16, 2010, http://www.cbsnews.com/stories/2010/05/26/national/main6520098.shtml; Daphne Lofquist, Terry Lugaila, Martin O'Connell and Sarah Feliz, "Households and Families: 2010, Census Brief." (U. S. Census Bureau, 2012), 18.

33 Graham, "Marriage Curbs by States Scored."

34 "N. A. A. C. P. Fighting Custody Award," *New York Times*, 10 July 1966.

35 "Questions and Answers for Census 2000 Data on Race," March 14, 2001. Accessed July 20, 2010, http://www.census.gov/census2000/raceqandas.html.

36 "Over 10 Million Americans and Growing: The Multiracial Community Commemorates 40 Years of Legal Interracial Marriage," May 2007. Accessed 20 July 2010, http://www.lovingconference.com/press/LDCNov06.pdf.

37 Chasing Daybreak, Accessed July 20, 2010, http://www.chasingdaybreak.com/.

38 Naomi Pabst, "Black and White and Read All Over," *The Village Voice*, January 24, 2006. Accessed February 2, 2010, http://www.villagevoice.com/2006-01-24/news/black-and-white-and-read-all-over/.

39 Naomi Pabst, "Blackness/Mixedness: Contestations over Crossing Signs." *Cultural Critique* 54 (2003): 179.

40 The category "mulatto" was taken off of the United States Census for the 1920 count.

41 Hughes quoted in Oscar Avila, "Obama's Census-Form Choice: 'Black,'" *Los Angeles Times*, April 4, 2010.

42 David R. Roediger, *Colored White: Transcending the Racial Past* (Berkeley: University of California Press, 2002), 9.

43 *The Economist*, accessed January 26, 2010, http://www.economist.com/blogs/lexington/2009/10/a_fool_of_a_judge_1.

Bibliography

Act XVI, *"Laws of Virginia,* April 1691" in William Waller Hening, *Hening's Statutes at Large,* Vol. 3 (Philadelphia: Thomas Desilver, 1823), 87.

Avila, Oscar. "Obama's Census-Form Choice: 'Black,'" *Los Angeles Times*, April 4, 2010.

"The Case Against Inter-racial Marriage," *The Economist*, October 17, 2009. Accessed January 26, 2010, http://www.economist.com/blogs/lexington/2009/10/a_fool_of_a_judge_1.

Catterall, Helen Tunnicliff (ed.), *Judicial Cases Concerning American Slavery and the Negro,* 5 vols. (1926; reprint, New York: Octagon Books, 1968).

Chasing Daybreak. Accessed July 20, 2010, http://www.chasingdaybreak.com.

Graham, Fred P. "The Law: Miscegenation Nears Test in High Court," *New York Times*, March 13, 1966.

—"The Law: Supreme Court Previewed: A Quieter Year Ahead," *New York Times*, October 1966.

—"Marriage Curbs by States Scored," *New York Times*, April 11, 1967.

Harris, Mark. *Pictures at a Revolution: Five Films and the Birth of a New Hollywood* (New York: Penguin Press, 2008).

Hodes, Martha. *White Women, Black Men: Illicit Sex in the 19th-Century South* (New Haven: Yale University Press, 1997).

"Interracial Couple Denied Marriage License by Louisiana Justice of the Peace," *The Huffington Post*, October 15, 2009. Accessed January 26, 2010, http://www.huffingtonpost.com/2009/10/15/interracial-couple-denied_n_322784.html.

"Interracial Marriage Rising but Not as Fast," *CBS News*, May 26, 2010. Accessed July 16, 2010, http://www.cbsnews.com/stories/2010/05/26/national/main6520098.shtml

Jones, Jeffrey M. "Record-High 86% Approve of Black-White Marriages," Gallup, September 11, 2011. Accessed August 30, 2013, http://www.gallup.com/poll/149390/record-high-approve-black-white-marriages.aspx.

Levine, Andrea. "Sidney Poitier's Civil Rights: Rewriting the Mystique of White Womanhood in *Guess Who's Coming to Dinner* and *In the Heat of the Night.*" *American Literature* 73 (2001): 365–86.

Library of Congress, American Memory. Accessed January 26, 2010, http://memory.loc.gov/ammem/awhhtml/awlaw3/slavery.html

Lofquist, Daphne, Terry Lugaila, Martin O'Connell and Sarah Feliz. "Households and Families: 2010, Census Brief." U. S. Census Bureau, April 2012.

"Louisiana Justice Who Refused Interracial Marriage Resigns," *CNN*, November 3, 2009. Accessed January 26, 2010, http://www.cnn.com/2009/US/11/03/louisiana.interracial.marriage/index.html.

"N. A. A. C. P. Fighting Custody Award," *New York Times*, July 10, 1966.

"Negro and White Wed in Nashville," *New York Times*, July 22, 1967.

"Over 10 Million Americans and Growing: The Multiracial Community Commemorates 40 Years of Legal Interracial Marriage," May 2007. Accessed July 20, 2010, http://www.lovingconference.com/press/LDCNov06.pdf.

Pabst, Naomi. "Blackness/Mixedness: Contestations over Crossing Signs." *Cultural Critique* 54 (2003): 178–212.

—"Black and White and Read All Over," *The Village Voice*, January 24, 2006. Accessed February 2, 2010, http://www.villagevoice.com/2006-01-24/news/black-and-white-and-read-all-over/

Pascoe, Peggy. *What Comes Naturally: Miscegenation Law and the Making of Race in America* (New York: Oxford University Press, 2008).

"Questions and Answers for Census 2000 Data on Race," March 14, 2001. Accessed July 20, 2010, http://www.census.gov/census2000/raceqandas.html.

Roediger, David R. *Colored White: Transcending the Racial Past* (Berkeley: University of California Press, 2002).

Scott, Vernon. "Kramer's Latest Film Also Has a Message," *Chicago Daily Defender*, December 13, 1967.

Sollor, Werner (ed.), *Interracialism: Black-White Intermarriage in American History, Literature, and Law* (New York: Oxford University Press, 2000).

"Summary of Actions Taken by the Supreme Court," *New York Times*, June 13, 1967.

"Supreme Court Agrees to Rule on State Miscegenation Laws," *New York Times*, December 13, 1966.

Warren, Earl. Opinion of the Court, Supreme Court of the United States, *Loving v. Virginia*, No. 395, Argued: April 10, 1967, Decided: June 12, 1967.

Warren, Kim Cary. *The Quest for Citizenship: African American and Native American Education in Kansas, 1880–1935* (Chapel Hill: University of North Carolina Press, 2010).

A Blues for Tom:
Sidney Poitier's Filmic Sexual Identities

Ian Gregory Strachan

Until racial integration became an accepted norm, the fear of racial contact was always translated by racist white folks into a fear of black male sexuality.

bell hooks, *We Real Cool*

The truth is I was tired of fighting Hollywood. Tired of trying to push the studios into making films with black male leads who fell in love with their leading ladies the way white stars did. Scripts kept coming to me, some for films that went on to become box-office hits. But in every one of them, the black male lead was neutered. Judging by those roles, you'd wonder if black men even knew what it meant to fall in love, much less to have sex. Two of the more memorable ones that were offered to me were Lilies of the Fields *and* To Sir, with Love. . . . *Sidney Poitier took both of those parts, and they rocketed him up to new, stratospheric heights of stardom. Everyone loved Sidney in those roles. . . . I didn't want to tone down my sexuality. Sidney did that in every role he took. I don't want to put the full rap on race. Sidney is a wonderful actor, and he mesmerized audiences with all his performances. But he knows as I do that these nuances were fundamental to his success.*

Harry Belafonte, *My Song: A Memoir*

Hollywood had not kept it a secret that it wasn't interested in supplying blacks with a variety of positive images. . . . I understood the value system of a make-believe town that was at its heart a racist place.

Sidney Poitier, *This Life*

You keep on sayin', go slow.

Nina Simone, *Mississippi Goddam*

In the summer of 1967, Sidney Poitier was interviewed by the *New York Times* reporter Joan Barthel at his plush penthouse suite in Manhattan. The apartment overlooked Central Park and the two had cocktails and dinner as they chatted. Poitier was enjoying what would turn out to be the greatest year of his acting career. He appeared to be Hollywood's darling. In a span of 20 years he had gone from being homeless to residing in a penthouse, through a combination of talent, hard work, determination, shrewd choices and luck. He had won an Oscar 4 years prior, in 1964, for his turn as Homer Smith in *Lilies of the Field* (1963), after first being nominated for his role in *The Defiant Ones* (1958). Poitier was starring in two hit movies at the time of the interview: *To Sir, with Love* and *In the Heat of the Night.* And that December, his third hit film, *Guess Who's Coming to Dinner*, would be released. Poitier was the biggest box-office draw in America, starring in three of the top grossing films in 1967.

But the story Barthel wrote after her interview was not about the extraordinary journey Poitier had taken from poverty and juvenile delinquency in the Bahama Islands to life as one of the most recognizable and celebrated black men in America and the world, the Martin Luther King Jr. of celluloid. The piece, titled, "He Doesn't Want to Be Sexless Sidney," was more about things left undone than what Poitier had accomplished.[1] Even as he stood at the pinnacle, Poitier, the black icon, claimed he was frustrated by the limits, the restrictions, placed on him as an artist. He was defensive about his roles. As enviable as his popularity and material success would be to anyone, white or black, a cloud hung over his achievements and he knew it. In his most celebrated films he had played cardboard characters, characters who were denied a black world to live in, black tones to speak in, and denied the most powerful of human emotions and most basic of behaviors: love and sex.[2] And most liberal white Americans loved him for it. It would perhaps have mattered far less to his critics what kinds of characters he played if his were not the only marquee representations of black men in Hollywood films.

Joan Barthel put the question to him directly: "Could your consistent portrayal of loveable neuters be considered playing the white Hollywood Establishment game?" She expanded: "See Sidney Poitier. See Sidney Poitier act. Act, Sidney, act—and show the world how enlightened we are." Barthel claimed Poitier's response was not defensive. Poitier said he "wouldn't call it 'playing along.' It's a choice, a clear choice. I would not have it so." He submitted that "if the fabric of the society were different [he] would scream to high heaven to play villains and to deal with different images of Negro life that would be

more dimensional." Then after refusing to accept that he was playing the white Hollywood Establishment's game, he used the metaphor of play, himself: "But I'll be damned if I do that at this stage of the game. Not when there is only one Negro actor working in films with any degree of consistency, when there are thousands of actors in films, you follow?"

Earlier in the article Poitier described the white Hollywood establishment and its approach to making movies that promote a liberal agenda but will only go so far to represent Black personhood in any semblance of fullness:

> [T]he guys who write these parts are white guys, more often than not; they are guys in a business, and they are subject to the values of the society they live in. And there are producers to deal with who are also white. And a studio with a board of directors to deal with who are also white. So they have to make him—the Negro—kind of a neuter, and it has to be avant-garde, which is easy, right? You put him in a shirt and a tie and give him a white collar job; you make him very bright and very intelligent and very capable at his job, then you can eliminate the core of the man: his sexuality. His sexuality is neutralized in the writing. But it's not intentional; it's institutional.

From a business point of view, the approach described by Poitier worked, for Hollywood. America was changing, thanks to the civil rights struggle, but none too quickly; some would say, only cosmetically. American movies preferred a gradualist approach, just like the country. Films like *A Patch of Blue* (1965) and *Guess Who's Coming to Dinner* (1967), films Poitier described in the Barthel interview as "interesting, marvelous fables" intended to "warm the heart," sold a safe, comforting integrationist message that made millions for Hollywood and enriched Poitier as well.[3] *In the Heat of the Night* steered clear of any hint of romance in the life of its hero, Virgil Tibbs. Where there were depictions of interracial romance in Poitier films, such depictions were offensive to ideologically diverse constituencies. White racists, white progressive intellectuals and many black intellectuals, especially those who were part of the Black Arts Movement, were all offended by the films.[4] More passionate scenes between Poitier and Katharine Houghton in *Guess Who's Coming to Dinner* were cut out of the film even before the movie premiered.[5] And the kiss between Poitier and Elizabeth Hartman in *A Patch of Blue* was cut out when it was screened in the South (where interracial marriage was illegal).[6] Poitier told Barthel that after filming *A Patch of Blue* "[he] was at [his] wits' end."

He went on to speak about his aspirations for a new sort of filmic represen-tation of black love, black desire, and black sexuality (heterosexuality): one he

could fashion himself. He wanted to make films that would not ignore the "core of the man" he played. Interestingly, when we look ahead 40 or 50 years to the end of the twentieth century and the beginning of the twenty-first, American films are arguably no less problematic in their representations of black sexuality. Cornel West contends that "Americans are obsessed with sex and fearful of black sexuality."[7] And Jacquie Jones notes,

> The imaging of Black sexuality in mainstream film, particularly black male heterosexuality, continues to be the most denormalizing factor in the definition of the Black screen character. By sabotaging the ability to create or maintain primary ties to other individuals through intimate contact, the Black male character calls into question not only his ability to function as a legitimate, full—in other words, normal—member of film culture but also cancels the ability to be perceived as capable of complete humanity.[8]

Poitier told Barthel that he wanted to make films that would affirm his own four daughters, who were being alienated by mainstream white culture. He wanted to make films that would elevate black women, celebrating their beauty. As he put it, he wanted to see them "glamorized and idolized and put on a pedestal and spoiled rotten." He added that he was actually not interested in relationships with white women on screen—even though in a radio interview he promised audiences that if the racier scenes Stanley Kramer had filmed made it into the final cut, folks had better "bring their aspirins" to the theater when *Guess Who's Coming to Dinner* was released.[9] He mentioned the treatment he had written for an upcoming film, *For Love of Ivy*, which would appear the following year, and he was clearly excited about the project.

Poitier's promises to audiences regarding *Guess Who's Coming to Dinner* were empty ones, however. The film premiered and all audiences saw was a kiss in a rear view mirror and a leading man who had sworn himself to celibacy until the wedding day—if his young white love's parents gave their blessing. Despite the fact that interracial marriage was illegal in Southern states at the time the project was in production, many did not hail it as a welcome groundbreaker. They were very critical, none more so than African American playwright and critic Clifford Mason, who had clearly read Barthel's article and was not buying what Poitier was selling. In a *New York Times* article titled "Why Does White America Love Sidney Poitier So?" he took aim:

> [Poitier] thinks these films have really been helping to change the stereotypes that black actors are subjected to. In essence, they are merely contrivances,

completely lacking in any real artistic merit. In all of these films he has been a showcase nigger, who is given a clean suit and a complete purity of motivation so that, like a mistreated puppy, he has all the sympathy on his side and all those mean whites are just so many Simon Legrees. . . . Gradualism may have some value in politics. But in art it just represents a stale, hackneyed period, to be forgotten as soon as we can get on to the real work at hand. And artistical NAACPism is all that this whole period of Sidney Poitier moviemaking stands for.[10]

Poitier later wrote in his second autobiography *A Measure of a Man* (2000) that a new mood was taking hold in black America and his image and his films were, by the end of the 1960s, clearly out of step. "There was more than a little dissatisfaction rising up against me in certain corners of the black community," he reflected. "The issue boiled down to why I wasn't more angry and confrontational. New voices were speaking for African-Americans, and in new ways. Stokely Carmichael, H Rap Brown, the Black Panthers."[11] The assassinations of King, Evers, Malcolm X, and the Kennedys played no small part in the faded appeal of integrationist message film. "According to a certain taste that was coming into ascendancy at the time," wrote Poitier, "I was an 'Uncle Tom,' even a 'house Negro,' for playing roles that were non-threatening to white audiences, for playing the 'noble Negro' who fulfills white liberal fantasies." As Mark Reid put it, white liberal filmmakers' "cheery vision of a race-blind America had increasingly become bruised and offensive to the economically disenfranchised black community."[12]

Two years after the Barthel interview, Maxine Hall Elliston expressed as much disgust in *Film Comment* at the evasions Poitier's films attempted as by the popularity and praise the films enjoyed:

The real issue here is the widespread acclaim that *Guess Who's Coming to Dinner* and other Poitier films have received. *To Sir, with Love, In the Heat of the Night* and *Guess Who's Coming to Dinner* have grossed over 20 million dollars and the money is still rolling in. Sidney, while Tom-ing his way toward a million dollars of his own, has succeeded in selling to the public a Black prince. . . . Whites will love to see this Black nigger try to crawl his way into white society, and at the same time hating him for kissing a white girl. And non-thinking Blacks will wallow in the glory of their Black movie star. *Guess Who's Coming to Dinner* completely ignores the real issues, however. The film coats, covers up, disguises and even hides the real problems of the racist Supernation. What this move boils down to is—warmed over white shit.[13]

The attacks of Mason, Elliston, and white critics as well were not merely attacks on a particular film but on the noble, suffering, too-good Poitier icon itself, built over nearly 20 years of liberal race problem films crafted by white writers, directors, and producers, with Poitier's willing participation. Poitier told Barthel that evening in his penthouse suite, "I said I would never ever work in a film that was not cause for the negro members of the audience to sit up straight in their seats. . . . And I've never sold out in the pictures I've made." The persona Poitier assumed was one that he felt, to some extent, reflected who he was and what he stood for.[14] But in the 10 years proceeding 1967, Poitier tried ardently to change his film persona, to come down off the cross, as it were, and live differently on the silver screen. This was as much about remaining a viable star after the ground had shifted beneath him as it was about broadening the depiction of black life. He did so by assuming the role of filmmaker and creating alternative stories to the ones white Hollywood typically manufactured. He chose to tell stories that were more geared toward black audiences and which took into account the black nationalist mood of the late 1960s and 1970s. And, he sought to change his image by achieving a level of sexual expression previously denied him.

We consider Poitier's efforts to recast himself on the screen as a sexual being, to "cast off" as it were, the white liberal construction of bourgeois black masculinity that he had himself helped to craft; to activate what the Hollywood message film had deactivated in the name of marketing fables of racial tolerance and integration to mostly white audiences. Poitier was at a stage of his career in the late 1960s when he had the resources and network to create his own opportunities and control the final product to a greater degree. In his post-1967 films, we see him shed the cloak of noble neuter and present himself as a man of passion and desire. A man uninterested in the moral education, recognition, or affirmation of whites; a man pursuing his own ends largely on his own terms. We not only contrast Poitier's performance of sexuality pre- and post-1967, but also look at the ways Poitier's characters over the next decade (1968–77) constructed a version of masculinity that ran counter to his previous roles and critiqued the macho action heroes of the Blaxploitation films—heroes who were in a sense a desecration of his iconic integrationist persona.

The racist constructions of black masculinity that the Poitier persona was working against in the first place were the Coon and the Black Buck. The Coon was foolish, lazy, childlike clownish, dishonest, and cowardly.[15] In terms of sexuality, however, the more relevant stereotype is the Buck: the black man

as sexual specter: demonic, ravenous, and animal.[16] The archetypal Buck in American film would be Gus, the "black" soldier of Griffith's *The Birth of a Nation* (1915), who wants nothing in the whole world more than to have a white woman.[17] If he can't marry one, he will rape one. *Birth* also provides us with an unforgettable scene of celebration in the South Carolina legislature. The black representatives pass a law legalizing interracial marriage and then leer at the white women in the gallery above before bursting into dance and song at their own good fortune. The Buck is not just hypersexual; he is a usurper, unruly, violent, and confrontational, in need of containment, control, suppression, or castration.

One of the most powerful reincarnations of Buck was Mr T's Clubber Lang character in *Rocky III* (1982) who promises not only to wipe the floor with Rocky but also to give his wife the pleasure she hasn't been getting. Sadly, this fear and demonization of the black man as criminal and menacing threat still plagues the American psyche even when a black man lives in the White House, and it still has potentially lethal repercussions for African American boys/men, as evidenced by the shameful handling of Harvard's Prof Henry Louis Gates Jr. as he attempted to enter his home or the murder of hooded teenager Trayvon Martin in Florida.[18] Even greater evidence, in the so-called postracial Obama age, is found in the systematic handing down of harsher sentences to black drug offenders than their white counterparts.[19]

Poitier's integrationist heroes worked against the highly offensive construction of the black male body as locus of wild, dangerous, sexual potency, a force that would pollute the white world and white order (order manifested in white men's sole access to white female bodies). In the contest over the white female body—the ultimate expression of patriarchal power in racist America—Poitier's characters demanded respect and equality but demonstrated no appetite, curiosity, or will to possess the white woman (as portrayed in *The Defiant Ones, Lilies of the Field, To Sir, with Love*).[20] The interracial love affair, which was part of the 1959 E. R. Brathwaite novel *To Sir, with Love*, was removed from the James Clavell film adaptation. Where romantic and therefore sexual interest was unavoidable because it was the very crux of the story, the "problem" to be solved as it were, his characters demonstrated the restraint of an uber-gentleman (*A Patch of Blue* and *Guess Who's Coming to Dinner*). Barthel described the Poitier persona as that of "an isolated paragon of sense and sensibility who roams the white world bringing order out of chaos, deftly solving the problems of nuns and blind girls and women with suicidal inclinations."

The adventure film *The Long Ships* (1964) is the one film in which Poitier is actually the most powerful man in his world, the Moorish Prince Aly Mansuh. He possesses a harem of women but he has taken a vow of celibacy until he acquires his goal, the gigantic golden bell, The Mother of Voices. Hence, even when he is fictively removed from white-dominated American society, he must display no sexual desire. Ed Guerrero writes that *The Long Ships* was guilty of "perhaps the most ridiculous and humiliating narrative contrivance, designed to uphold the protocols of white masculinity through Hollywood's erasure of Poitier's sexuality."[21]

In an early scene a brooding Poitier is confronted by his sexually frustrated (and scantily clad) white wife, Aminah (Rosanna Schiaffino):

Aminah: Take me with you.

Aly Mansuh: Your duties are here.

Aminah: My duties are with my husband. I can no longer sit and wish away the days as the other women do while you chase a legend, a fairytale that has already cost us dearly in lives and gold. I am your wife, my lord. Without your affection I wither and die. How long am I to be denied your attentions? How long am I to endure your abstinence from pleasure?

Aly Mansuh: Until Allah's divine guidance leads me to the treasures of Islam.

Director Jack Cardiff's artistic vision of the film was made to conform to the standards of the Motion Pictures Production Code, which desexualized Poitier as per usual, as Aram Goudsouzian describes:

Aly Mansuh should be a character with sexual energy. He presides over an interracial harem, and an early publicity still shows him kissing a white woman. But in the film's final cut, he has taken a bizarre oath of celibacy. . . . Even the entreaties of his favorite wife Aminah (Rosanna Schiaffino) fall flat. Later he calls the Viking princess Gerda (Bebe Loncar) to his quarters, but any passion between them ended up on the cutting-room floor. The Production Code Administration ordered editing of sexually suggestive scenes, which not only contributed to the plot's inconsistencies, but also reinforced . . . racial taboos.[22]

Poitier had told Joan Barthel that he had never sold out. But then he added, "Well, yes, I have, once or twice, for money and career reasons. I hated doing *Porgy and Bess*," he admitted. "There was another movie I hated equally as much but for different reasons: *The Long Ships*. To say it was disastrous is a compliment." Clifford Mason thought that Poitier's negative attitude toward the character of Aly Mansuh was telling: "[Mansuh] was nobody's eunuch or black mammy

busting his gut for white folks as if their problems were all that's important in the world," wrote Mason. He further writes, "And so the stern 'I hated it' . . . about doing 'The Long Ships' shows the confusion in [Poitier's] mind as to what constitutes dignity for Negroes in films."

No Way Out (1950), *Lilies of the Field* (1963), *Pressure Point* (1962), *A Patch of Blue* (1965), *The Slender Thread* (1965), and *Guess Who's Coming to Dinner* (1967) offer the world dignified, intelligent, restrained black heroes. Poitier's black body is contained, for the most part, in a uniform of white capitalist patriarchy, the suit and tie. The character's costume was intended to gain respect and recognition from a white society reluctant to give blacks equal access to the American Dream, by convincing them that Poitier's character was worthy of that access; he had learned the rules and could play by them. His characters, in the race problem films, would earn equality by overproving.[23] But even here he never threatened white male power—either by confrontational/inflammatory discourse, or by entering into all-out competition for the white female body. He was always prepared to defend himself if attacked, but he would not "[B]uck it up" by appearing politically militant or sexually aggressive.

Even beyond that, he would cover himself, as if his very skin—dark as it was—could unleash a sexual potency that could not be risked. His skin color, more so than Harry Belafonte's, was a sign of the oppressed, of those who were disadvantaged in the caste/class system.[24] However, as little as possible of his skin was revealed so as to control its potential to invite, incite, or repel. To borrow Elliston's phrasing when describing *Guess Who's Coming to Dinner*, Poitier himself was "coat[ed], cover[ed] up, disguise[d] and even hid[den]."

As Charles Johnson has put it in his essay "Phenomenology of the Black Body," the visual impact of blackness in a white society is "abrupt epidermalization"—acute attention to difference, and more specifically, a reduction of the human person to his/her skin and the myths, fears, fantasies, nightmares, and erasures signified by that skin.[25] Frantz Fanon put it aptly in *Black Skin, White Masks*: "I am given no chance. I am overdetermined from without. I am the slave not of the 'idea' that others have of me but of my own appearance."[26] Darker skin still signifies a more animal sexual nature and a tendency toward brutishness, even among late-twentieth-century and twenty-first-century films—including those with black directors. A telling example from more recent cinema is the variance in the staging of sex scenes between dark and lighter skinned black actors in films like *School Daze* (1988), *Mo' Better Blues* (1990), *Why Do Fools Fall in Love* (1998), and *About Last Night* (2014). The darker characters have

"wilder" sexual encounters and are filmed less romantically. Even when Poitier paired with actresses in romantic situations they have almost always been of a lighter complexion.

There is an arresting scene in *Guess Who's Coming to Dinner*, when the Draytons' black housekeeper Tillie (Isabel Sanford) stumbles upon Dr John Wade Prentice barebacked, changing his shirt. She then proceeds to "dress him down," calling him "one of those smooth talkin' smart ass niggers just out for all [he] can get." The scene strangely underlines the taboo against a man of Poitier's skin color. Dr Prentice, seeing her enter the room, quickly tries to cover himself rather than just stand there and engage, as if his chest were offensive or indecently exposed. She verbally punishes Prentice for daring to propose to a white woman but also, implicitly, for showing that too-black skin; exposing it recklessly to rarified air as it were, touching white things with it, and most of all threatening to touch a white woman with *his* "things." She disapproves of this marriage proposal but in that moment she is also rebuking his undress, the presumptuousness of his disrobing in the white folks' house, for beneath the suit she has found an impostor, "a nigger out for all [he] can get," not the world-renowned Dr John Wade Prentice. In essence, the Mammy confronts the Tom and calls him a no good Buck.

In *No Way Out*, though Poitier's Luther Brooks has a lovely wife, Cora (Mildred Joanne Smith), the scenes between the two are few; they show each other affection and love but there is no passion or overt desire. In *Lilies of the Field* Homer Smith seems to express no interest in sex, doesn't take a second look at any of those nuns as they go about their chores. He is just a nice guy who keeps whatever's in those tight jeans, in those jeans. In *Pressure Point* (1962) Poitier plays a detached psychiatrist, with no world, no home, no love interest— no name even. As for *In the Heat of the Night*, there's definitely sex going on in that little Southern town (abortions too) but no love interest for Sidney; he is cool, professional, supremely smart, and above that kind of thing.

In *Defiant Ones*, Poitier's Noah Cullen is certainly unruly and not contained by a European suit. He does not embody middle-class values nor does he overtly attempt to assimilate. He is a sharecropper unjustly sent to jail for defending himself. His character is not allowed a sexual liaison; Tony Curtis's is, however, and as such the white character is privileged and Poitier plays sidekick.

I would further submit that Poitier's Noah Cullen offsets his Buck antics by adopting some of the traits of another archetypal black character, the Mammy. He tends to Curtis' wound, always says thank you, and cares for the child Curtis

would rather leave unconscious on the ground. Cullen's role as nurturing partner is emphasized especially as the two men hold each during a downpour in the woods. However, it is clear who wears the pants in the relationship, because when a "better" woman (one possessing the requisite body parts and one who is white) shows up, Tony Curtis's Jackson trades up. Poitier's role really serves as the prototype in some respects for the sexless, caring black sidekicks that Hollywood would subsequently churn out like Danny Glover's Murtaugh in the *Lethal Weapon* films (1987–98), Djimon Hounsou's Juba in *Gladiator* (2000), and Terrence Howard and Don Cheadle's Rhodey in the *Iron Man* series (2008–13). Another example is *Last Vegas* (2013) where Morgan Freeman appears in a buddy film with Michael Douglas, Robert De Niro, and Kevin Kline but is the only lead character without a love interest.

The most successful and criticized examples of Poitier's sexually restrained hero were Gordon Ralfe of *A Patch of Blue* (1965) and Dr John Wade Prentice of *Guess Who's Coming to Dinner* (1967), in which Poitier plays the black gentleman par excellence. He is much desired by the white women opposite him but he controls his desire. One can argue though that the constraints imposed on Poitier's sexual expression did not mean he was unable to ignite sexual desire in the viewer.[27] It is not that Poitier lacks sexual appeal in these films—he was by this time very much the object of adoration by white and black women alike—but his appeal in these films lies in what he does not do rather than what he does, in what his audience cannot see rather than what they do see; his concealment, his containment, his formality.[28] And Poitier, born to Bahamian parents in 1927 and raised in the British Caribbean, would have aspired to be just that.

Poitier also displays passion—passionate indignation—but never too much, just enough to underline the injustices to which he is exposed and just enough to make him the most charismatic man on the screen at any time. In that passion and charisma, balanced by restraint, topped off with a brilliant, genuine smile, the lean, handsome Poitier achieved sex appeal with all his clothes on. His speech as well would have added to his mystique: he lacked an identifiable African American accent, and this as well created a distance for Poitier's persona—a distance between his characters and the blacks who white Americans encountered most often and felt bound to in a history of oppression. Thus, Poitier might not have had sex with white women, but he was the kind of black man acceptable for white women to desire sexually. He provides white audiences with the visual pleasure of gazing at a virile black man, which appeals

to their desire to transgress, but his "disguise" or "mask" also eases the fear such desire elicits.[29] Poitier presents a black male object of desire that is both familiar and nonthreatening to white audiences—given the almost total erasure of black cultural signifiers and the polite manners that characterize his portrayals. His superior intelligence, his contained fury, his proud bearing, his sophisticated cool, and his courage show through in a film like *In the Heat of the Night*, so much so that despite the absence of a love interest he is the most attractive and desirable man in the film.[30] Poitier exudes much of the suited cool and charisma that distinguished the black Jazz men of the 1950s.

If we were to view the sexual encounters of Poitier's persona in this era as a metaphor for American race relations, this acting out of white female desire juxtaposed with black male restraint functioned like a rehearsal for black admittance into white society, a kind of screen test to allay the fears of white patriarchy—a sexual simulation of the civil rights power struggle as told by white male Hollywood. Hollywood's approach to the integration struggle then was to summon fears of miscegenation and simultaneously allay them. In Poitier's vehicles integration could still mean separate but equal where sex was concerned. The white woman could not be trusted to honor the last bastion of racial separation, her body—presumably because of her moral and psychological weakness. But white men could trust Super Sidney to honor it. *Guess Who's Coming to Dinner*, as Susan Courtney rightly points out, stages white patriarchy's willing handover of the white female body to the black man, after rituals of deference have been performed and the white patriarch has been satisfied that the white daughter can maintain her class status.[31]

In *To Sir, with Love*, white patriarchy is never asked to demonstrate such magnanimity. Witness Poitier's rejection of the white student's affection and his gracious amusement at the lustful race-based remarks of the working-class white women in the bus. Witness the fact that (unlike in the actual book) he hasn't the slightest interest in the pretty white teacher with whom he works. As a promotional poster for *To Sir, with Love* put it, the movie presented "[a] story as fresh as the girls in their minis . . . as cool as their teacher had to be!"

Interestingly though Poitier and Hartmann's kissing scene in *A Patch of Blue* is far more passionate than anything remotely approached in the final cut of *Guess Who's Coming to Dinner*, though *Guess* is a later film. Perhaps Poitier's physical contact with a white woman was seen as more tolerable because the woman was blind and so squalidly working class as to be considered

Figure 15 Poitier and Hartman share a passionate kiss and embrace.

"poor white trash." She was a far cry from being the daughter of San Francisco white elites. Selina comes from a grotesque family; perhaps it was thought that sensibilities were less likely to be assaulted by the grotesquery of a black man holding a poor white woman in a passionate embrace and working hard to suppress his own sexual desire. It was arguably his most erotic scene as an actor during this period, all the more because of his internal emotional conflict, the transgression of taboos, and his obvious power advantages in that moment. After all, it is Selina who makes the explicit sexual advance in the scene.

For Love of Ivy inverts the problematic depiction of black sexuality and personhood that typifies Poitier's race problem films. Poitier is able, for the first time since he had appeared in *Paris Blues* (1961) alongside Diahann Carroll, to enact a black romance on the screen, and it is a story of his own invention. Whereas in *Paris Blues* his romance is subordinated to the Paul Newman-Joanne Woodward love affair—we never see Poitier and Carroll in bed or in any stage of undress—the black couple of *Ivy* is the center attraction: their beauty, their charm, their wit, their passion. Playing opposite Abbey Lincoln, Poitier is Jack Parks, a "good looking nogoodnick" as Beau Bridge's Tim describes him. Parks, a businessman by day and an illegal casino operator at night, gets blackmailed into dating a young black housekeeper who is threatening to leave the wealthy white family she works for because she feels she's missing out on life. Despite his initial reluctance and declarations that he is a "piranha," Parks falls in love with Ivy and Poitier is finally able to play the sophisticated, smooth, confident bachelor who seduces his love interest with come-hither looks and tender kisses. Poitier takes off his saint's robes and

Figure 16 Poitier's Jack Parks kisses Abbey Lincoln's Ivy.

plays a playboy and criminal (but still with a heart of gold). The film flirts with issues of race but remains lighthearted throughout. It simply wants to tell an entertaining love story of the kind Rock Hudson and Doris Day would have made in the 1950s.

Poitier dons a tuxedo in the film to a dinner, hosted by the Austin kids, where he will meet Ivy for the first time, and when he walks through the door Beau Bridges declares, "You're gorgeous." That sums up what is best about the film: it celebrates the beauty of the black characters, their charisma, and their glamour. Though the story is implausible and silly, it was a polished production that elevated depictions of black intimacy, romance, and, by extension, black humanity. The same Maxine Hall Elliston who had called *Guess Who's Coming to Dinner* "white shit" sings a different tune where *Ivy* is concerned.

> I know Sidney will be grateful that my ax has grown a little dull as far as he is concerned. I was pleased with this movie, his story and the acting. Let me say now that I know and am quite sure that Sidney is a human being, a man capable of emotion and feeling. I am so accustomed to Sidney and his white-on-white stoicism that it was refreshing to see this new side of him. It was not a feeling of pride but it did my heart good. Nevertheless—I guess the world is shocked—it did take a little getting used to see him kissing all over that woman in the bed. . . . Sidney can act, and he can add a comic touch that has now become known as his trademark. . . . His nuances of speech and facial expressions are a movie in themselves. . . . Poitier gives a freer, much more

liberated type of performance in this movie, and I thought that was good in itself. (30)

Poitier continued his departure from the neutered persona in his next film *The Lost Man* (1969), but the project was a confounding mess. It was written and directed by Robert Alan Arthur, the white screenwriter of *For Love of Ivy*. In this remake of a 1947 film about an IRA member on the run after a failed heist, Poitier plays Jason Higgs, an army veteran turned black militant in Philadelphia who orchestrates a payroll robbery to give money to the families of jailed members of a secret black organization. The robbery goes wrong and Higgs is a man on the run for the rest of the film. Poitier's portrayal of a Black Power militant is perhaps his worst acting outside of *The Long Ships*. He is unable to convincingly traverse the emotional territory the character needs to inhabit and the vacuous script is no help at all. He summons neither rage nor eloquence. His decision to wear dark shades through most of the film's opening scenes makes his character unknowable and uninteresting.

What is most notable about Jason Higgs is his sex life. *The Lost Man* is the one film in which a Poitier character rejects the advances of a black woman and instead runs into the arms of a white woman (the white woman Poitier would later live with and eventually make his second wife in 1976, Joanna Shimkus). A Canadian-born model and actress, Shimkus plays social worker Cathy Ellis. In a confusing turn of events, the black militant Higgs turns down the advances of Sally (Beverly Todd)—the black woman who shelters him, feeds him, gives him a bath in her tub and practically begs for his love— only to accept the advances of the upper-class, liberal white social worker. Presumably he rejects Sally's advances in order to protect her or because he sees no future hiding out in her apartment while the entire city is searching for him. The social worker tries unsuccessfully to help him escape capture, using the cover of her skin to get him past police blockades. She is the one he embraces and has feelings for. One cannot avoid the interpretive reading that critiques his militancy. Higgs chose the white girl because of the advantages whiteness could afford him. In the end, though, the two are shot by police and die in each other's arms—but not before Jason confesses his love for her and they presumably consummate—off camera, in "ellipsis," as Linda Williams would put it.[32] The only clues are that the scene fades out with them kissing and returns to them at a later juncture in which her hair is now down and he is asleep on the couch. Both are fully clothed, except for a few loosened buttons on Higgs' shirt.

Poitier's Higgs is a man of action, a man who is prepared to take what he wants in the world, but he doesn't really reflect patriarchal fantasies of power. He is obviously a woman magnet, but he lacks the machismo of Hollywood action heroes. If he did, he would kill with more zest, and he would have found the time to pull Beverly Todd's Sally into the tub with him; he would have made love to her because that's clearly what she needed, and he would still leave her to run off with the white woman. James Bond would have done no less and the Blaxploitation heroes who were soon to emerge would have done so as well. Indeed, one cannot help but note that when Sidney Poitier finally is left alone with a white woman and they make love (if that's what we should imagine happens after Higgs kisses Ellis), their reward is death—not what America was waiting for. The film was a critical and commercial failure. Larry Neal called Poitier "a million dollar shoe shine boy" for participating in another insipid white man's fantasy.[33] Biographer Aram Goudsouzian summed up Poitier's misstep by arguing that the star was "Too proud to change his virtuous image, too concerned with appeasing everyone, too ambitious to sacrifice mainstream appeal."[34] A year later, Poitier, who had separated from his black wife Juanita Hardy years earlier, moved to the Bahamas with Shimkus. He spent 4 years there, motivated in part by the desire to put some distance between himself, his critics, and even other black actors who had grown hostile.[35]

Poitier then reprised his role as Virgil Tibbs in the film *They Call Me Mr. Tibbs!* (1970). Poitier's crack detective now lives in San Francisco with his wife and two children. Racial conflict is largely avoided and Tibbs is called on to solve the murder of a prostitute. Though an inferior and forgettable film in almost every way, this sequel gives us a more rounded view of Tibbs. We see him as a man who loves, who cares for his family, who struggles to raise his children lovingly despite his stressful job and who turns to his lovely wife for solace (played by songstress Barbara McNair). Tibbs is a highly competent detective but one who is highly stressed; he comes home and seeks to escape his cares through sex with his wife.

At one juncture Tibbs comes home from work, walks past his daughter who's practicing standing on her head, and meets his wife bending over, tending to her potted plants. It is a wholesome slice of black middle-class life. Tibbs admires her behind for a moment, then bends down, and lightly spanks on her butt, catching her by surprise. In the middle of the frame the daughter looks on watching the scene of mild sexual play between her father and mother. In this scene Poitier keeps his promise to produce images that can affirm his own black daughters

Figure 17 Virgil Tibbs spanks his wife's derrière.

(he ultimately had six over two marriages). The black woman's buttocks, which have made her a mockery and a freak to racist whites since Sarah Baartman became the Venus Hottentot in the early 1800s, are affirmed by Poitier in the scene. The message intended is clear: black women are sexy and beautiful.

Though Poitier followed up with a third installment, *The Organization,* in 1971, Virgil Tibbs would not be the cinematic black hero of the 1970s. And neither was John Kane, Poitier's persona in *Brother John* (1971). Though providing us with a character who does have a love interest, and who knows how to handle himself in a fist fight, *Brother John* is every bit as ridiculous and frustrating as *The Lost Man* because he plays not just a throwback saint, but something akin to an angel. The more notable event of 1971 was Melvin Van Peebles' *Sweet Sweetback's Baadasssss Song,* which hit theaters with an X rating and introduced a new kind of black action hero—a reincarnation of the black buck, but one who beats the system rather than being destroyed by it. Sweetback fought and sexed his way to "freedom." He deployed superior violence and superior sex to win the day. He made women exclaim with delight and but shows not one bit of enthusiasm while serving up his impressive member—even sex can't make him lose his cool. *Superfly* hit theaters in 1971 as well, and gave black America a Kung fu-fighting, cocaine-snorting, drug-dealing hero. And *Shaft* (1972) would provide further weight to the new genre with its tough-as-nails private eye hero (Richard Roundtree). The stark terrain of the urban ghetto became the glorified world of black antiheroes, imposing, fearless, unapologetic, and lethal; and Hollywood cashed in on urban black youth's appetite for this new genre. Other notable manifestations were Jim Brown's *Slaughter* films, as

well as Fred Williamson's *Black Caesar* (1973), and *Hell Up in Harlem* (1973). For these hypermasculine heroes, sexual promiscuity, violent aggression, fierce independence, and antiestablishmentarianism were the hallmarks. It was American patriarchal power in black face, or, as Donald Bogle put it, it was the age of "the new style defiant buck hero."[36]

Lerone Bennett Jr., editor of *Ebony*, the organ of the black middle class, characterized this moment as one of "image confusion in the black community":

> The Negro stereotype is, in essence, a contrast conception, the negative pole of the familiar white dichotomies of good-evil, clean-dirty, white-black. In the pre-black days, Negroes generally reacted to the white image by defining themselves as counter-contrast conceptions. They tried, in other words, to become opposite Negroes, the opposite, that is, of white people said Negroes were. This symbolic strategy was abandoned by post-Watts blacks who are defining themselves as counter counter-contrast conceptions, as the opposite in short, of what Negroes said Negroes were. . . . The danger, to put it bluntly, is that blacks will go around and around in circles and end up in an old harbor of white clichés, with the mistaken impression that they are discovering new land. . . . [T]here is a way out which is neither a reaction to the white stereotype nor a reaction to the Negro reaction to the white stereotype. That way is to redefine the black image from a perspective free of the pressures of white influences. But in order to do that, we must create free black words, free, that is, of the need to propitiate or to curse white folks, free black words that sculpt new images of the black man, the black woman, and the black child.[37]

Poitier would later write in his autobiography *This Life* that "neither the exploitation films nor my films were sufficiently about them [black people], sufficiently representative of what in fact they were."[38]

His response as an actor, director, and producer was to try to provide an alternative to his own defunct persona *and* to Blaxploitation's "macho street dudes beating up redneck racists and gangster crooks in the 'get whitey' formula" as he described it.[39] Poitier plays a variety of characters in this period, from civil war veteran fighting off racist cowboys in *Buck and the Preacher* (1972) to wealthy widower looking for love in London in *A Warm December* (1973), to blue collar Everyman in over his head in a world of gangsters in the comedic movies *Uptown Saturday Night* (1974) and *Let's Do It Again* (1975), to black South African freedom fighter on the run in *The Wilby Conspiracy* (1975), and to slick, sophisticated con artist forced to mentor a bunch of rude juveniles in *A Piece of the Action* (1977).

Where sexuality was concerned, almost all his characters showed allegiance to one partner, a black woman, whom they genuinely loved, felt passionately about, sought to protect and care for, and to whom they were faithful. Though none of the films pushed the envelope in terms of depicting black lovemaking on the silver screen (*Superfly*'s bathtub love scene comes to mind), they are notable for Poitier's effort to find a middle ground culturally and politically. As critic Renata Adler described it in a review of *For Love of Ivy*, Poitier was attempting to do the "nearly impossible," and "grab the consensus around the middle and try to lug it, like some great cow, to a vanguard outpost."[40]

He wanted to avoid the negativity of most black action films; he wanted to entertain but he also wanted to send messages he felt would strengthen black communities and reinforce nonharmful behaviors. Though his male heroes operated well within the rubric of patriarchal notions of masculinity in most respects, there was an attempt on his part to depict characters whose sexual expression was not bestial, compulsive, or predatory. His heroes did not feed fantasies of patriarchal power in the ways audiences, black and white, were used to. His heroes showed vulnerabilities and knew right from wrong, even when they broke the rules.

A good example is Poitier's Steve Jackson in *Uptown Saturday Night* (1974). The character is far from hypersexual but he models love, desire, and affection for his wife, even if no time was made in the comedy for a sex scene. He tells his wife Sarah (Rosalind Cash) one quiet evening during a meal, "After 20 years of marriage, two kids and three jobs, you know? You still got the biggest butt I ever saw. You're my queen Sarah. You're my queen." The exchange epitomizes the sense of sexual play and affirmation for black beauty and love that typify the Poitier-Cosby trilogy.

The two most notable films during this period, for our purposes, are *A Warm December* (1973) and *The Wilby Conspiracy* (1975). Poitier attempted to duplicate the "success" of *Ivy* with another black romance (tuxedo and all), but *A Warm December* (directed by Poitier and produced by his company) was a much weaker artistic effort. It is the story of a wealthy widower and his young daughter on vacation in London. Dr Matt Younger falls in love with the mysterious and beautiful daughter of an African diplomat (played by Jamaican actress and model Esther Anderson). The film is notable not merely for its affirmation of black beauty, black love, black family, and black culture, but also because it defies viewers' expectations. Dr Younger is handsome, independently wealthy, and has a family with an obvious void, a wife and mother. We would

expect that his persistence and charm would pay off and he would get his girl, Catherine Aswandu. He pursues the beautiful woman and they start up a romance filled with long walks, tender embraces, passionate kisses, and adoring glances. His young daughter grows very fond of Catherine as well, but there's a complication: Catherine has sickle cell anemia and knows she doesn't have long to live. In the end, though Younger and his daughter hope she will choose to spend her remaining days with them, she elects not to. Although she wants to be a wife and mother before she dies, she wants even more to spare Matt Younger and his daughter from losing a wife and mother a second time. Catherine Aswandu's words of farewell to Younger are, "Farewell, my husband. Thank you for a warm December," and then the two embrace for the final time. Through the film, Poitier keeps his promise to have black women and girls put "on a pedestal and spoiled rotten." Esther Anderson won an NAACP Image Award for her performance. Though the film struggles in many ways, it is rare even 40 years later to find a black love story on film (much less a tearjerker) that tries to take the characters seriously as complex, intelligent, normal human beings looking for meaningful companionship, facing the kinds of challenges white characters have faced in hundreds of films. The final poignant scene shows Poitier's Dr Younger and his daughter flying back to America first class, holding hands, going on with their lives, clinging dearly to their love for one another, a family.

Poitier plays black freedom fighter Shak Twala in *The Wilby Conspiracy.* Pursued by racist Afrikaneer security agents as he attempts to deliver uncut diamonds to support the resistance against apartheid, Poitier does a much better job this time around of playing the revolutionary than he did in *The Lost Man.* It was much more familiar ground for him as he had played an African leader twice before in *Mark of the Hawk* (1957) and *Something of Value* (1957). Shak Twala never backs down from a fight and is totally committed to the liberation struggle. The film doesn't take itself completely seriously though; there's a fair amount of comic relief in what is essentially an interracial buddy film with Poitier and Michael Caine both running for their lives. Unlike *The Defiant Ones,* however, Poitier is not your typical sidekick, left out of the sexual fun. He has his "romantic" interlude, with a woman who betrays him as Tony Curtis did. Twala finds himself hiding in a secret closet behind a bookshelf with a beautiful dental assistant, played by former Miss India, Persis Khambatta. He seizes the opportunity (after years behind bars) to seduce the woman—an

Figure 18 Poitier and Khambatta in the closet.

intense, longing gaze is all that is required. Unable to resist the palpable desire Shak Twala emits, they have sex to a score of drums and flutes. This makes for the only scene in Poitier's career where he simulates lovemaking and it constitutes his most erotic performance in film.

Later in the film Persis Khambatta's character, Peris Ray, double-crosses Shak Twala and Twala's other Indian collaborator, Mukherjee. She shoots Mukherjee but is thrown down a mine shaft by Shak Twala, thereby obeying the apparent "rule" that any nonwhite woman who makes love to Poitier must die.

Poitier had come a long way from his polished, super clean, super refined persona in *Guess Who's Coming to Dinner*. Shak Twala is earthy, unkempt, yet proud. He demonstrates the strength and courage one expects from a Poitier character without the attendant burden of leading whites to repentance. He is a lover and a fighter, without being hypersexual, hyperviolent, or invincible.

It is safe to say that Sidney Poitier's film career in terms of box-office draw as an actor reached its apex in 1967, and though he would enjoy some success in later films as an actor and director, the images that remain seared in the American mind remain those of Gordon Ralfe, Homer Smith, Mark Thackery, Virgil Tibbs, and Dr John Wade Prentice: the affable black gentleman do-gooder. After 1967, Poitier altered his asexual image, and with the obvious poor choices aside, he managed to break new ground in black cinema. His 1970s films were no match for the cathartic Blaxploitation films in terms of their place in the popular black imagination because he resisted the impulse to display exaggerated power, but

they nonetheless made important statements about the black experience at a time when representations were limited and skewed.[41] Poitier set an example for those who followed. He demonstrated how a black artist could create his own opportunities in Hollywood and give other blacks work in front and behind the camera as well.

Poitier returned to acting after an 11-year hiatus between 1977 and 1988. He never regained his stature as a box office draw, however. In most of the roles he took for the big screen he played versions of the black buddy, with all that entails. *Shoot to Kill* (1988), *The Jackal* (1997), and *Sneakers* (1992) are examples. In his late career he made more television movies in fact, playing characters in whom the "core of the man" was usually ignored or downplayed, such as *The Strange Life of Noah Dearborn* (1999) and *The Last Brickmaker in America* (2001). In 1967, Poitier had called this practice "institutional," not "intentional." It is a dilemma that still plagues black, Asian, and Latino actors in Hollywood films and will probably continue to plague them, so long as they wield limited creative control over the films in which they appear.

Notes

1 Joan Barthel, "He Doesn't Want to Be Sexless Sidney," *The New York Times*, August 6, 1967.

2 As Donald Bogle put it decades later, Poitier's characters in the race problem films of the 1950s and 1960s were "non-funky, almost sexless and sterile." *Toms, Coons, Mulattoes, Mammies and Bucks*, 4th edn (New York: Continuum, 2001), 175–6.

3 Aram Goudsouzian estimates that Poitier made close to 10 million dollars from his three 1967 movies and *For Love of Ivy. Sidney Poitier: Man, Actor, Icon* (Chapel Hill: University of North Carolina Press, 2004), 293.

4 Mark Reid, "Given the general political climate and urban unrest, Malcolm X and Dr. King's murders were harbingers to the end of this cycle of integrationist films. . . . Interracial sentiment was anything but acceptable to the Black Arts Movement," *PostNegritude Visual and Literary Culture* (Albany: State University of New York Press, 1997), 112; Aram Goudsouzian, "That audiences flocked to *A Patch of Blue* signaled that many Americans still craved sentimental racial goodwill. That some critics resorted to snide hyperbole portended the demise of Poitier's image. That Klan members picketed his picture revealed how long the journey remained," *Sidney Poitier*, 243.

5 Goudsouzian *Sidney Poitier*, 282.

6 Ibid., 243.

7 Cornell West, "Black Sexuality: The Taboo Subject," in Rudolph P. Byrd and Beverly Guy-Sheftall (eds), *Traps: African American Men on Gender and Sexuality* (Bloomington: Indiana University Press, 2001), 301.

8 Jacquie Jones, "The Construction of Black Sexuality," in Manthia Diawara (ed.), *Black American Cinema* (New York: Routledge, 1993), 247.

9 Aram Goudsouzian, *Sidney Poitier*, 282.

10 Charles Mason, "Why Does White America Love Sidney Poitier So?" *New York Times*, September 10, 1967.

11 Sidney Poitier, *The Measure of Men: A Spiritual Biography* (New York: HarperCollins, 2000), 118.

12 Mark A. Reid, *PostNegritude Visual and Literary Culture*, 112.

13 Maxine Hall Elliston, "Two Poitier Films," *Film Comment* (Winter 1969): 28.

14 Poitier writes, "When I got to New York and when I got to Hollywood, for whatever reason or by whatever stroke of luck I was given the tremendous opportunity of doing work that could reflect who I was. And who I was had everything to do with Reggie and Evelyn and each cigar sold and each rock broken. That's how I've always looked at it: that my work is who I am. I decided way back at the beginning, back when I was still washing dishes in a barbecue joint in Harlem, that the work I did would never bring dishonor to my father's name." *The Measure of a Man*, 69.

15 Bogle, *Toms, Mulattoes, Mammies and Bucks*, 8.

16 Donald Bogle, *Toms, Mulattoes, Mammies and Bucks*, 10–18.

17 Miscegenation.

18 Abby Goodnough, "Harvard Professor Jailed; Officer Is Accused of Bias," *New York Times*, July 20, 2009, http://www.nytimes.com/2009/07/21/us/21gates.html?_r=0; Adam Weinstein and Mark Follman, "The Trayvon Martin Killing Explained," *Mother Jones*, March 8, 2012, http://www.motherjones.com/politics/2012/03/what-happened-trayvon-martin-explained. Patricia Hill Collins, *Black Sexual Politics* (New York: Routledge, 2004), 153.

19 Michelle Alexander, *The New Jim Crow* (New York: The New Press, 2012), 7.

20 Patricia Hill Collins: "In the United States, hegemonic masculinity is installed at the top of a hierarchical array of masculinities. All other masculinities, including those of African American men, are evaluated by house closely they approximate dominant social norms." *Black Sexual Politics*, 186. See also Frantz Fanon, *Black Skin, White Masks* (New York: Grove, 1967), 63.

21 Ed Guerrero, *Framing Blackness* (Philadelphia: Temple University Press, 1993), 72.

22 Goudsouzian *Sidney Poitier*, 221.

23 Donald Bogle, *Toms, Mulattoes, Mammies and Bucks*, 178.

24 Harry Belafonte felt that Poitier's darker complexion served as an advantage in being casted for race problem films. *My Song* (New York: Knopf, 2011), 208.

25 Charles Johnson, "A Phenomenology of the Black Body," in Rudolph P. Byrd and Beverly Guy-Sheftall (eds), *Traps: African American Men on Gender and Sexuality* (Bloomington: Indiana University Press, 2001), 229.

26 Frantz Fanon, *Black Skin, White Masks*, 116.

27 As Ben Arogundade puts it "Sidney was the sex symbol without sex." He also notes that he was "Hollywood's first major black male sex symbol, although not by design. . . . His promotion was not intended to have a sexual or beauty-related purpose, but to preserve the aesthetic order." *Black Beauty* (London: Pavilion, 2000), 86.

28 Aram Goudsouzian, *This Life*, 241.

29 Georges Bataille, "Men are swayed by two simultaneous emotions: they are driven away by terror and drawn by an awed fascination. Taboo and transgression reflect these two contradictory urges." *Erotism: Death and Sensuality* (San Francisco: City Lights, 1986), 68. As Linda Williams puts it, "The truly successful erotic transgression is one that maintains the emotional force of the prohibition." *Screening Sex* (Durham: Duke University Press, 2008), 15.

30 James Baldwin asserted that "Poitier's presence gives the film its only real virility." "This virility," Baldwin asserts, "is not the least compromised by the fact that has no woman, visibly . . ." *The Devil Finds Work* (New York: Dell, 1976), 55.

31 Susan Courtney, *Hollywood Fantasies of Miscegenation: Spectacular Narratives of Gender and Race, 1903–1967* (Princeton: Princeton University Press, 2005), 268.

32 Linda Williams, *Screening Sex*, 39–40.

33 Larry Neal, "Beware of the Tar Baby," *The New York Times*, August 3, 1969, D13.

34 Aram Goudsouzian, *Sidney Poitier*, 323.

35 Sidney Poitier, *This Life*, 337.

36 Donald Bogle, *Toms, Coons, Mulattoes, Mammies and Bucks*, 234.

37 Lerone Bennett, Jr., "The Emancipation Orgasm: Sweetack in Wonderland," *Ebony*, September, 1971, 110.

38 Sidney Poitier, *This Life*, 338.

39 Ibid., 338.

40 Renata Adler, "'Ivy,' or One Step At a Time?," *New York Times*, August 18, 1968, D1.

41 Mark Anthony Neal, *Soul Babies: Black Popular Culture and the Post-Soul Aesthetic* (New York: Routledge, 2002), 31–2.

Bibliography

Adler, Renata. "'Ivy,' or One Step at a Time," *New York Times*, August 18, 1968, D1.

Alexander, Michelle. *The New Jim Crow: Mass Incarceration in the Age of Colorblindness* (New York: The New Press, 2010).

Arogundade, Ben. *Black Beauty* (London: Pavilion, 2000).

Baldwin, James. *The Devil Finds Work: Essays* (New York: Dell, 1976).

Barthel, Joan. "He Doesn't Want to be Sexless Sidney," *New York Times*, August 6, 1967.

Bataille, Georges. *Erotism: Death and Sensuality* (San Francisco: City Lights, 1986).

Belafonte, Harry and Michael Shnayerson. *My Song: A Memoir* (New York: Knopf, 2011).

Bennett, Lerone, Jr. "The Emancipation Orgasm: Sweetback in Wonderland," *Ebony*, September, 1971, 106–18.

Bogle, Donald. *Toms, Mulattoes, Coons and Bucks* (New York: Continuum, 2003).

Collins, Patricia Hill. *Black Sexual Politics: African Americans, Gender and the New Racism* (New York: Routledge. 2004).

Courtney, Susan. *Hollywood Fantasies of Miscegenation: Spectacular Narratives of Gender and Race, 1903–1967* (Princeton: Princeton University Press, 2005).

Elliston, Maxine Hall. "Two Poitier Films." *Film Comment* 5, 4 (Winter 1969): 28.

Goudsouzian, Aram. *Sidney Poitier: Man, Actor, Icon* (Chapel Hill: University of North Carolina Press, 2004).

Guerrero Ed. *Framing Blackness* (Philadelphia: Temple University Press, 1993).

—"The Black Image in Protective Custody: Hollywood's Biracial Buddy Films of the 1980s," in Manthia Diawara (ed.), *Black American Cinema* (New York: Routledge, 1993), 237–46.

hooks, bell. *We Real Cool* (New York: Routledge, 2004).

Johnson, Charles. "A Phenomenology of the Black Body," in Rudolph P. Byrd and Beverly Guy-Sheftall (eds), *Traps: African American Men on Gender and Sexuality* (Bloomington: Indiana University Press, 2001), 223–35.

Jones, Jacqui. "The Construction of Black Sexuality," in Manthia Diawara (ed.), *Black American Cinema* (New York: Routledge, 1993), 247–56.

Mason, Clifford. "Why Do White People Love Sidney Poitier So?" *New York Times*, September 10, 1967.

Neal, Mark Anthony. *Soul Babies: Black Popular Culture and the Post-Soul Aesthetic* (New York: Routledge, 2002).

Poitier, Sidney. *This Life* (New York: Bantam, 1980).

—*The Measure of a Man* (New York: HarperCollins, 2000).

Reid, Mark A. *PostNegritude Visual and Literary Culture* (Albany: State University of New York Press, 1997).

West, Cornell. "Black Sexuality:The Taboo Subject," in Rudolph P. Byrd and Beverly Guy-Sheftall (eds), *Traps: African American Men on Gender and Sexuality* (Bloomington: Indiana University Press, 2001), 301–7.

"Black Masculinity on Horseback: From *Duel at Diablo* to *Buck and the Preacher* . . . and Beyond"

Mia Mask

In making Buck and the Preacher, *Poitier achieved several important goals. He established himself as a competent director and cemented his links to the black community. Even normally hostile militants like Donald Bogle were swayed by this film. Bogle declared it [was] "one of the more pleasant surprises of the new decade," noting that: "Here the fine American actor attempts to redeem himself and re-establish his roots with the black community. His character not only questions the inhuman white system and his white oppressors, but also takes direct action against them." As a result, Bogle observes, Poitier regained the audience his recent films had been alienating, the young urban black audience. "Black audiences openly screamed out in joy, and* Buck and the Preacher *emerged as a solid hit with the community."*
Lester Keyser and Andre Ruszkowski, *The Cinema of Sidney Poitier*

Between 1966 and 1972, Sidney Poitier starred in ten films, two of which were Western genre pictures: *Duel at Diablo* (1966) and *Buck and the Preacher* (1972). These two motion pictures were not merely star vehicles for the actor, who, in 1967, was the most successful Hollywood leading man thanks to three groundbreaking albeit fraught releases (*Guess Who's Coming to Dinner, To Sir, with Love,* and *In the Heat of the Night*). *Buck and the Preacher* is also Poitier's directorial debut. It is significant that Poitier chose to make his directing debut within this particular genre. After all, the Western genre is central to the hallowed notions of national culture, to nation and narration, and to theories of development. More specifically, this genre is imbricated in American myths

of the frontier. It engages shifting notions of masculinity; it's central to the enterprise of US imperialism; it's predicated on the ideology of Manifest Destiny, and has—in some cases—supplanted actual historical memory.

Historian Richard Slotkin has written critically and influentially about the myth of the frontier and its relationship to theories of development. "The Myth of the Frontier," for Slotkin, "is the American version of the larger myth-ideological system generated by the social conflicts that attended the modernization of the Western nations, the emergence of capitalist economies and nation-states."[1] To Slotkin's sweeping theory of development, I would add one specification regarding nation as it pertains to racial demographics. The myth-ideological system, of which he speaks, enacted a range of historical erasures with respect to African American participation in the development of the West. The cultural dimensions of myth are certainly not unfamiliar to Slotkin. "Myth performs," he writes, "its cultural function by generalizing particular and contingent experiences into the bases of universal rules of understanding and conduct; and it does this by transforming secular history into a body of sacred and sanctifying legends."[2] These sacred and sanctifying legends, their mythic landscapes and settings, as well as the concomitant fantasies of mastery that naturalized their ideology enamored a young, impressionable Sidney Poitier. He was struck by the image of America therein depicted; he was impressed by the African American participation in the West depicted on the silver screen, which he longed to see.

The Western as a cinematic genre has historically depicted an American society organized around codes of honor and personal, direct, or private justice, rather than rationalistic, abstract law, in which persons have no social order larger than their immediate peers, family, or themselves alone. Most Western films primarily offer narratives about European American settlers and their conquest of nature and the sovereignty of Native Americans. To many spectators, these motion pictures are precisely what Ward Churchill aptly describes in his book: *Fantasies of the Master Race: Literature, Cinema and the Colonization of American Indians*. Joanna Hearn makes a similar argument in her essay on silent Westerns. Beginning with the earliest silent films, Westerns were, according to Hearne, "a window on Euro-American popular culture representations of the encounter between tribal peoples and the United States military and educational establishments."[3]

As tales of wagon train expeditions (*The Big Trail*, 1930; *Covered Wagon*, 1923), settler journeys through hostile territory (*The Battle at Elderbush Gulch*, 1913; *Stagecoach*, 1939; *Fort Apache*, 1948), cross-country cattle drives (*Red River*,

1948), cavalry pictures (*Fort Apache*, 1948; *She Wore a Yellow Ribbon*, 1949; *Rio Grande*, 1950), settler culture, (*Destry Rides Again*, 1939; *Shane*, 1953), lynching parables (*The Ox-Bow Incident*, 1943; *The Unforgiven*, 1960; *Rosewood*, 1997), frontier injustice (*Jonny Guitar*, 1954; *The Searchers*, 1956; *The Unforgiven*, 1960; *Flaming Star*, 1960; *Heaven's Gate*, 1980), these genre films often revolved around the struggle of the lone, seminomadic wanderer: a gunfighter who valiantly defended his interests and those of the underdog or small, aggrieved parties (i.e., the family farmer, the homesteader, or common family man and his brood).[4] There are certainly many variations on the Western theme: the gunfighter Western, the *noir* Western, the melodramatic Western, the musical comedy, and the feminist Western. Given the genre's shameful history as a constituent component of colonial discourse and imperial enterprise, spectators are often surprised to discover black-cast Westerns from the 1930s and 1940s or the fact that Poitier starred in Western genre pictures.

But for Sidney Poitier, movies—and Westerns in particular—were also constitutive of American culture. To him they were a part of the myth-ideological system even though he did not articulate this connection in such terms. The films were associated with the hope, promise, and enterprising spirit signified by the Great Plains, by Monument Valley, and by the American landscape. Against the backdrop of this physical landscape, he believed Westerns could transform secular history into a body of sacred and sanctifying legends about black freedom, racial uplift from slavery, and national reimagining despite the atrocities of slavery.

Poitier knew that there was more to the west and to westward expansion than narratives of American imperialism, masculine prowess, the taming of the wilderness, and the settlement of the territories through the subordination of nature and the Natives in the name of Manifest Destiny. The dispossession of Native peoples, the confiscation of their territorial rights as indigenous peoples, and their gradual annihilation was considered collateral damage justified by the narrative strategies and rhetoric of empire. Consequently, in his two Western genre vehicles—but particularly *Buck and the Preacher*—Poitier sought to offer another vision of the west frontier, another model of the Western hero.

Poitier's Western star vehicles should interest us for several reasons. First, the Western is the quintessential American genre. It is the place where the "fundamental national ideals have been established."[5] His attempt to broaden this genre demonstrates his commitment to depict African American experience as constitutive of this national diasporic folklore. His participation was not naive or

uncritical of the myth-ideological system. Having been ruthlessly criticized for his assimilationist starring roles in many pictures, he was aware of the politics and ideology embedded in motion pictures and their global dispersal. As Lester Keyser and Andre Ruszkowski have documented, "Poitier wasn't fond of all the material in *Duel at Diablo* but he made it to restore an important piece of history and folklore to black people."[6] One of Poitier's primary aims in working in Westerns was to amend and complicate the cinematic record.

Second, these movies interest us because they held personal significance for Poitier. They marked the beginning of his personal connection to cinema at key junctures. It was in Nassau, Bahamas, that a young Sidney Poitier was first exposed to the movies, becoming an avid fan. According to biographer Carol Bergman, "He saw many Westerns starring such cowboy film idols as Tom Mix, Bob Steele, Gene Autry and Roy Rogers. Mesmerized by these gunslingers who seemed so real to him on the screen . . . he decided someday he would like to move to Hollywood, which he believed was the home of all cowboys. Caught up in the mannerisms of Westerns, he developed a swagger of his own, which he used to impress the local girls."[7] In some ways, the Western was partially impetus for, or the boyhood origin of, Sidney Poitier's movie career.

Third, this is the genre in which he would make his directorial debut. Joe Sargent was *Buck and the Preacher*'s original director. But it was Poitier who would bring the movie to fruition. Thus, the Western marks his movement from being a performing actor to a contemplative director, launching another phase of his distinctive career.

Poitier's Western vehicles are intriguing because the genre is rife with ideological contradictions. In terms of classical Hollywood filmmaking, the Western represents the best of times and the worst of times. From an industrial standpoint, the Western was *the* most commercially successful genre. But from a postcolonial standpoint—from the perspective of viewers of color—the Western has represented the cinematic imperial imaginary (the tropes, metaphors, and allegorical motifs constitutive of Euro-American superiority).[8] In their deconstruction of the Western genre, numerous scholars (i.e., Ward Churchill 1992; Shohat and Stam 1994; Jacqueline Kilpatrick 1999; Angela Aleiss 2005, etc.) have noted that it is a genre that spectacularized colonial domination while sustaining the film industry financially. How did Poitier negotiate the contradictions?

Poitier's appearance as a leading actor in these movies was always-already contradictory, a disruptive speech act, and an oxymoronic utterance. On the

one hand, his presence in these pictures was an intervention that problematized the hegemonic construction and representation of the West in history and film discourses. His presence in these films requires that we recall the "real," albeit problematic, existence, sacrifice, and patriotism of "Buffalo Soldiers" (the 9th and 10th Cavalry, the 24th and 25th Infantry regiments), "Black Rough Riders,"[9] and African American entrepreneurs[10] in the West, that were *not* fictionalized as "reel" screen characters.

This point is clearly expressed in the work of Christine Bold in her essay, "Where Did the Black Rough Riders Go?" She opens her essay thus:

> In 1898, for example, the African American Ninth and Tenth Cavalry rode into Cuba as part of what was widely trumpeted as the United States' first overseas war. Almost one hundred years later, they rode out as a band of vigilantes, intent on taking revenge for white racist violence, in Mario Van Peebles film *Posse* (1993). What happened to them between these two moments—representationally and actually—reveals a central racial dynamic in the making of US mass culture.[11]

Similarly, the scholarship of Quintard Taylor calls to mind the erasure of the history of black experience in the West. For Taylor, the saga of African American experience in the West began in November 1528 with the experiences of an African slave who came ashore in Galveston, Texas, as one of the survivors of an ill-fated expedition of 260 men that began in Havana, Cuba, 8 months earlier.[12] Taylor recounts the experiences of men who played crucial roles in Western history, some of whom moved to the Rocky Mountains and Pacific Northwest or settled in Montana, Santa Fe, and New Mexico during the antebellum years.

Another way of looking at these Western films in light of the repressed history is to recognize that Poitier's work renders visible the invisibility of blackness and black history in popular film and memory. The mise-en-scène of the frontier in mainstream movies is almost always a landscape populated by salt-of-the-earth Euro-American settlers, honor-bound gunslingers, and supposedly savage Indians. So, it's not only that the Native Americans are grossly misrepresented in the genre but also that African Americans—in all their complicity with the US government as cavalrymen and as doubly conscious subjects—are completely absent. Poitier's casting and performance is a progressive disruption of the otherwise regressively homogenous fantasy of American masculinity and chivalry expressed through the trope of the Western hero.

While his presence in a Western like *Duel at Diablo* could be read as a capitulation to the Hollywood status quo, and the imperial cultural imaginary,

a close historical interpretation of *Duel at Diablo* and *Buck and the Preacher* includes acknowledgment and discussion of these films as *revisionist* Westerns and as articulations of the anti-Western.

According to genre theorist John Cawelti, the revisionist Western emerged partially as a response to classic Westerns as the genre evolved. Revisionist genre pictures often assume an oppositional or negotiated[13] approach to the dominant cinematic paradigm and its narrative conventions. They offer an alternative episteme, a new way of looking at the subject, often incorporating heretofore-taboo, repressed, or radically unconventional themes, ideas, and aesthetics. Revisionist films jettison the stereotypes of Native Americans as savages—noble or otherwise. Revisionist Westerns also modify some of the hallowed tropes of the genre including the depiction of the Western hero.

The term "anti-Western" overlaps with the notion of revisionism. It refers to those films released between the late 1960s and early 1970s. It earmarks movies that sought to question the ideals and style of the traditional genre pictures with a darker, more cynical tone, with a focus on the lawlessness of the period. It encompasses films favoring realism over romanticism. In this case, it refers to the Westerns in which antiheroes are common, as are stronger roles for women and more sympathetic portrayals of American Indians, Mexicans, and African Americans.[14] The presence of Buffalo Soldiers, Rough Riders, and black entrepreneurs in Western genre films like *Duel at Diablo, Buck in the Preacher, Posse,* or *Rosewood* make these movies examples of the kind of generic revisionism discussed here. Furthermore, the inclusion of these subjects ironically renders revisionist pictures more historically accurate than their mainstream counterparts.

Duel at Diablo (1966)

Released in 1966, *Duel at Diablo* emerged at the time when the Western genre was already undergoing significant revision. Only 6 years earlier, United Artists released *The Unforgiven* (John Huston 1960) starring Burt Lancaster and Audrey Hepburn in an adaptation of Alan Le May's novel about an Indian foundling adopted by the Zacharys, a white family. Westerns after 1955 began to underscore the predicament of human nature and a sense of searching, as the films included more controversial themes such as racial prejudice, marital infidelity, rape, cowardly citizens, emotionally deranged characters, and graphic

violence. Those elements had never been entirely absent from Westerns prior to 1955, but after that year the implicit and the suggested became more explicit.[15] Westerns of the late 1950s and 1960s had heroes, but they were different from the traditional Western heroes. *The Unforgiven* (1960), like *The Searchers* (1956) before it, presented antiheroes. The classical Western hero, with superior moral qualities, like Will Kane of *High Noon* (Fred Zinnemann 1952), were—by now— long gone. The new protagonists and antiheroes were flawed figures; they were even men with inferior moral qualities who were looked down upon or held in contempt by other members of the community.

The Unforgiven questions the morality of the white homesteaders in a tale about a settler family and their adopted Indian daughter, Rachel. When the story begins, the Zacharys are a thriving and respected family on the Texas frontier. Yet when rumors of the young woman's Indian heritage begin spreading among white townsfolk, it sets off a series of events that culminates in the formation of a lynch mob. Years earlier, Rachel's father, Will Zachary, was killed by Kiowa Indians, leaving his oldest son Ben (Burt Lancaster) as the family patriarch. Ranchers from all around gather to prepare for a cattle drive to Wichita, Kansas. An old man, Abe Kelsey, who is believed to be crazy, hides in the brush nearby after claiming that Rachel Zachary is a Kiowa Indian. Her brothers Ben and Cash, believing the story to be a vengeful lie, try to kill old man Kelsey. Suddenly, a small group of Kiowa appears one night offering to trade horses with Ben in return for Rachel, claiming that old Kelsey told them that Rachel is *actually* their long-lost Kiowa sister. Soon after their offer to trade is rebuked, marauding Kiowa kill Charlie when he is returning to his ranch. In her grief, Charlie's mother accuses Rachel of being a "dirty Injun" and therefore responsible for the Kiowa's retaliatory actions. Ben leads the ranchers in tracking down old Kelsey and bringing him back to the Rawlins ranch to be hanged as a horse thief (when his real motive is vengeance). With a noose around his neck, old man Kelsey tells the gathered posse that, on an avenging raid against Kiowas led by himself and Will Zachary, Will found an infant and took the baby for his own. Kelsey's last confession, uttered with a noose around his neck, solidifies the rumors around Rachel and ignites white racism against the remaining Zachery clan.

The Unforgiven (1960) was also similar to *The Searchers* (1956) in that it revealed the alignment of antiblack and anti-Indian sentiments within the American mainstream community more blatantly than did previous Westerns. It depicted antiblack and anti-Indian sentiments as coterminous, and as constitutive

of white supremacy. As Slotkin asserted, these themes always existed in the Western, but now they were more explicit and more clearly articulated. For example, in one scene, Charlie's mother, an older woman, grieving the loss of her son who died preserving Rachel's honor denounces Rachel in front of the entire town by calling her a "Red Nigger!" Like *The Unforgiven,* John Ford's *The Searchers* (1956) was also based on a novel by Le May.

As Brian Henderson's seminal essay on *The Searchers* has established, Ford's *Searchers* was a metaphor for contemporary 1950s racial politics (i.e., *Brown v. Board of Education of Topeka Kansas*). *The Searchers*—like *The Unforgiven* after it—becomes explicable, according to Henderson, only if we substitute black for red and read a film about red-white relations in 1898 as a film about black-white relations in 1956.[16] The point is simple: Westerns released after 1960 are films in which we witness generic transformation, historical revisionism, metaphors for civil rights activism, and a shift in tone.[17] Sidney Poitier's star vehicles *Duel at Diablo* (1966) and *Buck and the Preacher* (1972) manifest generic transformation and overt evocations of civil rights discourse just like *The Unforgiven* and *The Searchers* did years earlier.

Figure 19 Poitier and Garner in *Duel at Diablo.*

Scholarly and biographical accounts of Poitier's work gloss over or omit the Westerns, viewing them as less important than other films in his oeuvre. *Diablo* and *Buck* are not as well known as social problem pictures like *The Defiant Ones* (1958), for which Poitier became the first black male actor to be nominated for an Academy Award. They are not as celebrated as *Lilies of the Field* (1963), for which he made history by becoming the first African American to win a Best Actor Oscar. They are not as historic as his performances in the first production of *A Raisin in the Sun* on Broadway (1959) and the film adaptation released in 1961. Nor are they as popular as the top three 1967 releases (i.e., *Guess Who's Coming to Dinner, In the Heat of the Night*, and *To Sir, with Love*) that made him the number one box-office star and the most popular film personality (of any race) that year. Finally, they are not as controversial as the overanalyzed, taboo-breaking *Guess Who's Coming to Dinner*. However, they are central to the scope and complexity of his star persona because they are part of the way he broadened the repertoire of black masculinity in cinema. The generic shifts apparent in films like *The Searchers* and *The Unforgiven*, coupled with the emergence of Italian, Spanish, and East German Westerns throughout Europe and the United States, demonstrated that the Western could and should also reflect African American characters, protagonists, and heroes.

Based on Marvin Albert best-selling novel, *Apache Rising, Duel at Diablo* is set in 1880. *Diablo's* credit sequence begins after lone, Utah frontier scout, Jess Remsberg (James Garner), is shown surveying a desolate valley. Through his binoculars, he discovers the body of a white man still hanging upside down from and Indian tipi cross. Further in the distance, he sees a lone mounted rider, crossing the desert plain on a thirsty horse. When the rider's horse collapses, the man is pursued by two Apaches who emerge from hiding. Jess guns them down and rescues the exhausted rider whom he discovers is a beautiful young woman named Ellen Grange (played by Ingmar Bergman's Swedish muse, bombshell Bibi Andersson). As they gallop across the plains to safety, celebrated composer Neal Hefti's orchestral score swells in the background to kickoff the credit sequence. Of the opening sequence and its musical tones critic Deborah Allison writes[18]:

> Ralph Nelson's *Duel at Diablo* (1966), which tracks the course of a barely visible rider, makes particularly explicit the filmic attraction of the landscape itself: its stunning cinematography is coupled with a title announcing the shooting location. In the vastness of such terrains as these, the riders are shown to be both bold and vulnerable.[19]

Like the sharp, deep-focus cinematography, the opening music is noteworthy. To begin, it was composed and conducted by Hefti who had arranged some of the biggest name bands in the country before he went on to become one of the most prolific writers of modern music. His most recent hit was the Academy Award nominated song, "What's New Pussycat!" In the movie's press kit, the score and theme song are described as featuring "a new musical approach."

The approach included introducing folk rock as well as R&B-inspired motifs. This newer, hipper score was designed to attract younger audiences: members of the Beat Generation. Central elements of "Beat" culture included rejection of received standards, innovations in style, experimentation with drugs, alternative sexualities, increased racial tolerance, an interest in religious exploration, a rejection of materialism, and explicit portrayals of the human condition. The sound track altered the tone and tenor of the film in a way consistent with *Duel at Diablo*'s themes of greater racial tolerance, accepting interracial relationships, recognition of mixed-race children, and more open-mindedness. All these themes were linked, in one way or another, to Poitier's character in the film and to the generic revisionism already in motion.

Not everyone appreciated this new musical approach. Neal Hefti's use of guitars evokes the soundtracks of Spaghetti Western, which were newly emerging and quickly becoming immensely popular. In 1964, Italian director Sergio Leone hired, and began collaborating with, composer Ennio Morricone to create a distinctive score for his innovative Western, *A Fistful of Dollars*. With the score for *A Fistful of Dollars*, Morricone began his 20-year collaboration with his childhood friend Alessandro Alessandroni. Alessandroni provided the whistling and the twanging guitar on the film scores. Morricone's orchestration called for an unusual combination of instruments and voices. Alessandroni's twangy guitar riff was also central to the main theme for *The Good, the Bad, and the Ugly* (1966). And, he can be heard as the whistler on the soundtracks for Sergio Leone's films *A Fistful of Dollars* (1964), *For a Few Dollars More* (1965), *Once Upon a Time in the West* (1968), and many others. He founded "I Cantori Moderni," an eight-singers choir, in 1961.

The first mainstream, crossover Spaghetti Western, *A Fistful of Dollars*, was released in Italy in 1964 and in the United States in 1967. At least one reviewer noted how much *Duel at Diablo* as a movie resembles (and to a lesser extent sounds like) a Spaghetti Western: "Though the Spaghetti Western had not yet fully penetrated the United States, it is clear in 1966 the genre was starting to have an influence on American directors."[20]

In fact, Spaghetti Westerns were beginning to have an impact on American directors. The influence of these films on *Diablo* can be seen even before the opening credit title sequence, as the screen displaying the Universal Studios logo is cut and penetrated from behind the screen by a long scalping knife with fresh blood dripping from it. This moment of playful generic self-reflexivity recalls other Western films with similarly playful title sequences. The 1965 Western comedy *Cat Ballou,* directed by Elliot Silverstein, opens with a similarly playful animated cartoon version of the Columbia Pictures' Torch Lady logo. At the beginning of *Cat Ballou,* the Torch Lady morphs into an animated version of herself, strips off her toga to reveal a cowgirl uniform, and starts shooting like Annie Oakley. Twenty seconds into the picture they have already established the tone of the film.[21] These kinds of playful credit sequences were characteristic of Spaghetti Westerns too. Leone's "Dollars Trilogy" was known for its abstract, cartoon title sequences.

After the title credits roll, the story of *Duel at Diablo* unfolds at Fort Concho. Colonel Foster, played by director Ralph Nelson, runs the fort. Jess Remsberg returns Ellen to her embittered husband Willard Grange (Dennis Weaver a.k.a "Chester" of TV's "Gunsmoke"). Her husband has grown resentful of his wife, whom he now considers "ruined" after her capture by Indians confirms she's been "taken,"—code for interracial sex and violation of the miscegenation taboo. It isn't until later that Willard and the others will learn that Ellen has given birth to a half-Indian child. The acceptance of Ellen's child becomes a major plot point later in the picture.

Back at Fort Concho, Colonel Foster requires Jess Remsberg to scout for an expedition led by Lieutenant Scotty McAllister (Bill Travers). Jess incidentally reports that he found McAllister's former scout, Tom Vance, hanged by Apaches. An Indian sympathizer who stands for greater racial tolerance, Jess has married a Comanche woman. But he is reluctant to help Scotty on any military expedition because he's recently learned that a white man killed his wife during a raid on her community. Herein lies the film's reversal of Western generic codes because it positions white racial bigotry and retaliatory violence as equally unjust.

Reluctantly, Jess Remsberg agrees to guide Lieutenant McAllister's expedition to move ammunition and water through hostile territory, hoping to save Ellen—who has since secretly absconded from Fort Concho to find her baby. Former Buffalo Soldier and Tenth Cavalry veteran, Sergeant Toller (Sidney Poitier), also rides along reluctantly.[22] Retired from military service, Poitier's Toller is now a

horse-wrangler hired by the army to break, train, and deliver 40 mounts for the US Cavalry. Toller wants no part of the military but it's the only way to collect what he's owed for the horses. After reconciling a misunderstanding about Jess's murdered wife, Toller and Remsberg become allies (in what might be one of the first iterations of the interracial buddy film genre).[23]

Meanwhile, Ellen returns to Indian chief Chata and his people, hoping to reunite with her infant son. But her return is met with hostility and the threat of vivisepulture. Chata's hostility toward Ellen, and his promise to bury her alive, marks a turning point of audience sympathy in this film. Whereas Jess Remsberg functioned as the liminal figure (the trope of the-white-man-gone-native), and while Ellen's abuse at the fort was proof whites could behave more savagely than Indians, Chata's threat to bury Ellen alive trumps these other aggressions and subverts the film's suggestion of Indian civility.

As McAllister's expedition enters hostile Indian territory, Poitier's Toller rides along. On the way, he's sent on a suicide mission into a trap laid for the cavalry. The Apache hide, allowing him to pass only to entrap the cavalry and their supply wagons once they follow behind. When the Apache fire ignites, Toller doubles back to fight and defend white interests, aiding the cavalry. Herein lies the complex and contradictory nature of African American participation in the Indian Wars as Buffalo Soldiers and US citizens. Both Poitier's Toller and Garner's Remsberg respect Native Americans' quest for sovereignty. This is demonstrated when Ellen ashamedly asks: "Do you think they'll stay on the reservation this time?" "Why *should* they?," Jess bitterly responds. It is also demonstrated when Toller confronts Ellen's husband, Will, for his anti-Indian racism and mistreatment of her infant son. Like Jess, Poitier's Toller is the voice of racial *tole*rance within the white community. He defends her from, and disarms, the threatening Will Grange. But his actions are contradicted by other actions. Toller's very first line in *Duel* is to ask: "How much for that scalp?" He unknowingly inquires about a trophy taken from Jess's murdered wife.

Though the film portrays Toller as more tolerant than most white men, the myth of Indian instigation overtakes the film's narrative. As such, the movie conforms to hegemonic discourses of anti-Indian American imperialism.

Eventually, the US Cavalry, Toller, and Ellen find themselves bunkered in at a makeshift fort. Under continual enemy fire, the US Cavalrymen prove no match for the warring Apaches. One by one they are picked off. Lieutenant Scotty McAllister suffers a broken leg in the crossfire. During an extended 2-day shootout, Toller guides the men but they are outnumbered. Will Grange is

Figure 20 Poitier plays Toller in *Duel at Diablo.*

captured and tortured. Lieutenant Scotty McAllister dies from his wounds. Even Toller is wounded when an arrow penetrates his arm. He and Ellen soon realize they are the remaining survivors. Encircled by enemy arrows, Toller helps Ellen hide her baby in a safe place. Herein *Duel at Diablo* reproduces the "imagery of encirclement," a conventional visual trope of the Western genre. Wounded, and low on ammunition, they are finally rescued by additional US Cavalry led by Jess Remsberg who has finally returned from avenging his wife's murder.

At the time of its release, audiences responded to *Duel at Diablo* with some skepticism. Authors Lester Keyser and Andre Ruszkowski noted that even with Poitier as a cavalry-trained gunfighter, there was, director Ralph Nelson revealed in an interview, a good deal of audience backlash. "In *Duel at Diablo,* the audiences seemed to have been surprised and skeptical about the presence of a Negro cowboy." But Nelson and Poitier—who had collaborated previously

on the Academy Award–winning *Lilies of the Field*—based Poitier's character Toller on a book titled *The Negro Cowboy*, a recent publication by University of California Professors Philip Durham and Everett Jones, which was serialized by several newspapers around the time of *Duel*'s release. *The Negro Cowboy* was a powerful indictment of the omissions and oversights of white historians.[24]

Even with this attempt at realism, some film critics felt Poitier failed to project virile masculinity. In fact, one critic went so far as to assert that Poitier appears "as a rather dandified Army veteran." Such criticism questioned his character's masculinity by implying his effeminacy. Indeed, his character Toller remains remarkably unsullied until the final scenes of the film. This criticism dovetails with film historian Ed Guerreo's assertion that "the conventions of the war story and the Western isolate Poitier from romantic encounters."[25] Heterosexual coupling has long been the conventional way virility is visualized in American film. For Poitier to be without a romantic interest was to render him less manly and suspect. But to cast him opposite white women as love interests positioned him as a sellout. Taking these criticisms of inefficacy and impotence one-step further, African American playwright Clifford Mason wrote:

> In *Duel at Diablo* (Poitier) did little more than hold Garner's hat, and this after he had won the Academy Award. What white romantic actor would take a part like that? He gets to kill a few Indians, but Garner gets the girl and does all the fighting. Poitier was simply dressed up in a fancy suit with a cigar stuck in his mouth and a new felt hat on his head.[26]

Throughout the 1960s, Mason was one of Poitier's most outspoken critics. He always found Poitier lacking in political zeal, charismatic appeal, and black masculine prowess no matter what role he played. However, it is possible to view Poitier's work here, and elsewhere, as a hegemonic negotiation to use Stuart Hall's paradigm. Arguably, Poitier's character Toller is in negotiation with white masculinity, with white supremacy, with Manifest Destiny, and with the sacred and sanctified legends upon which the Western genre is predicated. To address Mason's specific criticism of effeminacy I would offer one key scene, which contradicts the claim that he's weak and unmanly.

In a scene that demonstrates Toller's horsemanship, bravery, and endurance, he is shown riding and training unbroken, bucking horses. Arguably, this scene—perhaps more than some others—functions to validate Poitier's Toller as a Westerner, as a cowboy, and as a physically virile specimen of a man. His ability

to ride, tame, and break these horses stands in synecdochically for the lore, the landscape, and the lifestyle of the Western frontier. And, while his work with these animals does position him as a "cowboy" rather than a "cattleman" with all that Steven Cohan says this distinction implies,[27] it is an attempt to reflect some of the real labor performed by blacks on the frontier. It's proof not only of the character's masculinity but also of Toller's ability to domesticate, cultivate, and tame the Wild West.

It is important to note that women and romantic entanglements have long been peripheral to the main themes featured in the Western genre. To know the Western genre well is to know that women and heterosexual romance—perhaps more than anything else—symbolized the domestication of virile masculinity rather than its actualization. Therefore, this might be the one instance where Poitier's missing love interest is not an indication of his emasculation. In his book, *The Invention of the Western Film,* Scott Simmon makes an important observation: "There is little denying that the woman in the A-Western is so marginalized that the very ideas she embodies prove unworthy even of synthesis into the films' resolutions."[28] Elsewhere in his tome, Simmon makes this point more emphatically when he writes:

> But the definitional antagonism of men and women in Westerns is never used as dynamically as it is routinely in Hollywood's other genres to explore conflicting ideas. When the man and woman come together at the end of a Western, it's without the satisfying reconciliations that end, say, a Katherine Hepburn—Cary Grant screwball comedy or an Astaire—Rogers musical. "Cowboys don't get married—unless they stop being cowboys."[29]

In the Western movie, involvement with women is represented as encumbrance rather than free-spirited manliness.

Seeing Poitier and his stunt double (the world-famous black rodeo champion Roy Quirk)[30] subdue the bucking broncos evokes the memorable equestrian theatrics of John Ford's famous film *Rio Grande* (1950), the third installment of Ford's cavalry trilogy in which young, able-bodied cavalry recruits ride Roman style over fences. Suffice it to say, good horsemanship has always been a tenant of the genre and proof of one's masculinity. This scene and the film in general make an intervention. They link the African American presence in the West and Poitier's star persona to the mythic mise-en-scène of Western heroics.

Not insignificantly, Toller's disciplining of these horses is echoed in a later scene when Will Grange steps out of line. Toller is the only man on the expedition

to strip Will's gun and make him stand down. It's a scene in which Toller "breaks" Will the way he broke the defiant will of the wild horses. In the process, he simultaneously defends the rights of women, mothers, children, and those marked as racially other against the racism and sexism exhibited by Grange. Thus, to disagree with Clifford Mason, Poitier's masculinity is not constructed as deficient by the narrative of the film.

What was confusing for the 1960s civil rights minded audiences was that Poitier's Toller joined forces with white men against Indians—something Poitier would overturn with his next foray into the genre, his directorial debut: *Buck and The Preacher*.

Buck and the Preacher (1972)

In 1970, Poitier was slated to star in *Buck and the Preacher*. In an interview for the documentary, *Sidney Poitier: One Bright Light* (Lee Grant 2000) the actor-director-producer admits that friend Harry Belafonte approached him with the idea for the film. "There had never been a film about the relationship between blacks and Indians," he tells the interviewer. Based on the story written and researched by black writer (and assistant director) Drake Walker, *Buck and the Preacher* addresses this void in American history and film. Initially, Joseph Sargent was chosen by Poitier and Belafonte to direct. But when the rushes for the early scenes came in, they were disappointed. One week after the crew arrived in Durango, Mexico (a town an hour by air, northwest of Mexico City), Poitier threw Sargent a party and let him go.

According to many accounts Poitier had an "almost . . . maniacal devotion to the project and to the integrity of a black vision of the West. . . ." According to Sargent, it was Poitier who

> had breathed and lived with it since its conception. No one knew the material better than he did. He should be the man to put it on the screen. In no way would it work with another director. He had thought it all out beforehand, and whenever I wanted to change that concept, I met with resistance. It's his film. It's as simple as that, and there was nothing racial about it whatever.[31]

While Sargent completely believed that racial politics played no role, all accounts confirm that Poitier did want to make a particular kind of ideological intervention with this genre film. He wanted to rewrite the sacred and sanctified

legends of early American history on film. He wanted to see the black American journey and contribution to Western United States presented on film.

Look journalist George Goodman told yet another story. In his beautifully illustrated article, Goodman claimed that Sargent's dismissal was because he was shooting it like a TV show.[32] Goodman reported Poitier flatly telling Belafonte: "We might as well face it. We needed a black man for a sensitive job about black people."

By this point in his career, Poitier had formed *E and R Productions,* using his parents' Reginald and Evelyn's initials. E & R Productions would—Poitier told the press—"make films that show a truer picture of American Negroes to movie audiences."[33] A few years earlier while working on the movie *Brother John,* executive producer Joel Glickman and Sidney Poitier started an apprentice program to train film technicians. They recruited and hired novices, or trainees, paying them $150 a week plus living expenses.

The goal was to break the barriers created by Hollywood's complex unionization system, which systematically excluded minority groups—particularly African Americans. Addressing this very issue, Glickman was quoted as saying: "You can't do big period Westerns in the States anymore. The costs are prohibitive. And, the Hollywood unions have to realize they no longer have a majority on the technical expertise."[34] According to the author of the *Variety* article in which Glickman was quoted, the "Mexican union regulations require a full Mexican crew, but as on all American productions there is a nucleus supervisory crew brought from Hollywood. The unique thing about *Buck and the Preacher* is that half of that nucleus of production personnel, the stuntmen and the cast are black." Still, with the apprentice program in place, barriers remained. "Even if the trainees get their cards," said Glickman, "they're still bucking the seniority list, which is an outdated, medieval, system that has nothing to do with a man's creativity or skill. Everyman with a union card in his pocket in Hollywood should have the right to be employed on an equal basis, regardless of race, creed or color."[35] Thus with a budget of $2.5 million from Columbia Pictures, Poitier, his actors, and a predominantly Mexican crew were able to realize a goal that had heretofore eluded him.

In the film, Poitier portrays Buck, a former Union cavalryman who finds himself alive after the Civil War and decides to put his talents as an army scout to work as a wagon master leading newly freed slaves ("Exodusters") from the Louisiana territory to settle somewhere in the Northwest near Canada.[36] Along the trail, Buck encounters a jackleg minister going by the name "Preacher."

He is the self-appointed official of the "High and Low Order of the Holiness Persuasion Church." A seedy, itinerant evangelist, Preacher becomes Buck's comrade in arms.

Before joining the cast of *Buck and the Preacher*, Harry Belafonte had amassed wealth and fame singing in swank supper clubs. According to *Daily News* entertainment writer Wana Hale, Belafonte preferred singing to filmmaking. But when Poitier asked him to play the Preacher, and described the character he was to play, Belafonte was intrigued. "The Preacher is something different, and I wanted to give it a try, said Harry."[37] Belafonte's wife, Julie Robinson-Belafonte, portrays Sinsie, an Indian woman and an interpreter who speaks fluent English. In the film, Sinsie is the wife of an Apache Mescalero Indian chief played by Mexican actor Enrique Lucero.[38] Ruby Dee, Poitier's costar from *A Raisin in the Sun*, stars as Ruth, Buck's loving and cunning wife.

The very first title images in *Buck and the Preacher* are sepia-toned stills of African Americans driving wagon trains set against a Western landscape. This title sequence, like the reflexive title sequences in *Duel at Diablo, Cat Ballou*, The Dollars Trilogy, and *Butch Cassidy and the Sundance Kid*, also reveals generic reflexivity and revisionism. The opening credits roll to the folksy, syncopated rhythms by legendary jazz composer Benny Carter. Notable blues musicians Sonny Terry and Brownie McGhee performed on Carter's soundtrack. Terry, a blind African American Piedmont blues musician, played the memorable harmonica. He was widely known for his energetic blues harmonica style, which frequently included vocal whoops and hollers, and imitations of trains and foxhunts. This soulful soundtrack does for *Buck and the Preacher* what Ennio Morricone's whistler did for Sergio Leone's Dollars Trilogy. It lent a distinctive bluesy tone to the picture. It offered a twist on the conventional Western score that hinted at history and memory but with a new attitude.

Alex Phillips Jr.—the director of photography—manages a transition between these sepia title images and the opening scene, which gradually fades from sepia to color. This transition from sepia to color was used to great success in *Butch Cassidy and the Sundance Kid* (1969). The sepia-toned titles were compared to the sepia images in *Bonnie and Clyde* (1967)[39] and noted for the way they evoked nostalgia for the past and a confrontation with history.

The film opens on the small caravans of African American wagon trains moving northwest. En route, a posse of white mercenaries led by the villainous Deshay (Cameron Mitchell) rounds up. Deshay and his gang try to stop Buck

and the wagon train because his employers want to keep these former slaves working on the plantations they've left behind.

During one of the many white raids on the black wagon train, the ruthless gang overturn family wagons, kill the livestock, shoot men, women, and children, and burn grain in an effort to deter the newly manumitted slaves from seeking greener pastures. Deshay dutifully serves his employers: the landed Southern gentry anxious to maintain prewar master-slave relationships. These scenes are crucial to redressing the history of slavery and the history of Reconstruction on film. *Buck and the Preacher* seeks to set the cinematic record straight about the kinds of retaliatory vigilantism and Ku Klux Klan violence African Americans faced during Reconstruction. The attempt to make such a historical intervention is, itself, a reason to study a groundbreaking film like *Buck and the Preacher*.

Upon witnessing the impact of multiple attacks, Preacher joins forces with Buck. Together, they kill the crackers responsible. But this can be accomplished only by joining forces with local Indian tribes and warriors. Buck needs the help of Native tribes in order to gain safe passage through the territory.

The climactic scene, during which a Native American and African American political alliance is negotiated, is the most powerful in the film. In an effort to address the financial losses endured by the wagon families, Buck and the Preacher decide to rob the town bank. But the conversation that engenders their decision is itself revealing of the characters' motives and indicative of generic transformation.

While sitting on a hillside one morning, Preacher shares his sad life story of having been a slave. We learn that he inherited his profession (the uniform and the Bible) from his former slave master, a man who was both his slave master and a religious con artist. Preacher's master was also a jackleg pastor who owned Preacher when he was a boy. One day, the white minister sent the 16-year-old boy on an errand. When the youth returned home, he discovered the old man had sold his mother off for 200 dollars. That night, when his master asked to be put to bed, the young man drowned his master, inheriting his possessions and trade.

After sharing this dehumanizing tale of servitude, Preacher asks Buck how he plans to obtain the money needed for the remaining Exoduster families. In retaliation for the dehumanizing racial violence Buck and Preacher witnessed and endured, they decide to fight back against the social and economic system that has profited from slavery. They decide to rob a bank. Their decision to become bank robbers puts them on the wrong side of the law, but it parallels

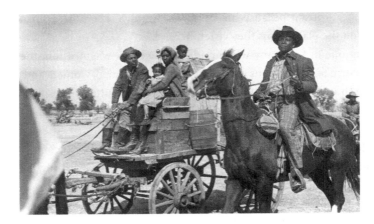

Figure 21 Poitier on horseback in *Buck and the Preacher.*

the banditry of other mythic Western characters, namely, the eponymous figures of *Butch Cassidy and the Sundance Kid* (1969). Yet, whereas Butch and Sundance robbed banks out of self-interest, Buck and the Preacher steal to earn remuneration to end slavery.

In town, Buck, Preacher, and Ruth successfully pull off their heist. But a vicious posse of gunmen follows. Eventually, they come to an open range with the posse hot on their heels. Suddenly, out of nowhere, a Native American war party, defending the boundaries of their territory, rides up from the hills, allowing Buck, Preacher, and Ruth to pass by while creating a barrier for the sheriff and his posse. The message is clear. They have crossed the line into the Indian territory. This is the climax of the movie not because it's a chase scene with stunt riding; it's climactic because it marks the moment when the movie reveals the heretofore-unknown alliance between Native Indians and black Americans. It's an alliance that would have resonated with civil rights era audiences, keenly aware of the necessity for interracial and cross-cultural coalitions of political protest.

Once they ride up into the mountains, Buck meets with an Indian chief and his translator wife, Sinsie (Julie Robinson). Buck requests the tribe's assistance in fighting the posse of white men. But the chief refuses, explaining he cannot spare his men or ammunition to fight the "Yellow Hair." In this context, "Yellow Hair" is a general term given to white men. The chief also reminds Buck that they were once enemies when Buck fought for the white man's army against Indians. Buck leaves with his request refused. But shortly thereafter, the posse tries again to attack the wagon trains. This time, the Native Americans who said

they would not fight Buck's battle send several warriors to help and become the force that turns the tide of the shootout in Buck's favor. Together, this black-Indian coalition succeeds in stopping the sheriff and his posse.

The closing scenes of *Buck and the Preacher* resonate at two levels; at the diegetic (or narrative) and at nondiegetic registers. At the diegetic level, this ending provides a historic critique of white supremacy and its role in the colonization of the United States; it also offers a powerful account of the destruction of Indian civilizations; it gives Poitier's character, Buck, a chance to repent for his complicity with the US Army as a Buffalo Soldier; and it forges an alliance between subjugated communities of color.

At the extra-diegetic level, these closing scenes enable Sidney Poitier to demonstrate his talent as a skilled director. Using this film as a vehicle, Poitier offers generic revision of the Western genre. He molds the Western genre into something mythic and powerful and sacred and sanctified for African American, Native American, and Mexican American civil rights era audiences. He overturns the tropes and conventions of the genre by positioning and aligning spectators with African Americans and Indians rather than white cowboys, cattlemen, and settlers. Taken collectively, *Buck and the Preacher* is not only a creative product; it's also a liberating act of resistance—like much of Sidney Poitier's career. Out of recognition for Poitier's career-long efforts to challenge stereotypes and caricatures of black masculinity, President Barack Obama awarded Poitier the Medal of Freedom. In the larger context of what Poitier sought to achieve through his films, Obama's award for his landmark career makes sense.

It is worth mentioning that the reception of the film was intriguing. Generally, African American audiences enjoyed the picture. Biographers have documented as much. Take, for example, the work of film historians Keyser and Ruszkowski. The African American press was also favorable. For example, *Black Stars* magazine described Buck as "Daniel Boone and John Shaft without the usual Hollywood glitter." But in this particular celebratory review, the critic inadvertently champions the politically reprehensible notion of killing Indians when he writes:

> John Wayne has been settling the West and murdering redskins singlehandedly for far too long. The meaning and dramatic role played by America's black population in the development of the West has lain dormant.[40]

Ironically, *Buck and the Preacher* is antithetical to the kind of white supremacist cowboys-and-Indians role-playing this reviewer references. Critical commentary

of this nature reflects the varying degrees to which reviewers understood the nuanced politics of the picture.

Poitier intended to make an intervention with this film, and he did not want his celebrity to overshadow the picture or its reception. Yet he was aware of his status as a token "model minority" and sensed the potential impact of his public persona on his filmmaking. For example, in his 1980 autobiography, *This Life*, he makes this concern evident by writing:

> I was somehow being pushed to save the world. I was somehow being pushed to raise my black brothers and sister to the next level. I was being pushed to change the world as it related to me and mine. I was being pushed to do the impossible. I figured that black people just wouldn't survive without me saving them through dealing with the pressures on myself. I didn't think the world would survive if I didn't live and develop in a certain way. And, my eye was fastened to the possibility that somewhere in those years my dream could materialize and I could shoot through a barrier into uncharted waters where no black actor had ever been before.[41]

Thankfully, *Buck and the Preacher* did push the boundaries of American film culture. It demonstrated an alternative vision of filmmaking that included more African American production staff. It also offered generic revision by constructing a credible depiction of the frontier with people of color. It challenged the cinematic landscape by providing filmic representation of white supremacy defeated by black-Indian solidarity long before similarly progressive television miniseries like *Roots* or movies like *12 Years a Slave* (Steve McQueen 2013). It provided an alternative to the assimilationist and integrationist movies for which Poitier was vehemently criticized during the civil rights movement (i.e., *Lilies of the Field*, *Guess Who's Coming to Dinner*, *Patch of Blue*). And, finally, *Buck and the Preacher* sought to redress the relationship between film and historical memory.

Sidney Poitier's commitment to radical social change was an ethic he sought to pass on to the next generation both through his films and his family life. In his interview with entertainment journalist Wanda Hale, Poitier said: "I'm going to ask my daughters to promise me to be Women's Lib. Women have the right to be a man's equal and I want them to take advantage of it for progress."[42] Clearly, Poitier's two Western vehicles, *Duel at Diablo* and *Buck and the Preacher*, are much like his life and career. They stand as remarkable examples of his attempts to negotiate the racial hegemony of American film culture while moving the discourse created therein to more fertile, complex, and progressive ground.

Notes

1 Richard Slotkin, *The Fatal Environment: The Myth of the Frontier in the Age of Industrialization, 1800–1890* (Norman: University of Oklahoma Press, 1985), 33.

2 Ibid., 19.

3 Joanna Hearne, "The Cross-Heart People: Race and Inheritance in the Silent Western." *Journal of Popular Film & Television*, 30, 4 (Winter 2003): 181.

4 John Cawelti, *The Six Gun Mystique Sequel* (Bowing Green, OH: Bowling Green State University Popular Press, 1999).

5 This is a quote from a comment made by Clyde Taylor in the documentary *Paul Robeson: Here I Stand* directed by St Claire Bourne.

6 Lester Keyser and Andre Ruszkowski, *The Cinema of Sidney Poitier: The Black Man's Role on the American Screen* (San Diego and New York: A. S. Barnes & Company, Inc., 1980), 92. "I agreed to make it soley because I would have a role as a Negro Cowboy . . . no one knows the Negro contribution to the building of the West. . . . I also did the film because it gave me an opportunity to give a hero imagery to Negro children who love Westerns." Keyser and Ruszkowski cite "Poitier Shows What Films Teach," *Catholic Standard and Times* (Philadelphia), July 28, 1967, p. 3.

7 Carol Bergman, *Sidney Poitier* (New York, New Haven, Philadelphia: Chelsea House Publishers, 1990), 25.

8 Ella Shohat and Robert Stam, *Unthinking Eurocentrism: Multiculturalism and the Media* (New York: Routledge, 1994), 137.

9 Christine Bold, "Where Did the Black Rough Riders Go?" *Canadian Review of American Studies* 39, 3 (2009): 275.

10 Quintard Taylor, "African American Men in the American West, 1528–1990," in *In Search of the Racial Frontier: African Americans in the American West, 1528–1990* (New York: W. W. Norton, 1998), 119–202.

11 Bold, 274.

12 Taylor, 103.

13 Hall, Stuart, *Encoding and Decoding in the Television Discourse* (Birmingham, England: Centre for Cultural Studies, University of Birmingham, 1973), 507–17.

14 These films are also critical of big business, the American government, masculine figures (including the military and their policies), and a turn toward historical authenticity.

15 R. Philip Loy, *Westerns in a Changing America, 1955–2000* (Jefferson, North Carolina and London: McFarland & Company), 35.

16 Brian Henderson, "The Searchers: An American Dilemma," in Bill Nichols (ed.), *Movies & Methods Volume II* (Berkeley and London: University of California Press, 1985), 429–49.

17 Andrea Levine, "Sidney Poitier's Civil Rights : Rewriting the Mystique of White Womanhood in *Guess Who's Coming to Dinner* and *In the Heat of the Night.*" *American Literature* 73, 2 (June 2001): 365.

18 Writer and composer Neal Hefti arranged for some of the biggest names in jazz and popular music. He wrote the Academy Award–nominated song, "What's New Pussycat!" He was the composer and conductor of the music for *Duel at Diablo.* See the press kit available at the Schomburg Center for Research in Black Culture.

19 Deborah Allison, "Title Sequences in the Western Genre: The Iconography of Action." *Quarterly Review of Film and Video* 25 (2008): 107–15.

20 http://www.badmovieplanet.com/unknownmovies/reviews/rev371.html

21 http://www.myfilmviews.com/2012/01/19/the-story-behind-the-columbia-pictures-logo/ and http://www.alexsbrain.com/2011/01/cat-ballou-1965-columbia-logo-animation.html

22 *Buffalo Soldiers* originally were members of the U.S. 10th Cavalry Regiment of the United States Army, formed on September 21, 1866 at Fort Leavenworth, Kansas. The nickname was given to the "Negro Cavalry" by the Native American tribes they fought; the term eventually became synonymous with all of the African American regiments formed in 1866.

23 This movie could be noted as an early precursor to movies like *Skin Game* with Louis Gossett, *100 Rifles, Silver Streak,* and several decades later *The Lethal Weapon* franchise with Danny Glover and Mel Gibson.

24 Keyser and Ruszkowski, *The Cinema of Sidney Poitier*, 92.

25 Ed. Guerrero, *Framing Blackness: The African American Image in Film* (Philadelphia: Temple University Press, 1993), 72.

26 Clifford Mason quoted in Alvin H. Marill's *The Films of Sidney Poitier* (Secaucus, NJ: The Citadel Press, 1978), 141.

27 Steven Cohan, *Masked Men: Masculinity and the Movies in the Fifties* (Bloomington: Indiana University Press, 1997), 201–63. See the chapter "Why Boys are Not Men."

28 Scott Simmon, *The Invention of the Western Film: A Cultural History of the Genre's First Half-Century* (New York: Cambridge University Press, 2003), 110–12.

29 Ibid.

30 See the press kit for *Duel at Diablo* at the Schomburg Center for Research in Black Culture.

31 Keyser and Ruszkowski, *The Cinema of Sidney Poitier,* 150. The authors are citing a *Variety* magazine article entitled, "U.S. Black Settlers of Wild West Pic Had to Be Directed by Poitier," *Variety*, March 17, 1971.

32 George Goodman, "Durango: Poitier meets Belafonte. Two Wary Rivals Patch Up a Fight to Make a Movie Together," *Look,* August 24, 1971, 56–61.

33 Keyser and Ruszkowski, *The Cinema of Sidney Poitier,* 146.

34 No author cited. "U.S. Black Settlers of Wild West Pic Had to Be Directed by Poitier," *Variety*, March 17, 1971.

35 Ibid.

36 Walter Price Burrell, "Buck and the Preacher," *Black Stars*, February 1972, pp. 58–60.

37 Wanda Hale, "Movies, Sidney Poitier—A Star's Director," *Daily News*, March 26, 1972, s7.

38 Ibid., Mrs Belafonte obtained, through Columbia, a taped recording of the voice of an actual Apache reading the lines delivered by her and Lucero in the script. She then spent several days in seclusion on the Venezuelan island of Aruba getting a deep tan and memorizing the Apache pronunciation. This was her first major film role and first significant show business appearance since her marriage to Belafonte 15 years prior. She was a former member of the famed Katherine Dunham dance troupe.

39 Keyser and Ruszkowski, *The Cinema of Sidney Poitier*, 146.

40 Ibid.

41 Sidney Poitier, *This Life* (New York: Alfred A. Knopf, 1980), 198.

42 Wanda Hale, "Movies, Sidney Poitier—A Star's Director," *Daily News*, March 26, 1972, s7.

Bibliography

Aleiss, Angela. *Making the White Man's Indian: Native Americans and Hollywood Movies* (Westport, CT: Greenwood Publishing Group, 2005).

Allison, Deborah. "Title Sequences in the Western Genre: The Iconography of Action." *Quarterly Review of Film & Video* 25 (2008): 107–115.

Allmendinger, Blake. *The Cowboy: Representation of Labor in an American Work Culture* (New York and Oxford: Oxford University Press, 1992).

—*Imagining the African American West* (Lincoln: University of Nebraska Press, 2005).

Bergman, Carol. *Sidney Poitier* (New York, New Haven and Philadelphia: Chelsea House Publishers, 1990).

Bold, Christine. "Where Did the Black Rough Riders Go?" *Canadian Review of American Studies* 39, 3 (2009): 273–97.

Brod, Harry and Michael Kaufman (eds), *Theorizing Masculinities* (Thousand Oaks, CA: Sage Publications, 1994).

Burton, Art T. *Black, Red and Deadly: Black and Indian Gunfighters of the Indian Territory, 1870–1907* (Fort Worth, Texas: Eakin Press, 1994).

—*Black Gun, Silver Star: The Life and Legend of Frontier Marshal Bass Reeves* (Lincoln: University of Nebraska Press, 2008).

Buscombe, Edward. "Painting the Legend: Frederic Remington and the Western." *Cinema Journal* 23, 4 (Summer 1984): 12–27.

—(ed.), *The BFI Companion to the Western* (London: British Film Institute, 1988).

—*Stagecoach* (London: British Film Institute, 1992).

Buscombe, Edward and Roberta Pearson. *Back in the Saddle: New Essays on the Western* (London: British Film Institute, 1998).

Cameron, Ian and Douglas Pye (eds), *The Book of Westerns* (New York: Continuum Publishing Company, 1996).

Cawelti, John. *The Six Gun Mystique Sequel* (Bowling Green, OH: Bowling Green State University Press, 1999).

Churchill, Ward. *Fantasies of the Master Race: Literature, Cinema, and the Colonialization of American Indians*, ed. M. Annette. Jaimes (San Francisco, California: City Lights Publishers, 2001).

Cleto, Fabio. *Camp: Queer Aesthetics & the Performing Subject, A Reader* (Ann Arbor: University of Michigan Press, 1999). Translated by Jonathan Cape (New York: Hill and Wang, 1972).

Clinton, Catherine. *The Black Soldier: 1492 to the Present* (New York: Houghton Mifflin Books for Children, 2000).

Cohan, Steven. *Masked Men: Masculinity and the Movies in the Fifties* (Bloomington: Indiana University Press, 1997).

Countryman, Edward and Evonne von Heussen-Countryman, *Shane* (London: British Film Institute, 1999).

Courtney, Susan. *Hollywood Fantasies of Miscegenation: Spectacular Narratives of Gender and Race, 1903–1967* (Princeton, NJ: Princeton University Press, 2005).

Cornell, R. W. *Masculinities* (Cambridge: Blackwell Publishers, 1995).

Dickens, Homer. *What a Drag: Men as Women and Women as Men in the Movies* (New York: Quill, 1984).

Drummond, Phillip. *High Noon* (London: British Film Institute, 1997).

Duberman, Martin (ed.), *Queer Representations: Reading Lives, Reading Cultures* (New York: New York University Press, 1997).

Du Bois, W. E. B. *The Souls of Black Folk: Essays and Sketches* (Chicago: A. C. McCulurg, 1903).

Durham, Philip and Everett L. Jones. *The Negro Cowboys* (New York: Bison Books, 1983).

Ellen, Holly. "Where Are the Films about Real Black Men and Women?" *New York Times*, June 2, 1974, Sec. II.

Everett, Anna. *Returning the Gaze: A Genealogy of Black Film Criticism, 1909–1949* (Durham and London: Duke University Press, 2001).

Frayling, Christopher. *Sergio Leone: Something to Do With Death* (New York: Faber & Faber, 2000).

Fulwood, Neil. *The Films of Sam Peckinpah* (London: B. T. Batsford, 2002).

Gallagher, Tag. *John Ford: The Man and His Films* (Berkeley, Los Angles and London: University of California Press, 1986).

Goodman, George. "Durango: Poitier Meets Belafonte," *Look,* August 24, 1971, 56–61.

Green, Douglas B. *Singing in the Saddle: The History of the Singing Cowboy* (Nashville, TN: Country Music Foundation Press, 2005).

Hale, Wanda. "Movies, Sidney Poitier—A Star's Director," *Daily News*, March 26, 1972, s7.

Hall, Stuart. "Encoding and Decoding in the Television Discourse," Centre for Cultural Studies, University of Birmingham, CCS Stenciled Paper no. 7, 1973.

Hamalainen, Pekka. *Comanche Empire* (New Haven and London: Yale University Press, 2008).

Hearne, Joanna, "The Cross-Heart People: Race and Inheritance in the Silent Western." *Journal of Popular Film & Television* 30, 4 (Winter 2003): 181.

Henderson, Brian. "The Searchers: An American Dilemma," in Bill Nichols (ed.), *Movies and Methods Volume II* (Berkeley and London: University of California Press, 1985).

Katz, William. *Black Indians: A Hidden Heritage* (New York: Simon Pulse, 1997).

—*The Black West: A Documentary and Pictorial History of the African American Role in the Westward Expansion of the United States* (New York: Harlem Moon, 2005).

Keyser, Lester and Andre H. Ruszkowski. *The Cinema of Sidney Poitier: The Black Man's Changing Role on the American Screen* (San Diego and New York: A. S. Barnes & Company, Inc., 1980).

Kilpatrick, Jacquelyn. *Celluloid Indians: Native Americans and Film* (Lincoln, NE: University of Nebraska Press, 1999).

Kimmel, Michael. *The Gender of Desire: Essays on Male Sexuality* (Albany: State University of New York Press, 2005).

Levine, Andrea. "Sidney Poitier's Civil Rights: Rewriting the Mystique of White Womanhood in *Guess Who's Coming to Dinner* and *In the Heat of the Night.*" *American Literature* 73, 2 (June 2001): 365–86.

Liandrat-Guigues, Suzanne. *Red River* (London: British Film Institute, 2000).

Lipsitz, George. *The Possessive Investment in Whiteness: How White People Profit from Identity Politics* (Philadelphia: Temple University Press, 1998).

Loy, Phillip R. *Westerns and American Culture, 1930–1955* (Jefferson, NC: McFarland & Company, 2001).

—*Westerns in a Changing America, 1955–2000* (Jefferson, NC: McFarland & Company, 2004).

Manchel, Frank. "Losing and Finding John Ford's *Sergeant Rutledge* (1960)." *Historical Journal of Film, Radio and Television* 17 (June 1997): 245–59.

Marill, Alvin. *The Films of Sidney Poitier* (Secaucus, NJ: The Citadel Press, 1978).

Massey, Sara R. *Black Cowboys of Texas* (College Station, TX: Texas A & M University Press, 2000).

McGee, Patrick. *From Shane to Kill Bill: Rethinking The Western* (Malden, MA: Blackwell Publishing, 2007).

Newton, Huey P. "A Revolutionary Analysis of *Sweet Sweetback's Baadasssss Song.*" *The Black Panther Inter-communal News Service* 6 (June 1971): A-L.

Nyong'o, Tavia. "Racial Kitsch and Black Performance." *Yale Journal of Criticism: Interpretation in the Humanities* 15, 2 (2002 Fall): 371–91.

Poitier, Sidney. *This Life* (New York: Alfred A. Knopf Press, 1980).

Robertson, Pamela. *Guilty Pleasures: Feminist Camp From Mae West to Madonna* (Durham and London: Duke University Press, 1996).

Self, Robert T. *Robert Altman's McCabe & Mrs. Miller: Reframing the American West* (Lawrence, KS: University of Kansas, 2007).

Shohat, Ella and Robert Stam. *Unthinking Eurocentrism: Multiculturalism and the Media* (New York: Routledge, 1994).

Simmon, Scott. *The Invention of the Western Film: A Cultural History of the Genre's First Half-Century* (Cambridge: Cambridge University Press, 2003).

Slotkin, Richard. *The Fatal Environment: The Myth of the Frontier in the Age of Industrialization, 1800–1890* (Norman: University of Oklahoma Press, 1985).

—*Gunfighter Nation: The Myth of the Frontier in Twentieth-Century America* (Norman: University of Oklahoma Press, 1992).

—*Regeneration Through Violence: The Mythology of the American Frontier, 1600–1860* (Norman: University of Oklahoma, 2000).

Sontag, Susan. "Notes on Camp." First published in *Partisan Review* 31, 4 (Fall 1964): 515–30.

Stewart, Jacqueline. *Migrating to the Movies: Cinema and Black Urban Modernity* (Berkeley, Los Angles and London: University of California Press, 2005).

Straayer, Chris. *Deviant Eyes: Deviant Bodies: Sexual Re-Orientations in Film and Video* (New York: Columbia University Press, 1996).

Strode, Woody and Sam Young. *Goal Dust: The Warm and Candid Memoirs of a Pioneer Black Athlete and Actor* (New York and London: Madison Books, 1990).

Studlar, Gaylyn and Matthew Bernstein. *John Ford Made Westerns: Filming the Legend in the Sound Era* (Bloomington, IN: Indiana University Press, 2001).

Taylor, Quintard. "African American Men in the American West, 1528–1990." *Annals of the American Academy of Political and Social Science*, 569, 1 (May 2000): 102–19.

Walker, Janet (ed.), *Westerns: Films Through History* (New York and London: Routledge, 2001).

Willard, Tom. *Buffalo Soldiers* (Mass Market Paperbacks: Forge Books, 1997).

Wood, Robin. *Rio Bravo* (London: British Film Institute, 2003).

Stepping behind the Camera: Sidney Poitier's Directorial Career

Keith Corson

Sidney Poitier's "second" career in Hollywood as a director is an often forgotten, marginalized, or derided aspect of an artist who has come to symbolize blackness in the American cinema. One of the clearest articulations of the divide between Poitier's reputation as an actor and a director can be found in John Guare's 1990 play *Six Degrees of Separation*. Guare dramatizes the true-life story of David Hampton, a con artist who gained access to a group of rich white socialites by posing as the fictitious "Paul Poitier," son of Sidney.[1] While the story speaks volumes about the central role Poitier's image has played in shaping and sustaining a self-congratulatory white liberal construct, it also touches on Poitier's disappearance from the public eye and the declining artistic significance of his film work through the 1980s. When asked by a wealthy white family about his father, Paul explains, "He's doing a movie," and continues to relate details from the anticipated film project, a big-budget adaptation of the Broadway musical *Cats*.[2] This comedic reference simultaneously strains credulity, taking Paul's fanciful lie to ridiculous and audacious levels, while also factoring in a decline in the level of quality and taste in Poitier's work as a director that makes a filmed version of *Cats* plausible. This brief sequence, more than any other moment in the play, speaks to the perception of Poitier at the end of the 1980s. After two decades working as a director, his legacy remained rooted in his performances in the 1950s and 1960s, with his directorial career serving as mere fodder for a punch line.

The mythology of the Poitier icon revels in the replaying of particular images; slapping the face of a white plantation owner in *In the Heat of the Night* (1967, Norman Jewison), reaching out for Tony Curtis's hand at the end of *The Defiant Ones* (1958, Stanley Kramer), or perched atop a ladder,

Christ-like, in *Lilies of the Field* (1963, Ralph Nelson). As a director, his films are bereft of similar iconography that can be used to place Poitier's body as a clear stand-in for a supposedly singular black experience, not to mention the fact that they lack the underlying social context of being made and released in the midst of the civil rights movement. However, the notion that Poitier's work as a director is somehow less important is far from accurate and speaks to recurring limitations in how blackness in cinema is addressed, focusing largely on representation while ignoring or undervaluing African Americans as cultural producers. Along with Michael Schultz, the only other contemporary black director working on a similar trajectory at major studios, Poitier helped sustain the presence of black filmmakers in Hollywood in the aftermath of the blaxploitation cycle.[3] Just as Poitier carried the burden of representing black actors (and black Americans at large) throughout the 1950s and 1960s, his work behind the camera in the 1970s and 1980s played an equally important role in the continuum of black representation and involvement in the American film industry. More importantly, his directorial work challenges notions of a politically and aesthetically monolithic "black community," as his perspective diverges from other contemporary black screen artists, both creatively and commercially. Nevertheless, Poitier's work as a director is rarely invoked when summarizing his accomplishments in Hollywood. This is partly due to a desire to keep Poitier frozen as a symbol of the black freedom struggle, necessitating the omission of a directorial career that produced a group of films deemed to have little social or artistic value by contemporary critics.

The prevailing opinion that Poitier's directorial output is of low artistic quality, or even an embarrassing blemish to his legacy, must be balanced by the context in which these films were made. Particular attention must be paid to the changing landscape of the US film industry; Poitier's age and influence in Hollywood; and dramatic shifts in social, cultural, and political climate. More importantly, to make sense out of Poitier's work as a director, we must first recognize the limitations of how aspects of "quality" are most commonly assigned and challenge the methodology of film history, particularly as it relates to using film criticism as an authoritative source. There are a number of reasons that mainstream critics were largely unreceptive to Poitier's films, with responses ranging from indifference to open hostility. Part of the critical aversion to his films can be traced to Poitier's actors-first approach. His heavy use of long takes and loose narrative structure not only allows for improvisation, but also gives his films an odd rhythm and pace that violates the slick and studied approach

to film language that was being normalized by a new generation of film school–trained directors in the 1970s. Poitier also strayed from making the types of films that critics champion in terms of genre and intended audience, lacking self-important messages geared toward white liberal audiences or consciously highbrow fare for the art house circuit. Poitier initially directed films about black experiences geared specifically for a black audience, and later attempted to make popular entertainment for mainstream America. The fact that his films received reviews ranging from poor to tepid from contemporary critics is of little interest, largely because the response is so predictable. What is more telling are the varying legacies of his work, with some films now hailed as cornerstones of African American screen culture and others relegated to the dustbin of history.

Poitier completed nine films as a director: *Buck and the Preacher* (1972), *A Warm December* (1973), *Uptown Saturday Night* (1974), *Let's Do It Again* (1975), *A Piece of the Action* (1977), *Stir Crazy* (1980), *Hanky Panky* (1982), *Fast Forward* (1985), and *Ghost Dad* (1990). These films span genre, including comedy, Western, melodrama, thriller, and musical, while their fortunes at the box office range from flop to blockbuster. His work as a director can be separated into two parts: (1) the first five features in which he also appeared as an actor, and (2) the subsequent four films he made serving only as director. Poitier's appearance in front of the camera is the most obvious point of separation, but there are other telling differences. The first group of films was produced primarily during the blaxploitation cycle, the five-year run (1972–76) in which black-focused films were produced and distributed at an unprecedented rate in Hollywood.[4] His transition into the director's chair coincided with a number of other African Americans being given similar opportunities, including Melvin Van Peebles, Ossie Davis, Ivan Dixon, and Gordon Parks (both junior and senior), to name only a few. Poitier differed from his peers largely on the basis of his legacy and continued drawing power as an actor, not to mention the fact that the active role he played as a producer allowed him flexibility, artistic control, and a level of financing that was not available to other black filmmakers. Thanks in large part to the power Poitier held with studios through various production deals, he was able to branch out in the 1970s and experienced his greatest success as a director making comedies, first with *Uptown Saturday Night* and its follow-up *Let's Do It Again*, and later with *Stir Crazy*, which was one of the top grossing films of all time when it was released.

The reversal of Poitier's fortunes in the 1980s came with a culmination of factors ranging from the shifting perspectives of Hollywood studios to Poitier's

own changing sensibilities. There is a wide gulf separating Poitier's first film, the highly politicized and artistically ambitious *Buck and the Preacher*, to his last film, the decidedly apolitical popcorn entertainment of *Ghost Dad*. This transition from an artistic and socially conscious filmmaker into a seemingly detached and unsuccessful director-for-hire can be traced through three of his films in particular: *A Piece of the Action*, his final film as an actor/director; *Stir Crazy*, his most successful film; and *Fast Forward*, his most visible failure. These films find Poitier alternately at his most ambitious, his most successful (in terms of box office at least), and at his most out of touch. The context of production as well as content of the films help shed light on his work as a director, providing a rationale for his successes and failures.

A Piece of the Action

Making his final appearance as an actor-director, Poitier's fifth film, *A Piece of the Action*, blends the social consciousness of his first two directorial efforts with the outer trappings of his far more successful comedies opposite Bill Cosby. This attempt to combine two seemingly incongruous tendencies touches on Poitier's growing confidence as a director, which shows not only in the film's more clearly developed narrative and technical aspects, but also in Poitier giving his most self-assured performance of the decade. The growing pains of his first four features did not come as a surprise, as Poitier was hesitant about his ability to direct himself from the onset and made the transition to working behind the camera before he deemed himself ready to take on the responsibility. Remembering the day he took over the production of *Buck and the Preacher*, Poitier writes that he was, "putting on a hat I had no intention of wearing for at least another three or four years."[5] Of course, in that span of time he would complete four features as a director, creating his own opportunities while also learning on the fly how to make films. Poitier was hesitant to act in the films he directed, best exemplified by his initial concept for *Uptown Saturday Night*, which he wanted to star stand-up comics Redd Foxx and Richard Pryor, but was forced to star in himself due to his production contract through First Artists and Warner Bros.[6]

Following the success of *Uptown Saturday Night* and *Let's Do It Again*, Poitier looked to move away from comedies and attempted to make a biopic of the anticolonialist Amilcar Cabral, but was unable to secure financing for the

project.[7] Instead, he chose to re-team with Cosby for a project that could be easily marketed along the same lines of their first two films, but would reflect his personal politics via a screenplay from Charles Blackwell. Poitier's story concept (which is credited to his pseudonym "Timothy March") looked to address his growing disconnect from black youth. Straying from the folk humor of its predecessors, the narrative instead functions as a sort of morality play about personal and community responsibility. As opposed to Richard Wesley, who wrote *Uptown* and *Let's Do It Again*, Blackwell brought with him the generational sensibilities of Poitier and Cosby, informed by the civil rights movement and middle-class aspirations rather than a younger generation informed by Black Power and the postindustrial ghetto.

Poitier and Cosby play a con man and a safe cracker who get blackmailed by a police detective (James Earl Jones) to volunteer at a community outreach center in Chicago for troubled black teenagers. Poitier takes over in the classroom, reworking similar elements from *Blackboard Jungle* (1955, Richard Brooks) and *To Sir, with Love* (1967, James Clavell), delivering impassioned speeches on the importance of self-respect and good manners. The plot is an inversion of *Uptown* and *Let's Do It Again*, with Poitier and Cosby playing criminals who are forced to give back to the community, rather than people of the community forced to navigate the underworld. The dramatic weight and the straightforward message of *A Piece of the Action*, however, is where the third pairing departs from the other two, making notions of a Cosby–Poitier trilogy cosmetic at best.[8] Although the interplay between the two provides a few comedic moments, Cosby and Poitier share little screen time and the structure and mood of the story has less in common with the previous comedies than it does the social messages of *Buck and the Preacher* and *A Warm December*. The result is an often didactic statement on black youth that functions as a denunciation of the mythology of blaxploitation and what Richard Majors would later term the "cool pose."[9]

The title *A Piece of the Action*, as explained in the film, uses the terminology of street hustling and applies it instead to becoming a member of the middle class. The film looks to reverse the blaxploitation construct of the street hustling antiheroes evident in *Super Fly* (1972, Gordon Parks, Jr.), *The Mack* (1973, Michael Campus), and *Black Caesar* (1973, Larry Cohen) by reforming both the teacher and students into productive, perfectly assimilated members of society. While a number of blaxploitation-era films looked to revisit the racial uplift message of the 1950s or paint a sociological portrait of the black urban underclass, *A Piece of the Action* exhibits a generational divide that is shown

through the eyes of older, more conservative black characters.[10] The film presages Cosby's more recent comments regarding the hip-hop generation, but ultimately expresses the shifting persona of Cosby in the 1970s, where his focus on education began to dominate his work, forming a pedagogic black conservatism that would eventually resonate with a mass crossover audience on television.[11] Coming at the end of the blaxploitation cycle, *A Piece of the Action* shows Poitier's sensibilities aligning with Hollywood, attempting to make peace with the pervading themes of the era by offering a new vision of middle-class idealism and assimilation. As Hollywood moved away from black-focused narratives in the following years, Poitier also transitioned to working solely as a director, making films with multiethnic casts.

Stir Crazy

The first line of dialogue in *Stir Crazy* arrives in the form of a question, spoken off-screen during the opening montage sequence. With shots of the Brooklyn Bridge and the Manhattan skyline, Gene Wilder's protagonist asks, "Who needs Hollywood?" In 1980, Sidney Poitier may have very well been asking himself the same question. What motivation was left for someone who had succeeded as an actor, director, and producer to continue working in Hollywood, particularly seeing that despite his efforts and influence, the film industry had reverted back to the same limited investment in black screen artists that defined Poitier's career in the 1950s and 1960s? For Poitier, the answer came in the challenge of directing without the benefit of having himself in front of the camera. Thanks to his track record at the box office, his new contract with Columbia allowed him the freedom to step away from acting and devote all of his attention to directing. As opposed to his peers who found themselves shut out of the industry after the fall of blaxploitation, Poitier observed that, "Fortunately for me, I was not at the mercy of the marketplace."[12] In the 1970s, Poitier had been able to utilize his celebrity status to create new projects that focused on black themes, not to mention employing black writers, performers, and crew members. In the 1980s, his perspective dramatically changed, as his approach to making films was no longer premised on a subversion of studio policies and sentiments and began to more closely align with normative commercial entertainment.

In terms of box office appeal, his first film working exclusively as a director would prove to be the biggest success of Poitier's career. *Stir Crazy* is built around

Gene Wilder and Richard Pryor, who play two friends wrongfully convicted of armed robbery and sent to prison. A classic escape narrative, with a subplot involving prison rodeos, the story serves a secondary function to the comedic improvisation of its stars.[13] Like *Uptown* and *Let's Do It Again*, the screenplay for *Stir Crazy* functions as a loose outline that leaves room for improvisation.[14] Poitier uses three camera set-ups to provide Pryor and Wilder freedom to move and improvise, nurturing the same creative spontaneity as he had with the Cosby comedies, but providing a more dynamic visual end product with extra coverage providing the ability to intercut between a single performance, instead of being tied to a lone, static take. Poitier's growing competence in handling comedy and providing space for Pryor and Wilder to work off of each other pays off in a number of scenes, even if much of the remainder of the film is undistinguished.

Columbia most likely had modest ambitions for *Stir Crazy* from the outset, but as fortune would have it the film became a surprise blockbuster, surpassing $100 million at the US box office to finish behind only *The Empire Strikes Back* (1980, Irvin Kershner) and *Nine to Five* (1980, Colin Higgins), among films released that year.[15] *Stir Crazy*'s crossover success went beyond anything seen before by a black director, causing the *Washington Post* to ask, "What acceptable excuse could there be for perceiving Poitier as an exclusively "black" filmmaker after "Stir Crazy" gets around?"[16] While Poitier was not the first black director to make a film that was not populated primarily with black actors or geared toward a multiethnic audience, the success of *Stir Crazy* seemed to signal the eventual ascendancy of Poitier as a director in the new blockbuster climate of Hollywood.[17]

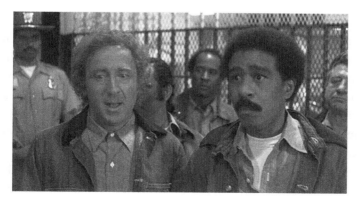

Figure 22 Gene Wilder and Richard Pryor star in *Stir Crazy*.

Looking critically at the reasons for *Stir Crazy*'s success, however, helps explain not only why Poitier was never able to duplicate its success, but it also minimizes the role that his work as a director played in the film's box office returns. Although the Wilder and Pryor pairing had been successful 4 years earlier in *Silver Steak* (1976, Arthur Hiller), much of the clamor for *Stir Crazy* came from the media blitz that followed Pryor setting himself on fire in his Northridge home just weeks after shooting wrapped.[18] While Poitier oversaw editing and prepared for the film's release, Pryor found himself elevated to another level of stardom as he recovered from his injuries. His release from the hospital in late 1980 and a candid round of television interviews regarding the incident proved far more effective than any studio marketing scheme. Largely because of his erratic behavior during shooting, Pryor's performance was minimized in the final cut of *Stir Crazy*, turning him into a supporting character for Wilder instead of a star on equal footing.[19] Nevertheless, Pryor shared top billing in the promotion of *Stir Crazy* and the notoriety of the Northridge fire helped transform the film from a modest comedy into a Hollywood blockbuster, skewing perceptions for critics and audiences alike, with the hope that Pryor's genius would be captured in the film, helping to overshadow flaws in his performance and in the film as a whole. In retrospect, the end result is yet another missed opportunity for Pryor, whose largely frustrating body of film work never matched the genius he exhibited on stage or on record. Initially, *Stir Crazy* looked to point toward a bright future for Poitier as a director, but it actually marks his final hurrah as a major player in Hollywood.

Fast Forward

Writing in 1980, Poitier saw a new set of roadblocks as well as opportunities for black filmmakers. That year *Stir Crazy* was the only American film with a black protagonist to receive a distribution deal by studios or independents and with Wilder receiving the lion's share of screen time, its being considered a black-focused film is tenuous at best. Poitier preached the same sort of lesson of self-determination that he delivered in *A Piece of the Action*, telling his fellow black screen artists in his autobiography *This Life* that, "We're going to have to make most of our films. I think we should no longer expect the white filmmaker to be the champion of our dreams."[20] In some ways, this statement is overly simplistic, glossing over cinema's capital-intensive nature and the limited access to financing

for black filmmakers. But Poitier also noted the changing landscape of media industries, looking toward cable and the home video market to provide new opportunities for black filmmakers.[21] The success of Spike Lee and the black film explosion in the 1990s largely benefitted from VHS and (to a lesser extent) cable, with box office grosses and the ability of a distributor to secure a large number of screens no longer being the be-all and end-all of a film's fortunes.

These changes were a decade away, and in the meantime Poitier continued his move toward the mainstream in Hollywood by reteaming with Wilder for *Hanky Panky*. The film failed to make an impression at the box office and brought Poitier's reputation as a director into question. With one film remaining on his contract with Columbia, Poitier attempted to pull off an ambitious musical project that he hoped would connect with a youth audience. The 1985's *Fast Forward*, however, would be his low point as a director both at the box office and in terms of critical response. Working with a cast of dancing newcomers, the film is an inept attempt to pander to the MTV generation that shows little knowledge of popular culture. Reworking themes from more successful films of the 1980s —namely "the three Fs": *Footloose* (1984, Herbert Ross), *Flashdance* (1983, Adrian Lyne), and *Fame* (1980, Alan Parker) as well as the break-dancing films *Breakin'* (1984, Joel Silberg) and *Beat Street* (1984, Stan Lathan)—the story revolves around a group of teenagers trying to make it big as dancers and singers in New York. The plot is formulaic and the acting reflects the cast's lack of experience, giving the film a stilted quality, with songs and dance numbers egregiously out of touch with current trends. Ending with a triumph at a big talent show, the film carries an intended message about the culture industry, greed, and the crafting of image, but the overriding optimism in the film mutes most of its critical commentary.

At first glance, the film would seem to suggest Poitier to be completely out of step with the 1980s, as the final film pales in comparison to even the most mundane offerings to the MTV generation. However, the backstory of the production helps explain the film's failures. Poitier began work on the story with a simple concept based on his own experiences in New York as an aspiring actor—with young people struggling to find success and eventually succeeding despite long odds—but originally intended for the film to star Michael Jackson, fresh off of the success of *Thriller*.[22] Jackson verbally agreed to appear in the film, and Richard Wesley went forward with the screenplay, leaving space for improvisation and bountiful dance numbers that could be transformed by Jackson's charisma and songs he would bring to the project. As production drew

nearer, slated to start shooting in the summer of 1984, Jackson unexpectedly dropped out of the project at the insistence of his father, instead joining his brothers on the Victory concert tour. Without a star, Poitier's troubles were magnified by his contractual status with Columbia. With an expiry date on his three-picture deal approaching, Poitier was left with the decision to either go ahead and make *Fast Forward* that summer or forfeit studio financing.[23] The film looks like a rushed and poorly planned effort, largely because it was—assembling cast, songs, and choreography just a few weeks before shooting began.

It may not be useful to speculate on a picture that might have been, but the trajectory of Poitier's career would have likely changed had his initial concept for *Fast Forward* as a Michael Jackson vehicle been realized. Jackson was at the height of his stardom and had a fascination with movies that led him to break new ground in music video, largely in collaboration with well-known filmmakers.[24] While he had costarred in *The Wiz* (1978, Sidney Lumet), Hollywood had yet to capitalize on his talents, although Jackson's cinematic ambition would play out the next year with the 3-D Disneyland attraction *Captain Eo* (1986, Francis Ford Coppola), with the pop star playing a magical spaceship pilot alongside a crew of puppets. While the theme park attraction was well received, it made Jackson more emotionally inaccessible to the public and forfeited the charm and power to communicate that could have been shown with the stripped down character he was slated to play in *Fast Forward*.

With a cast of newcomers in Jackson's place, *Fast Forward* was a difficult film to sell. Compounding scathing reviews was the unfortunate coincidence of opening opposite *The Breakfast Club* (1985, John Hughes) at the box office.[25] While John Hughes uncannily tapped into the mood of youth culture in 1985 (albeit from a decidedly Anglophilic perspective) Poitier could not have looked further removed. Hughes's films were informed by new trends in music, often turning his characters' bedroom walls into an index of fashionable pop bands, while the musical numbers in *Fast Forward* come across as staged show-tunes, with balletic choreography masquerading as street dance. The film attempts to incorporate elements of hip-hop, reworking the dance crew battles from *Beat Street* and *Breakin'*, but the choreography of Broadway veteran Rick Atwell fails to convey any semblance of the style, form, or function of breaking. The musical numbers share a similar disconnection from either hip-hop or rock, with a group of film composers and songwriters providing the film with a show tune sensibility that is more reflective of a Las Vegas revue than anything that would appeal to the MTV generation.

Fast Forward became the undoing of Poitier as a director and a financial disaster for Columbia. Emblematic of the studio's decline and mismanagement in the 1980s under the management of their parent company Coca-Cola, the budget for *Fast Forward* reached a reported $17 million and due to poor reviews and ineffective marketing the film only earned $2.7 million at the box office.[26] The *Boston Globe*'s review of *Fast Forward* echoed the prevailing sentiment, saying, "(Poitier) should leap back to the other side of the camera before his well-deserved reputation is completely tarnished by his directorial career."[27] Over the next few years he did just that, appearing in *Shoot to Kill* (1988, Roger Spottiswood) and *Little Nikita* (1988, Richard Benjamin) before making his final film as a director with the Bill Cosby vehicle *Ghost Dad* in 1990. This final effort was far less ambitious than any of his previous films, without any noticeable trace of Poitier's style or perspective. Instead, the film cashes in on the star's television persona and signifies a dramatic shift in the personal and creative dynamic between Poitier and Cosby.

Conclusion

Following *Ghost Dad*, Poitier retreated from directing, refocusing his efforts on acting (mostly for television projects) and eventually becoming a member of the executive class when he joined the Walt Disney Company as president in 1994.[28] More importantly, Poitier became an elder statesman in Hollywood and a celebrated memoirist, providing a personal perspective on his life and career. As a memoirist, Poitier is introspective and open, yet he rarely talks about his approach as a director, at least from an artistic standpoint. Directing, one would believe by reading between the lines of his statements (and omissions), is largely a tool for control in Hollywood, and not a creative enterprise on par with acting. Whether it be directing or writing under the assumed name of Timothy March, Poitier strived to find his creative voice on film outside of performance. Yet his work as a writer and a director never seemed to effectively articulate his perspective, and in many ways can be read as a transitional experiment separating his acting career and his later incarnation as a memoirist and folk philosopher.

Poitier's work as a director is often disappointing and contradictory, complicating the accepted notions of his legacy. His films put forth a directorial philosophy and have stylistic earmarks, but they do not necessarily invite an

auteurist reading. Although he showed flashes of creative inspiration and made a few box office hits, a majority of his films were critically panned and commercial disappointments. While his entry into directing seemed to provide a window into his thoughts on race and his desire to cultivate a creative community among black artists, his work in the 1980s became markedly deracialized. Instead of trying to unpack these contradictions, the public remains interested in Poitier more as a living symbol, a reminder of their liberal goodwill, and chooses to deal with his life and career on simple and uncomplicated terms. But if we truly want to know the measure of the man, it is essential that we take into account his failures along with his successes. Poitier never claims to be the heroic symbol of perfection he often portrayed on-screen, and it is essential that the entirety of his career not be condensed into a handful of supposedly representative moments.

Notes

1 Dan Barry, "About New York; He Conned the Society Crowd but Died Alone," *New York Times*, July 19, 2003.

2 John Guare, *Six Degrees of Separation* (New York: Dramatist Play Service, 1990), 18.

3 Other black directors managed to complete commercially distributed features in the decade following blaxploitation, but their work was either completed largely outside the realm of Hollywood studios (Fred Williamson and Jamaa Fanaka, for example) or limited to a single film (as was the case with Richard Pryor, Prince, Stan Lathan, and Gilbert Moses).

4 At the height of this trend, nearly one out of every four American films released was black-focused, over a quarter of which are credited to black directors. Myriad reasons led to the sudden and dramatic decline in black-focused film production at the end of 1976. Of Poitier's first five films, only *A Piece of the Action* was made outside of the temporal framework of blaxploitation, being produced and released in 1977.

5 Sidney Poitier, *This Life* (New York: Alfred A Knopf, 1980), 327.

6 On Poitier's hesitancy to direct himself, see Keyser and Ruszkowski (170). Information on the proposed casting of Foxx and Pryor comes from a personal interview with *Uptown*'s screenwriter Richard Wesley (conducted October 9, 2009, in the New York City).

7 Aram Goudsouzian, *Sidney Poitier: Man, Actor, Icon* (Chapel Hill: University of North Carolina, 2004). (348–9). Cabral was an African nationalist who helped

Guinea-Bissau achieve independence, only to be assassinated in 1973. Poitier did find time to make a filmic commentary on African politics before shooting *A Piece of the Action*, returning to working as a hired actor in *The Wilby Conspiracy* (1975, Ralph Nelson), starring opposite Michael Caine in a sort of antiapartheid reworking of *The Defiant Ones* set in South Africa.

8 For a discussion of the Poitier–Cosby films as a trilogy, see, Mark Anthony Neal, *Soul Babies: Black Popular Culture and the Post-Soul Aesthetic* (New York: Routledge, 2002), 28.

9 Richard Majors, *Cool Pose: The Dilemmas of Black Manhood in America* (New York: Simon & Schuster), 1993.

10 Examples include *Claudine* (1974, John Berry), *Cornbread, Earl and Me* (1975, Joseph Manduke), *The Monkey Hu$tle* (1976, Arthur Marks), and *Together Brothers* (1974, William A. Graham), to name a few.

11 Cosby's work on educational television fare like *Fat Albert and the Cosby Kids* and *The Electric Company* coincided with his earning a doctorate in education from the University of Massachusetts-Amherst.

12 Poitier, *This Life*, (343).

13 The film was originally titled *Prison Rodeo*.

14 Gene Wilder, *Kiss Me Like a Stranger: My Search for Love and Art* (New York: St. Martin's, 2005), 184.

15 http://boxofficemojo.com/yearly/chart/?yr=1980&p=.htm

16 Gary Arnold, "Slapstick in the Slammer," *Washington Post*, December 12, 1980.

17 Michael Schultz had already made *Sgt. Pepper's Lonely Hearts Club Band* (1978) and *Scavenger Hunt* (1979), while Bill Gunn's *Stop* (1970) and Gordon Parks' *The Super Cops* (1974) provide earlier examples of black directors making films with largely white casts.

18 Shooting wrapped the last week of May, 1980, and the Northridge fire incident occurred on June 11, 1980.

19 John A. Williams and Dennis A. Williams, *If I Stop I'll Die: The Comedy and Tragedy of Richard Pryor* (New York: Thunder's Mouth, 1991), 142.

20 Poitier, *This Life*, 350.

21 Ibid.

22 Wesley interview.

23 Goudsouzian, *Sidney Poitier*, 361.

24 Among the directors Jackson worked with are John Landis, Francis Ford Coppola, Martin Scorsese, Spike Lee, and John Singleton.

25 *Fast Forward* grossed $2.7 million, while *The Breakfast Club* grossed $45 million, http://boxofficemojo.com/movies/?id=fastforward.htm, http://boxofficemojo.com/movies/?id=breakfastclub.htm

26 Mark Pendergrast, *For God, Country, and Coca-Cola: The Definitive History of the Great American Soft Drink and the Company That Makes It*, 2nd edn (New York: Basic, 2000), 340–85.

27 Goudsouzian, *Sidney Poitier*, 361.

28 Poitier joined the studio following the death of Frank Wells. See, Gilles Whittel, "Sidney Poitier Is Made President of Walt Disney," *The Times*, November 25, 1994; Gerard Evans, "Sidney Poitier Lands the Top Job at Disney," *The Evening Standard*, November 24, 1994. Unfortunately, Poitier found himself with little power in a company that was wildly dysfunctional under CEO Michael Eisner. See, James B. Stewart, *Disney War* (New York: Simon & Schuster, 2005).

Bibliography

Arnold, Gary. "Slapstick in the Slammer," *Washington Post*, December 12, 1980.

Barry, Dan. "About New York; He Conned the Society Crowd but Died Alone," *New York Times*, July 19, 2003.

Donalson, Melvin. *Black Directors in Hollywood* (Austin: University of Texas, 2003).

Evans, Gerard. "Sidney Poitier Lands the Top Job at Disney," *The Evening Standard*, November 24, 1994.

Goudsouzian, Aram. *Sidney Poitier: Man, Actor, Icon* (Chapel Hill: University of North Carolina, 2004).

Guare, John. *Six Degrees of Separation* (New York: Dramatist Play Service, 1990).

Guerrero, Ed. *Framing Blackness: The African American Image in Film* (Philadelphia: Temple University, 1993).

Keyser, Lester J. and André Ruszkowski. *The Cinema of Sidney Poitier: The Black Man's Changing Role on the American Screen* (New York: A. S. Barnes, 1980).

Majors, Richard. *Cool Pose: The Dilemmas of Black Manhood in America* (New York: Simon & Schuster, 1993).

Neal, Mark Anthony. *Soul Babies: Black Popular Culture and the Post-Soul Aesthetic* (New York: Routledge, 2002).

Pendergrast, Mark. *For God, Country, and Coca-Cola: The Definitive History of the Great American Soft Drink and the Company That Makes It*, 2nd edn (New York: Basic, 2000).

Poitier, Sidney. *This Life* (New York: Alfred A Knopf, 1980).

—*The Measure of a Man: A Spiritual Autobiography* (San Francisco: HarperSanFrancisco, 2000).

Reid, Mark A. *Redefining Black Film* (Berkeley and Los Angeles: University of California, 1993).

Stewart, James B. *Disney War* (New York: Simon & Schuster, 2005).

Wesley, Richard. Personal interview. October 7, 2009. New York, NY.

Whittel, Gilles. "Sidney Poitier Is Made President of Walt Disney," *The Times*, November 25, 1994.

Wilder, Gene. *Kiss me like a Stranger: My Search for Love and Art* (New York: St. Martin's, 2005).

Williams, John A. and Dennis A. Williams. *If I Stop I'll Die: The Comedy and Tragedy of Richard Pryor* (New York: Thunder's Mouth, 1991).

No Shafts, Super Flys, or Foxy Browns: Sidney Poitier's *Uptown Saturday Night* as Alternative to Blaxploitation Cinema

Novotny Lawrence

It is no coincidence that Sidney Poitier's ascendance in the motion picture industry coincided with the emergence of the civil rights movement. While Dr Martin Luther King Jr. and swarms of blacks and liberal whites took to the streets in the 1950s to protest America's skewed racial politics, Poitier fought the battle for equality in motion pictures, portraying characters that embodied Dr King's nonviolent philosophy. His performances in social problem films such as *No Way Out* (1950), *Blackboard Jungle* (1955), and *The Defiant Ones* (1958) did much to cut against Hollywood's stereotyped caricatures of black masculinity—the loyal Tom, buffoonish coon, and the savage buck.[1] Poitier so perfectly played the role of the tormented black man who maintains his integrity in the face of racism that Donald Bogle contends that in the 1950s the actor emerged as the model hero for an integrationist age. "In all of his films he was well educated and intelligent. He spoke proper English, dressed conservatively, and had the best table manners," notes Bogle. "For mass white audiences, Sidney Poitier was a black man who had met their standards. He was also acceptable to black audiences because of his values and virtue."[2]

Poitier occupied the integrationist role throughout the 1960s when he became the world's most popular movie star, appearing in films examining black/white relationships such as *Lilies of the Field* (1963), *A Patch of Blue* (1965), *In the Heat of the Night* (1967) and *Guess Who's Coming to Dinner?* (1968), among others. Because of their focus on American racial politics, the aforementioned films have historically garnered critical and scholarly attention; however, as we continue to examine Sidney Poitier's career, it is imperative that we fill in the gaps to create a

more holistic legacy by giving more consideration to his work beyond the 1960s. Working from that perspective, the actor's 1970s films are also significant, yet they have received far less academic attention. In the decade that was dominated by the oft-controversial black exploitation (blaxploitation) cinema, Poitier directed and starred in several features that represented a shift from his typical film persona. This chapter focuses on Poitier's *Uptown Saturday Night* (1974), which, at the time of its release, functioned as a significant alternative to the blaxploitation films that dominated the box office. In particular, the chapter begins with a short overview of blaxploitation cinema, and then details how *Uptown's* narrative, protagonists, and display of black intimacy counter the predominant blaxploitiation representations.

The blaxploitation movement

To fully understand *Uptown's* significance, it is necessary to briefly discuss the blaxploitation movement, which emerged as a result of three main factors: the historic misrepresentation of blacks in motion pictures, the civil rights movement, and Hollywood's financial struggles. In the late 1960s, these social, political, and economic factors converged, leading Hollywood to consistently target the black movie-going audience as a viable demographic for the first time in the industry's history. Thus, in *Blaxploitation Films of the 1970s: Blackness and Genre*, I define blaxploitation films as "movies made between 1970 and 1975 by black and white filmmakers in the attempt to capitalize on the African-American film audience."[3]

Although many accounts of the blaxploitation movement begin with Melvin Van Peebles's independent hit, *Sweet Sweetback's Baadasssss Song* (1971), Hollywood's exploration of the films actually began with United Artists' *Cotton Comes to Harlem* (1970), which was released 9 months prior to *Sweetback*.[4] *Harlem* was based on displaced, African American author Chester Himes's detective series *La Reine De Pommes*, which he wrote after relocating to France as a result of his inability to garner consistent success in the United States as a writer. The gritty crime series was a major sensation and Himes sold the screen rights to producer Samuel Goldwyn Jr., who envisioned turning the books into a motion picture franchise.[5] Goldwyn initially hired white scriptwriter Arnold Perl to pen the film adaptation of *Cotton Comes to Harlem*. However, after reading the first draft of the screenplay, Goldwyn was dissatisfied, because he

felt that it lacked an authentic representation of black life. He contacted Ossie Davis, whom he had originally hired to star as one of the film's detectives, for suggestions about how the script could be improved. Davis provided minor revisions and Goldwyn was so impressed by his work that he asked him to provide a major rewrite of the original screenplay. Davis rewrote the script and Goldwyn later hired him to direct *Harlem*, which at that time made him just the third black man to direct a Hollywood feature.[6]

Harlem tells the story of police detectives Coffin Ed Johnson (Raymond St Jaques) and Gravedigger Jones's (Godfrey Cambridge) attempts to recover $87,000 that was stolen from the Harlem community during a back-to-Africa rally. The film presented a fresh perspective of black inner-city life previously unexplored in Hollywood cinema. In particular, with the exception of one scene, *Harlem* was filmed entirely in Harlem, which allowed Davis to showcase the community's residents, businesses, and notable landmarks such as the historic Apollo Theatre. While the film toned down the crime and violence present in the novel, adding comedic elements and satirizing long-standing black stereotypes, it kept Himes's vision of Harlem and, thus, black inner-city life intact. In *Spectacular Blackness*, Amy Abugo Ongiri explains:

> Himes's work formed the unacknowledged contours for contemporary under-standings of racial exchange and conflict and perceptions of African American culture and cultural production. Chester Himes not only provided an important catalyst for the Black Power-era cultural revolution when he created the African American urban underclass in *Cotton Comes to Harlem* . . . he prefigured cultural trends in African American culture that continue to the present moment.[7]

Depicting a previously unexplored aspect of African American identity, *Harlem* ushered in the majority of the characteristics that came to define blaxploitation cinema. As I outline in *Blaxploitation Films of the 1970s*, those conventions include a black hero or a heroine, a predominantly black urban setting, black supporting characters, a white villain, a contemporary rhythm-and-blues soundtrack, and plot themes that address the black experience in contemporary American society.[8]

Although *Harlem* featured a unique vision of the African American experience, its box office success was perhaps the biggest factor in the rise of the blaxploitation movement. Filmed on a budget of $1.2 million, the film grossed over $8 million in its theatrical run.[9] According to United Artists sales

representative James Veld, an estimated 70 percent of the film's total gross came from black audiences.[10] Discussing *Harlem's* box office achievement, *Variety* columnist Ronald Gold summarized, "What this means, according to trade reasoning, is that it is now possible to make pictures aimed specifically, for black filmgoers—and expect to make a substantial profit—without worrying too much about what the rest of the public will think."[11]

Gold's assessment proved accurate as *Cotton Comes to Harlem* helped establish black filmgoers as a viable demographic, popularized black-themed film, and ignited a new Hollywood trend. In *Film/Genre*, Rick Altman explains, "When conditions are favourable, single studio cycles can be built into industry-wide genres."[12] As previously noted, United Artists released *Harlem*, and after its solid box office performance, other studios attempted to duplicate the company's success by producing their own black-themed films. For example, MGM, Warner Brothers, and American International Pictures released *Shaft* (1971), *Super Fly* (1972), and *Coffy* (1973), respectively. The films all turned a profit, demonstrating that the blaxploitation movement had indeed become an industry-wide phenomenon.

Although blaxploitation films provided African Americans with more opportunities to work in all aspects of the motion picture industry, as the burgeoning movement gained momentum its perceived overreliance upon violence, sex, and drug content created a backlash against the films. In 1972, Junius Griffin, president of the Beverly Hills–Hollywood branch of the NAACP, condemned the movement:

> We must tell both white and black movie producers that we will not tolerate the continued warping of our black children's minds with the filth, violence, and cultural lies that are all pervasive in current productions of so-called black movies. We must tell black and white movie producers that the transformation from the stereotyped Stepin Fetchit to super-nigger on the screen is just another form of cultural genocide.[13]

Griffin was not alone in his assault on blaxploitation films. A group of Los Angeles civil rights organizations—the NAACP, the Southern Christian Leadership Conference (SCLC), and the Congress of Racial Equality (CORE)—joined forces to form the Coalition Against Blaxploitation (CAB) with the distinct goal of establishing a review board to rate black movies with classifications such as "superior," "good," "acceptable," "objectionable," or "thoroughly objectionable."[14]

CAB's proposed review board sparked a public debate among black performers, directors, critics, and intellectuals. *Super Fly* star, Ron O'Neal, was among the first to speak out against CAB: "They're saying they know better than the black people themselves what they should look at, that they're going to be the moral interpreters for the destiny of black people. I'm so tired of handkerchief-head Negroes moralizing the poor black man."[15] *Shaft* director Gordon Parks Sr. also opposed the review board:

> The so-called black intellectuals' outcry against black films has been blown far out of proportion. . . . As for a black review board to approve scripts and pre-edit finished films, forget it. The review board is already established and is moving from one theater line to another.[16]

The controversy surrounding blaxploitation films persisted throughout the movement's duration, eventually playing a role in its demise just 5 years after it began. However, while blaxploitation films remained viable, motion picture screens were saturated with films such as *Blacula* (1972), *Coffy* (1973), *The Mack* (1973), *Cleopatra Jones* (1973) and *Foxy Brown* (1974), providing what many critics and scholars alike contend was a monolithic glimpse at black inner-city life.

Uptown Saturday Night

When black exploitation films exploded onto theater screens in the early 1970s, African American filmgoers flocked to theaters in droves to view the films' black heroes overcome adversity. Sidney Poitier, who had worked so hard to move the African American cinematic image beyond the confines of stereotypical caricatures, was among those fans. As he recounts in his autobiography *This Life*:

> Generally these black heroes were seen beating up on white Mafia guys; it was "get whitey" time—which certainly added immeasurably to the popularity of their films. I know because I was there at the box office putting down my three dollars to see Jim Brown and Fred Williamson do their stuff. Yeah—I, too, enjoyed seeing the black guys beating up on the white guys for a change. It was delicious. And not only did I like watching the revenge syndrome at work, I also liked watching my fellow actors at work.[17]

Though Sidney Poitier enjoyed the blaxploitation films, shortly after the movement began he began to have concerns about their financiers' intentions. He explains:

> My understanding of the film business told me that the producers who were making black exploitation films were not interested in much beyond the buck; past the point where that buck stopped, there wasn't a genuine interest in the black audience as such. A healthy interest in the black community would have required a noticeable shifting of emphasis in the content and intent of such films, yet I noticed a dangerous disregard of the hopes and aspirations of black people. I reluctantly arrived at the conclusion that the black exploitation filmmaker, seeing the overwhelming response to the revenge syndrome, elected to use that one-dimensional theme as the dramatic frame for almost all the films they would make for black consumption. . . . Not one among these producers, to my knowledge, cared to think otherwise.[18]

Recognizing Hollywood producers' commitment to the limited blaxploitation formula, Poitier set out to make a film that would offer black moviegoers a different, yet recognizable, representation of the African American experience. One of the advantages that the actor had when he set out on that pursuit was that he had formed his own film company, First Artists. Importantly, in 1969, under the guidance of Creative Management talent agent Freddie Fields, Poitier cofounded the production company with Barbara Streisand and Paul Newman.[19] Artists functioned as a subsidiary of Warner Bros. using what was at the time a very unique business model. Each partner was guaranteed the opportunity to make three pictures as long as the projects' budgets did not exceed $3 million. In return, the actors would forgo their upfront salaries for a percentage of their respective film's final gross.[20]

Poitier's co-ownership of First Artists freed him from typical Hollywood constraints such as funding and distribution. However, when he initially pitched *Uptown* to the First Artists management team, they expressed concerns, because the first film that he directed for the company, *A Warm December* (1973), had failed to turn a profit. After hours of discussion with the management team, Poitier finally ended the conversation about whether or not he would make *Uptown* by explaining, "Look, whether you like it or not, my contract calls for you to give me up to three million dollars to make a movie. I intend to do this picture, so let's not create a problem for each other."[21] The management team relented, providing Poitier with the capital to make *Uptown*, which he also produced and starred in as Steve Jackson.

Given his status in the film industry, Poitier certainly wielded enough star power to make *Uptown* a success. Nevertheless, he envisioned the film with an all-black star cast and personally assembled the film's assortment of players, including Bill Cosby who costars as Wardell Franklin. Although Cosby is most well known today for his role as Heathcliff Huxtable on the highly acclaimed sitcom, *The Cosby Show* (1984–92), he was a staple of the entertainment industry long before that series' inception. Cosby initially achieved stardom in the 1960s, first as a comedian and then as an actor. Just as Poitier's early film roles forged a more progressive black cinematic image, Cosby's comic personality also cut against traditional constructions of black masculinity. Discussing the comedian's work in *Primetime Blues*, Donald Bogle explains, "Cosby perfected the persona of a man puzzled and frazzled by life's little absurdities and domestic headaches but he was always in control of his emotions. . . . To his credit, Cosby himself— the master of nonethnic anecdotes—never came across as a Black man trying to be white. He managed to hold on to his ethnic grit—through his rhythm and his attitude."[22] Cosby's safe yet charismatic persona allowed him to transition to television and film, where he starred in the groundbreaking series *I, Spy* (1965– 68), *The Bill Cosby Show* (1969–70), and movies such as *Man and Boy* (1971) and *Hickey and Boggs* (1972).

In addition to Poitier and Cosby, *Uptown* features several other prominent black actors. The film stars Harry Belafonte and Calvin Lockhart in the roles of rival gangsters, Geechie Dan Buford and Silky Slim, respectively. Moreover, popular comedians, Flip Wilson and Richard Pryor, and renowned actor, Roscoe Lee Brown, make cameo appearances in *Uptown*. In addition to recruiting

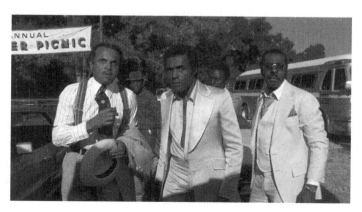

Figure 23 Harry Belafonte, Calvin Lockhart, et al. in *Uptown Saturday Night*.

a bevy of black talent to appear in the film, Poitier also provided African Americans opportunities to work behind the camera. In total, *Uptown*'s crew comprised more than 1,300 blacks in acting and studio jobs. Significantly, "at least one out of four of the technical crew . . . was black," an extremely diverse group given Hollywood's history of discrimination against blacks in all aspects of the motion picture industry.[23]

Penned by Richard Wesley, *Uptown* tells the story of Steve Jackson and Wardell Franklin, two working-class buddies, who devise a plan to visit Madame Zinobia's, an illegal after-hours place of leisure for the black elite. Dressed in their nicest suits and using a fake letter written on a letterhead introducing them as diamond moguls, Jackson and Franklin gain admission into Zinobia's, taking full advantage of the hip establishment's offerings. Unfortunately, their evening is cut short when armed, masked men break in and rob Zinobia's. Among the items that the robbers steal is Jackson's wallet, which he later discovers contains a winning lottery ticket. Determined to regain the ticket so that he can collect the $50,000 prize, Jackson and Franklin take to the streets in search of the men who committed the crime. Their hunt leads them to gangster Geechie Dan Buford who they initially suspect robbed Zinobia's. However, their meeting with him is interrupted by rival gang member Silky Slim, who is attempting to negotiate a partnership with Buford. Jackson and Franklin immediately recognize his distinct voice as the lead Zinobia robber and inform Buford, explaining that among the items that Slim stole is a letter detailing the whereabouts of $300,000 worth of diamonds. Anxious to get his hands on the jewels, Buford strikes up a partnership with Slim, Franklin, and Jackson. The remainder of the film chronicles Franklin and Jackson as they attempt to outwit the gangsters and gain access to the items stolen from Zinobia's so that they may recover the winning lottery ticket.

The narrative

Uptown's narrative deviates from blaxploitation films' most pervasive storylines and themes, which shifted in the years immediately following *Cotton Comes to Harlem*'s release. Specifically, *Harlem* followed the traditional detective film narrative—a crime is committed, which prompts the hero/heroine's search to discover the perpetrator and uncover his/her motives—yet also incorporated comedic elements. Ensuing films such as *Sweetback* and *Super Fly* added the

final two predominant blaxploitation characteristics, violence and a display of black sexuality, and emphasized grittier crime–action–ghetto narratives in which black protagonists overcame white villains. For example, *Sweetback* depicts the title character killing two white police officers and successfully escaping to Mexico, while *Super Fly*'s Youngblood Priest overcomes a racist white police commissioner who is pressuring him to continue selling drugs on his behalf.

Importantly, crime–action–ghetto narratives represent blacks metaphorically overcoming the racism perpetuated against African Americans by the oppressive establishment or "The Man." However, as David E. James explains in "Chained to Devil Pictures":

> The utility of that image was compromised and almost entirely countered by the displacement of attention away from the properly political analyses of the situation of Black people and from the possibilities of ameliorating it by systemic social change. By focusing the problem of the ghetto exclusively on local criminal issues, blaxploitation spoke directly to the everyday experience of its audience; but its generic conventions—the redress of wrong by the superhero vigilante rather than by community control; the portrayal of corruption as a police or Mafia aberration rather than as endemic and structural; the backhanded glorification of heavy drugs, prostitution, and other forms of self-destruction that sublimated resentment rather than channeling it in socially useful directions; and a chauvinist, macho anti-intellectualism—allowed for a vicarious release of anger in ways that threatened the power and prejudice of neither the state nor its local institutions.[24]

These storylines became so popular with fans of blaxploitation cinema that, by the time United Artists released the *Harlem* sequel, *Come Back Charleston Blue* (1972) 2 years after the original, the film's light approach seemed like a vestige of the past and failed to connect with audiences.[25]

In regard to the narrative, *Uptown* is comparable to *Harlem*, rather than more violent, gritty canon blaxploitation films like *Sweetback*, *Shaft*, *Super Fly*, and *The Mack*. Like the pioneering blaxploitation movie, it also follows the traditional detective film narrative. However, while *Harlem* chronicles two police detectives whose job is to seek justice, *Uptown* features a pair of reluctant, untrained sleuths. As Poitier explained in an interview with *Sepia* magazine, "[I] sought out to create a comedy set in the black community, a story of the chase by a pair of amateur detectives . . . after some hoodlums who have robbed them in an after-hours night club."[26]

Uptown operates as a significant alternative to the blaxploitation films that were dominating the box office at the time of its release, because it is a comedy that moves away from the allegorical tales of black victory over white. Instead, the villains are black gangsters, Geechie Dan Buford and Silky Slim, who resort to illegitimate means in their attempt to achieve the American Dream. In doing so, they prey upon their own people, adding yet another obstacle for blacks suffering from the US social, economic, and political discrimination to overcome. Rather than depicting Jackson and Franklin metaphorically defeating "The Man," they outsmart Buford and Slim, ridding the black community of dangerous criminals. Moreover, the duo also regains the lottery ticket that allows them to legitimately overcome their working-class environs that emerged as a result of white flight, power, and privilege.

The characters

In addition to moving away from the crime–action–ghetto narrative, *Uptown* features a construction of black male identity vastly different from the violent, hypersexualized characters presented in blaxploitation films. As Donald Bogle explains, blaxploitation cinema "introduced the new style black film (based on dissent and anger) in which the black male's sexuality, for too long suppressed, had come to the forefront. Now the bucks took center stage."[27] Defined as "big baadddd niggers, oversexed and savage, violent and frenzied as they lust for white flesh," it can be argued that traces of the buck are visible in *Shaft*'s title character and *Super Fly*'s Youngblood Priest.[28] For example, the former features John Shaft as a street-savvy private detective, quick to resort to violence, and seemingly always on the prowl for his next sexual conquest. Similarly, *Super Fly* depicts Youngblood Priest as a street-wise drug dealer trained in martial arts. He also has relationships with a white woman and a black woman whose primary goal in the film seems to be to fulfill his sexual desires. Though liberating for black audiences, these characters also had the potential to reinforce whites' long-standing fears about black masculinity.

Critics of blaxploitation cinema were disturbed by the hyperviolent and oversexed representations of the films' black male protagonists. Specifically, in "Shaft Can Do Everything, I Can Do Nothing," the *New York Times* critic Clayton Riley explained: "A swift fist and a stiff penis, that's the Shaftian way: pistols and dynamite are only optional equipment. The wonder is that grown

men can still play such games with themselves in producing—even as escapist entertainment—the sort of simplistic macho violence Shaft employs in his encounters with both men and women."[29]

Super Fly suffered from similar criticism. Tony Brown, who at the time of the film's release, was the executive producer of television's *Black Journal* and dean of the School of Communications at Howard University, asserted:

> Self hate . . . is being packaged in such films as *Super Fly*. The major film studios appear to have become the new pushers in the black community—selling dope, prostitution, and degenerate heroes in a careful mixture of sex, violence, and white women. Obviously what is needed by the Black community to counteract this type of *Super Fly* blaxploitation is a BIG BLACK SWAT.[30]

The Steve Jackson and Wardell Franklin characters mark important departures for both Poitier and Cosby, who became stars appearing as "acceptable" middle-class black characters in Hollywood productions geared toward largely white audiences. While such representations were necessary during the 1960s, as the ideology of the civil rights movement shifted from Dr King's nonviolent protest to Black Nationalist philosophies, Poitier and Cosby were able to explore characters more firmly rooted in the working-class black community. For example, gone are the middle-class environs and three-piece suits that had played such an integral role in constructing the performers' "safe" screen personas. Like many of their blaxploitation counterparts, Jackson and Franklin are depicted as blue-collar citizens living in a predominantly black urban space where they endure the same systemic hardships as their African American brothers and sisters.

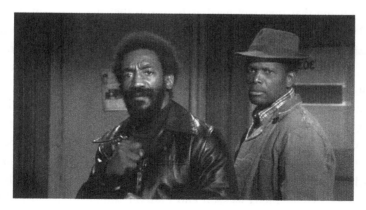

Figure 24 Cosby and Poitier in *Uptown Saturday Night.*

While Jackson and Franklin suffer from the same inequalities as many of their blaxploitation counterparts, *Uptown* parodies the burgeoning movement's hypermasculine heroes, a common cinematic occurrence. As Dan Harris explains in *Film Parody*, "As cinema quickly developed its own canons and conventions, it also began to parody its own narrative scenarios and device."[31] Although Harris is referring to the evolution of early motion pictures, the principle lends itself to blaxploitation cinema. After films such as *Harlem, Sweetback, Shaft,* and *Super Fly* firmly established the conventions of the blaxploitation movement, other black films began to parody its narrative devices.

Importantly, *Uptown* is not the outright mockery of blaxploitation featured in *I'm Gonna Git You Sucka* (1988), *Undercover Brother* (2002), and *Black Dynamite* (2009); instead, the film engages in subtle critiques recognizable to the segment of the black movie-going audience that had made blaxploitation cinema a success. For example, it is immediately apparent that Jackson and Franklin are parodies of prototypical blaxploitation protagonists when the duo sets out to recover the stolen lottery ticket. The characters lack the charisma and skills, both violent and sexual, that Shaft and Youngblood Priest possess. Therefore, much of *Uptown*'s humor derives from observing Jackson and Franklin navigate the streets as regular folk attempting to put blaxploitation protagonists' methods of operation into practice, actions that emphasize their normality. For example, when they initially begin their search, they are met with inquisitive, confused, and angry stares as they try to identify the Zinobia robbers simply by looking at them. The duo soon realizes that their strategy is not working one evening when the police arrest a suspicious-looking Franklin after they mistake him for a suspect in another crime.

Recognizing that they will need assistance if they are to regain the lottery ticket, Jackson and Wardell seek to hire a private detective, an act that further emphasizes the fact that they lack the same agency as blaxploitation's most notable protagonists. They turn to low-rent Private Detective Sharp Eye Washington (brilliantly played by Richard Pryor) who also emerges as a parody of blaxploitation heroes. Unlike John Shaft, who is handsome and suave, Washington's constant twitching and sweaty brow make him appear as if he is on the verge of having a nervous breakdown. While Washington's appearance and mannerisms make it clear that he is unlike the take-no-stuff blaxploitation heroes, he drives the point home when he takes direct aim at *Shaft*'s title character as he nervously enlightens Jackson and Franklin about the harsh realities of his job. He explains: "In the movies they always got some super nigga killin' them white boys in the mafia and beatin' up the crooked police. That's not true.

And women, black detectives in a movie always got the women. I haven't had a woman in months! That's the real truth of it." Here, Sharp-Eye Washington is clearly referencing John Shaft, whose confidence, penchant for violence, and sexual prowess allow him to effortlessly navigate Greenwich Village and Harlem as he works to solve his case. Moreover, whether intentional or not, Sharp-Eye Washington's dialogue adds validity to Clayton Riley's "Shaft Can Do Everything, I Can Do Nothing" article, which criticizes John Shaft as a dangerous and unrealistic construction of black masculinity.

After discovering that Sharp-Eye Washington is a con man, Jackson and Wardell once again take to the streets in search of the Zinobia robbers. It is here that *Uptown* continues to emphasize that the amateur sleuths lack the sufficient skills to solve the case, while further parodying blaxploitation protagonists. Their investigation leads them to The Waldorf, a seedy neighborhood bar, in search of a gangster named Little Seymour and his sidekick Big Percy. When they initially arrive at the tavern, none of the customers is willing to provide information regarding the whereabouts of Little Seymour. Determined to gather information, Franklin picks a fight with a meek customer that he easily dispatches and loudly declares to Jackson and the other patrons, "You dig it! You knock a dude down you get some respect!" The duo continues to try to lure Little Seymour out with insults, with Jackson firing the ever-dangerous barb at the gangster's mother. The diminutive Little Seymour eventually emerges alongside his menacing bodyguard, Big Percy. While it seems, that Big Percy should be their primary concern, it is Little Seymour who exacts revenge upon Jackson and Franklin, beating them both up to teach them a lesson about loud talking the wrong person.

The Waldorf scene further illustrates that Jackson and Franklin do not possess the same prowess as a John Shaft or Youngblood Priest who would have been capable of saving themselves from the situation. However, it is important to note that although not hypermasculine, Jackson and Franklin are not completely inept. In the end, they emerge as thinking folk who possess the mental capacity to outwit Silky Slim and Geechie Dan and reclaim the missing lottery ticket.

Black intimacy

In addition to providing an alternative to blaxploitation protagonists, Steven Jackson's relationship with his wife also breaks away from the problematic representations of black women and black intimacy depicted in many

blaxploitation films. Bogle explains: "Very few [blaxploitation] films attempted to explore a black woman's tensions or aspirations or to examine the dynamics of sexual politics within the black community."[32] Instead, females often emerged as sex toys for the films' protagonists. In "Brother Caring for Brother," Mary E. Mebane notes, "*Shaft's Big Score* (1972) actually opened on an explicit bedroom scene," while "*Black Caesar* (1973) includes a scene in which a black woman is beaten and sexually assaulted by the title character."[33] *Super Fly* depicts women in a similar light. Youngblood Priest has both a white girlfriend and a black girlfriend, whom he often treats with contempt. While his black love interest is significant to the film's conclusion, her most lengthy appearance is in an explicit sex scene between she and Priest.

In contrast, Jackson shares a warm relationship with his wife Sarah based on love, caring, and understanding. This is best exemplified in one of the film's early scenes when audiences first see the characters together in their very modest home. Jackson and Sarah reflect upon several of their memories, including how they initially met, their first date, and other events that occurred during their courtship. This quiet scene ends with Jackson telling Sarah that she is his queen. Although short, the scene is a marked contrast from blaxploitation films, as well as the majority of Hollywood cinema in that it depicts a moment of black intimacy rarely depicted on the silver screen up to that point in motion picture's history.

Uptown's release

Despite featuring an all-star cast and a fresh narrative, *Uptown* opened to mixed critical reception. For example, Vincent Canby of the *New York Times* wrote, "*Uptown Saturday Night* is essentially a put-on, but it's so full of good humor, and when the humor goes flat, of such good spirits, that it reduces movie criticism to the status of a most nonessential craft."[34] In contrast, Penelope Gilliat of the *New Yorker* criticized Poitier's performance, direction, and the film: "Poitier is not an inventive comic talent—he is erratic behind the camera and amiable but not funny in front of it. When the funny set pieces stop, the film sputters—but not before delivering a carnival of fine comic characters."[35]

Although *Uptown* garnered mixed reviews, the film further illustrated the black movie-going audience's viability and that African Americans would fill theaters to view other films besides blaxploitation offerings. In its opening week,

Uptown grossed $272,576 at the box office and appeared sixth on *Variety's* list of top grossing films.[36] It continued to perform well in the ensuing weeks, grossing $320,702 in its second week of release and $334,291 dollars in its eleventh week of release.[37] *Uptown* eventually grossed $7,400,000 in domestic film rentals, which was $1.4 million dollars more than *Shaft* had grossed 3 years earlier.[38]

Uptown's strong box office performance was a major validation for Sidney Poitier who commented, "The success of *Uptown Saturday Night* told me that black people wanted to laugh at themselves and have fun. They were weary of being represented on the local movie screen by pimps, hustlers, prostitutes, private detectives, violence, macho men, and dirty words. They wanted to have good clean family-type fun, and my recognition of that hunger committed me to try at fulfilling that need."[39]

Working from the aforementioned perspective, Poitier reteamed with Cosby for two more films, *Let's Do it Again* (1975) and *A Piece of the Action* (1977). Like its predecessor, *Again* is a comedy featuring an all-star black cast that includes Calvin Lockhart, John Amos, Denise Nicholas, and Jimmie Walker, among others. The film tells the story of Clyde Williams (Poitier) and Billy Foster (Cosby) who find themselves in a pinch with gangsters after they fix a boxing match to raise money for their fledgling lodge. In contrast, while *Action* features moments of humor, Ian Strachan explains in "The Measure of Men: Legacies of Poitier's *A Piece of the Action*" that of all the films that Poitier directed in the 1970s, *Action* "is the most ideologically, complex, the most overtly political, and the most prescient" (2012, 92). Set in Chicago, IL, the film chronicles successful master thieves Manny Durrell (Poitier) and Dave Anderson (Cosby), who have made a fine living stealing from "The Man." Their fortunes turn when retiring black police officer, Joshua Burke (James Earl Jones), blackmails them into taking on the challenge of transforming 30 incorrigible ghetto youth into productive citizens in a 3-week span. As Strachan summarizes,

> *A Piece of the Action* attempts cinematic sleight of hand. The film's narrative tries to have it both ways. On one hand, the film seeks to push all the buttons necessary to satisfy the expectations of black audiences who had enjoyed a steady diet of black outlaw heroes on the big screen: heroes birthed out of a Black Nationalist mood and a keen sense of alienation from mainstream America. . . .

On the other hand, it attempts to deliver the acceptably mainstream message of playing by the rules, respect for others, pulling oneself up by one's bootstraps

and pursuing the American Dream through honest hard work: an assimilationist message.[40]

Although *Again* and *Action* address vastly different themes, both achieved financial success, albeit to varying degrees. Released in 1975, the year marking blaxploitation's decline, *Again* provided a comical alternative to the waning blaxploitation cinema and continued to demonstrate that blacks were indeed a viable box office demographic, grossing $11.8 million in domestic film rentals.[41] Though *Action* proved the least lucrative of the three Poitier/Cosby films, accumulating $6.7 million in domestic film rentals, it is important to note that it was released in 1977 when Hollywood had ceased production of blaxploitation films in favor of crossover hits.[42] Thus, like its predecessors, *Action* continued to validate black filmgoers, while at the same time illustrating that African Americans remained hungry for cinematic representations of their experiences, subject matter that in Hollywood's crossover productions was and currently remains ignored.

Conclusion

The purpose of this chapter has been to discuss Sidney Poitier's *Uptown Saturday Night* as an alternative to blaxploitation cinema. It is important to note that this chapter is not meant to function as an outright criticism of those films, because at the times of their releases, blaxploitation pictures featured black heroes never before seen in Hollywood cinema and provided African Americans with an unmatched number of opportunities to work in the motion picture industry. Moreover, as S. Craig Watkins contends in *Representing: Hip Hop Culture and the Production of Black Cinema*:

> The mid-to latter part of the 1960s and early 1970s was a period of serious economic transition and uncertainty for the film industry as the realities of 'white flight' from increasingly volatile cities altered the profile of moviegoers accessible to the owners of theaters located in many downtown districts. Demographic shifts in the population meant that theater owners had to appeal to a growing concentration of young, black urban moviegoers. Blaxploitation was, in part, a swift response to a changing racial geography and market that allowed the film industry to recoup some of its financial losses during this period of transition by shifting some of its resources to the production of films that targeted young black moviegoers.[43]

Taking blaxploitation's significance into account, the films' limitations were their reliance upon hypermasculine heroes, crime–action–ghetto narratives, and their depictions of black intimacy. Poitier's *Uptown* functions as an important alternative to blaxploitation's dominant portrayals of black performers and black life. While his earlier characters demonstrated that black males were much more than toms, coons, and bucks, *Uptown* cut against blaxploitation's monolithic representations of black life, depicting working-class friends suffering from the same discrimination as an oft-ignored segment of the US black population. Moreover, the film is a comedy that depicts a healthy glimpse at black intimacy rarely before included in motion pictures. Thus, much like he had done early in his career, Poitier used *Uptown Saturday Night*, as well as *Let's Do It Again* and *A Piece of the Action*, to challenge Hollywood's predominant constructions of African Americans that have for all too long, on film and in the world at large, reaffirmed long-standing black stereotypes.

Unfortunately, *Uptown* is rarely discussed alongside Poitier's more popular films such as *In the Heat of the Night* and *Guess Who's Coming to Dinner*. To an extent, this is understandable given the film's lighthearted approach. However, if we are to properly evaluate and pay homage to Poitier, then we must include discussions of *all* of his work. With Will Smith having purchased the rights to *Uptown Saturday Night* with the intention of rebooting it with an all-star cast ala Steven Soderberg's *Ocean's 11* (2001), perhaps interest in the original will be renewed, earning it more attention in critical and academic discourse. To do anything less would indeed leave a significant gap in motion picture history and, more importantly, in Sidney Poitier's legacy.

Notes

1 Donald Bogle, *Toms, Coons, Mammies, Mulattos, and Bucks: An Interpretive History of Blacks in American Films* (New York: Continuum Press, 2003), 3–10.

2 Ibid., 175–6.

3 Novotny Lawrence, *Blaxploitation Films of the 1970s: Blackness and Genre* (New York: Routledge, 2007), 18.

4 Paula J. Massood, *Black City Cinema: African American Urban Experiences in Film* (Philadelphia: Temple, 2003), 87.

5 Ronald Gold, "Director Dared Use Race Humor: Soul as Lure for Cotton's B.O. Bale," *Variety*, September 30, 1970, 62.

6 Ossie Davis and Ruby Dee, *With Ossie and Ruby: In This Life Together* (New York: William Morrow, 1998), 335–6.

7 Amy Abugo Ongiri, *Spectacular Blackness: The Cultural Politics of the Black Power Movement and the Search for a Black Aesthetic* (Charlottesville: University of Virginia Press, 2010), 4.

8 Novotny Lawrence, *Blaxploitation Films of the 1970s*, 18–20.

9 Rudolph Chelminski, "'Cotton' Cashes In: All Black Comedy Is Box Office Bonanza," *Life*, August 28, 1970, 58.

10 Quoted in Ronald Gold, "Director Dared Use Race Humor: Soul as Lure for Cotton's B.O. Bale," 1.

11 Ibid., 1.

12 Rick Altman, *Film/Genre* (Britain: BFI Publishing, 1999), 61.

13 (*Variety* 1972, 2) "NCAAP Blasts 'Super-Nigger' Trend," *Variety*, August 16, 1974.

14 (*Independent Film Journal* 1972, 5).

15 (*Variety* 1972, 5).

16 (*New York Times* 1972, 3.19).

17 (1980, 339–40).

18 (Poitier 1980, 342).

19 In 1971 Steve McQueen became a partner in the company, followed in 1976 by Dustin Hoffman.

20 Barabaratimeless, http://barbratimeless.com/2009firstartists.htm, accessed, August 18, 2013).

21 (Poitier 1980, 346).

22 (2001, 115).

23 (*Sepia* 1974, 39),

24 (1987, 134).

25 Producers' reliance upon the crime–ghetto–action narrative played a seminal role in the blaxploitation movement's eventual demise. In *Framing Blackness*, Ed Guerrero explains that by the end of 1973, Hollywood perceived that black audiences were tiring of the endless reworking of the crime–action–ghetto formula and observed that successful black films like *Sounder* (1972) and *Lady Sings the Blues* (1972), which toned down the black–white confrontation, attracted black and white audiences alike (1993, 105).

26 (1974, 38).

27 (2003, 238).

28 (2003, 13–14),

29 (1972, D9).

30 (*Jet* 1972, 57).

31 (2000, 11).

32 (2003, 252).

33 (1973, 11.13.6).
34 (1974, 25).
35 (qtd. in Parish and Hill 1989, 328–9).
36 (1974, 12).
37 (*Variety* 1974, 9).
38 (Parish and Hill 1989, 327).
39 (Poitier 1980, 348).
40 (2012, 348).
41 (Parish and Hill 1989, 204).
42 (Ibid., 236).
43 (1998, 95).

Bibliography

Altman, Rick. *Film/Genre* (Britain: BFI Publishing, 1999).

"Barbaratimeless: The Second Decade." Accessed August 18, 2013, http://barbratimeless.com/2009firstartists.htm.

"Black Movie Boom—Good or Bad?" *New York Times*, December 1973.

Bogle, Donald. *Primetime Blues: African Americans on Network Television* (New York: Farrar, Straus, and Giroux, 2001).

—*Toms, Coons, Mammies, Mulattos, and Bucks: An Interpretive History of Blacks in American Films*, 4th edn (New York: Continuum Press, 2003).

Canby, Vincent. "Uptown Saturday Night," *New York Times*, June 17, 1974.

Chelminski, Rudolph. "'Cotton' Cashes In: All Black Comedy is Box Office Bonanza," *Life*, August 28, 1970.

Davis, Ossie and Ruby Dee. *With Ossie and Ruby: In This Life Together* (New York: William Morrow and Company, Inc., 1998).

Gold, Ronald. "Director Dared Use Race Humor: Soul as Lure for Cotton's B.O. Bale," *Variety*, September 30, 1970.

Guerrero, Ed. *Framing Blackness: The African American Image in Film* (Philadelphia, PA: Temple University Press, 1993).

Harries, Dan. *Film Parody* (Britain: BFI Publishing, 2000).

Independent Film Journal. "'Black'Lash on 'Black'Busters," September 4, 1972.

James, David E. "Chained to Devil Pictures: Cinema and Black Liberation in the Sixties," in Mike Davis, Manning Marable, Fred Pfeil and Michel Sprinker (eds), *Year Left Vol. 2: Towards a Rainbow Socialism-Essays on Race, Ethnicity, Class, and Gender* (New York: Verso Press, 1987).

Lawrence, Novotny. *Blaxploitation Films of the 1970s: Blackness and Genre* (New York: Routledge Press, 2007).

Massood, Paula J. *Black City Cinema: African American Urban Experiences in Film* (Philadelphia: Temple University Press, 2003).

Mebane, Mary E. 1973. "Brother Caring for Brother," *New York Times*, September 23, 1973.

"NCAAP Blasts 'Super-Nigger' Trend," *Variety*, August 16, 1974.

Ongiri, Amy Abugo. *Spectacular Blackness: The Cultural Politics of the Black Power Movement and the Search for a Black Aesthetic* (Charlottesville: University of Virginia Press, 2010).

Parish, James Robert and George H. Hill. *Black Action Films: Plots, Critiques, Casts and Credits for 235 Theatrical and Made-for-Television Releases* (Jefferson, NC: McFarland, 1989).

Poitier, Sidney. *Sidney Poitier: This Life* (New York: Alfred A. Knopf, 1980).

Riley, Clayton. "Shaft Can Do Everything, I Can Do Nothing," *New York Times*, 13 August, D9.

Sepia. "A Quarter Century of Movies for Sidney Poitier," August 1974.

Strachan, Ian Gregory. "The Measure of Men: Legacies of Poitier's *A Piece of the Action*," in Mia Mask (ed.), *Contemporary Black American Cinema: Race, Gender and Sexuality at the Movies* (New York: Routledge Press, 2012), 87–108.

"*Super Fly* Called 'Sophisticated Commercial for Cocaine,'" *Jet*, October 1972.

"Uptown Saturday Night," *New York Times*, June 17, 1974.

Watkins, S. Craig. *Representing: Hip Hop Culture and the Production of Black Cinema* (Chicago: University of Chicago Press, 1998).

Transcending Paul Poitier: *Six Degrees of Separation* and the Construction of Will Smith

Willie Tolliver Jr.

Will Smith now occupies a position in Hollywood that is unrivaled by any other black performer, and the meaning of his star status has historical and cultural implications that have not been fully examined. This analysis contributes to an examination of the Smith phenomenon by taking another look at his first major film performance in Fred Schepisi's 1993 film *Six Degrees of Separation*. Smith's being cast as the hustler who impersonates the son of Sidney Poitier has a particular rightness; Smith is indeed the inheritor of Poitier's legacy in terms of breaking new ground for blacks in film. It is significant that Smith was voted the top box office star of 2008 by the Quigley Poll, the first black actor to be so honored since Sidney Poitier in 1968.[1] Poitier won visibility and dignity for black representation in Hollywood film; Smith extends this legacy and engages racial representation as it intersects with class and gender. This complex of issues contained within Smith's screen personae sustains his iconicity, and these valances of significance find their source in his seminal performance as Paul Poitier in *Six Degrees of Separation*. Through close readings of Paul's characterizations of his "father" and of his conceptions of race and identity, this chapter explores how the image and meaning of Sidney Poitier shapes Paul's experience as well as Smith's profile as an actor. The objective is to demonstrate Smith's debt to Poitier and the ways in which his stardom extends and complicates the racial discourse established by his legendary predecessor.

From his emergence as a rap artist in the early 1980s through his transition to television in the situation comedy *Fresh Prince of Bel-Air* to his current position as a major figure in Hollywood, Will Smith has accomplished something truly remarkable. He is the most successful black man in the history of popular

entertainment. In terms of power lists, he is the number one black male, and he is second only to Oprah Winfrey.[2] The range of his appeal is unprecedented. For instance, he was the first black actor to rise to the top echelon of Hollywood stars who surpassed the $20 million per picture salary mark.[3] His films have grossed more than 4.4 billion dollars, a record no other actor, black or white, can surpass.[4] Smith is also the only black actor whose films are profitable beyond the parameters of the American market; his appeal is truly global. His achievement has not been given the full and serious recognition and analysis it deserves.

Why does this particular black male celebrity enjoy such acceptance across so many borders? Why is he able to reach such varying and even disparate audiences? Certainly his early success in rap and television laid the groundwork for an international profile. In terms of his personal traits, however, the immediate answer is his humor and charm, which constitute a currency that earns him universal good will. The other most often cited response is that he is nonthreatening. He does not fit the prevailing stereotype so often purveyed by popular culture of black men: a figure associated with violence, social aberrance, and hypermasculinity. This geniality, the point of commonality of his screen personae, has been deliberately cultivated to this end. The question remains: what does his atypicality mean, and what does it tell about the American and international consumers of his image?

The important work that Smith does through his film performances is to signify race for mainstream audiences. Smith functions as a text or an icon that signifies race, but does so in a way that contests given racial discourses. Does he in fact signify race in a different way, or does he signify a new and different code of blackness? Because of the ambivalence of his racial signifying, he is able to transcend established racial categories and thus to be read by a wide range of interpreters. He is a walking deconstruction, if a deconstructed text contradicts itself, and thus fails to convey a stable meaning. The way he contains contradictory racial messages may account for his pop cultural status. His messages are so oppositional that they speak to all cultural consumers, so contradictory that they cancel each other out and Smith emerges triumphant.

Smith's genius is that he is able to manipulate at will the racial sign, which for the most part he does not carry, and he does this better than any other contemporary black male actor. This racial dexterity is what differentiates him from other celebrated black actors such as Denzel Washington or Eddie Murphy. Smith is distinct from Washington and Murphy in that his portrayals

do not rely upon conventional notions of black identity. Both Murphy's and Washington's characters inhabit the world of racial difference in a way that Smith's do not. Smith's characterizations move the black male figure into new and unexpected spaces, and to the extent that he does this, he has cultural import and achieves iconicity.

Central to Smith's function as a racial paradigm is his early performance in *Six Degrees of Separation*. In Fred Schepisi's 1993 film adaptation of John Guare's play, Smith plays a con artist named "Paul Poitier," based on a real-life figure, who ingeniously gains entrance to the apartments of a series of influential New Yorkers. His ruse is to claim to be the son of Sidney Poitier, one of the Harvard friends of the children of these families. When he reveals the identity of his famous father, he turns to the audience to deliver a speech in which he recites the biography of Poitier. This moment situates Poitier, or the idea of Poitier, at the center of the film's racial discourse and its emphasis on the civil rights movement and issues of assimilation. This scene reveals what Poitier means to the characters within the film. For the Kittredges and the other duped families, Poitier functions as a touchstone for the liberal conscience: "the barrier breaker of the fifties and sixties."[5] Donald Bogle offers the following characterization of the Poitier appeal:

> Poitier's ascension to stardom in the mid-1950s was no accident . . . in this integrationist age Poitier was the model integrationist hero. In all his films he was educated and intelligent. He spoke proper English, dressed conservatively, and had the best table manners. . . . His characters . . . were the perfect dream for white liberals anxious to have a colored man in for lunch or dinner.[6]

For Paul himself, Poitier has a more expedient meaning. David Hampton, the real-life con-man model for Paul, disclosed that in order to gain entry to the legendary dance club Studio 54, he had to choose a celebrity as his fictional father. His choices were Sidney Poitier, Harry Belafonte, or Sammy Davis Jr. He chose Poitier because "he was the class act of the three."[7] In Poitier, Paul could not have a better model for fashioning an identity that would give him access, not only to the right clubs, but to Fifth Avenue as well.

Beyond this, in the diegetic world of the film, Paul's motives for impersonation and performance are never clear; he has no intention of theft or harm. When the police are called, the families are asked what crime has this young man committed. They can only answer: "He cooked us dinner. . . . He told us the story of *The Catcher in the Rye*."[8] He seems simply to want to have their lives for a brief

moment. He wants to be part of what America promises. His journey is a dream of assimilation, an archetypal journey from the margin to the center.

Scott Poulson-Bryant has written that the Paul Poitier character contains within his story the history of black people in America.[9] One can read this history in Smith's performance. This is borne out in this scene in which Paul prepares dinner for the Kittredges, the art dealer Flan, his wife Ouisa, and his South African client. Paul's journey from Central Park into the Fifth Avenue apartment of the Kittredge's is the assimilationist journey of the black man into the American dream and the price he pays for it. Paul desires entry in order to see for himself what it is he has been educated to covet. In order to gain entry, Paul has to wound himself (he stabs himself in the side and then rings their doorbells, begs for help, claiming to be a friend of their children). The wound is a metaphor for the psychic violence required for social acceptance. He has to discard his own identity, whatever it may have been, and put on another, emblematized by the metaphorical pink shirt, the possession of the Kittredge son. He has transformed himself into "a well-adjusted, articulate, deracialized, and desexualized preppy who espouses a colorblind, anti-affirmative action stance."[10] His new identity is one he has learned, appropriated, and constructed for his personal gain and for the assurance of his hosts.

In his next speech, Paul discusses how his father, Sidney Poitier, has no real identity because he is an actor: "he has no life—he has no memory—only the scripts producers send him in the mail through his agents. That's his past."[11] David Roman makes the observation that this concept of role-playing as identity is the essence of the black American experience, identity as a fulfillment of those social roles that have been conceptualized and authorized by the white

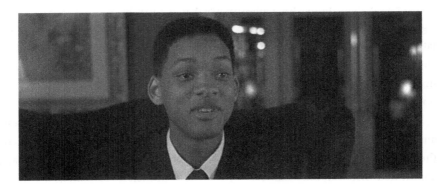

Figure 25 Smith plays Paul Poitier in *Six Degrees of Separation*.

power structure.[12] Certainly during the course of the evening presented in the film, Paul functions in a number of these prescribed social roles that historically have been designated for black people: he cooks the meal, cleans up afterward, and serves as the entertainment. As Jennifer Gillan observes, not only does Paul assume the role of Uncle Tom but Mammy as well.[13] His fascinating stories justify his presence; he earns his keep. Even more symbolic of Paul's ironic representation of black progress is the fact that he does get a place at the table, but (interestingly, at his own insistence) he doesn't get to eat.

Paul's remarks about his past, which he makes during his preparation of the dinner, reveal his maneuver to win the acceptance of Flan and Ouisa:

> I never knew I was black in that racist way till I was sixteen and came back here. Very protected. White servants. After the divorce we moved to Switzerland, my mother, my brother and I. I don't feel American. I don't even feel black. I suppose that's very lucky.[14]

Most interesting here is what Paul says about his racial identity. He uses his fantasy of Poitier's family life to construct an identity that transcends race through class privilege and celebrity. At one level, Paul's self-creation expresses a desire for class ascendancy. It also expresses a wish to be elevated out of racial definition. The fictional Paul has been created for this specific audience, and it is an identity that decentralizes or deracializes blackness in order to appease his well-intentioned white audience in the Kittredge kitchen. He communicates to them that he will not oblige them to confront the issue of race or their white guilt. As a result, they are free to embrace him. Still, there seems to be a deeper reason for Paul's denial of race and racism. Either he is operating out of self-hatred, or he has discovered a brave new world of deracinated, hybridized blackness.

Yet Paul takes his cue from his "father." In *Guess Who's Coming to Dinner*, Poitier effaces his blackness as a strategy to negotiate the approval of the father of the white woman he wishes to marry. In one scene, Poitier's character, John Wade Prentice, has a discussion with Matt (Spencer Tracey), his putative father-in-law, about the natural rhythm of black people. Prentice dismisses this notion as a myth. Matt insists.

> MATT: But hell. You can *see* it. Why, you can't turn on a television set without seeing those kids dancing—and I still say the colored kids—they're *better* than the white kids.
>
> JOHN: But there's an explanation for that. It's our dancing and it's our music. We *brought* it here. I mean, you can *do* the Watusi—but I am the Watusi.[15]

Notice in this scene how Poitier's character admirably refutes the common black stereotype and how indeed his entire character has been constructed to effect such a refutation. He even expresses black cultural pride. To contemporary eyes, Poitier's performance now seems remarkably assertive and confident, and in ways that are not replicated by the postracial star Will Smith. Poitier counters Tracy point for point, even to the point of reminding the older white man that he is going to marry his daughter and that, assuming that there will be children, he will also possess her sexually. Yet, despite this boldness, in the interchange about the Watusi, Poitier's character negotiates a subtle maneuver whereby he backs away from the idea of black exceptionality in favor of black normativity. At the end of the scene, Poitier suppresses an uneasy laugh as if in reaction to a bad joke. In his self-deprecation he assumes deference to Spencer Tracy, which goes beyond respectfulness of his elder to a reinforcement of racial hierarchy. This accommodation is the means by which Poitier's character achieves his goal of an interracial marriage. As dinner guests Paul and Poitier offer performances of blackness that dexterously engage race at the same time that they mask it, making it possible for them to get through the door and into the dining room of White America.

This avoidance of blackness is Will Smith's own strategy for shaping his persona and career. He takes Poitier's effacement of race to a new level. Smith's distancing of race has been often noted and critiqued. Victor Wong asserts that "[Smith] is clearly not linked with the ghetto culture of recent times, nor does he seem obviously to conform to any previous racist Hollywood stereotypes of black males. . . . Of past representations, he seems closest to the positive, non-threatening image of blackness created by Sidney Poitier."[16] The connection between Smith and Poitier in their removal from conventional black male identities is underscored by Bogle in his analysis of Poitier's appeal to America's then emerging black middle class:

> Black America was still trying to meet white standards and ape white manners, and he became a hero for their cause. He was neither crude nor loud, and, most important, he did not carry any ghetto cultural baggage with him. No dialect. No shuffling. No African cultural past. . . . In short, he was the complete antithesis of all the black buffoons who had appeared before in American movies. This was one smart and refined young Negro, and middle-class America, both black and white, treasured him.[17]

Both Poitier and Smith share an identity in crossover star status and their willingness to contain their blackness in order to attract audiences across racial

boundaries. Poitier was constrained by history into this position. Smith seems to have chosen this position of racial appeasement and denial as a deliberate career calculation and also as a matter of personal conviction. Wong notes how often successful color-blind casting works with Smith. Most of his film characters were conceived as white, and many of these roles were first offered to white actors. Wong concludes: "This would almost suggest that Will Smith does not even belong among Hollywood representations of blackness, being outside them—certainly he himself would seem to encourage such a view."[18] One telling detail about his own personal racial politics is his statement in an interview after the election of President Obama. He confessed the following:

> It was as if some part of me was validated. It was something that I've known for a long time that I couldn't really say: "You know guys, I really don't think America is a racist nation." I know that I feel like that sometimes but I just don't believe that. There are racist people who lived out there but I don't think America as a whole is a racist nation. Before Obama won the presidency I wasn't allowed to say that.[19]

That Smith should invoke Obama is not surprising. There are specific similarities between Smith and Obama in terms of the debates they generate. Obama's biraciality, educational background, and class status raise questions about the authenticity of his blackness. Likewise, Smith has had to withstand charges of inauthenticity from the beginning of his career as a middle-class rapper who crossed over to the mainstream.

Like their precursor Poitier, both are comfortable in white spaces, and both are black men with whom the white power structure feels comfortable. This is the truth then Senator Joe Biden declared in his much criticized comments about Obama on the eve of the 2008 Presidential campaign. He described Senator Obama as being "the first mainstream African American who is articulate and bright and clean and a nice-looking guy."[20] It has been commented about Smith that his casting in the Paul Poitier role ultimately made sense because he is "the sort of black kid white folks like the Kittredges might let into their home."[21]

These two black men, perhaps the most famous on the globe, are similar in their abilities to negotiate race on the public stage. Armond White claims that Smith may even have the edge. In his review of Smith's 2007 film *Hancock*, White writes:

> Smith and Obama . . . share a smooth, casual approach to popularity. Both accept racial identification but not in any polarizing way: their black, white

and in-between appeal has a beige complexion. Asserting or rescinding racial identity at will, Smith has mastered the game that Obama is just learning.[22]

Indeed, this is true. What Obama has recently accomplished in terms of racial legerdemain in the political field, Will Smith has been doing in Hollywood for the past 20 years.

These descendents of Poitier have answered his call, but with a variation. While Smith reiterates Poitier's containment of race, he also goes further to a position that could be termed postracial. (I use the term "post-racial" not in a political sense but to describe a trend in representation.) As has been stated earlier, what distinguishes Smith as a star is his ability to manipulate his signification of race. He wears his racial sign at will. Poitier, however, always wears the racial sign. The argument of his screen persona and his private identity is that he must be seen and valued for his character, but it is the color of his skin that gives that value meaning. Whereas Smith most often neutralizes race and becomes a figure that can be read in multiple ways.

Smith's move from the racial to the postmodern and postracial is exemplified in his performance as Agent James West in 1999's *Wild, Wild West*. This performance can be compared with Poitier's as Noah Cullen in the 1958 film *The Defiant Ones*. Both films are categorized as interracial buddy films, a genre through which Hollywood most often explores race relations in America. Throughout the history of these films, the partnering of the white male and the black male serves to valorize and benefit the former. The latter functions as a support or caretaker. Melvin Donaldson defines the plot formula as follows: "The relationship between the interracial male characters serves as the story's center or a focused plot point in the film. Usually antagonistic at the beginning, the development of the relationship and its consequential existence by the film's end are crucial to the story line."[23]

The Defiant Ones follows this master narrative as it also shifts the ideological bias from racial difference and hierarchy to racial understanding and equality. In the film, two prisoners Cullen (Poitier) and Joker Jackson (Tony Curtis) are thrown from a train that is transporting them to a penitentiary. The two are chained together as they struggle to escape. They must break through the racial, psychological, and cultural barriers that separate them in order to secure their freedom. The nuances of struggle can be seen in the sequence during which they have difficulties getting themselves out of a clay pit. As soon they climb to the top of the ravine, they fall back in the muck. This scene is faithfully reproduced in *Wild, Wild West*. Smith and Klein evade flying boomerang weapons by leaping

into each other arms and falling into a pool of mud. When they land, Smith feels an itch in his nose and sneezes comically into Klein's face.

Notice the difference in meaning and affect of the two scenes. In *The Defiant Ones*, the racial tension is manifest and constant. In *Wild, Wild West*, the struggle of the interracial male duo, two secret agents out to foil the treasonous plans of a madman, is played for laughs, which diffuses the tension. But the tension is different, and this is attributable to how Smith is read. His character carries no racial markers. In fact, the color-blind casting of Smith in the role of Agent West—originated on television by the white actor Robert Conrad—accentuates the character's anomalous racial profile. Smith's character is interestingly ahistorical, as a black federal agent in post–Civil War America would not exist; he would have to be an imaginary Negro. What does it mean for the interracial buddy dynamic when the black partner is not effectively black? If the racial edge is taken away, another tension emerges from the subtext of the genre: homoeroticism. Indeed, throughout the film the interactions between Smith and Kevin Kline have a homoerotic charge that hovers between the implicit and the explicit. This intimation of same-sex attraction confounds the racial narrative here, opens up alternative space for black male representation, and allows Smith, by diminishing the threat of black male sexuality, to render his screen persona safe for mainstream consumption.

One of ironies of the history of African American male stardom is the declination in the line of development from Poitier to Smith. This is evident in the construction of their film characters in terms of their sexuality and heterosexual relationships. Within limits, Poitier's screen personae embodied, at times, a definite sense of sexuality as represented in their relationships with women, both black and white. Smith's characters are rarely seen as sexual beings with fully dimensional relationships with women of any kind. In his major Hollywood films, Poitier was paired with actresses in narratives that foregrounded his characters' chemistry with women. Most notable is his interplay with Abbey Lincoln in *For Love of Ivy*. As mentioned earlier, Poitier's Dr Prentice in *Guess Who's Coming to Dinner* asserts the inevitable sexual dimension of his future marriage to Joey. Their mutual physical attraction is obvious because, given the differences in their ages and accomplishments, there could be little else between them. Even in the 1965 *A Patch of Blue*, about the romantic bond between a young black man and a blind white teenager, the kiss between Poitier and Elizabeth Hartman carries a tremendous charge.

These are romantic moments and sexual postures that are not replicated in Smith's oeuvre. Smith seems instead to inherit the legacy of the sexless, suited Poitier in *In the Heat of the Night* (1967). Smith operates within a more progressive time than Poitier, one that generally does not have a problem with the spectacle of black male sexuality as evidenced by the reception of certain performances by such actors as Denzel Washington, Don Cheadle, Terence Howard, Wesley Snipes, and Jamie Foxx. Yet, Smith's characters are curiously desexualized as if they are products of the 1950s or early 1960s.

In his entire career, Smith has been paired with white actresses three times (*Bad Boys*; *I, Robot*; and *Hancock*), and in these films the relationships are more contentious than romantic. When he is paired with an actress of color, she is either Latina (such as Eva Mendes in *Hitch*, who has almost made a career out of starring opposite black male actors who are prevented from having white actresses as costars) or racially ambiguous (Rosario Dawson, Thandie Newton, Zoe Saldana). When he is depicted as being in a relationship with a black woman (*Independence Day*; *Wild, Wild West*; *I Am Legend*), the relationship is not sexualized, or the woman disappears from the narrative. In effect, Smith is as sexually constrained by Hollywood as Poitier was 50 years ago, if not more so.

Tom Carson, in an essay on race and sex in contemporary films, notes the persistent reluctance of Hollywood to cross the line in depicting interracial sexuality. This taboo and its attendant fear of black male sexuality have the effect of limiting artistic and career possibilities for black actors. Instead of being cast as romantic leads, the top-tier of black actors must find their niches in comedy and action genre films. For instance, Denzel Washington, whose position in the industry approaches Smith's, rarely plays a romantic lead, although he is more than suited for this character type. Even Smith himself is not immune to this restriction. In his analysis of *Hitch*, among the highest grossing romantic comedies in film history, Carson comments on how the film avoids the possibilities of interracial romance. Smith is paired with Eva Mendes, but the two comically never make a connection, which would not be the case with two white actors. Even more remarkable is the way the very formula of romantic comedy is distorted in order to avoid interracial coupling. Smith, as Hitch, the relationship advice guru, is the Cary Grant figure. Kevin James, as his bumbling client, is the Ralph Bellamy figure, the classic hapless second male lead. Amber Valletta is the romantic prize, the beautiful heiress or the Irene Dunne or Carole Lombard figure. In the typical narrative, Ralph Bellamy is displaced, and Cary Grant wins the affection of the heiress. According to this

narrative logic, at the end of *Hitch*, it should not be James and Valletta, but Smith and Valletta who march down the aisle. Given that Smith has the good will of the world's film audiences, it is not clear that these audiences would have a problem with this romantic match. It is Hollywood that has the problem, no doubt out of consideration for the economic forces that fuel filmmaking and that militate against pushing envelopes and taking risks. One might wonder why Smith, who can do virtually whatever he likes, still feels his film characters can operate only within the racial/sexual paradigms of the past. The answer is that he cannot afford to take any chances. Carson is explicit about this: "Will Smith may be the biggest African-American box-office draw in history . . . and his shrewdness about exactly what he can and can't get away with is a major reason he's successful."[24] This knowledge about the limits of his reach as a star is what he takes from Poitier, who, despite moments of resistance and masculine assertion, managed "to suppress any hint of sexual allure or interest."[25] This is a lesson that Smith has learned perhaps too well.

Yet, in terms of the representation of the male body, Poitier's body, despite the sexual interdictions and the reticences of his time period, emerges as an object of marked sexual allure in his films. In *Lilies of the Field* (1965), for instance, Poitier's body is on constant display in tight white pants, and he is often caught in various states of undress. His body is offered up to the gaze of the audience and even to the nuns in the film, who are not unappreciative. In *To Sir, with Love* (1967), as Mark, the high school teacher in London, he is the recipient of admiring looks from his female students as well as women on the public buses. Smith never receives this kind of obvious sexual objectification. Smith's body is often discussed, particularly in terms of the increase of his musculature over the course of his career. His body functions very much as does any male action star (Arnold Schwarzenegger, Sylvester Stallone)— as functional armor, but not unambiguously as the object of desire. This distinction is most clear in Smith's one nude scene in 2004's *I, Robot*.[26] At the beginning of the film, his character, Del Spooner, is seen taking a shower and the camera slowly tracks into the bathroom to the bathtub where he stands. The details of the mise-en-scène are meant to project his vulnerability and paranoia, and not his sexual appeal. To heighten this effect, the scene was to feature Smith in frontal shots. However, as he joked on talk shows during the film's initial release, his penis was digitally removed for the American market. This anecdote reveals, in its most explicit and literal form, a motivation behind the history of the cinematic representation of the black male body,

including the star personae of both Poitier and Smith: namely its project of emasculation.

Smith's transformation of the black male star from Poitier's civil rights–era symbol into a postmodern, postracial global icon can also be traced by the way the two actors differently inhabit the essential sartorial symbol of masculinity: the two-piece suit. From its invention during the Industrial Revolution in the nineteenth century as a function of the establishment of the processes of capitalism (the mass production of men's clothing requiring regimentation in order to secure profits), the men's suit also developed as a representation of that capitalist power. The suit acquired social and cultural significance in that it became an indication of a man's removal from manual labor and his position as the owner of property and thus his status and power.[27] To the extent this power was maintained by a social hierarchy, it was predicated on the subjugation of bodies that did not have the means or access to this power—namely black men. The wearing of the suit by black men is a troubled phenomenon, and the wearing of this symbol of manhood has a special significance for the definition and assertion of black identity. Hazel Carby in *Race Men* notes how the formal suit and tie embodies black intellectual power as it is worn by W. E. B. Du Bois and Cornel West.[28]

On and off screen in his sleek and elegant dark suits, Poitier, along with the stylish Jazz men of the era, represented the advent of a new black masculinity in the early 1960s. Manthia Diawara claims that Poitier was the singular image of Pan African modernity, providing for the men who were to lead emerging African nations a paradigmatic style of black manhood to present on the international stage.[29] This image is most manifest in 1967's *Guess Who's Coming to Dinner* and *In the Heat of the Night*. Smith recognizes and signifies this image in 1998's *Men in Black*. He, too, appropriates the masculinist suit as he projects himself into the film markets of the world. The difference between Smith and Poitier in their wearing of the suit is that Poitier asserts his pride and accomplishment through the language of fashion, while Smith parodies and constrains black male power.

The narrative trajectory of *Men in Black* takes Smith's character, J, from the street to the center of the organization, a secret government agency that tracks aliens (from outer space). In doing so, the film replicates the process of integration and assimilation, and this transformation is carried out through J's changes of wardrobe. When he is recruited for the agency, he wears the brightly colored sportswear of youth culture: T-shirts, jogging pants, designer

sneakers, baseball caps. Upon his initiation into the company, he is rewarded with a black suit, which conveys multiple meanings. Instead of signaling black male pride in achievement, the suit represents a faceless authoritarian bureaucracy, the *Men in Black* or government agents out to suppress reports of UFO sightings. These figures were popularized by the comic books of Lowell Cunningham.[30] Smith's acceptance into the fold means cooption into the system, and the black suit becomes a marker of the conformity required for assimilation. In this process, his blackness is erased, and his unruly black body is contained by the black suit.

Despite this containment, Smith is able to maintain the essence of his black masculinity through the irruptions of cool in his attitude and dialogue. After the process of his identity reassignment is complete and Smith puts on the regulation suit, Tommy Lee Jones, as K the recruiting agent, tells Smith that this is "the last suit you'll ever wear." Smith quips to his new supervisor, "You know what the difference is between me and you? I make this look good!"[31] As Victor Wong notes, this affirmation of J's black identity moves Smith into a new territory of representation of young black males in mainstream American film. He writes: "Smith differs slightly from Poitier because, not only does he make blackness palatable, his blackness is eminently desirable, a trend that partly arises from hip hop. Where Poitier is 'non-funky,' J is very funky, and he knows it."[32]

Although Smith may assert blackness in specific moments in *Men in Black*, his authority is still undermined and ultimately diminished. In addition to the black suit, the final accessory Smith receives upon his successful initiation is a

Figure 26 Smith plays Jay in *Men in Black*.

weapon. The joke is that K gives J an unusually small gun, a "noisy cricket," while he gives himself an enormous "series four de-atomizer." This touch of humor refutes the myth of the big black penis. It also effectively emasculates Smith, allaying white male anxiety about black male sexuality, and thus rendering him safe for mainstream film audiences.

The transaction with the phallic guns has a specific cultural relevance. Smith in his uniform black suit can be read against one of the most controversial photographs in contemporary art: Robert Mapplethorpe's *Man in a Polyester Suit*. This photograph was part of the cultural zeitgeist at the moment of Smith's ascendance to major stardom. The image of a black man in a three-piece suit with his head cropped out of the frame and his outsized penis emerging from the fly of his pants has been criticized and rebuked for decades. Its importance lies in its direct visualization of the source of fear and anxiety within the American racist mind. Kobena Mercer describes its power:

> Mapplethorpe summons up one of the deepest mythological fears in the supremacist imagination: namely, the belief that all black men have monstrously large willies. In the phantasmic space of the white male imaginary, the big black phallus is perceived as a threat not only to hegemonic white masculinity but to Western civilization itself.[33]

In the initiation scene in *Men in Black*, Smith confronts this stereotype, recognizes it, and disarms it with his tiny gun. His ability to negotiate these images and to defuse them creates the possibility of his stardom. Poitier himself does the same, as Richard Dyer describes Poitier's persona coming "up against the backlog of images of black men."[34]

If there are similarities between Smith and Poitier in terms of the constitution of their star personae, it is because Smith has studied and mastered the career strategies of his predecessor. Both found a way to circumvent the barriers to their progress by containing their blackness and sexuality. Their reward is a popularity and acceptance that is global in scope. The more telling sign of that embrace is the way Smith in *Six Degrees of Separation* and Poitier in *Guess Who's Coming to Dinner* find their way into the hearth and home of liberal America. It is almost as though Smith takes Poitier's place at the table. "Paul" Poitier constructs a fictional identity in an act of imagination just as Poitier as a boy dreamed of another life. For Paul "the imagination is the passport we create to take us into the real world."[35] He never gets to that world. Paul may claim to be Poitier's son, but it is the actor who portrays him who actually fulfills and surpasses that dream.

Notes

1 Jill Sergeant, "Will Smith Voted 2008's Top Money-Making Star," *Reuters*, January 2, 2009. Accessed March 3, 2010, http://www.reuters.com/article/idUSTRE50130820090102.

2 Howard Karren (ed.), "Power List 2007: Top 50," *Premiere*, May 26, 2008. Accessed September 30, 2010, http://www.premiere.com/actorspower-list-2007-top-50.html.

3 Victor Wong, "Men in Black: Does Will Smith's Race Matter?" *Alternate Takes*, July 21, 2005. Accessed February 17, 2010, http://www.alternatetakes.co.uk/?2005,7,6,print

4 Sean Smith, "The $4 Billion Man," *Newsweek*, April 9, 2007, 82–4.

5 John Guare, *Six Degrees of Separation* (New York: Vintage, 1990), 25. All quotations from the film are taken from the published version of the play.

6 Donald Bogle, *Toms, Coons, Mulattoes, Mammies, & Bucks: An Interpretive History of Blacks in American Film* (New York: Continuum, 1973, 1993), 175–6.

7 Jeanie Kasindorf, "Six Degrees of Impersonation," *New York*, March 25, 1991, 42.

8 Guare, *Six Degrees*, 58–9.

9 Scott Poulson-Bryant, "Dreaming Cinema: Acting Out," *Vibe*, February 1994, 96.

10 Jennifer Gillan, "No One Knows You're Black!: Six Degrees of Separation and the Buddy Formula." *Cinema Journal* 40 (2001): 49.

11 Guare, *Six Degrees*, 31.

12 David Roman, "Fierce Love and Fierce Response: Intervening in the Cultural Politics of Race, Sexuality, and AIDS," in Emmanuel S. Nelson (ed.), *Critical Essays: Gay and Lesbian Writers of Color* (New York: Haworth, 1993), 203.

13 Gillan, "No One Knows," 48.

14 Guare, *Six Degrees*, 30.

15 William Rose, *Guess Who's Coming to Dinner* Screenplay Final Draft, February 15, 1967. Accessed September 26, 2010, http://www.mypdfscripts.com/screenplays/guess-whos-coming-to-dinner.

16 Wong, "Men in Black."

17 Bogle, *Toms, Coons*, 176.

18 Wong, "Men in Black."

19 Leslie O'Toole, "An Interview with Will Smith," *The Daily Express*, January 13, 2009. Accessed February 17, 2010, http://www.dailyexpress.co.uk/posts/view/79786.

20 Adam Nagourney, "Biden Unwraps '08 Bid with an Oops!" *The New York Times*, February 1, 2007. Accessed September 30, 2010, http://nytimes.com/2007/02/01/us/politics/01biden.html.

21 Veronica Chambers, "Willing," *Premiere*, January 1994, 76.

22 Armond White, "The Pursuit of Crappyness," *New York Press*, July 24, 2008. Accessed October 9, 2008, https://master.nypress.com/21/27/news&columns/feature.cfm.

23 Melvin Donaldson, *Masculinity in the Interracial Buddy Film* (Jefferson, NC: McFarland, 2006), 10.

24 Tom Carson, "Skin Flicks," *Gentlemen's Quarterly*, June 2005, 120.

25 Ibid.

26 For a more complete discussion of the significances of Smith's body in *I, Robot*, see Palmer. Lorrie Palmer, "Black Man/White Machine: Will Smith Crosses Over." *The Velvet Light Trap* 67 (2011): 28–40.

27 For a full analysis of the meaning of the men's business suit, see Joanne Entwistle, *The Fashioned Body: Fashion, Dress and Modern Social Theory* (Cambridge, UK: Polity, 2000), 172–4.

28 Hazel Carby, *Race Men* (Cambridge, MA: Harvard, 1998), 21–2.

29 Manthia Diawara, "Poitier and the African Imaginary of Modernity," (keynote address presented at The Sidney Poitier International Conference and Film Festival, Nassau, Bahamas, February 23, 2010).

30 Lowell Cunningham, *The Men in Black* (Newbury Park, CA: Malibu Graphics, 1990).

31 Ed Solomon, *Men in Black (1997) Movie Script*. Accessed September 30, 2010, http:sfy.ru/?script=men_in_black.

32 Wong, "Men in Black."

33 Kobena Mercer, "Just Looking for Trouble: Robert Mapplethorpe and Fantasies of Race," in Houston A. Baker, Jr., Manthia Diawara and Ruth H. Lindeborg (eds), *Black British Cultural Studies* (Chicago: University of Chicago Press, 1996), 284.

34 Richard Dyer, introduction to *Heavenly Bodies: Film Stars and Society*, 2nd edn (New York: Routledge, 2003), 12.

35 Guare, *Six Degrees*, 34.

Bibliography

Bogle, Donald. *Toms, Coons, Mulattoes, Mammies, & Bucks: An Interpretive History of Blacks in American Films* (New York: Continuum, 1993).

Carby, Hazel. *Race Men* (Cambridge, MA: Harvard, 1998).

Carson, Tom. "Skin Flicks," *Gentlemen's Quarterly*, June 2005, 119–22.

Chambers, Veronica. "Willing," *Premiere*, January 1994, 74–7.

Cunningham, Lowell. *The Men in Black* (Newbury Park, CA: Malibu Graphics, 1990).

The Defiant Ones. Directed by Stanley Kramer, 1958 (Santa Monica, CA: MGM, 2001, DVD).

Diawara, Manthia. "Poitier and the African Imaginary of Modernity." Keynote address at The Sidney Poitier International Conference and Film Festival, Nassau, Bahamas, February 23, 2010.

Donaldson, Melvin. *Masculinity in the Interracial Buddy Film* (Jefferson, NC: McFarland, 2006).

Dyer, Richard. *Heavenly Bodies: Film Stars and Society* (New York: Routledge, 2003).

Entwistle, Joanne. *The Fashioned Body: Fashion, Dress and Modern Social Theory* (Cambridge, UK: Polity, 2000).

Gillan, Jennifer. "'No One Knows You're Black!': *Six Degrees of Separation* and the Buddy Formula." *Cinema Journal* 40 (2001): 47–68.

Guare, John. *Six Degrees of Separation* (New York: Vintage, 1990).

Guess Who's Coming to Dinner. Directed by Stanley Kramer, 1967 (Culver City, CA: Columbia Pictures, 1999. DVD).

Karren, Howard (ed.), "Power List 2007: Top 50," *Premiere*, May 26, 2008. Accessed March 3, 2010, http://www.premiere.com/actorspower-list-2007-top-50.html.

Kasindorf, Jeanie. "Six Degrees of Impersonation," *New York*, March 25, 1991, 40–6.

Men in Black. Directed by Barry Sonnenfeld, 1997 (Culver City, CA: Sony, 2002. DVD).

Mercer, Kobena. "Just Looking for Trouble: Robert Mapplethorpe and Fantasies of Race," in Houston A. Baker, Jr., Manthia Diawara and Ruth H. Lindeborg (eds), *Black British Cultural Studies* (Chicago: University of Chicago, 1996), 278–92.

Nagourney, Adam. "Biden Unwraps '08 Bid With an Oops!" *The New York Times*, February 1, 2007. Accessed September 30, 2010, http://nytimes.com/2007/02/01/us/politics/01biden.html

O'Toole, Lesley. "An Interview with Will Smith," *The Daily Express*, January 13, 2009. Accessed February 17, 2010, http://www.dailyexpress.co.uk/posts/view/79786

Palmer, Lorrie. "Black Man/White Machine: Will Smith Crosses Over." *The Velvet Light Trap* 67 (2011): 28–40.

Poulson-Bryant, Scott. "Dreaming Cinema: Acting Out," *Vibe*, February 1994, 96.

Roman, David. "Fierce Love and Fierce Response: Intervening in the Cultural Politics of Race, Sexuality, and AIDS," in Emmanuel S. Nelson (ed.), *Critical Essays: Gay and Lesbian Writers of Color* (New York: Haworth, 1993), 195–219.

Rose, William. *Guess Who's Coming to Dinner* Screenplay Final Draft. February 15, 1967. Accessed September 26, 2010, http://www.mypdfscripts.com/screenplays/guess-whos-coming-to-dinne

Serjeant, Jill. "Will Smith Voted 2008's Top Money-Making Star," *Reuters*, January 2, 2009. Accessed March 3, 2010, http://www.reuters.com/article/idUSTRE50130820090102

Six Degrees of Separation. Directed by Fred Schepisi, 1993 (Santa Monica, CA: MGM, 2000. DVD).

Smith, Sean. "The $4 Billion Man," *Newsweek*, April 9, 2007, 82–4.

Solomon, Ed. *Men in Black (1997) Movie Script*. Accessed September 30, 2010, http:sfy.ru/?script=men_in_black

White, Armond. "The Pursuit of Crappyness," *New York Press*, July 24, 2008. Accessed
 October 9, 2008, https://master.nypress.com/21/27/news&columns/feature.cfm

The Wild, Wild West. Directed by Barry Sonnenfeld (Los Angeles: Warner, 1999. DVD).

Wong, Victor. "Men in Black: Does Will Smith's Race Matter?," *Alternate Takes*, July 21,
 2005. Accessed February 17, 2010, http://www.alternatetakes.co.uk/?2005,7,6,print

Index

Alpert, Hollis 99, 108, 112
American Civil Liberties Union
 (ACLU) 150
An American Dilemma: The Negro
 Problem and Modern
 Democracy 46, 48, 89
American dream 171, 248
American Negro Theatre 21, 34, 48–51
Anderson, Esther (as Catherine Aswandu
 in *A Warm December*) 181–2
antimiscegenation 149, 151

Bad Boys 262
Bailey, Pearl 98, 113, 119
Baldwin, James 9, 10
Band of Angels, A 2
"Barack the Magic Negro" 18–19
Bardwell, Keith, Justice 145–6, 156
Barthel, Joan 164, 166–7, 169, 170
Beat Street 225, 226
Belafonte, Harry 13, 23, 61–2, 66–8,
 70, 111, 117, 120, 139, 163,
 171, 204, 206, 239, 255
Birth of a Nation 62–3, 169
Black Arts Movement 10, 165
Blackboard Jungle 7, 63, 65–6, 140,
 221, 233
Black buddy 76, 77, 184, 261
Black Panthers 167
Black Power Movement 8, 10–12, 21, 81,
 141, 221
 see also Black Panthers
"Black Rough Riders" 193, 194
Black sexuality (buck) 168, 169, 171,
 172, 179, 233
 see also Mr. T (Clubber Lang)
black sexuality (heterosexuality) 165–6
Black Skin, White Masks 171
blaxploitation (cinema) 23, 168, 178,
 180, 183, 218, 221–2, 234,
 237–8, 242–6

 see also Blaxploitation Films of the
 1970s: Blackness and Genre;
 Coalition Against Blaxploitation
Blaxploitation Films of the 1970s: Blackness
 and Genre 234
Bogle, Donald 64, 111–12, 189, 233,
 239, 255, 258
A Bound Man: Why We Are Excited About
 Obama and Why He Can't
 Win 19
Braithwaite, E. R. 129, 132, 135, 136,
 137, 141, 169
Brown v. Board of Education 47, 76,
 105, 196
Buck and the Preacher 23, 111, 180,
 189, 191, 194, 196–7, 204–7,
 209, 210, 219, 220, 221
"Buffalo Soldiers" 193, 194
Butch Cassidy and the Sundance Kid 206,
 208

Carmen Jones 107, 109, 111–12, 114
Carmichael, Stokely 9, 81, 167
Carroll, Diahann 21, 98, 106, 175
Cheadle, Don 262
 as Rhodey in *Iron Man* series 173
Churchill, Ward 190, 192
Civil Rights Act (1964) 76
Civil Rights Movement 75, 218, 221, 233
 1967 conference 9
 Civil Rights Bill (1966) 6
 civil rights campaign (1963) 9
 Evers, Medgar 167
 "I Have a Dream" 8
 March on Washington 9, 48
 Montgomery Bus Boycott 7–8, 81
 Voting Rights Act (1965) 76
 see also Civil Rights Act (1964); King,
 Martin Luther, Dr.; Southern
 Christian Leadership Conference
Clavell, James 129–37, 139, 141, 169, 221

Coalition Against Blaxploitation 236–7
Congress of Racial Equality 236
Coon 168, 233
Cosby, Bill 220, 221–3, 227, 239
 as Anderson, Dave in *A Piece of the
 Action* 247
 as Foster, Billy *Let's Do It Again* 247
 as Huxtable, Heathcliff *in The Cosby
 Show* 239
 see also Ghost Dad
Cotton Comes to Harlem 234–6,
 240–1, 244
Council for the Improvement of Negro
 Theater Arts 108
Cripps, Thomas 37, 110–11
Crow, Jim 6, 7, 12, 21, 122, 148, 151
Curtis Tony 75, 123, 217, 260
 see also Jackson, John "Joker"

Dandridge, Dorothy 98, 112, 119
Davis, Ossie 41, 50, 219, 235
Davis, Sammy, Jr. 98, 106, 113, 115, 255
Dee, Ruby 23, 41, 50, 206
Defiant Ones, The 7, 8–9, 74–5, 77, 78, 80,
 87–91, 112, 123, 164, 169, 172,
 182, 197, 217, 233, 260–1
Demille, Cecil B. 99–100
Drayton, Christina 147, 149
Drayton, Joey 146, 149, 152–5, 157
Drayton, Matt 13, 147, 149, 153, 157
Dreams of My Father 15
DuBois, W. E. B. 46, 264
Duel at Diablo 189, 192–4, 196–9, 201,
 202, 206, 210
Duncan, Todd 102–3, 120

E and R Productions 205
Eckstine, Billy 61–2, 69
Edge of the City, The 1
Ehrenstein, David 17, 18
Ellison, Ralph 31–2, 123
 see also Invisible Man
Elliston, Maxine Hall 167, 168, 171, 176
Endicott 84, 90, 91

Fanon, Frantz 171
Fast Forward 219, 220, 224–7
Fistful of Dollars, A 198

For a Few Dollars More 198
For Love of Ivy 166, 175–7, 181, 261
Freeman, Morgan 17, 173
Fresh Prince of Bel Air 253

Gable, Clark 2
Gates, Henry Louis, Jr. 169
Gershwin, George 98–103, 104–6,
 109–10, 114, 119–21
Gershwin, Ira 101, 102, 105, 120
Ghost Dad 219, 220, 227
Gillespie (Chief) 78–81, 83, 85, 87
Goldwyn, Samuel 4, 105–10, 112–14,
 119–23
Goudsouzian, Aram 170, 178
Guerrero, Ed 120, 170, 202
Guess Who's Coming to Dinner 2, 7,
 10–20, 64–5, 67, 136, 146–9, 152,
 154, 155, 157, 164–6, 167, 169,
 171–4, 176, 183, 189, 197, 210,
 233, 249, 257, 261, 264, 266
Gullah 101, 102

Hammerstein Oscar 100–1
Hansberry, Lorraine 109, 114
 see also Raisin in the Sun, A
Harlem Renaissance 99
Hemings, Sally 148
Hepburn, Katharine 16, 19, 147
 see also Drayton, Christina
Heyward, Dorothy 99–100, 103, 108
Heyward, DuBose 99–101, 103, 108
Hitch 262–3
hooks, bell 163
Horne, Lena 14
Houghton, Katharine 2, 165
 see also Drayton, Joey
"house Negro" 167
Howard, Terrence 262
 as Rhodey in *Iron Man* series 173
Humphrey, Beth 145–6, 156

I Am Legend 262
Independence Day 262
In the Heat of the Night 1, 7, 9–10, 13,
 16, 68, 74–7, 79–83, 85, 87–91,
 164–5, 167, 172, 174, 189, 197,
 217, 233, 249, 262, 264

intramasculine gender hierarchy 85
Invisible Man 31, 123
Island in the Sun 66–7
"Island in the Sun" 68

Jackson, Jesse 14, 19
Jackson, John "Joker" 75, 77, 79–82, 88,
 172, 260
Jackson, Michael 225, 226
 see also *Thriller*; *Wiz, The*
Jefferson, Thomas 148
Jewison, Norman 74, 217

Keyser, Lester 189, 192, 201
Khambatta, Persis (as Ray, Peris in *The
 Wilby Conspiracy*) 182–3
King, Martin Luther, Jr. 6–8, 11–14, 21–4,
 76, 81, 109, 132, 139, 148, 164,
 167, 233, 243
Kramer, Stanley 2, 11, 74, 112, 123, 147,
 154, 166, 217
Ku Klux Klan 155

Lee, Spike 225
 see also *Mo' Better Blues*; *School Daze*
Let's Do It Again 23, 180, 219–21, 223,
 247–9
Lilies of the Field 7, 9, 17, 163–4, 169,
 171–2, 197, 210, 218, 233, 263
Lincoln, Abbey 175, 261
Little Nikita 227
Little Rock School Integration
 Crisis 87, 90
Lockhart, Calvin 239, 247
Lonely Londoners, The 129
Long Ships, The 170, 177
Lost Boundaries 31
Lost Man, The 177
Loving v. Virginia 148, 149–51, 155–6

McKay, Terence 145–6, 156
McNally, Stephen (as Wharton in
 No Way Out) 36, 38–40, 46
"magic Negro" 7, 17–18
Malcolm X 68, 89, 167
Mammy 172, 257
Mamoulian, Rouben 100, 107, 120
Mandela, Nelson 19

Manifest Destiny 190, 191, 202
Mankiewicz, Joseph 32–3, 38–43,
 45, 112
"March Against Fear" 11
Marshall, Thurgood 14
Martin, Trayvon 169
"masculine sameness" 85
Mason, Clifford 10, 166, 168, 170,
 202, 204
Men in Black 264–6
miscegenation 67, 148, 151, 174
Mo' Better Blues 171
Myrdal, Gunnar 46, 89

NAACP 19, 32, 81, 150, 236
Newman, Paul 175, 238
"noble Negro" 167
Noonan, Ellen 101–3, 121
No Way Out 1, 4, 21, 31–4, 43, 46,
 49–53, 171, 172, 233

Obama, Barack 2, 5, 6, 13, 15,
 17–18, 24, 69–70, 157, 169,
 209, 259–60
 see also "Barack the Magic Negro"; *A
 Bound Man: Why We Are Excited
 About Obama and Why He
 Can't Win*; *Dreams of My Father*;
 "magic Negro"; *What Obama
 Means: for Our Culture, Our
 Politics, Our Future*
"Other" 83, 86
*Otto Preminger: The Man Who Would Be
 King* 98

Paris Blues 175
Parks, Gordon 219, 237
Parks, Gordon, Jr. 219, 221
Patch of Blue, A 1, 165, 169, 171, 173–4,
 210, 233, 261
Patriarchy 73, 85, 174
Peters, Brock 113, 118
"Phenomenology of the Black Body" 171
Piece of the Action, A 23, 180, 219, 220–2,
 224, 247–8, 259
Pieterse, Jan Nederveen 73, 74
Poitier, Jaunita 20
Poitier, Paul 217, 253, 255, 259, 266

Poitier, Reginald and Evelyn (Sidney
 Poitier's parents) 20, 173, 205
 see also E and R Productions
Poitier, Sidney
 as Brooks, Luther in *No Way Out* 1,
 35–43, 45, 172
 as Cullen, Noah in *The Defiant
 Ones* 9, 75, 77, 79–80, 82,
 85–6, 88, 90, 123, 172, 260
 as Durrell, Manny in *A Piece of the
 Action* 247
 as Higgs, Jason in *The Lost Man* 177–8
 as Jackson, Steve in *Uptown Saturday
 Night* 181
 as Kane, John in *Brother John* 179
 as Kimani in *Something of Value* 3
 *Life Beyond Measure: Letters to My
 Great-Granddaughter* 138
 Measure of a Man, The 138, 139, 167
 as Miller, Gregory in *Blackboard
 Jungle* 3, 65–6
 as Parks, Jack in *For Love of Ivy* 175–6
 as Porgy in *Porgy and Bess* 3, 115–20
 as Prentice, John Wade in *Guess Who's
 Coming to Dinner* 10, 15–16,
 65–6, 146, 149, 152–5, 157,
 172–3, 183, 257, 261
 as Ralfe, Gordon in *A Patch of Blue* 1,
 173, 183
 as Robertson in *Red Ball Express* 3
 as Ru, Rau in *A Band of Angels* 2
 "Sexless Sidney" 164
 as Smith, Homer in *Lilies of the
 Field* 9, 172, 183
 "Super Sid" (also Super Sidney) 79–80,
 86, 112, 174
 as Thackeray, Mark in *To Sir, With
 Love* 129, 130, 134–9, 140,
 183, 263
 This Life 138–9, 163, 180, 210,
 224, 237
 as Tibbs, Virgil in *In the Heat of the
 Night* 9–10, 16, 75, 78–80,
 83–7, 91, 165
 as Tibbs, Virgil in *The
 Organization* 179, 183
 as Tibbs, Virgil in *They Call Me Mr.
 Tibbs* 178, 183

 as Twala, Shak in *The Wilby
 Conspiracy* 180–3
 "Why Does White America Love
 Sidney Poitier So?" 166
 as Williams, Clyde *In Let's Do It
 Again* 247
 as Younger, Matt, Dr. in *A Warm
 December* 181–2
 as Younger, Walter Lee in *A Raisin in
 the Sun* 3, 16
Porgy and Bess 3, 4, 97–123, 170
 see also "Why Negroes Don't Like
 Porgy and Bess"
Preminger, Otto 35, 107–9, 113–15,
 118–19, 120
 *see also Otto Preminger: The Man
 Who Would Be King*
Pressure Point 171, 172
Pryor, Richard 220, 223–4, 244

Racial Integrity Act (1924) 150
racism 40, 48, 163
 Loving, Mildred Jeter 149–50
 Loving, Richard 149–50
 Loving Decision Conference 156
 see also Crow, Jim; *Loving v. Virginia*;
 Racial Integrity Act (1924)
Raisin in the Sun, A 3, 16, 109
Red Ball Express 3
Richards, Beah 146, 154
Rimler, Walter 103, 120
Robeson, Paul 61–2, 68, 69
Roundtree, Richard (as John
 Shaft) 179, 244
 see also Shaft; "Shaft Can Do
 Everything, I Can Do Nothing"
Ruszkowski, Andre 189, 192, 201

Sanford, Isabel 152, 172
School Daze 171
Schwerner, Michael 87–8
Seales, Lawrence 130–6, 140–1
Searchers, The 191, 195–7
Shaft 23, 237, 241, 242, 244
"Shaft Can Do Everything, I Can Do
 Nothing" 242, 245
Sharpton, Al 15, 18, 19
Shimkus, Joanna (as Cathy Ellis) 177, 178

Shoot to Kill 184, 227
Six Degrees of Separation 17, 69, 217,
 253, 255, 266
Slender Thread, The 171
Slotkin, Richard 190, 196
Smith, Mildred Joanne 172
Smith, Oliver 97, 114, 121
Smith, Will 17, 62, 68, 69, 249, 253–5,
 258–66
 as Agent James West 260
 as Spooner Del in *I, Robot* 262–3
 see also Bad Boys; *Fresh Prince of*
 Bel Air; *Hitch*; *I Am Legend*;
 Independence Day; *Men in Black*;
 Wild Wild West
Sneakers 184
Something of Value 182
Southern Christian Leadership
 Conference 6, 9, 20, 24, 236
Sportin' Life 113–15, 118, 121
Steiger, Rod 10, 13, 75
stereotype 7, 11, 14, 17, 62, 63, 67, 73–80,
 82–9, 91, 103, 109, 113, 166,
 168, 180, 194, 209, 233, 236,
 249, 254, 258
Stir Crazy 219–20, 222–4
Strange Life of Noah Dearborn, The 184
Superfly 23, 179, 181, 221, 236, 240–1,
 242–4, 246
Sweet Sweetback's Badasssss Song 23, 179,
 234, 240–1, 244
 see also Van Peebles, Melvin

Mr. T (Clubber Lang) 169
Thompson, Era Bell 109, 120

Thriller 225
Todd, Beverly (as Sally in *The Lost*
 Man) 177–8
To Sir, with Love 7, 9, 17, 64, 129, 137–40,
 163–4, 167, 169, 174, 189, 197,
 221, 263
Tracy, Spencer 2, 13, 16, 19, 147, 148,
 257–8
 see also Drayton, Matt

Uncle Tom 2, 16, 63, 167, 172, 233, 257
Unforgiven, The 191, 194, 195, 196, 197
Uptown Saturday Night 23, 180, 181, 219,
 220–1, 223, 234, 238–40, 242,
 244, 246–9

Van Peebles, Melvin 179, 219, 234
Villareol, Anthony 130, 138, 139

Warm December, A 23, 180, 181, 219,
 221, 238
Washington, Denzel 2, 62, 68, 254, 262
West, Cornel 166, 264
What Obama Means: for Our Culture, Our
 Politics, Our Future 19
"Why Negroes Don't Like *Porgy*
 and Bess" 120
Wilder, Gene 222–5
Wild Wild West 260–2
Williamson, Fred (*Black Caesar*; *Hell Up in*
 Harlem) 180, 221
Winfrey, Oprah 19, 254
Wiz, The 123, 226

Zanuck, Darryl F. 4, 33, 41, 44–7

Lightning Source UK Ltd.
Milton Keynes UK
UKOW06f2141220516

274799UK00009B/110/P